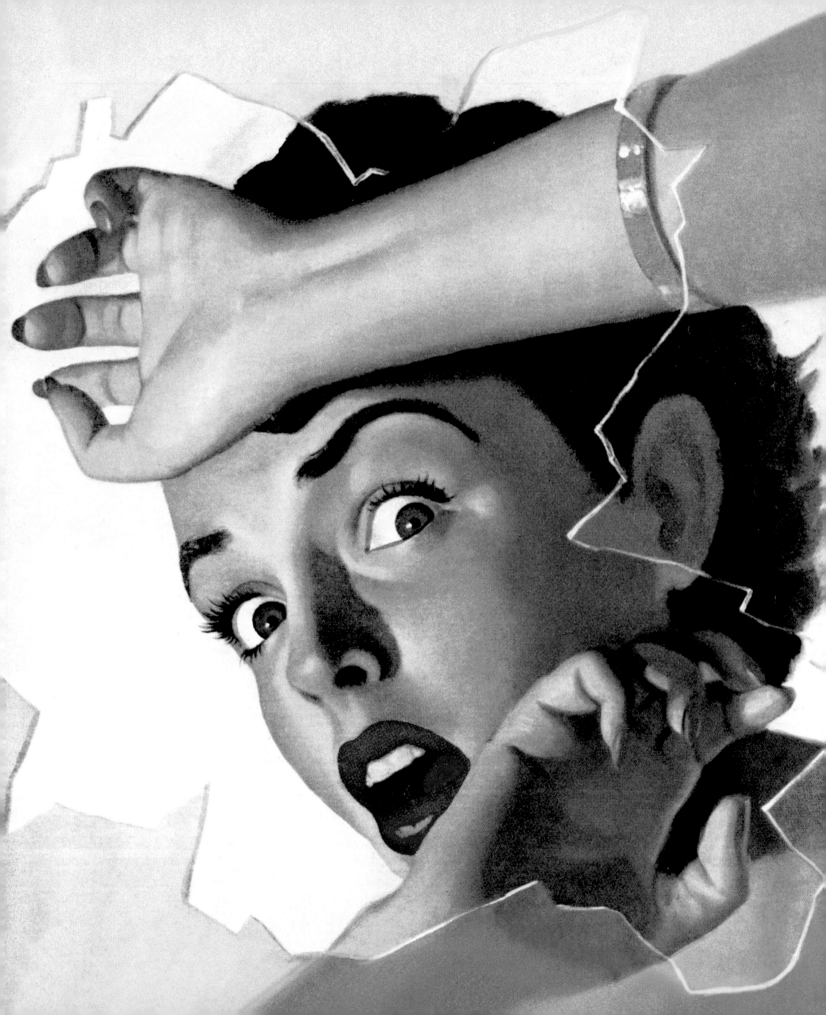

BY ERIC GODTLAND • EDITED BY DIAN HANSON

TRUE CRIME DETECTIVE Magazines 1924-1969

TASCHEN

HONG KONG KÖLN LONDON LOS ANGELES MADRID PARIS TOKYO

PAGE 1 *True Crime Cases*, September 1950

PAGE 2 *True Detective*, July 1953

OPPOSITE *Amazing Detective Cases*, July 1942

© 2008 TASCHEN GmbH
Hohenzollernring 53, D-50672 Köln
www.taschen.com

All text by Eric Godtland except as noted.
Edited by Dian Hanson, Los Angeles
Designed by Josh Baker and Cara Walsh, Los Angeles
Editorial coordination by Martin Holz, Cologne
German translation by Harald Hellmann, Cologne
French translation by Bernard Clément, Paris
Production by Stefan Klatte, Los Angeles

Printed in China
ISBN 978-3-8228-2559-4

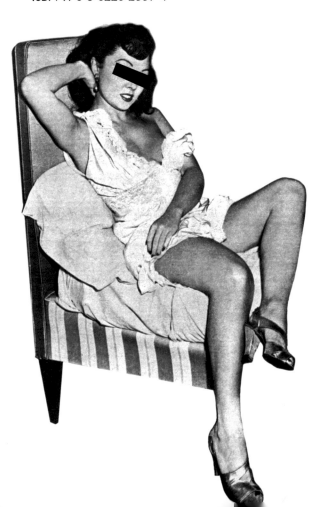

"FROM AUTHENTIC POLICE RECORDS"

TRUE CRIME DETECTIVE

MAGAZINES 1924-1969

Contents

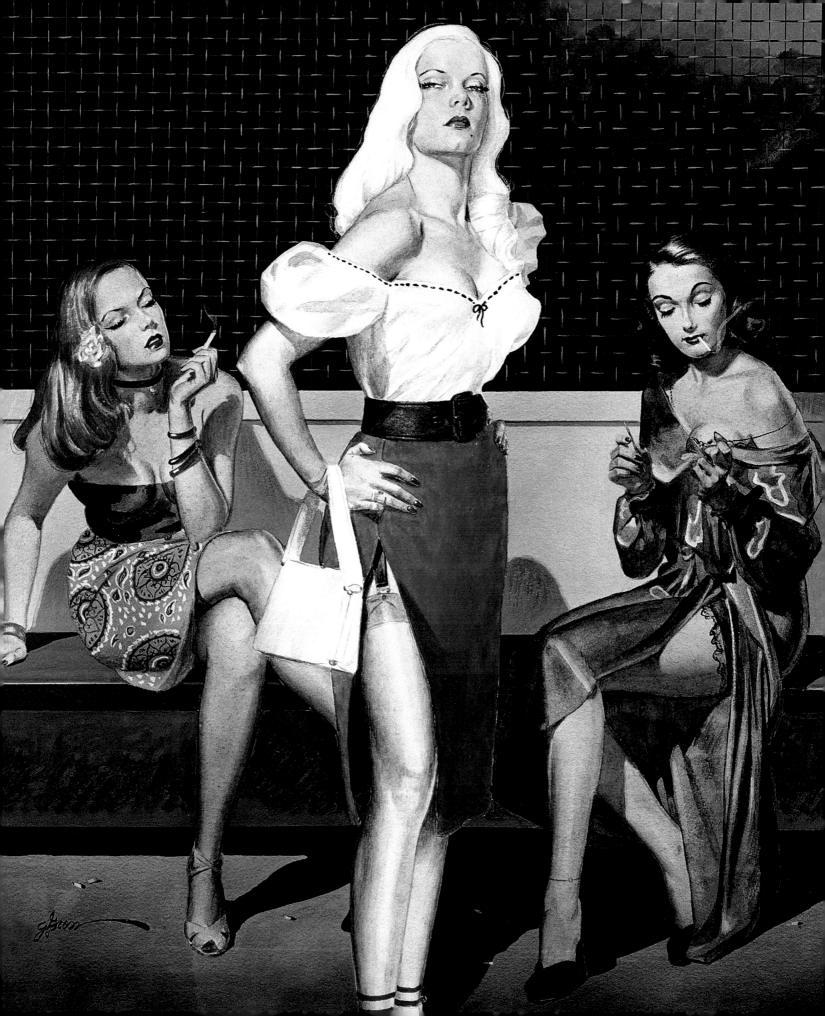

DETECTIVE MAGAZINES: THE PERFECT ORCHID

by Eric Godtland

Any screenwriter will tell you, "The only things every good movie script must have are sex and violence." Which is to say, life. Sex and violence represent the two peaks of human passion, man's greatest desire and direst fear, the best and worst of human existence, our beginning and our end. Perhaps this is why the combination of sex and violence is such a potent and irresistible taboo, not just the bones of a good film script, or a constant on the nightly news, but the basis for most entertainment today. Of course, news and entertainment have become essentially one. In all but the most primitive outposts people now expect to know what's going on all over the planet, to monitor not just the events in one's own neighborhood, but to check in on crises in Zimbabwe and scandal in Liechtenstein.

Wherever we go, in public and private spaces, the media feed us this colorful, voyeuristic parade of pumped-up human passion. At times we all disapprove, but that just means a particular image has exceeded our personal comfort level. In our hearts, we're all smitten. When the handsome hero defeats the bad guy to free the damsel, call it romance or adventure if you please, but boil away the heroic flesh and there are the same old bones. We're so used to feasting on the media's sex-and-violence stew we assume it has been this way forever, but mass media — born with the newspaper — is a relatively new development. Just 150 years ago newspapers were the province of the educated elite, providing the sort of sober coverage needed to keep the peasants in their place. It took pictures to capture the attention of the largely illiterate working class, the sort of pictures that made a visceral and immediate impact. Can anybody guess what kind of pictures these were?

It was crime and passion that led the illiterate to buy newspapers; sex and violence that made them want to learn to read, and one of the most important bridges leading from the original elite media to the current-events cacophony of today was the detective magazine. This genre was the first to artfully sensationalize all the prurient themes with which we are bombarded today.

What caused the detective genre to suddenly spring up in the mid-19th century? Print technology existed from roughly 1450, but in the 400 years between the invention of moveable type and the first true crime publications, who profited from the printing press? The answer is a very small percentage of the population. For the average European — the alehouse keeper, the corner gin-dram seller, the wood cutting/wool carding/hog farming peasants of the world — the printing press packed all the leisure time entertainment punch of a hand-operated gardening tool. The vast majority of the citizenry could not read and were wowed only by the occasional woodcut or copper litho of sensational or prurient interest. *Gin Lane* and *Beer Street* by William Hogarth caused such a stir in 1751, as did the occasional line drawings on broadsides depicting street crime, public hangings, bloody battles or the nefarious doings of "savage peoples" discovered on other continents. Entertaining as these depictions were, they differed greatly in intent and presentation from the true crime reporting and reality programming of today.

These early broadside illustrations were generally intended for a purpose beyond simple public information. Events and their depiction were carefully constructed to sway the public to a specific conclusion or moral end. *Beer Street* was a happy ideal, while *Gin Lane* was a hopeless wasteland. Neither existed; the illustrations were based on selected realities of the time, like political cartoons. Actual seedy and scandalous

OPPOSITE George Gross original, 1950

ABOVE *Dynamic Detective*, December 1937

> **"It was crime and passion that led the illiterate to buy newspapers; sex and violence that made them want to learn to read."**

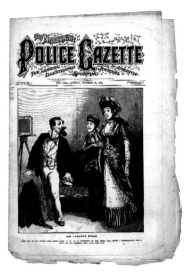

OPPOSITE *Nick Carter Weekly*, March 1902

ABOVE & BELOW *The National Police Gazette*, December 1895

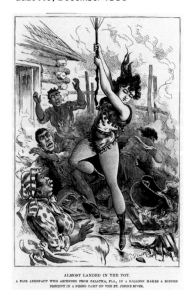

events were not yet fit subjects for news, just subjects for sermonizing.

Arguably, in this early era true crime coverage and other "reality" entertainment, so omnipresent today, took a back seat to reality itself. Among the illiterate, visceral mouth-to-ear stories and gossip held sway. For entertainment value the primordial media could not compete with actual public hanging, witch burning, Visigoth repelling, pestilence, famine, and day-to-day crime.

The cylinder printing press, invented in 1811, helped bring news from outside the neighborhood to the metropolitan rabble. During the 1830s further advances produced a "penny press," so named because it could turn out broadsheets cheaply enough to be sold profitably for a penny. Newspapers were suddenly within the means of most and began covering subjects of interest to a previously ignored group of readers: the working class. True crime coverage was quickly found to be a favorite with this newly literate sector. As both literacy and print technology further improved, the Western world experienced a newspaper boom. In the United States alone there were 2,526 separate newspaper titles published in 1850.

For America this print revolution coincided with an urban crime wave. In the big Eastern cities, New York in particular, crime proliferated within the hungry, packed-in, largely immigrant neighborhoods. With the rapid population growth people not only ceased to know their neighbors, they didn't know their neighbors' language, traditions, or social ways. With so many strangers and strange cultures thrown together, the fear grew beyond gossip's ability to convey it. It was within this climate of crime and fear of crime that true crime reporting began in earnest.

FATHER OF THEM ALL — *THE NATIONAL POLICE GAZETTE*

Through the first half of the 1800s crime story approaches were explored in both the daily papers and the weekly forerunners of magazine publishing. Publications flourished or died based on the public's opinion of these approaches. It was during this experimental era that the fundamental building blocks of the detective genre emerged: violence, scandal, and — most of all — sex. Naturally these elemental themes branched and spawned new interest-grabbing subthemes: rape, drug abuse, serial murder, bondage, and that Victorian favorite, moral degeneration. Many of the New York papers set themselves up as crusaders for the rights of the poor and justified stories on incest, rape, and other salacious crime as part of this campaign. No matter what the motive, this was the first time the press assaulted good taste and moral values. Its weapon was cheap pulp, a flimsy grade of paper favored by tabloids catering to the poorer classes.

The first wave of attack was textual; it was the second, visual leap that sowed the seeds of the 20th century detective magazine. This leap was taken by *The National Police Gazette*.

Like many newspapers of the mid-19th century, *The Police Gazette* took a sensational and prurient tone in covering crime, all in the name of moral public service. When it launched in 1845 it was, like its competitors, sparse on illustration. It wasn't until 1876 that the *Gazette* hit on the formula that propelled it ahead of the pack. This evolution is well summarized by Mark Gabor in *The Illustrated History of Girlie Magazines*:

"The National Police Gazette's *most active publishing years were 1845 to 1920. But its*

NICK CARTER
WEEKLY

Issued Weekly. By Subscription $2.50 per year. Entered as Second Class Matter at New York Post Office by STREET & SMITH, 238 William St., N. Y.

No. 272.

Price, Five Cents.

NICK CARTER AND THE GUILTY GOVERNOR
OR, THE AMERICAN DETECTIVE AND THE RUSSIAN OFFICER

"STAND BACK!" CRIED NICK, STERNLY; "THIS WOMAN SHALL NOT SUFFER FROM YOUR COWARDLY ATTACKS WHILE I CAN RAISE A HAND TO HELP HER."

BY THE AUTHOR OF NICK

MASSACRE MAP AND DIAGRAM

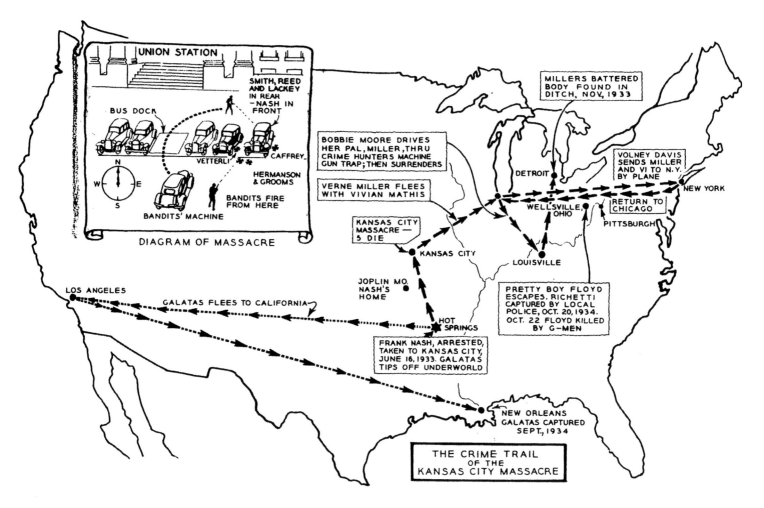

UNION STATION

SMITH, REED AND LACKEY IN REAR — NASH IN FRONT

BUS DOCK

VETTERLI

CAFFREY

HERMANSON & GROOMS

BANDITS' MACHINE

BANDITS FIRE FROM HERE

DIAGRAM OF MASSACRE

MILLERS BATTERED BODY FOUND IN DITCH, NOV. 1933

BOBBIE MOORE DRIVES HER PAL, MILLER, THRU CRIME HUNTERS MACHINE GUN TRAP; THEN SURRENDERS

VERNE MILLER FLEES WITH VIVIAN MATHIS

VOLNEY DAVIS SENDS MILLER AND VI TO N.Y. BY PLANE

DETROIT

NEW YORK

WELLSVILLE, OHIO

RETURN TO CHICAGO

PITTSBURGH

KANSAS CITY MASSACRE — 5 DIE

KANSAS CITY

LOUISVILLE

JOPLIN MO. NASH'S HOME

PRETTY BOY FLOYD ESCAPES. RICHETTI CAPTURED BY LOCAL POLICE, OCT. 20, 1934. OCT. 22 FLOYD KILLED BY G-MEN

LOS ANGELES

GALATAS FLEES TO CALIFORNIA

HOT SPRINGS

FRANK NASH, ARRESTED, TAKEN TO KANSAS CITY, JUNE 16, 1933. GALATAS TIPS OFF UNDERWORLD

NEW ORLEANS GALATAS CAPTURED SEPT., 1934

THE CRIME TRAIL OF THE KANSAS CITY MASSACRE

DILLINGER

history is best seen in two distinct phases — before and after 1876. The former represents the period of its truly crusading, albeit sensational journalism. The latter — reflected in The Gazette's switch from white to bright pink paper — is characterized by the addition of highly illustrated, purely exploitative stories on crime, sexual offenses, violence, impropriety, debauchery, vulgarity, brothels, and the dregs of urban life ...

"Richard K. Fox, the owner of the magazine from 1876 on and the man responsible for the 'new image' of The Gazette, was quoted as saying, 'If they can't read, give them plenty of pictures.'"

It was not just crime and vice that propelled *The Gazette* forward, but visual representation of these heretofore forbidden topics, especially the frank reporting of seduction, marital infidelities and other "indiscretions."

It was all there. Every element of the detective genre succeeded first in *The National Police Gazette* at least 50 years before the first true crime detective magazine was printed. Competitors to *The Gazette* clamored in, pushing the genre's limits and honing its style, but none had its staying power. Although the format changed many times, *The National Police Gazette* survived until 1982 for an astounding 137-year run.

WHY DETECTIVE MAGAZINES?

The development of the true crime detective magazine from *The Gazette* forward is the real story of this book and will be told decade by decade in the following chapters. Before we get there, however, it is interesting to discuss why the format succeeded so well, in any and every time period.

Although they have finally expired, true crime magazines enjoyed a surprisingly long and pros-

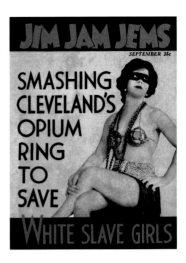
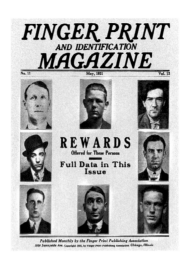

perous life, outliving much more mainstream and seemingly popular periodical categories. It is amazing to note that they sold steadily while photo-news magazines (*Life*, *Look*, *See*) and film magazines (*Film Fun*, *Screen Play*, *Photoplay*) declined and disappeared. Is the work of a detective that much more fascinating and special than a film actor's? And did some visionary realize in the 1920s that, "Yes! This is the form that will last for decades"?

Doubtful.

All fields of entertainment — literature, theater, periodicals, radio, film, television — began without convention. Each time a new medium is invented the workable formulas must be found. Terrible ideas must be explored to find the good ones, the perennial winners of a given medium. Was there any reason to believe that superheroes would dominate comics? Who knew that wrestling would work over and over on television, or that *TV Guide* would be the world's largest-circulation magazine? One-man plays? Killer fish films? Were any of these obvious? Trial and error turns up some strange favorites, and for a shockingly long time the detective format hung in there with the best, if not the best respected.

Detectives always inhabited the second tier of magazine publishing. It was the layer well below news and fashion, where niche markets are the target. Because niches are in constant evolution this secondary layer of publishing is very tumultuous, always in flux. The fan and craft magazines (remember needlepoint and woodworking?), hugely popular from the 1920s through the 1960s, have been almost completely replaced by pop biography, computer, and video game titles in the last 20 years. Car and music magazines continue through mutation and innovation, each new generation killing and consuming its parents. Remember the monster magazines? *Creepie*, *Eerie*, where are you? Replaced by *Scream Queens Illustrated*, I suspect. Better stay light and move fast if you want to make money selling folded paper from the second tier of the wooden racks. So in this constantly changing, fortune-dashing business, how did the seemingly oddball detective magazines not only hang on, but flourish, for a solid 70 years?

THE PERFECT HYBRID

With hindsight, the reasons for the success of true crime magazines are more obvious today than during their golden years. Now it is clear that they succeeded by being something akin to all of our modern reality programming wrapped in a single package. Detective magazines crisscross all human vice without getting mired in any one of them. They pull from every prurient fascination to create a stew of titillating Big Themes: vice, violence, sex, death. Before it devolved, the detective genre offered a safe vantage point from which to survey the whole of human weakness, and provided a balance with respect to the topic. When you bought a detective magazine you bought a license to investigate things that would otherwise be embarrassing to explore too deeply. In fact, "detective magazine" is a misnomer — true crime magazines were rarely about detectives. Instead, you, the reader, were the detective. Or perhaps more the detective's fellow traveler. It's the same way as while watching *America's Most Wanted*, or *Cops*, or *CSI: Miami* on American television today you are not a cop or a coroner, but nonetheless borrow a piece of those professions' sanction to hunt and pursue, to tackle and handcuff, to ghoulishly dissect and examine. Without this protective framework of identification with the cop or the coroner you might be seen (or

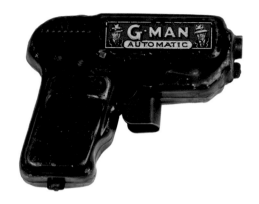

"Detective magazines crisscross
all human vice... they pull from
every prurient fascination to create
a stew of titillating Big Themes."

see yourself) as a thug or a ghoul. So it went with detective magazines.

If, in the 1930s or '40s or '50s, your mother, spouse or boss looked over your shoulder and saw a naked girl's body sawed in half and demanded to know, "What on earth are you looking at?" you had an alibi. "Oh Mom, it's just a detective magazine" apparently worked well enough to get some pretty sick stuff in the door month after month.

OK, so maybe you weren't a pro yourself, but you were shoulder-to-shoulder with the pros, looking at life head-on in order to make the world a better place; reading detective magazines was the act of a good citizen. And if you were also titillated by the pictures accompanying the story on wholesome Protestant girls sold into white slavery, that was an excusable side effect of your important research into the human condition. If anyone challenged your reading material as dwelling on sex or death, here is where the delicate moral balancing act came in.

Detective magazines may have been the perfect hybrid of the magazine world. What made them so perfect, and provides the true key to their success, is what they were not. Detective magazines were not girlie magazines, they were not horror magazines, they were not bondage magazines — yet they combined aspects of all these and more. One could not be accused of reading a directly classifiable, socially unacceptable "dirty" magazine when read-

ing a detective. They were full of shock and titillation yet were sold right out there on the newsstand with *Look* and *Life*, not under the counter with the perverted stuff. Sure, there were naked girls, and hot ones, too, "but it's a story about Chinese opium dens!" you could quickly point out to the skeptic, demonstrating that you didn't buy it based on woody potential; nudity was pertinent to the story. And all those gruesome hammer murders with grainy shots of bashed skulls? "There is great coverage of the trial" might have neutralized that one.

But what about when the magazines went into decline in the 1970s and desperate publishers pushed the prurient aspect to 11 on a scale of one-to-10? When covers showed naked girls bound and gagged, swinging upside down in remote back woods while red-necked assailants licked their chops and held Bowie knives to jugulars? At this point maybe the mom, the spouse, the boss would no longer buy your story about it being educational, but even at this point the psychological redirect could work for some.

If you were one of those readers with violent fantasies, one who really did just buy the magazines for the gore and misogyny, or even the rare reader who acted on his violent fantasies, that "detective" in the title allowed you to grasp at life's last little thread of decency, to still imagine yourself, somehow, as the good guy. The Detective.

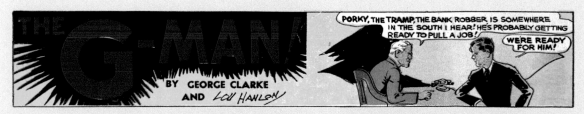

Follow the adventures of the G-Man every day in the Daily Mirror

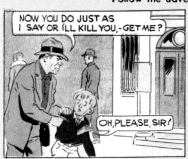

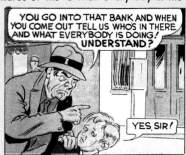

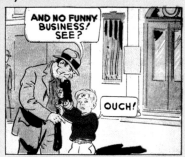

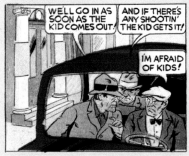

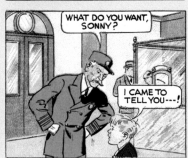

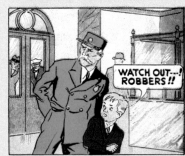

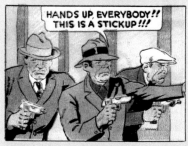

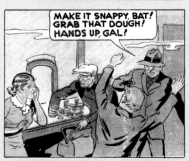

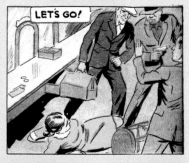

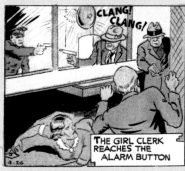

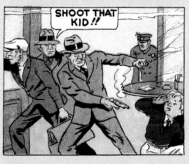

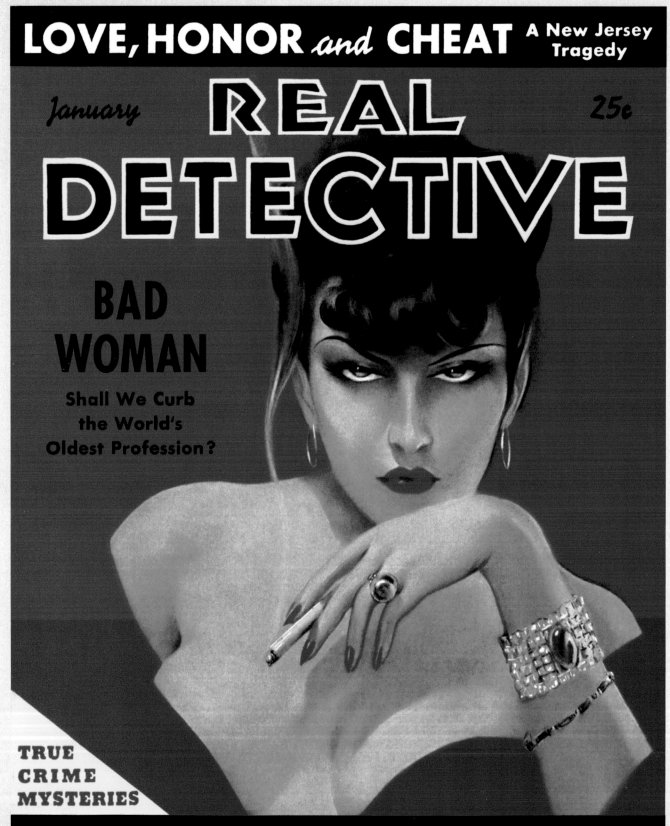

LOVE, HONOR *and* **CHEAT** A New Jersey Tragedy

January **REAL** 25¢

DETECTIVE

BAD WOMAN

Shall We Curb the World's Oldest Profession?

TRUE CRIME MYSTERIES

Clue of the **CLICKING BOOT HEELS**

How Washington's Society "Raffles" was Trapped

SMOKING!
by Eric Godtland

It is difficult today to understand exactly how a smoking woman was regarded in the early 20th century. If not precisely illegal it was nonetheless shocking, a mark of rebellion and moral degeneracy. To the first two generations of detective magazine readers, a woman with a cigarette was the incarnation of evil. From *The National Police Gazette*, June 1, 1895:

SMOKED LIKE A MAN

It was a Brooklyn young woman who startled and astounded the occupants of the smoking car of the Kings County [rail] road recently by settling herself comfortably in one of the seats and asking the nearest man for a match with which to light the cigarette she held daintily between her thumb and forefinger. She was young, handsome and fashionably attired, and when she had lighted the composition of paper and tobacco, she smoked with gusto.

The guard was so paralyzed with astonishment that he forgot to call out the next station.

The Gazette was a national newspaper, if a sleazy one, that found this occurrence so unusual it warranted a full write-up accompanied by a large litho illustration of the smoker. One imagines it provoked both outrage and arousal.

Remember the original Virginia Slims cigarette ad campaign of the late 1970s and early '80s? It tied a woman's right to smoke in with the women's liberation movement. At the turn of the previous century that was indeed the case, but few men or women embraced this scandalous liberation. For most Americans smoking represented nothing less than a disgusting affront to womanhood, the moral

Man kann sich heute nur noch schwer ausmalen, wie eine rauchende Frau im frühen 20. Jahrhundert auf ihre Zeitgenossen gewirkt haben muss. Das Rauchen war Frauen zwar nicht direkt verboten, aber es war schockierend, ein Ausdruck der Rebellion und ein Indiz für moralische Verkommenheit. Für die ersten beiden Lesergenerationen von Detective Magazines stellte eine rauchende Frau die Personifikation des Bösen dar. In der *National Police Gazette* vom 1. Juni 1895 lesen wir:

SIE RAUCHTE WIE EIN MANN

Die Passagiere im Raucherabteil der Kings-County-Bahn waren sprachlos, als eine junge Frau aus Brooklyn es sich auf einem der Plätze bequem machte und den neben ihr sitzenden Mann um ein Streichholz bat, um sich eine Zigarette anzuzünden, die sie geziert zwischen Daumen und Zeigefinger hielt. Sie war jung, hübsch und modisch gekleidet, und nachdem sie ihre Komposition aus Papier und Tabak entzündet hatte, rauchte sie genüsslich.

Der Schaffner war so konsterniert, dass er vergaß, die nächste Haltestelle auszurufen.

Die *Gazette* war zwar eine etwas anrüchige, aber doch überregionale Zeitung, die diesen Vorfall für so ungewöhnlich erachtete, dass sie ihr nicht nur einen Bericht wert war, sondern auch eine große Abbildung der Raucherin. Diese wird sicherlich ebenso viel Empörung wie heimliche Erregung ausgelöst haben.

Erinnert sich noch jemand an die erste Werbekampagne für Virginia Slims

Il est difficile aujourd'hui de comprendre exactement comment les fumeuses étaient considérées au début du XX^e siècle. Certes, les femmes avaient le droit de fumer, mais cette habitude choquait ; elle était le signe d'une rébellion et d'une décadence morale. Pour les deux premières générations de lecteurs de magazines policiers, une femme cigarette aux lèvres était l'incarnation du mal. Voici un extrait de la National Police Gazette du 1^er juin 1895 :

ELLE FUMAIT COMME UN HOMME

Une jeune femme de Brooklyn a récemment fait sursauter et sidéré les occupants du wagon fumeurs de la ligne ferroviaire de Kings County en s'installant dans l'un des sièges et en demandant au passager le plus proche une allumette pour allumer la cigarette qu'elle tenait délicatement entre le pouce et l'index. Elle était jeune, belle et vêtue à la dernière mode et quand elle eut allumé son mélange de papier et de tabac, elle fuma avec délice.

Le contrôleur fut si pétrifié d'étonnement qu'il en oublia d'annoncer l'arrêt suivant.

La *Gazette* était un journal d'envergure nationale, porté sur le scabreux. Son directeur trouva cet incident si saugrenu qu'il lui accorda un compte-rendu en bonne et due forme, illustré d'une grande lithographie de la fumeuse. On peut imaginer le scandale et l'excitation des lecteurs…

Vous souvenez-vous des campagnes publicitaires de la fin des années 1970 ? Elle présentait le fait de fumer comme un droit, dans la lignée du Mouvement de

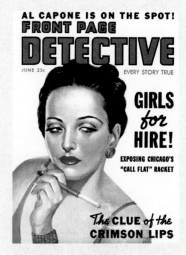

OPPOSITE *Real Detective*, January 1938

ABOVE *Front Page Detective*, June 1937

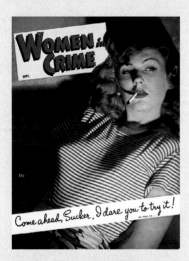

ABOVE *Women in Crime*, September 1947

CENTER *Real Detective*, April 1931

BELOW *Detective Cases*, October 1956

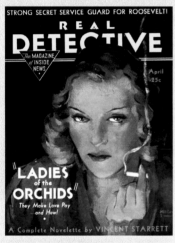

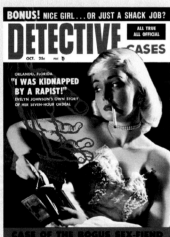

character equivalent of a woman who steals money from the blind and enjoys gangbangs with basketball teams. Utterly repulsive. Or was it?

The visual aspect of this moral outrage, however unacceptable, was an aphrodisiac for many men of the era. A woman who dared risk society's wrath by smoking was probably sexually daring as well. Sure, she was bad — and most certainly going to hell — but in the meantime she just might "let you …" The smoking woman used her mouth so provocatively, and this oral urge could lead to other things. This was the kind of girl who would come up and see your etchings, have some Madeira, and know all along that the etchings were not the point. Sure, you would have to be cautious. Any girl reckless enough to smoke would likely be mixed up in other things: rackets, white slavery, marihuana, or worse. You could end up in big trouble. She sure looked great sucking that cigarette, though …

Understanding the contradictory feelings about women and cigarettes lends perspective to the legions of smoking molls and dames that populated the detective magazines into the early 1960s. It was not the case, as those coming of age in our modern anti-smoking environment might assume, that "everybody smoked back then." Smoking was a statement, and women knew as well as men what image they were projecting when they did it. As the image changed with the decades so the covers changed on the detective magazines.

In the '20s smoking covers were rare, as women were mostly represented as damsels in distress to be rescued by the noble detectives.

In the '30s, when Ma Barker and Bonnie Parker could fire a gun with the best of the boys, cigarettes became part of the criminal profile. Bad girls sneered from the covers through plumes of sensual smoke.

In the early '40s the magazines took a dreary patriotic turn. Wartime requires men to embrace the hero fantasy, and women were once again portrayed as helpless victims awaiting rescue, or as agents of the military themselves. None of this left much room for bad girls or cigarettes. After the war bad girls returned with a vengeance, as men came home to confront wives and sweethearts grown independent while filling men's jobs in the factories. It was during this

in den späten 1970ern beziehungsweise frühen 1980ern? Da wurde das Recht der Frau, Zigaretten zu rauchen, mit der Frauenbewegung verknüpft. An der Schwelle zum 20. Jahrhundert war das tatsächlich so, doch nur wenige Männer oder Frauen begrüßten diese skandalöse Freiheit. Für die meisten Amerikaner stellte eine rauchende Frau eine abscheuliche Beleidigung des Weiblichen insgesamt dar und war moralisch so zu bewerten, als würde eine Frau Blinden Geld wegnehmen und Spaß am Rudelbumsen mit Basketballteams finden. Abgrundtief widerwärtig. Oder?

Die visuelle Seite dieser schockierenden Unmoral, so inakzeptabel sie war, wirkte damals auf viele Männer wie ein Aphrodisiakum. Eine Frau, die es wagte, sich der Verachtung der gesamten Gesellschaft auszusetzen, ging vielleicht auch in sexueller Hinsicht ein Stück weiter. Gut, sie war schlecht und würde sicherlich in die Hölle kommen, doch bis dahin konnte sie einen vielleicht …? So provokativ, wie die rauchende Frau ihren Mund einsetzte, konnten diese oralen Gelüste vielleicht noch zu etwas anderem führen. Natürlich musste man auf der Hut sein. Ein Mädchen, dass leichtlebig genug war, um zu rauchen, war vermutlich auch in andere schlimme Dinge verwickelt: in kriminelle Machenschaften, Mädchenhandel, Marihuana oder Schlimmeres. Da konnte man sich großen Ärger einhandeln. Aber sie sah schon klasse aus mit dieser Fluppe zwischen den Lippen …

Man muss sich der zwiespältigen Gefühle in Bezug auf Frauen und Zigaretten bewusst sein, um zu verstehen, warum rauchende Gangsterbräute und Flittchen bis in die frühen 1960er-Jahre hinein die Detective Magazines bevölkerten. Rauchen war ein Statement, und die Frauen wussten so gut wie die Männer, welches Image sie damit vermittelten. Dieses Image änderte sich natürlich im Laufe der Zeiten, was sich auch in den Covern niederschlug.

In den 1920ern sah man auf den Titelbildern kaum rauchende Frauen, denn Frauen waren meistens vom Typ verfolgte Unschuld, die auf die Rettung durch den edlen Detektiv wartete.

In den 1930ern, als Ma Barker und Bonnie Parker den Finger genauso schnell am Abzug hatten wie die Kerle, wurde die Zigarette zur Insignie der Kriminellen. In sinnliche Rauchschleier

Libération des Femmes. Au début du siècle, c'était sans doute le cas, mais peu d'hommes ou de femmes ont adhéré à cette libération. Pour la plupart des Américains, fumer n'était qu'un dégoûtant affront à la féminité, et la fumeuse était à peu près aussi immorale qu'une femme qui aurait dépouillé un aveugle ou pris du plaisir à se faire prendre à la chaîne par une équipe de joueurs de basket. Vraiment répugnant ! Vraiment ?

La représentation visuelle de cet outrage aux bonnes mœurs était un aphrodisiaque pour beaucoup d'hommes de l'époque. La femme qui osait défier les convenances en fumant était aussi audacieuse sur le plan sexuel. Elle était à coup sûr mauvaise et elle irait certainement en enfer, mais que de promesses annonçaient ces lèvres avides… La fumeuse se servait de sa bouche pour provoquer et cette oralité affichée suggérait d'autres plaisirs oraux. C'était le genre de filles capable d'accepter votre invitation à examiner vos estampes japonaises tout en sachant que ce n'était pas du tout d'estampes japonaises qu'il s'agissait. Évidemment, vous auriez à vous montrer prudent. Il était probable qu'une fille assez dépravée pour fumer soit mêlée à d'autres activités prohibées, racket, traite des Blanches, trafic de marihuana ou pire encore.

En comprenant les sentiments contradictoires qu'éprouvaient nos grands-pères sur les femmes et la cigarette, on apprécie à leur juste valeur les fumeuses qui peuplèrent les couvertures des magazines policiers jusqu'au début des années 1960. Les jeunes adultes de notre époque anti-tabac imaginent sans doute que « tout le monde fumait à l'époque ». Absolument pas. Fumer était une façon de s'affirmer et les femmes qui fumaient savaient quelle image elles projetaient en exhibant une cigarette. L'image de celle-ci changea avec les décennies.

Dans les années 1920, les couvertures avec fumeuses étaient rares parce que les femmes étaient représentées comme des pauvres innocentes en détresse que de nobles policiers sauvaient du péril.

Dans les années 1930, quand Ma Barker et Bonnie Parker pouvaient rendre la pareille aux gangsters les plus violents, la cigarette devint un accessoire à part entière. Les filles arboraient un rictus méprisant à moitié voilé de fumée.

time that a new breed of publisher appeared, notably Lionel White and Adrian B. Lopez, men whose prior experience was scandal and pin-up magazines. Their covers took the femme fatale to her lurid extreme: spike heels, fishnet hose, slit skirts, tight sweaters, gaudy jewelry — and the ever-present cigarette.

The early '50s represented the peak of cigarette imagery. Smoking women had become common enough for men to regularly see them in real life, but the taboo had not yet died. It was a less dire immorality now, more adventuresome than daunting, and what man didn't want a tumble with an adventuress? Through the detective magazines he could live the fantasy.

The late '50s saw detective cover girls moving once again toward the victim role, and as more girlie magazine publishers entered the field, towards the simple, smiling pin-up. Cigarettes went into decline.

By the '60s women's smoking was fast losing its stigma, and uppity bad girls were losing their allure for the detective audience. At the end of the '60s, when publishers adopted the frightened-female-victim cover almost exclusively, cigarettes had all but disappeared. The conjecture is that the second wave of women's liberation, beginning in 1963, so unnerved the detective magazine readers they lost their taste for strong bad girls. As the sexual revolution piled on more change, and more female rebellion, their fantasies shifted to subduing the uppity bitches and making them pay for their bra burning and backtalk. Thus bad girl and frightened victim became one, and a girl just can't smoke while she's screaming in terror.

gehüllte, schlimme Mädchen grinsten einen nun von den Covern spöttisch an.

In den frühen 1940ern bekamen die Magazine einen faden, patriotischen Touch. In Kriegszeiten haben sich Männer ganz mit der Heldenrolle zu identifizieren, und die Frauen warteten wieder als hilflose Opfer auf ihre Rettung oder waren selbst in Uniform. Nach dem Krieg, als die Männer heimkehrten und feststellen mussten, dass ihre Frauen und Freundinnen selbstständig geworden waren und in den Fabriken Männerarbeit leisteten, kehrten sie dafür umso massiver zurück. In dieser Phase tauchte eine neue Art von Verlegern auf, Leute wie Lionel White und Adrian B. Lopez, die sich vorher hauptsächlich mit Skandal- und Pin-up-Heften beschäftigt hatten. Sie reizten das Motiv der Femme fatale voll aus: High Heels, Netzstrümpfe, seitlich geschlitzte Röcke, enge Pullover, auffälliger Schmuck – und die allgegenwärtige Zigarette.

Ihren Höhepunkt erlebte die Zigarettensymbolik in den frühen 1950ern. Männer konnten mittlerweile auch im wirklichen Leben rauchende Frauen sehen, aber verpönt war es immer noch. Es galt jedoch nicht mehr als gravierende moralische Verfehlung, es wirkte eher abenteuerlustig als erschreckend, und welcher Mann wäre einem kleinen Abenteuer abgeneigt?

Ende der 1950er-Jahre sah man Frauen wieder verstärkt in der Opferrolle oder, als sich weitere Verleger von Girlie Magazines dem Genre zuwandten, als harmloses Pin-up. Die Zigaretten kamen langsam aus der Mode.

In den 1960ern konnten rauchende Frauen kaum noch jemanden schocken, und die arroganten Gangsterbräute verloren ihren Reiz für die Leserschaft. Als man dann zum Ende des Jahrzehnts praktisch nur noch verängstigte Frauen auf den Titelbildern sah, waren die Zigaretten endgültig out. Die Vermutung liegt nahe, dass die um 1963 einsetzende zweite Welle der Frauenbewegung den Lesern der Detective Magazines gründlich die Lust auf böse Mädchen, die eine dicke Lippe riskierten, verdorben hatte. Der gesellschaftliche Umbruch durch die sexuelle Revolution und die Frauenbewegung ließ sie nun eher davon träumen, den vorlauten Weibern die vielen Widerworte heimzuzahlen. So wurden böse Mädchen und verängstigte Opfer eins, und ein Mädchen kann schlecht rauchen, wenn es vor Entsetzen aufschreit.

Au début des années 1940, les magazines prirent un tournant patriotique. C'était la guerre et les hommes valides devaient se cantonner aux fantasmes héroïques tandis que les femmes redevenaient des victimes impuissantes attendant d'être secourues.

Les circonstances ne laissaient guère de place aux filles de mauvaise vie et aux cigarettes. Après la guerre, ces dames revinrent en force, tandis que les hommes découvraient des épouses ou petites amies qui avaient conquis leur indépendance en remplaçant leurs hommes dans les usines. C'est à cette époque qu'apparut une nouvelle race d'éditeurs, celle des Lionel White et des Adrian B. Lopez, des hommes qui avaient jusque-là démontré leur savoir-faire dans des feuilles à scandales. Ils radicalisèrent la femme fatale exposée en couverture : talons aiguilles, bas résille, jupes courtes, chandails moulant, bijoux clinquants et l'inévitable cigarette.

Le début des années 1950 représente l'apogée de cette représentation de la cigarette. Les fumeuses étaient devenues communes et les hommes en croisaient dans la vie de tous les jours, mais le tabou n'avait pas disparu. Fumer avait cessé d'être aussi immoral, la cigarette suggérait plus une personnalité d'aventurière que de rebelle, et quel homme aurait refusé un faux pas avec une aventurière ?

À la fin des années 1950, on vit à nouveau les cover-girls réduites au rôle de victime et les nouveaux magazines de charme privilégiaient la pin up souriante. Les cigarettes commençaient à passer de mode.

Dans les années 1960, fumer cessait d'être répréhensible pour les femmes et les filles de joie arrogantes perdaient de leur attraction sur le public des magazines policiers. À la fin des années 1960, les cigarettes avaient pratiquement disparu. La seconde vague de la libération des femmes, en 1963, indisposa tant les lecteurs de magazines qu'ils en perdirent le goût des femmes de mauvaise vie. Alors que la révolution sexuelle exigeait toujours plus de changements, et poussait les femmes à une révolte plus radicale, les fantasmes masculins évoluèrent vers la vengeance : il fallait soumettre ces chiennes arrogantes et leur faire payer leurs insolences. La mauvaise femme et la victime aux abois se confondirent… et une fille qui hurle de terreur ne fume pas.

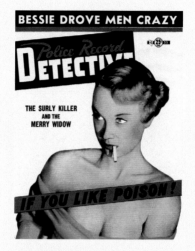

ABOVE *Police Record Detective*, 1953

CENTER *Women in Crime*, Summer 1946

BELOW *Famous Police Cases*, November 1950

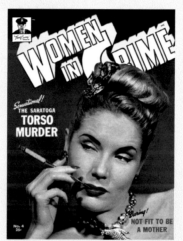

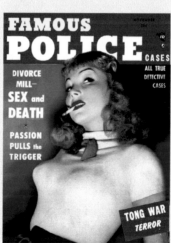

OCTOBE[R]

15
CENTS

UNCENSORED
DETECTIVE

THE
FATAL CLUE OF
THE COP KILLER'S NOSE

•

PASSION'S
PAY-OFF

DETECTIVE MAGAZINES, ORCHIDEEN IM SUMPF

von Eric Godtland

Wenn Sie einen Drehbuchautor nach der Erfolgsformel für ein Filmskript fragen, wird er antworten: Sex und Gewalt. Mit anderen Worten: Die dramatischen Höhepunkte des Lebens. Sex und Gewalt markieren die beiden extremen Pole des menschlichen Gefühlsspektrums, das größte Verlangen des Menschen und seine tiefsten Ängste, das Beste und das Schlimmste der menschlichen Natur, den Anfang und das Ende unseres Lebens. Vielleicht ist die Kombination von Sex und Gewalt darum so unwiderstehlich. Sie ist nicht nur die wichtigste Zutat jedes guten Filmskripts oder allgegenwärtiges Thema in den Nachrichtensendungen, beinahe unser gesamtes Entertainment beruht heute darauf. Nachrichten und Unterhaltung sind praktisch eins geworden. Nahezu überall auf der Welt erwarten die Menschen heute, über das Geschehen auf dem Rest des Planeten informiert zu werden. Sie wollen nicht nur die Ereignisse in ihrer unmittelbaren Nachbarschaft mitverfolgen, sondern auch Krisen in Simbabwe oder einen Skandal in Liechtenstein.

Wo immer wir uns aufhalten, ob im öffentlichen oder privaten Raum, permanent versorgen uns die Medien mit diesem schillernden, voyeuristischen Panorama menschlicher Leidenschaften. Mitunter erhebt sich Protest, wenn ein bestimmtes Bild unsere persönliche Schmerzgrenze überschreitet, doch im Grunde unseres Herzens sind wir alle sensationslüstern. Wir wollen sehen, wie der attraktive Held den Schurken bezwingt, um die Schöne zu retten, und ob man es nun Liebesdrama oder Abenteuer nennt, wenn man das heroische Beiwerk weglässt, bleibt das altvertraute Gerüst übrig. Wir sind so an das Gemisch aus Sex und Gewalt in den Medien gewöhnt, dass wir davon ausgehen, es wäre immer schon so gewesen, doch sind Massenmedien, wie sie mit dem Aufkommen der Zeitungen entstanden, ein relativ junges Phänomen.

Vor 150 Jahren waren Zeitungen nur für die gebildete Oberschicht bestimmt und bedienten sich einer nüchternen Sprache, um den Pöbel abzuschrecken. Es bedurfte der Bilder, um das Interesse der weitgehend des Lesens unkundigen Arbeiterschicht zu wecken, und zwar Bilder, die einen emotional und unmittelbar ansprachen. Dreimal darf man raten, was für Bilder das waren.

Es waren Verbrechen und Leidenschaft, die die ungebildeten Schichten zum Kauf von Zeitungen animierten, Sex und Gewalt, die sie motivierten, lesen zu lernen. Eines der wichtigsten Genres, das dem Wandel eines ursprünglich elitären Mediums zu unserer heutigen Event-Kakofonie den Weg bereitete, war das der Detective Magazines. Diese Magazine waren die Ersten, die auf raffinierte Weise die aufsehenerregenden Themen, mit denen man uns heute bombardiert, reißerisch inszenierten.

Was war der Grund dafür, dass dieses Genre Mitte des 19. Jahrhunderts so plötzlich aufkam? Der Buchdruck existierte bereits seit etwa 1450, aber wer profitierte in den 400 Jahren bis zur Einführung der ersten Kriminalhefte von der Erfindung der Druckerpresse? Nur ein sehr geringer Prozentsatz der Bevölkerung. Für den Durchschnittseuropäer, den Schankwirt, den Straßenhändler, den Schweinehirt, den Kleinbauern oder den Wollweber bot die Druckerpresse einen ungefähr ebenso großen Freizeitwert wie ein Gartenrechen. Der Großteil der Bevölkerung konnte nicht lesen und musste sich damit begnügen, seine niederen Instinkte gelegentlich durch einen Holzschnitt oder einen Kupferstich sensationellen oder sexuellen Inhalts ansprechen zu lassen. *Gin Lane* und *Beer Street* von William Hogarth erregten 1751 solches Aufsehen, ebenso wie Illustrationen auf großformatigen Flugschriften, auf denen Straßenkriminalität, Hinrichtungen, blutige Schlachten

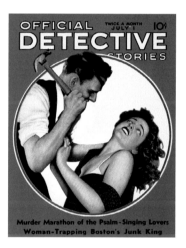

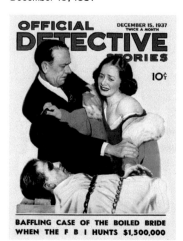

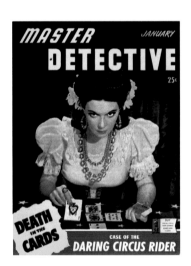

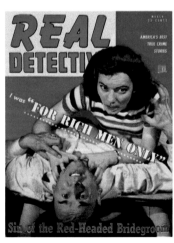

oder die schändlichen Taten der „Wilden", die man auf fremden Kontinenten entdeckt hatte, dargestellt waren. So unterhaltsam diese Abbildungen auch waren, sie unterschieden sich in Intention und Präsentation deutlich von den Kriminalreportagen und Reality-Programmen unserer Gegenwart.

Nahezu immer verfolgten diese frühen Illustrationen auf Flugschriften Absichten, die über eine reine Information der Öffentlichkeit hinausgingen. Ereignisse und ihre Vermittlung wurden sorgfältig konstruiert, um das Publikum zu einer bestimmten Schlussfolgerung und moralischen Beurteilung zu lenken. *Beer Street* war ein glückliches Schlaraffenland, während *Gin Lane* eine hoffnungslose Einöde darstellte. Natürlich existierten sie nicht, die Illustrationen bezogen sich auf bestimmte Themen des Zeitgeschehens – wie politische Karikaturen. Wirklich anrüchige und skandalöse Ereignisse waren noch nicht Gegenstand von Nachrichten, sie gaben lediglich Anlass zu Moralpredigten.

In diesem frühen Stadium stand die Berichterstattung über wahre Verbrechen und andere Formen der „Reality"-Unterhaltung wohl hinter der tatsächlichen Realität zurück. Die ungebildeten Schichten waren gebannt von emotional aufgeladenen Mund-zu-Mund-Berichten und Gerüchten. Was den Unterhaltungswert anbelangte, waren die frühen Printmedien für die tatsächlich stattfindenden Hinrichtungen, Hexenverbrennungen, Westgotenabwehrschlachten, Pestepidemien, Hungersnöte und alltäglichen Verbrechen keine Konkurrenz.

Die 1811 erfundene Zylinderschnellpresse trug dazu bei, Nachrichten über einen engeren Kreis hinaus zum Proletariat der Großstädte zu tragen. In den 1830er-Jahren entstand die sogenannte Penny Press, die es ermöglichte, Zeitungen beziehungsweise Flugblätter so günstig herzustellen, dass man sie für einen Penny pro Stück verkaufen konnte. Plötzlich waren Zeitungen für fast jeden erschwinglich und begannen damit, Themen für eine Zielgruppe aufzubereiten, die sie bis dato ignoriert hatten: die Arbeiterschicht. Berichte über wahre Verbrechen erwiesen sich bald als ein Lieblingsthema dieser neuen Leserschicht. Die Alphabetisierung und die Fortschritte in der Drucktechnik bescherten der westlichen Welt einen wahren Zeitungsboom. 1850 gab es allein in den Vereinigten Staaten 2526 verschiedene Zeitschriftentitel.

In den USA fiel diese Revolution im Printwesen mit einer Welle der Kriminalität in den Großstädten zusammen. In den großen Städten im Osten, vor allem in New York, stieg die Verbrechensrate unter den Hunger leidenden, in übervölkerten Vierteln zusammengepferchten Immigranten sprunghaft an. Erst in diesem Klima des Verbrechens und der Verbrechensangst entstand die ernsthafte Berichterstattung über True Crime, authentische Kriminalfälle.

DIE *NATIONAL POLICE GAZETTE* – DIE MUTTER ALLER MAGAZINE

In der ersten Hälfte des 19. Jahrhunderts versuchte man sich in den Tageszeitungen und in den Vorläufern unserer heutigen Wochenmagazine an Kriminalreportagen. Während dieser Experimentierphase bildeten sich die Grundbausteine des Detective-Genres heraus: Gewalt, Skandale und vor allem Sex. Außer diesen Hauptthemen fanden sich natürlich noch zahlreiche das Interesse fesselnde Unterthemen: Vergewaltigung, Drogenmissbrauch, Serienmörder, Bondage und das Lieblingsthema der viktorianischen Ära, die moralische Dekadenz. Viele dieser Publikationen aus New York spielten sich als Vorkämpfer für die Rechte der Armen auf und rechtfertigten Storys über Inzest,

Vergewaltigung und andere schlüpfrige Verbrechen als Teil ihres Kreuzzugs. Aber welche Motive auch dahintersteckten, die Presse verletzte hier jedenfalls zum ersten Mal vorsätzlich die Grundsätze des guten Geschmacks und die allgemeinen Moralvorstellungen. Ihre Waffe war das billige Pulp-Papier, ein minderwertiges, holzhaltiges Papier, auf dem die meisten Revolverblätter für die Unterschichten erschienen.

Die erste Zumutung fand allein auf Textebene statt, erst die zweite, die visuelle Attacke, legte den Keim für die Detective Magazines des 20. Jahrhunderts. Das Blatt, das diesen Sprung wagte, war die *National Police Gazette.*

Wie viele Zeitungen aus der Mitte des 19. Jahrhunderts schlug die *National Police Gazette* in ihrer Berichterstattung über Kriminalität einen reißerischen und schlüpfrigen Tonfall an, und das im Namen der öffentlichen Moral. Als sie 1845 erstmals erschien, war sie wie ihre Konkurrenzblätter recht spärlich bebildert. Erst 1876 fand die *National Police Gazette* die Erfolgsformel, mit der sie sich vom Rest der Meute absetzen konnte. In der *Illustrated History of Girlie Magazines* hat Mark Gabor diese Entwicklung auf den Punkt gebracht:

„*Die rührigsten Jahre der* National Police Gazette *lagen zwischen 1845 und 1920. Doch ihre Geschichte lässt sich am besten in zwei verschiedenen Phasen betrachten – vor und nach 1876. Die erste Phase ist gekennzeichnet durch einen wahrhaftig missionarischen, wenngleich sensationslüsternen Journalismus. Charakteristisch für die zweite – markiert durch die Umstellung von weißem auf strahlend rosafarbenes Papier – ist die Hinzufügung großzügig illustrierter, rein die Sensationsgier bedienender Storys über Verbrechen, Sexualdelikte, Gewalt, Obszönitäten, Ausschweifungen, Vulgarität, Bordelle und den Abschaum der Großstadt ...*

Richard K. Fox, ab 1876 Besitzer der Zeitschrift und verantwortlich für das ‚neue Image‘ der Gazette, wird der Ausspruch zugeschrieben: ‚Wenn sie nicht lesen können, gebt ihnen reichlich Bilder.‘"

Es waren nicht nur Verbrechen und Unzucht, die die *Gazette* zum Verkaufsschlager machten, sondern auch die optische Aufbereitung dieser zuvor tabuisierten Themen, insbesondere die unverblümte Berichterstattung über Unzucht, eheliche Untreue und andere „Indiskretionen".

Es war schon alles da. Jedes Element des Detective-Genres war bereits in der *National Police Gazette* erfolgreich getestet worden, mindestens 50 Jahre bevor das erste echte True Crime Magazine auf den Markt kam. Nachahmer der *National Police Gazette* ließen nicht lange auf sich warten. Sie verfeinerten deren Stil und erweiterten die Grenzen des Genres noch mehr, doch keiner unter ihnen hatte den langen Atem der *Gazette.* Auch wenn sie häufig die Aufmachung änderte, hielt sich die *National Police Gazette* bis 1982 und brachte es damit auf die beeindruckende Lebensdauer von 137 Jahren.

WARUM DETECTIVE MAGAZINES?

Die Entwicklung der Detective Magazines seit den Tagen der *Gazette* ist das eigentliche Thema dieses Buches und wird in den folgenden Kapiteln Jahrzehnt für Jahrzehnt aufgerollt. Doch bevor wir damit beginnen, sollte man sich fragen, warum ein derartiges Format so viele Jahrzehnte hindurch so erfolgreich war.

Auch wenn sie letztendlich verschwanden, haben sich True Crime Magazines überraschend lange Zeit am Markt behaupten können und so manches andere anfangs populäre Genre überlebt. Es ist erstaunlich, dass sie konstante Verkaufszahlen vor-

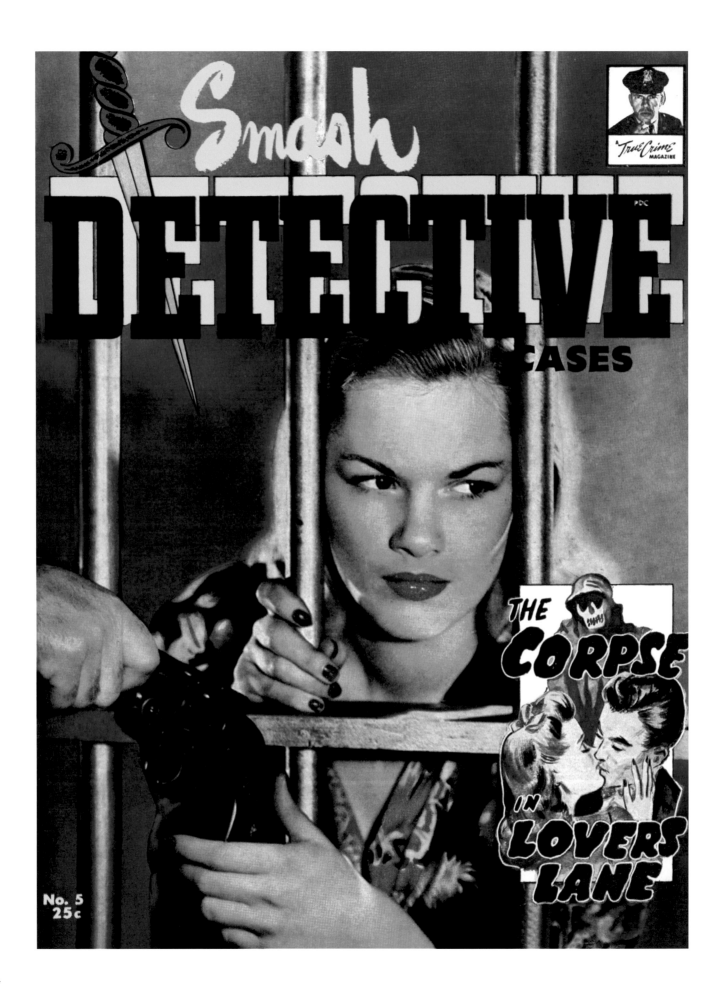

> **"Es waren Verbrechen und Leidenschaft, die die ungebildeten Schichten zum Kauf von Zeitungen animierten, Sex und Gewalt, die sie motivierten, lesen zu lernen."**

weisen konnten, während illustrierte Nachrichtenmagazine (*Life, Look, See*) und Filmzeitschriften (*Film Fun, Screen Play, Photoplay*) irgendwann einbrachen und schließlich verschwanden. Ist die Arbeit eines Ermittlers um so vieles faszinierender als die eines Filmschauspielers? Oder hat irgendjemand mit hellseherischen Fähigkeiten in den 1920er-Jahren gesagt: „Das ist es! Dieses Genre wird über Jahrzehnte erfolgreich sein!"

Wohl kaum. Alle Bereiche der Unterhaltungsindustrie – Literatur, Theater, Zeitschriften, Radio, Film, Fernsehen – kannten anfangs keine Regeln. Jedes neue Medium muss seine Erfolgsformel erst finden. Wer hätte erwartet, dass Superhelden einmal die Welt der Comics beherrschen würden? Wer hätte ahnen können, dass Wrestling ein Bombenerfolg im Fernsehen oder der *TV Guide* das auflagenstärkste Magazin der Welt werden würden? Einpersonenstücke? Filme über Killerfische? War irgendetwas davon vorauszuberechnen? Durch Herumprobieren kristallieren sich oft unerwartete Favoriten heraus, und für verblüffend lange Zeit zählte das Detective-Format zu den erfolgreichsten, wenn auch nicht respektabelsten.

Der angestammte Platz der polizeilichen oder privaten Ermittler war schon immer die zweite Liga der Printmedien, der Bereich unterhalb von Nachrichten und Mode, in dem man sein Zielpublikum in Nischenmärkten sucht. Da diese Nischen sich permanent verändern, ist dieser Bereich des Printwesens sehr unruhig, ständig in Bewegung. Die Hobby- und Bastelhefte – erinnert sich noch jemand an Petit-point-Stickerei oder Brandmalerei? –, die von den 1920er-Jahren bis in die 1960er-Jahre immens erfolgreich waren, sind in den letzten 20 Jahren praktisch vollständig von Zeitschriftenreihen mit Pop-Biografien sowie Computer- und Videospiel-Titeln ersetzt worden. Auto- und Musikmagazine

überleben durch Anpassung und Innovation, jede neue Generation tötet und verschlingt ihre Eltern. Erinnern Sie sich noch an Monster-Magazine? *Creepie, Eerie*, wo seid ihr geblieben? Ersetzt durch *Scream Queens Illustrated*, nehme ich an. Wie konnte an diesem unberechenbaren Markt ausgerechnet das auf den ersten Blick etwas ausgefallene Detective Magazine über sieben Jahrzehnte nicht nur überleben, sondern florieren?

DIE PERFEKTE MISCHUNG

Mit etwas Abstand sind die Gründe für den Erfolg dieses Genres leichter auszumachen: Es brachte schon alle Reality-Formate, die wir heute kennen, unter einen Hut. Detective Magazines streiften jedes menschliche Laster, aber nie lange genug, um sich selbst die Finger allzu schmutzig zu machen. Aus allem, was die menschliche Sensationsgier fesselt, stellten sie ein Potpourri packender existenzieller Themen zusammen: Laster, Gewalt, Sex, Tod. Ehe es irgendwann entartete, bot das Detective-Genre eine sichere Warte, von der aus man das menschliche Drama betrachten konnte. Mit dem Detective Magazine kaufte man den Freibrief, sich Dingen zu widmen, mit denen man sich sonst nicht eingehender zu beschäftigen wagte. Tatsächlich ist die Bezeichnung Detective Magazine nicht ganz zutreffend – True Crime Magazines handelten nur selten von Detektiven oder Polizisten. Vielmehr war man selbst als Leser der Ermittler. Oder besser gesagt der Begleiter des Ermittlers. Als Zuschauer der heute populären amerikanischen Fernsehsendungen wie *America's Most Wanted, Cops* oder *CSI: Miami* ist man ja auch nicht Polizist oder Leichenbeschauer, dennoch maßt man sich mit ihnen das Recht an, Menschen zu verfolgen, zu ergreifen, in Handschellen abzuführen, auf schaurige Weise

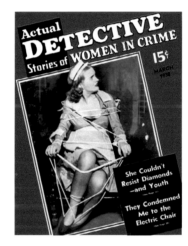

OPPOSITE *Smash Detective Cases*, 1946

ABOVE *Actual Detective Stories of Women in Crime*, March 1938

BELOW *Tru-Life Detective Cases*, October 1942

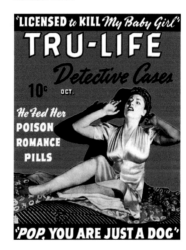

"Detective Magazines streiften jedes menschliche Laster ... Aus allem, was die menschliche Sensationsgier fesselt, stellten sie ein Potpourri packender existenzieller Themen zusammen."

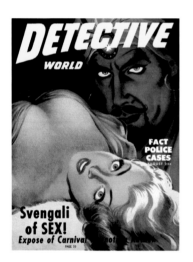

OPPOSITE *Scoop Detective Cases*, March 1942

ABOVE & BELOW *Detective World*, August 1948

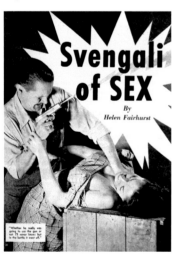

zu sezieren und zu untersuchen. Ohne diesen schützenden Rahmen der Identifikation mit dem Cop oder Gerichtsmediziner könnte man vor anderen – oder vor sich selbst – als gewaltaffin oder pervers dastehen. Ebenso verhält es sich mit den Detective Magazines.

Hätte einem in den 1930er-, 1940er- oder 1950er-Jahren der Chef, der Ehepartner oder die Mutter über die Schulter geblickt und den zersägten Körper eines nackten Mädchens gesehen, hätte man auf die Frage „Was um Himmels willen guckst du dir da an?" ein gutes Alibi gehabt. „Ach, das ist bloß ein Detective Magazine" reichte offenbar aus, um Monat für Monat ziemlich anstößiges Material ins Haus bringen zu dürfen.

Okay, vielleicht war man selbst kein Profi, aber man stellte sich Seite an Seite mit den Profis der rauen Wirklichkeit, um die Welt ein Stück sicherer zu machen. Detective Magazines zu lesen war gewissermaßen eine Bürgerpflicht. Und wenn einen die Bilder erregten, die die Geschichten über grundanständige weiße Mädchen begleiteten, die als Lustsklavinnen verkauft wurden, war das eine entschuldbare Nebenerscheinung beim Studium der menschlichen Natur.

Detective Magazines waren womöglich die perfekte Mischung in der Zeitschriftenwelt. Was sie so perfekt machte, erklärt sich am besten durch das, was sie alles nicht waren: Detective Magazines waren keine Girlie Magazines, sie waren keine Horror-Magazine und keine Bondage-Hefte, dennoch waren sie von allem etwas und noch viel mehr. Niemand konnte einem den Vorwurf machen, ein eindeutig sozial indiskutables, „schmutziges" Heft zu lesen, wenn man ein Detective Magazine in der

Hand hielt. Die Hefte strotzten vor Schockern und Anzüglichkeiten, wurden aber dennoch offen neben Magazinen wie *Look* und *Life* angeboten und nicht unter der Ladentheke gehandelt, wie die richtig perversen Sachen. Gut, da sah man nackte Mädchen, aufreizende noch dazu, doch die illustrierten schließlich eine Story über „chinesische Opiumhöhlen", wie man jedem Skeptiker, der einem lüsterne Motive unterstellen wollte, sofort entgegenhalten konnte; sie waren unerlässlich für die Story. Und all diese grausamen Hammermorde mit grobkörnigen Fotos von eingeschlagenen Schädeln? „Die Berichterstattung über den Prozess ist hochinteressant!" ließ sich da clever kontern.

Und was war, als die Magazine in den 1970er-Jahren einbrachen und ihre verzweifelten Verleger immer neue Schmierigkeitsrekorde aufstellten? Als man auf den Titeln nackte, gefesselte und geknebelte Mädchen sah, die in entlegenen Waldgebieten kopfunter aufgeknüpft waren, während irgendwelche geifernden Hinterwäldler ihnen Bowie-Messer an die Halsschlagader hielten? Da hätten Mutter, Ehepartner oder Chef einem die Story von der Bildungslektüre vielleicht nicht mehr abgekauft. Aber bei einigen Lesern funktionierte die psychologische Selbstrechtfertigung offenbar selbst da noch.

Für Leser, die tatsächlich in gewalttätigen Fantasien schwelgten und solche Magazine wegen der blutigen Details und des darin zum Ausdruck kommenden Frauenhasses kauften oder ihre Gewaltfantasien gar auslebten, bot der *Detective* im Titel den letzten Zipfel menschlichen Anstands, an den sie sich klammern konnten, um sich doch noch irgendwie als „der Gute" vorzukommen. Als Ermittler.

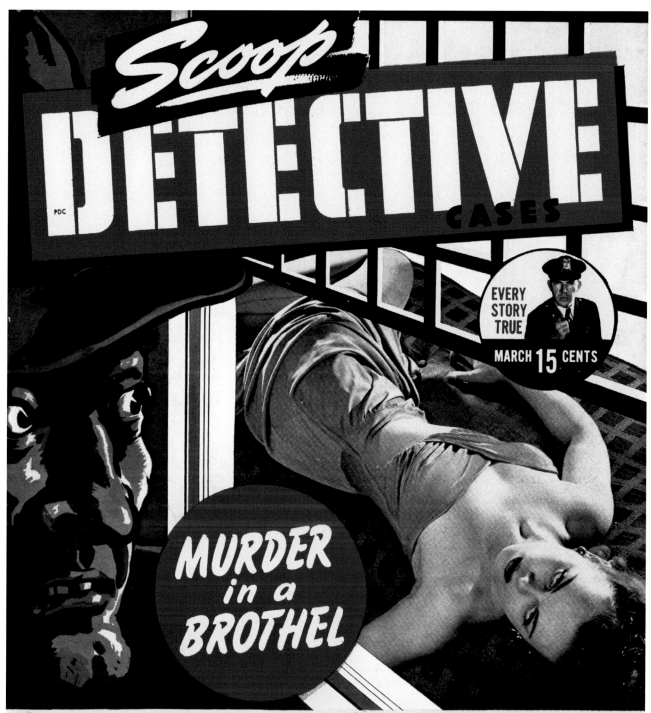

Scoop DETECTIVE CASES

PDC

EVERY STORY TRUE

MARCH 15 CENTS

MURDER in a BROTHEL

Can you guess the amazing ending to this true crime story?

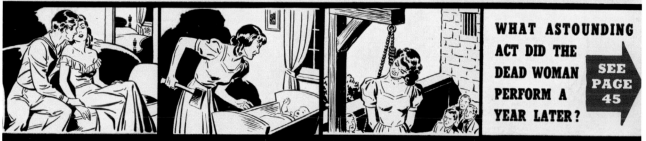

WHAT ASTOUNDING ACT DID THE DEAD WOMAN PERFORM A YEAR LATER?

SEE PAGE 45

Beautiful Maggie Dickson cheated on her husband.

When her sin was found out she killed her love child.

Maggie was convicted, and hanged for her crime.

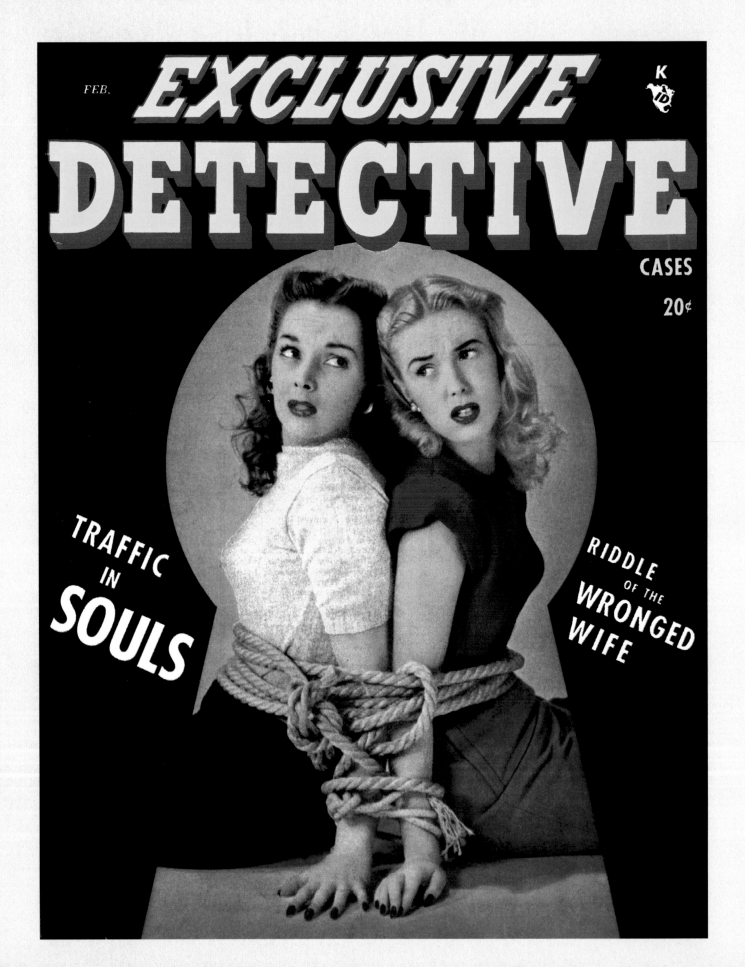

SORRY, I'M TIED UP RIGHT NOW
by Dian Hanson

Go type "bondage" into your eBay search engine and see how many detective magazines pop up. As stated in our introduction, detective magazines satisfied a slew of prurient interests, and one of the most common, most prurient, and perhaps most satisfying, was the bondage interest.

The original concept that justified bound women on detective magazine covers was the classic damsel in distress. When the artist painted a lovely, well-dressed woman trussed up like a rodeo calf for *Daring Detective* back in 1935, we assume his intention was to arouse the viewer's heroic instincts. Some bad guy had tied that woman up and it was up to the good guy — i.e., our reader — to rescue her and reap the rewards of her gratitude. Of course we can only assume his noble intentions, since we weren't there when the painting was made and clearly there were men in 1933, as today, who'd prefer leaving the lady tied up to rescuing her, or to tie her up themselves. Capturing and subduing a desirable woman is an ancient, if not an entirely civilized, male instinct. In the early days of the detectives there was a certain innocence about catering to this instinct, however, that eroded away in the decades to follow.

Bondage covers were rare from 1924 to 1929, when the magazines were groping for identity, and still rare in the '30s, when women were commonly portrayed as cunning aggressors. In the '40s bondage covers saw a sharp increase, since wartime needs heroes and heroes need damsels to rescue.

Real Detective was the title that first took the bit with bondage. The magazine had closely imitated *True Detective*

TSCHULDIGUNG, BIN GERADE ETWAS GEBUNDEN

Tippen Sie mal „Bondage" in die Suchmaske von E-Bay und warten Sie ab, wie viele Detective Magazines dann auftauchen. Wie schon in der Einleitung erwähnt, bedienten diese Magazine eine ganze Reihe eher schlüpfriger Interessen, und eines der beliebtesten und schlüpfrigsten darunter war das Thema „Bondage".

Ausgangspunkt für die Darstellung gefesselter Frauen auf den Covern von Detective Magazines war das klassische Motiv der verfolgten Unschuld. Wir wollen zugunsten des Coverkünstlers, der 1935 für den *Daring Detective* eine hübsche, gut gekleidete Frau malte, die wie ein Paket verschnürt war, annehmen, dass er nur die Absicht hatte, im Betrachter heroische Instinkte zu wecken: Da hatte doch irgendein Schurke diese arme Frau gefesselt, und es war die Sache des guten Kerls, das heißt des Lesers, sie zu retten und die Früchte ihrer Dankbarkeit zu ernten. Eine begehrenswerte Frau gefangen zu nehmen und sich gefügig zu machen ist ein uralter, wenn auch nicht zivilisierter Instinkt des Mannes. In den frühen Tagen der Detective Magazines bediente man diese Gelüste noch mit einer gewissen Unschuld, einer Unschuld, die sich allerdings mit den Jahren verflüchtigen sollte.

Zwischen 1924 und 1929, als die Blätter noch tastend nach ihrer Identität suchten, gab es nur wenige Bondage-Cover, und auch in den 1930ern, in denen die Frauen normalerweise als hinterhältige Angreiferinnen dargestellt wurden, blieben sie die Ausnahme. In den 1940ern stieg ihre Zahl sprunghaft

DÉSOLÉE, MAIS JE NE SUIS PAS LIBRE

Tapez « bondage » sur le moteur de recherche d'*ebay* et vous allez voir combien de magazines policiers apparaissent. Comme nous le disions en introduction, les *detective magazines* satisfaisaient toute une série de pulsions érotiques, dont l'une des plus communes, la plus excitante et peut-être la plus satisfaisante était celle du bondage.

Le concept original qui justifiait la présence de femmes ligotées sur des couvertures de magazines policiers était le grand classique de la demoiselle en détresse. Quand en 1935, un peintre peignit pour *Daring Detective* une femme bien habillée, ficelée comme une génisse après un rodéo, on peut supposer que son intention était d'exciter les instincts chevaleresques du lecteur. Un méchant avait ligoté cette femme et il revenait au gentil, à savoir vous et moi, de la sauver et de récolter les fruits de son dévouement. Bien sûr, une telle noblesse d'intention n'est qu'une simple hypothèse ; après tout, nous n'étions pas là quand ce tableau a été peint et, en 1933 comme aujourd'hui, il existait des hommes qui auraient préféré laisser cette pauvre femme attachée plutôt que de la délivrer, d'autres qui se seraient même proposé de la ficeler à leur idée. Capturer et soumettre une femme désirable est un instinct masculin fort ancien, sinon très civilisé. Aux premiers temps des *detective magazines*, il existait une certaine innocence quant à la satisfaction de cette pulsion, innocence qui s'éroda peu à peu lors des décennies qui suivirent.

Les couvertures « bondage » étaient rares entre 1924 et 1929, à l'époque où

OPPOSITE *Exclusive Detective Cases*, February 1948

ABOVE *Daring Detecive*, October 1935

"The new bondage audience didn't mind at all when the detective magazines shifted towards sleaze at the end of the '40s."

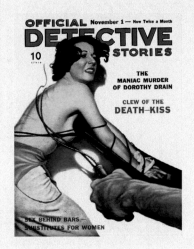

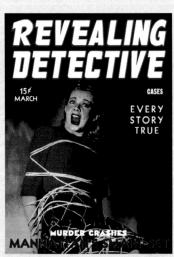

through the early '30s. In the late '30s it went in search of its own identity, including a switch from painted to photo covers around 1938. Unlike other titles this switch didn't seem to be about saving money, as the magazine appeared to pour all of its previous painting budget into elaborately staged, luridly tinted photo extravaganzas. It was as if the art director was attempting to create photographically what the pulp artist painted: a crime in action, with victim and perpetrator frozen in mid-commission. The effect looked frozen, and comical, as the models had limited acting skills, but for bondage fans it marked the beginning of a long, happy relationship.

The new bondage audience didn't mind at all when the detective magazines shifted towards sleaze at the end of the '40s. When the original owners sold off to girlie and scandal publishers in the early '50s it was cause for celebration in the kink quarters. And when painted covers were completely replaced by realistic photo covers in the '60s, covers increasingly featuring women as helpless, immobilized victims, bondage enthusiasts couldn't have been more pleased.

For bondage connoisseurs the late '60s heralded the third golden age of detective magazines. Every true crime title in publication at that point used rope on its cover, with women trussed to chairs, to beds, to trees, and many more creative tetherpoints. The bondage purist may point out that the covers didn't always use the preferred rope (white cotton), that the knots were sloppy and in most cases wouldn't have restrained a struggling woman for long, but these were minor irritations against the thrill of seeing one's fetish publicly displayed on the

an, denn zu Kriegszeiten braucht man Helden, und Helden brauchen Jungfrauen, die sie retten können.

Real Detective war das erste Blatt, das sich an Bondage versuchte. In den frühen 1930ern hatte sich das Magazin noch stark an *True Detective* orientiert. In den späten 1930ern bemühte es sich um ein eigenes Profil; dazu zählte auch, dass es um 1938 von gemalten zu Fotocovern überging. Diesen Schritt tat es anscheinend nicht wie viele andere Blätter aus Gründen der Kosteneinsparung, denn das ganze Budget, das früher für Coverillustrationen vorgesehen war, wurde in aufwendig inszenierte, grellfarbige Fotos investiert. Es scheint, als habe der Artdirector versucht, mit Mitteln der Fotografie das zu erzielen, was vorher der Illustrator geleistet hatte: eine packende Verbrechensszene, die Täter und Opfer im entscheidenden Moment einfriert.

Die neue, an Bondage interessierte Klientel störte es nicht, dass die Magazine Ende der 1940er-Jahre in Richtung Skandalblatt abdrifteten. Als die alten Verleger in den frühen 1950er-Jahren ihre Magazine an die Herausgeber von Sex- und Skandalblättern verkauften, war das für die Freunde des Pikanten ein Anlass, die Sektkorken knallen zu lassen. Und als in den 1960ern die Coverillustrationen ganz durch realistische Fotos ersetzt wurden und es zunehmend häufiger hilflose, gefesselte Frauen zu sehen gab, waren die Bondage-Fans im siebten Himmel.

Für dieses Publikum stellt der Zeitraum von Ende der 1960er- bis Mitte der 1970er-Jahre das dritte goldene Zeitalter der Detective Magazines dar. Jeder True-Crime-Titel dieser Epoche

les magazines cherchaient leur identité, et elles l'étaient encore dans les années 1930, alors que les femmes étaient déjà couramment présentées comme de redoutables adversaires. Dans les années 1940, les couvertures de bondage connurent une expansion spectaculaire : les guerres ont besoin de héros et les héros de demoiselles à secourir.

Real Detective fut le premier à exploiter le filon. Le magazine était depuis les années 1930 une copie de *True Detective*. À la fin des années 1930, il se mit en quête de sa propre identité, et passa de la couverture peinte à la photo dès 1938. À la différence de certains de ses confrères, cette mutation n'était pas justifiée par une volonté d'économie, dans la mesure où le magazine consacrait un budget important à des photos extravagantes, aux mises en scènes raffinées et aux couleurs criardes. Comme si le directeur artistique avait tenté de créer sous forme photographique ce que peignait l'artiste *pulp* : le crime en train de se commettre, la victime et le meurtrier figés pour l'éternité juste avant l'instant fatal. L'effet était saisissant et comique, car les modèles avaient des dons d'acteurs limités, mais pour les fans du bondage, ce virage marquait le début d'une longue relation.

Le nouveau public bondage ne vit aucun inconvénient à ce que les *detective magazines* virent au sordide à la fin des années 1940. Quand les propriétaires initiaux vendirent leurs titres à des éditeurs de tabloïds au début des années 1950, les lubriques applaudirent. Et quand, dans les années 1960, les couvertures peintes furent remplacées par des photos réalistes qui repré-

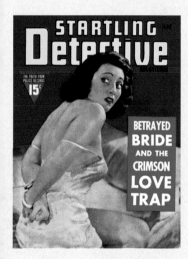
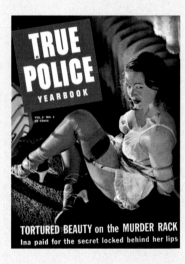
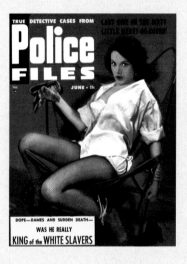
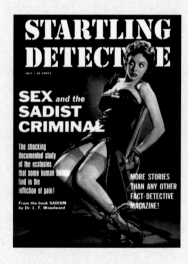

newsstand. As when a submissive male stumbles upon one of Helmut Newton's big dominant blondes in a fashion magazine, removing the fetish image from its usual purely pornographic context and flaunting it in public doubles the titillation.

Not that all bondage enthusiasts were comfortable with the way detectives treated their interest. Bondage and violence don't automatically, or even generally, mix in the sexual stew. This is why B&D (bondage and discipline) are separated from S&M (sadism and masochism) in the fetishist's lexicon. For many the object of bondage is to control rather than to inflict pain, and a huge knife pressed to a bound woman's throat interferes with this man's, or woman's, fantasy. Nonetheless, there were, and are, enough fans willing to accept an intruding weapon to make detective magazine bondage covers popular from their beginnings to this day.

Just check eBay — but don't you dare outbid me.

brachte Stricke auf seinen Covern: Man fesselte die Frauen an Stühle, Betten, Bäume und alle erdenkliche andere originelle Dinge. Bondage-Puristen mochten vielleicht etwas daran auszusetzen haben, dass nicht immer die bevorzugte Sorte von Stricken – weiße Baumwolle – zum Einsatz kam und die Knoten so locker waren, dass ein sich windendes Opfer nicht allzu lange gebraucht hätte, um sich daraus zu befreien, doch das waren nur kleinere Schönheitsfehler angesichts der prickelnden Erfahrung, jetzt seine geheimsten Gelüste öffentlich am Zeitungsstand ausliegen zu sehen. Wenn ein Fetisch-Motiv aus seinem gewöhnlichen, rein pornografischen Kontext herausgenommen und in aller Öffentlichkeit präsentiert wird, verdoppelt das den Reiz.

Natürlich waren nicht alle Bondage-Anhänger mit der Art und Weise einverstanden, in der die Detective Magazines ihre Leidenschaft aufgriffen. Bondage und Gewalt vertragen sich nicht unbedingt, eigentlich sogar nur in den seltensten Fällen. Darum werden B&D und S&M im fetischistischen Wörterbuch getrennt.

Für viele Bondage-Liebhaber geht es bei Bondage um Kontrolle, nicht darum, Schmerz zuzufügen, und ein überdimensionales Messer, das einer gefesselten Frau an die Kehle gedrückt wird, passt nicht in die Fantasien eines solchen Mannes — oder einer solchen Frau. Nichtsdestoweniger gab und gibt es immer genug Fans, die eine störende Waffe in Kauf nehmen, wenn sie nur ihre Bondage-Cover bekommen.

Schauen Sie einfach mal bei E-Bay nach – aber wagen Sie es nicht, mich zu überbieten.

sentaient souvent des femmes impuissantes et paralysées, les enthousiastes du bondage exultèrent.

Pour les connaisseurs du bondage, la période qui va de la fin des années 1960 au milieu des années 1970 représente le troisième âge d'or des *detective magazines*. Les femmes étaient attachées à des chaises, des lits, des arbres. Les puristes du bondage souligneront sans doute que ces couvertures n'utilisaient pas toujours leur corde favorite, que les nœuds étaient négligés et dans la plupart des cas n'auraient pas paralysé une femme qui se débattait ; mais ce n'étaient là que des objections mineures devant le frisson de voir son objet fétiche s'étaler en public chez les marchands de journaux. De même, quand un mâle soumis tombe sur une grande blonde dominatrice de Helmut Newton dans un magazine de mode, le fait que cette image fétiche soit extraite de son contexte pornographique et affichée en public renforce beaucoup son excitation.

Ceci dit, les enthousiastes du bondage n'étaient pas toujours à l'aise avec la façon dont les magazines policiers traitaient leur passion. Bondage et violence ne font pas toujours bon ménage au lit. C'est pour cette raison que le lexique fétichiste sépare B&D d'une part et, d'autre part, S&M. Pour beaucoup, le but du bondage est plus de contrôler que d'infliger une souffrance et un énorme couteau posé sur la gorge d'une personne ligotée pourrait nuire à ses fantasmes. Il y avait et il reste assez de fans disposés à accepter une arme dans le décor pour que les couvertures bondage des magazines policiers, fidèles depuis des lustres à cette formule, n'aient rien perdu de leur popularité.

TRUE MYSTERY

FEBRUARY • 25c • ANC

The MAD KILLER and the SEVEN STRANGLED BEAUTIES

VICE and VIOLENCE in PARIS

LES DETECTIVE MAGAZINES OU LA PERFECTION DE L'ORCHIDÉE

Eric Godtland

N'importe quel scénariste vous le confirmera. Tout bon scénario doit comporter deux éléments : le sexe et la violence. C'est-à-dire la vie. Le sexe et la violence représentent les deux sommets de la passion humaine, le plus grand désir et la peur la plus profonde de l'être humain, le meilleur et le pire de l'existence, notre commencement et notre fin. Peut-être est-ce la raison pour laquelle le mélange de sexe et de violence est un tabou si puissant et si irrésistible, non seulement le b.a.-ba d'un bon scénario de film ou un élément incontournable des infos du soir mais la substance même de la plupart des divertissements d'aujourd'hui. Et n'oublions pas qu'informations et divertissements sont devenus essentiellement identiques. Partout dans le monde, sauf chez les peuplades les plus primitives, les gens, aujourd'hui, veulent être tenus au courant de tout ce qui se passe sur la planète, pas seulement des événements qui se produisent dans le voisinage, mais aussi des crises qui surviennent au Zimbabwe et des scandales qui affectent le Liechtenstein.

Où que nous allions, qu'il s'agisse d'un espace public ou privé, les médias nous gavent de cette pittoresque et voyeuriste parade de la passion humaine poussée à l'extrême. S'il nous arrive parfois de la désapprouver, c'est seulement parce qu'une image a dépassé les limites de notre confort personnel. Mais au fond, nous sommes tous captivés par ces représentations. Chaque fois que le beau et fringant héros terrasse le méchant pour libérer la demoiselle prisonnière, peu importe qu'on appelle cela aventure ou romance. Derrière l'habillage héroïque, on retrouve les mêmes bons vieux ingrédients. Nous sommes si habitués à nous régaler de ce mélange médiatique de sexe et de violence que nous supposons qu'il en a toujours été ainsi. Pourtant les mass média nés avec les journaux connaissent un développement relativement

récent. Il y a 150 ans, les journaux s'adressaient à l'élite cultivée à laquelle ils fournissaient une synthèse de l'actualité, et les croquants restaient à leur place. Il fallut attendre les images imprimées pour capter l'attention de la classe ouvrière majoritairement analphabète. Des images douées d'un impact viscéral et immédiat. Devinez de quel genre d'images il s'agissait ?

C'est la soif de crime et de passion qui ont poussé ces analphabètes à acheter des journaux. Le sexe et la violence leur ont donné envie de lire. Et les magazines policiers ont servi de passerelle entre la presse sérieuse des débuts et le magma d'actualités proposé par la presse people que nous connaissons aujourd'hui. Ce genre a été le premier à exploiter habilement, sur un mode sensationnel, tous les thèmes scabreux dont on est aujourd'hui gavé à outrance.

Quelle est la cause de l'apparition soudaine des magazines policiers au milieu du XIXᵉ siècle ? L'imprimerie existe depuis l'an 1450 environ. Mais qui a profité de cette technologie durant les 400 ans qui ont séparé l'invention des caractères mobiles des premières publications d'histoires criminelles ? Un tout petit pourcentage de la population. Pour l'Européen moyen, le tavernier, le vendeur de gin au verre, le bûcheron éleveur de porcs et cardeur de laine, les journaux n'étaient pas beaucoup plus excitants que les outils dont ils se servaient tous les jours. L'immense majorité des citoyens européens ne savaient pas lire et les occasionnelles gravures sur cuivre ou sur bois qu'ils trouvaient parfois devaient être particulièrement suggestives pour susciter leur intérêt. *Gin Lane* et *Beer Street* de William Hogarth firent sensation en 1751 comme les dessins satiriques décrivant les crimes de rue, les pendaisons publiques, les batailles sanglantes ou les agissements infâmes des « peuples de sauvages »

OPPOSITE *True Mystery*, February 1955

BELOW *Daring Detecive*, August 1940

«C'est la soif de crime et de passion qui ont poussé ces analphabètes à acheter des journaux. Le sexe et la violence leur ont donné envie de lire.»

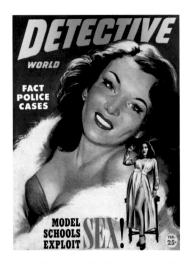

ABOVE *Detective World*, February 1948

BELOW *Detective World*, October 1950

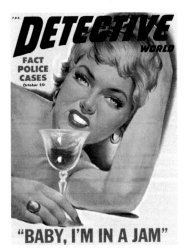

découverts sur les autres continents. Si divertissantes que fussent ces illustrations, elles différaient beaucoup, tant dans leurs intentions que dans la représentation du crime et de la réalité, des médias d'aujourd'hui.

Dans la quasi-totalité des cas, ces illustrations marginales d'autrefois ne visaient pas simplement à informer le public. Les événements et leur description étaient soigneusement construits pour amener le lecteur à une conclusion et une moralité spécifique. *Beer Street* représentait un idéal de bonheur tandis que *Gin Lane* dépeignait une Angleterre ravagée par un alcoolisme destructeur. Aucune de ces deux rues n'existait. Les illustrations étaient basées sur des détails pris dans la réalité de l'époque, comme pour les caricatures politiques. Les événements vraiment scandaleux et sordides n'étaient pas encore des sujets exploitables par les médias mais seulement par les prédicateurs dans leurs serments.

On pourrait dire qu'en ces débuts du journalisme, la véritable chronique du crime et le divertissement par le fait divers si omniprésent aujourd'hui, ne pouvaient rivaliser avec la réalité elle-même. La population analphabète était captivée par les rumeurs, récits et ragots qui se transmettaient de bouche à oreille. En termes de divertissement pur, les médias de l'époque étaient dépassés par les pendaisons en public, les bûchers sur lesquels on brûlait les sorcières, la chasse aux envahisseurs barbares, la peste, la famine, et la litanie des crimes au quotidien.

La presse à imprimer rotative, inventée en 1811, a contribué à fournir au petit peuple des villes des informations provenant du vaste monde. Dans les années 1830, de nouveaux progrès ont permis aux industriels de la presse de sortir des journaux à un penny. Devenus soudain accessibles à la grande majorité, les quotidiens se mirent à couvrir des sujets qui intéressaient un groupe de lecteurs auparavant inconnu d'eux : la classe ouvrière. Les chroniques d'affaires criminelles devinrent rapidement les grands favoris d'une classe qui sortait peu à peu de l'illettrisme. Avec l'évolution des techniques d'imprimerie et le recul de l'analphabétisme, les grandes nations industrialisées connurent un boom de la presse. On dénombrait 2 526 titres différents en 1850 rien qu'aux États-Unis.

Pour l'Amérique, cette révolution de l'imprimé coïncida avec une vague de criminalité urbaine. Dans les grandes cités de l'Est, et en particulier à New York, la délinquance criminelle prospérait dans les quartiers surpeuplés à population majoritairement immigrée et affamée. Avec l'accroissement rapide de la population, les gens ne connaissaient plus leurs voisins et, bien souvent, ne comprenaient ni leur langue, ni leurs traditions, ni leurs coutumes. Dans une telle foison de cultures, les peurs se propageaient trop vite pour que le bouche à oreille pût jouer son rôle modérateur. C'est dans ce climat de crime et de peur du crime que le véritable reportage criminel a connu son premier essor.

LA *NATIONAL POLICE GAZETTE* – L'ANCÊTRE DE CE GENRE

Pendant la première moitié du XIXe siècle, les quotidiens et les hebdomadaires s'essayèrent aux histoires criminelles, leur prospérité ou leur disparition dépendant des réactions du public à leurs approches du sujet. Cette période expérimentale posa les jalons du genre « détective » : violence, scandale et surtout affaires sexuelles. Ces trois thèmes élémentaires se ramifièrent en thèmes secondaires

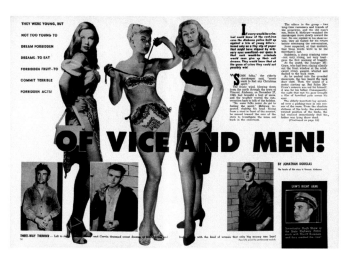
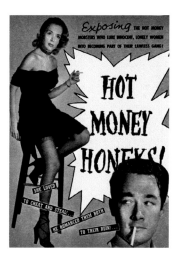
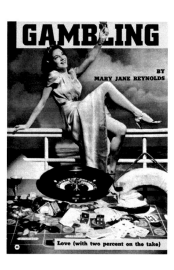

tout aussi sensationnels : le viol, la drogue, les meurtres en série, le sadomasochisme et la dégénérescence morale – sujet favori de l'époque victorienne. De nombreux journaux new-yorkais s'érigèrent en croisés des droits des pauvres, justifiant ainsi les histoires d'inceste, de viol et autres crimes salaces qu'ils publiaient. Quelles que fussent ses motivations, c'était la première fois que la presse malmenait le bon goût et les valeurs morales, avec pour arme le papier bon marché que réservaient les tabloïds aux classes défavorisées. Le premier assaut aux bonnes mœurs se limita au texte jusqu'à ce que l'offensive visuelle sème le germe des magazines policiers du xxᵉ siècle. Le premier à sauter le pas fut la *National Police Gazette*.

Comme beaucoup de périodiques du milieu du XIXᵉ siècle, la *National Police Gazette* adopta dans ses rubriques criminelles un ton libre et sensationnel, au nom de la moralité publique. Lors de son lancement, en 1845, les illustrations y étaient aussi rares que chez ses concurrents, et ce n'est qu'en 1876 que la *Gazette* trouva la formule qui devait la propulser en tête. Mark Gabor résume bien cette évolution dans son *Histoire illustrée des magazines de charme* :

« C'est entre 1845 et 1920 que la *National Police Gazette* connut sa période la plus prospère. Mais son histoire se partage en deux phases distinctes : avant et après 1876. La première représente la période de journalisme vraiment moralisateur quoique sensationnel. La seconde, que traduit le passage d'un papier blanc à un papier rose brillant, se caractérise par l'accumulation de récits, abondamment illustrés, de meurtres, d'agressions sexuelles, d'actes violents, inconvenants, de débauches, de vulgarité, d'histoires de maisons de passe, et de toute la vie crapuleuse que sécrète la ville moderne… »

Richard K. Fox, qui prit la direction du magazine à partir de 1876 et fut le responsable de la nouvelle image de la *Gazette* aurait dit : « S'ils ne savent pas lire, bombardez-les d'images ! ».

Mais les progrès de la *Gazette* n'étaient pas seulement dus à l'exploitation du crime et du vice. Son succès s'explique aussi par la représentation visuelle de thèmes jusque-là prohibés et notamment des comptes-rendus très crus d'aventures galantes, adultères et autres « indiscrétions ».

Tout y était. Tous les ingrédients du genre policier firent la preuve de leur efficacité dans la *National Police Gazette*, au moins 50 ans avant que les premiers véritables magazines du genre fassent leur apparition. Les concurrents de la *Gazette* rivalisèrent de premières pages tapageuses, repoussant les limites du genre et pastichant son style, mais aucun ne put l'égaler. Bien qu'elle ait dû très souvent changer de format, la *National Police Gazette* survécut jusqu'en 1982, totalisant une longévité record de 137 ans !

POURQUOI DES MAGAZINES POLICIERS ?

Le développement des magazines policiers à partir de la *Gazette* est le véritable sujet de cet ouvrage et nous allons le raconter, décennie après décennie, dans les chapitres suivants. Il est intéressant cependant de s'arrêter sur la question du format : comment expliquer le succès immuable de ce dernier ?

S'ils ont fini par disparaître, les véritables magazines policiers ont connu une longue prospérité, qui dépasse de loin celle des périodiques grand public toutes catégories confondues. Il est, par exemple, surprenant de noter qu'ils se vendaient encore alors que les magazines d'informations tels *Life*, *Look* ou *See*, ou encore les magazines de

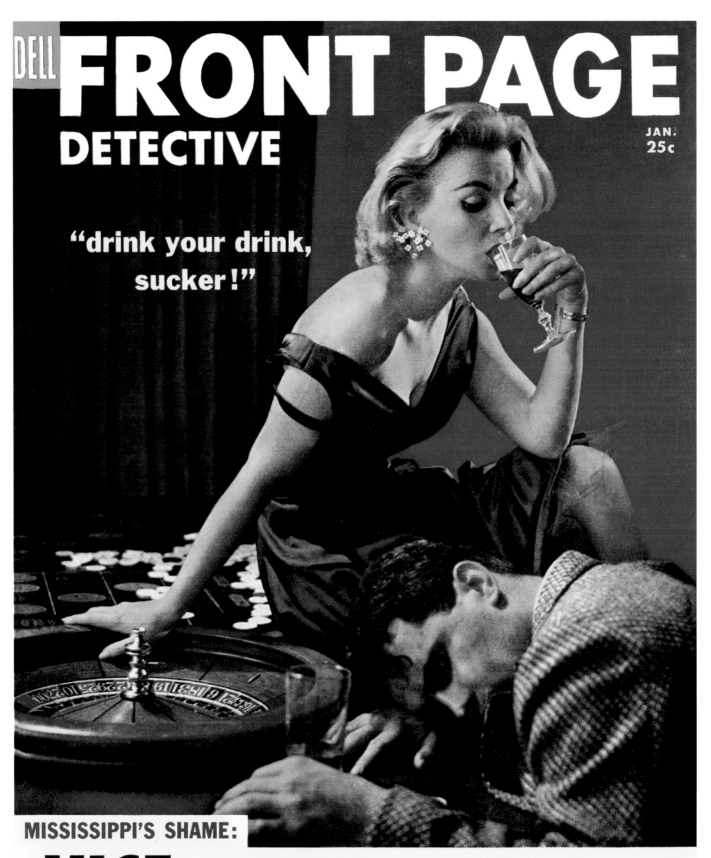

> « Les detective magazines entre-
> mêlent tous les vices humains...
> Ils excitent les fascinations
> scabreuses pour ces grands thèmes
> que sont la mort, la violence,
> le sexe et le vice. »

cinéma comme *Film Fun*, *Screen Play*, *Photoplay*, périclitaient et disparaissaient. Le travail de l'enquêteur est-il beaucoup plus fascinant et particulier que celui de l'acteur ? Un visionnaire aurait-il compris dans les années 1920 quelle formule allait marcher pendant des décennies ?

Peu probable.

Tous les domaines du divertissement, la littérature, le théâtre, la radio, le film, la télévision, ont tâtonné quelque temps avant de trouver leur voie. Chaque fois qu'un nouveau médium est inventé, la formule du succès fait l'objet de recherches et d'essais. On commence par tester de très mauvaises idées avant de trouver les bonnes, celles qui s'avéreront par la suite propres à séduire le public pendant longtemps. Comment deviner, au début, que les superhéros allaient dominer l'univers de la B. D. ? Qui aurait prédit que les combats de catch allaient faire un tabac sur le petit écran ou que *TV Guide* deviendrait le magazine le plus vendu au monde ? Comment prévoir le succès des one man shows ? Celui des films dont le héros est un squale sanguinaire ? Rien de moins évident a priori. C'est ainsi que, d'essais en erreurs, on a vu apparaître d'insolites favoris et que, pendant une durée incroyablement longue, les magazines policiers ont été très appréciés du public (même s'ils ne méritaient pas un tel succès).

Les *detective magazines* ont toujours été rangés à un rang inférieur au sein de la presse périodique, bien après les magazines d'informations ou de mode, et ils ciblaient les marchés secondaires. En évolution constante, ce marché, toujours à l'affût de la demande, n'a cessé de se transformer. Les magazines de travaux manuels et autres métiers d'art pour amateurs (pour brodeuse ou ébéniste du dimanche), très populaires des années 1920 aux années 1960, ont été presque complètement rem-

placés ces vingt dernières années par des titres de musique pop, d'informatique ou de jeux vidéos. Les magazines automobile et de musique se maintiennent, de mutations en innovations successives, chaque nouvelle génération supprimant et remplaçant la précédente. Vous souvenez-vous des magazines d'horreur ? *Creepie*, *Eerie*, où êtes-vous ? Remplacés par *Scream Queens Illustrated*, je parie. Si vous voulez faire de l'argent dans ce secteur des périodiques, vous avez donc intérêt à vous montrer souple et réactif. Mais alors, dans ce monde en perpétuelle évolution, où les fortunes se font et se défont en un clin d'œil, comment expliquer la réussite persistante, pendant plus de 70 ans, des *detective magazines*, si « ringards » à première vue ?

L'HYBRIDE PARFAIT

À posteriori, les raisons du succès des magazines policiers sont aujourd'hui davantage perceptibles que durant leur âge d'or. Il est maintenant évident qu'ils le doivent à leur capacité à rassembler dans un seul support tous les aspects de la réalité moderne dans laquelle nous vivons. Les *detective magazines* entremêlent tous les vices humains sans s'attarder trop longtemps sur chacun d'eux. Pour concocter leur ragoût, ils excitent les fascinations scabreuses pour ces grands thèmes que sont la mort, la violence, le sexe et le vice. Avant de se ramifier, ce genre offrait un poste d'observation d'où l'on pouvait sans risque jouir d'une vue d'ensemble de toutes les faiblesses humaines, tout en gardant ses distances avec le sujet. On achetait avec ces magazines le droit de sonder des tréfonds qu'il aurait été gênant d'explorer dans la réalité. Le terme « magazine de détective » est d'ailleurs impropre – il y était peu question de détectives. C'est le lecteur qui jouait ce rôle, ou plutôt celui

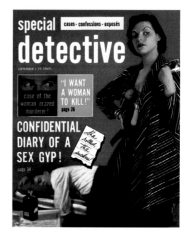

OPPOSITE *Front Page Detective*, January 1956

ABOVE *Special Detective*, September 1956

BELOW *Real Crime Detective*, March 1955

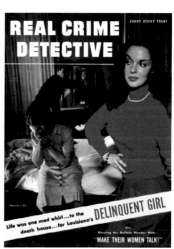

OPPOSITE *True Detective*, March 1966

ABOVE *True Police Cases*, June 1948

d'un compagnon d'enquête. De la même manière qu'en regardant *America's Most Wanted*, *Cops* ou *CSI: Miami* à la télévision, on n'est ni policier ni médecin légiste, mais on endosse une part de leurs prérogatives professionnelles, le temps de traquer un criminel et de lui passer les menottes, ou de disséquer le cadavre d'une victime. Sans le bouclier de l'identification aux héros du petit écran, le téléspectateur passerait (même à ses propres yeux) pour un voyou ou un déterreur de cadavres. La lecture d'un *detective magazine* offrait la même possibilité de catharsis.

Dans les années 1930, 1940 ou 1950, si votre mère, votre femme ou votre patron s'indignait de vous voir penché sur la photo d'un corps de femme coupée en deux à la scie, vous aviez un alibi – « Mais ce n'est qu'un magazine de détective ! » – qui vous permettait de faire entrer tous les mois à la maison ou au bureau des publications parfaitement dégoûtantes.

On ne faisait pas partie des détectives professionnels, mais on les côtoyait. La lecture du magazine était un acte de bon citoyen, on regardait la vie en face pour rendre le monde meilleur. Et si l'on était émoustillé au passage par des illustrations de saines jeunes filles protestantes victimes de la traite des Blanches, c'était l'à-côté inévitable d'une étude approfondie sur la condition humaine. Si quelqu'un venait à contester ces lectures douteuses ou morbides, on pouvait toujours prendre la moralité pour excuse.

Les magazines policiers sont peut-être l'hybridation la plus réussie du monde des magazines illustrés. Ce qui faisait leur perfection (et la véritable clé de leur succès), c'est surtout ce qu'ils n'étaient pas : ni magazines de filles nues, ni magazines d'horreur, ni magazines sadomasochistes, tout en combinant des aspects de ces trois genres, ainsi

que de quelques autres. On ne pouvait accuser leurs acheteurs de s'adonner à des lectures directement qualifiables de « cochonnes » et socialement inacceptables. Quoique remplis d'histoires choquantes et émoustillantes, on les trouvait dans les kiosques à côté de *Look* et de *Life*, et non pas sous le comptoir avec les magazines réservés aux érotomanes. On y trouvait certes des femmes dénudées, souvent même plus que sexy, mais leur lecteur pouvait toujours expliquer aux sceptiques : « C'est une histoire de repaires d'opium en Chine ! », prouvant ainsi qu'il n'avait pas acheté un magazine érotique. La nudité des femmes faisait partie de l'histoire. Et toutes ces épouvantables photos en gros plans de crânes fracassés à coups de marteau ? Les pièces à conviction du procès !

Mais dans les années 1970, alors que le déclin s'annonçait, les éditeurs repoussèrent les limites du salace et de l'atroce. Les couvertures exhibèrent alors des filles ligotées et bâillonnées, pendues la tête en bas au fond d'un bois obscur, entourées de rustauds baraqués qui leur léchaient les côtes, un poignard tendu vers leur veine jugulaire. Les mères, femmes et patrons des lecteurs ont dû avoir du mal à croire aux valeurs éducatives et morales de ces magazines. Pourtant, même à cette époque, la notion contestable de redressement moral était peut-être encore présente chez certains lecteurs.

Pour celui qui faisait partie de ces lecteurs en proie à des fantasmes de violence, de ceux qui n'achetaient ces magazines que par machisme et par attrait du sang, l'appellation « détective » dans le titre lui garantissait la décence sociale et morale et lui laissait le rôle de l'enquêteur, le type bien de l'histoire.

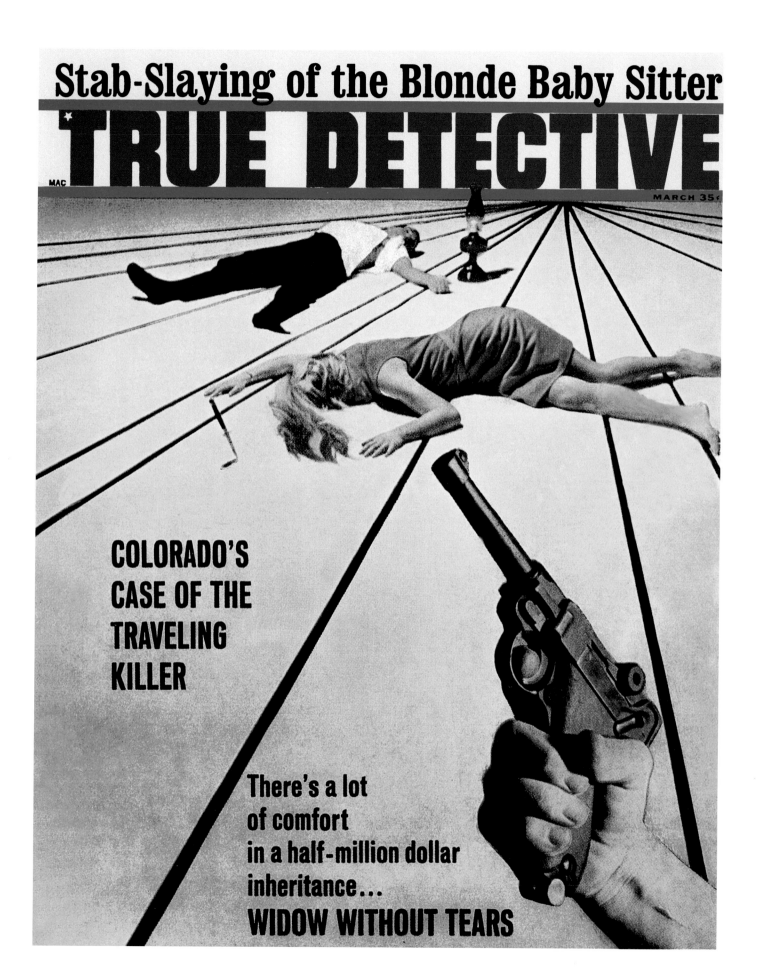

1924-1929

The first "true crime" titles were born in 1924 when New York-based Macfadden debuted True Detective Mysteries, and an undistinguished pulp called Detective Tales was reborn as Real Detective Tales. Largely fiction-based until 1928, both gradually became emboldened to cover "real" crime.

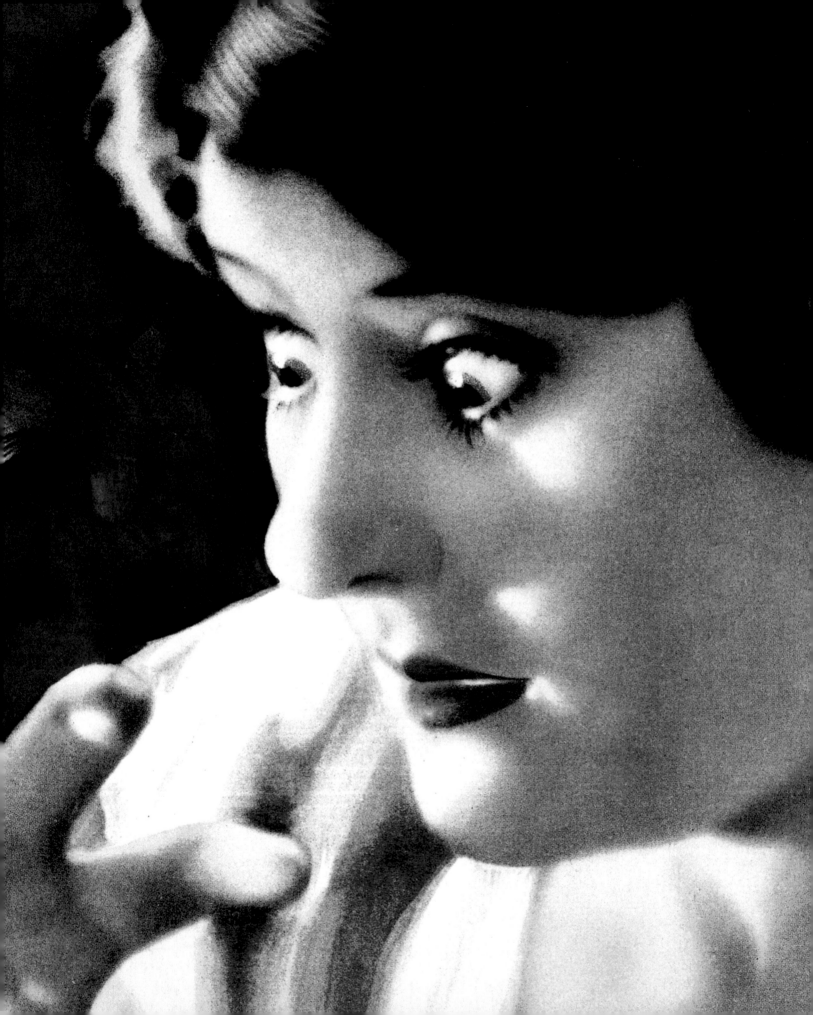

THE GRAND
IMMORALITY PLAY
by Eric Godtland

The magazines that were to transform true crime into America's first reality entertainment were initially just new titles in a well-established fiction tradition. The first detectives in American literature appeared in the stories of Edgar Allan Poe. Poe himself was inspired by the memoirs of French adventurer Eugene Francois Vidocq, who ran a private security service in Paris in the early 1800s. Vidocq was not widely read in the United States, though, so it was Poe who got the credit for creating the infallible detective as archetypical hero with the publication of *The Murders in the Rue Morgue* in 1841. The story was so popular Poe brought his detective back for *The Purloined Letter* in 1844, and again for *The Mystery of Marie Roget*, a sequel to *Rue Morgue*, in 1850. Poe's detective was a towering and noble figure, a man who used amazing analytical abilities and subtle insights to solve crimes and bring his criminals to a just end. In *The Mystery of Marie Roget* he directly presaged a convention of the early detective magazines by fictionalizing an actual case: the disappearance of Mary Rogers of New York City, who he moved to Paris and thinly disguised with a transparent name change. The success of Poe's stories established a precedent for other writers to hone and develop the fictional detective and crime mystery. Charles Dickens' *Bleak House*, for example, depends upon a murder mystery. Dickens actually died while writing another crime story, *The Mystery of Edwin Drood*, in 1870.

Not all 19th century detective writers were talented novelists, however. Dime novels date to 1860, and the first dime novel detective series, *Old Cap Collier Library*, launched to great success in 1883. Old Cap appeared in only a few of the stories in his books, acting more as an emcee to introduce a host of detective heroes. His success spawned

New York Detective Library two months later, whose most popular sleuth was Old King Brady. *Old Sleuth Library* followed in the multi-story form in 1885, clinging to the apparent charm of "old" in any detective title. In fact, most of the detectives in these books were dashing young men, as was the case with Nick Carter, who debuted in 1886.

Nick Carter was the first detective to have an entire dime novel devoted to his exploits alone. The prototypical red-blooded American do-gooder, Nick split his time between detective work and international adventuring. He was so popular his character was kept alive until 1936, going from publisher to publisher as *Nick Carter Library*, *Nick Carter Weekly*, *Nick Carter Stories*, and finally *Nick Carter Magazine*. Through this 50-year run the "Nick" stories were written by dozens of authors who managed to keep the two-fisted character amazingly consistent.

Cementing the connection between the higher-quality detective stories and these dime novels and early magazines was Sir Arthur Conan Doyle's *Sherlock Holmes* series. After his character's debut in the novel *A Study in Scarlet* (1887) Doyle wrote 60 stories about the sleuth between 1887 and 1927. Many were first published in *The Strand* magazine, where Doyle introduced the serial story with a new Holmes episode each issue. Sherlock Holmes was a far more complex character than Nick Carter, an incredible logician with human frailties and "outsider" tendencies. This balance of eccentricity and genius (Holmes was a cocaine-sniffing, woman-hating, middle-aged bachelor who spent an unusual amount of time with Dr. Watson) so captivated the collective imagination of the reading public that when Doyle killed off Holmes to devote time to his "more serious" writing there were public protests in front of the publishers' offices.

PAGE 38 *True Detective Mysteries*, January 1925

OPPOSITE *True Detective Mysteries*, October 1924

> **"I could not bear the thought of cutting up the beautiful creature who was my new daughter's mother. I stole the mother's body from the dissecting room."**
> — *TRUE DETECTIVE MYSTERIES*, JANUARY 1925

OPPOSITE *True Detective Mysteries*, March 1925

ABOVE *Detective Story Magazine*, April 1923

BELOW *Flynn's*, March 14, 1925

Fleshing out this new, more sophisticated detective genre was Doyle's brother-in-law E. W. Hornung. As the century turned, Hornung invented the first serial antihero, A. J. Raffles, who bookended Doyle's infallible detective with an equally infallible and compelling criminal. Raffles was an English gentleman, patriot, and cricket player whose inheritance was insufficient to cover the pleasures of his class. He was therefore forced to pull off daring heists, with every escape an excruciating close call. Between them, Doyle and Hornung forged the early templates for James Bond and all the slick aristocrat sleuths, spies, and thieves of 1950s and 1960s Hollywood. They also established a taste within the reading public for the complexities of crime from both sides of the act, solving and committing. It was this taste that would later be fed by the true crime genre.

In 1915 the American publisher Street & Smith decided to inject some Sherlock Holmes-style sophistication into *Nick Carter Stories*. The magazine was renamed *Detective Story Magazine*, and though Nick fiction continued (and *Nick Carter Magazine* was still to come), English detective stories ran alongside. The idea was to satisfy fans of both the urbane detective and the American roughneck, and sales seemed to say they accomplished their goal. Every major mystery writer of the day was published in *Detective Story* and as the magazine's profits increased, competitors appeared. Detective fiction was entering its Golden Age, and providing inspiration for the first true crime magazines.

Technically, the first true crime titles were born in 1924 when New York-based Macfadden introduced *True Detective Mysteries*, and an undistinguished pulp called *Detective Tales* was sold to a publisher in Chicago and reborn as *Real Detective Tales*. Both these new titles were largely fiction-based for the first four years of their runs, as they had been designed to compete with *Detective Story Magazine* and new competitors *The Black Mask* and *Flynn's*. Ironically, the only magazine experimenting with true crime stories at all during this period was *Flynn's*, the least popular of the three.

REALITY SETS IN

Around 1928 both *True Detective Tales* and *Real Detective Tales* split from the crime fiction genre. Although both had previously featured stories based around real crime, they'd held back on actual names, photos, and explicit details. Gradually, though, both became emboldened to cover real crime alongside the fiction. *True Detective* showed more daring, moving to a completely true crime format by 1929. *Real Detective*, having changed its title to the clumsy *Real Detective Tales and Mystery Stories* in 1927, continued mixing fiction with reality until 1931.

Why the shift? One answer would be that the competition for good writers and stories was fierce, but it is more likely that someone — Macfadden or his editor John Shuttleworth — finally noticed that what was going on in the streets and speakeasies was even more entertaining than fiction.

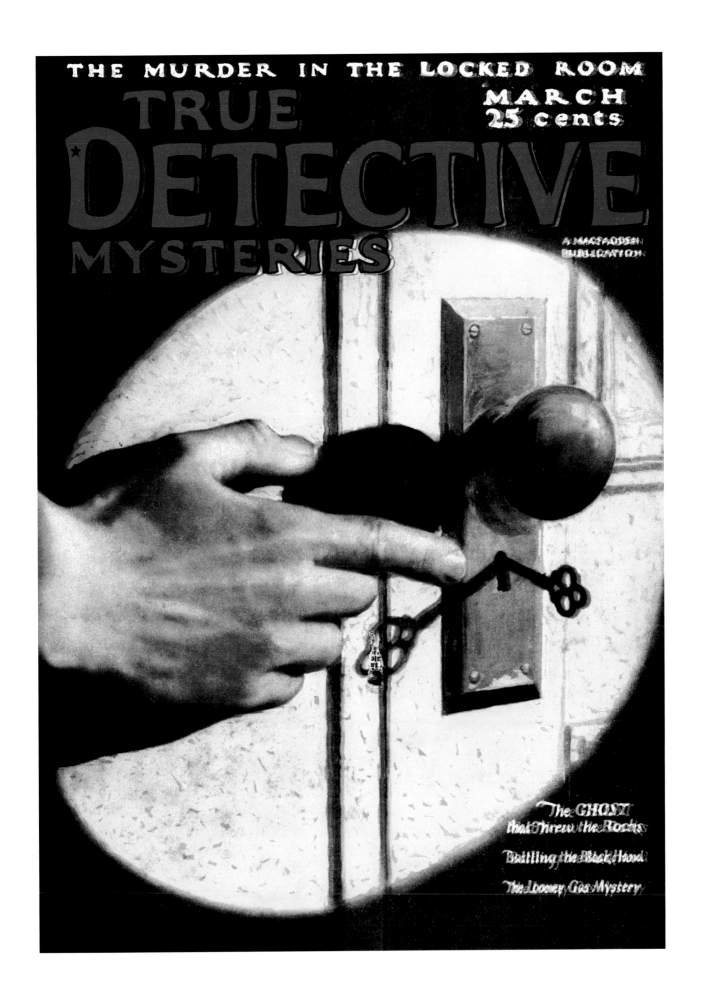

THE MURDER IN THE LOCKED ROOM

MARCH
25 cents

TRUE

★DETECTIVE

MYSTERIES

A MACFADDEN
PUBLICATION

The GHOST
that Threw the Rocks

Battling the Black Hood

The Looney Gas Mystery

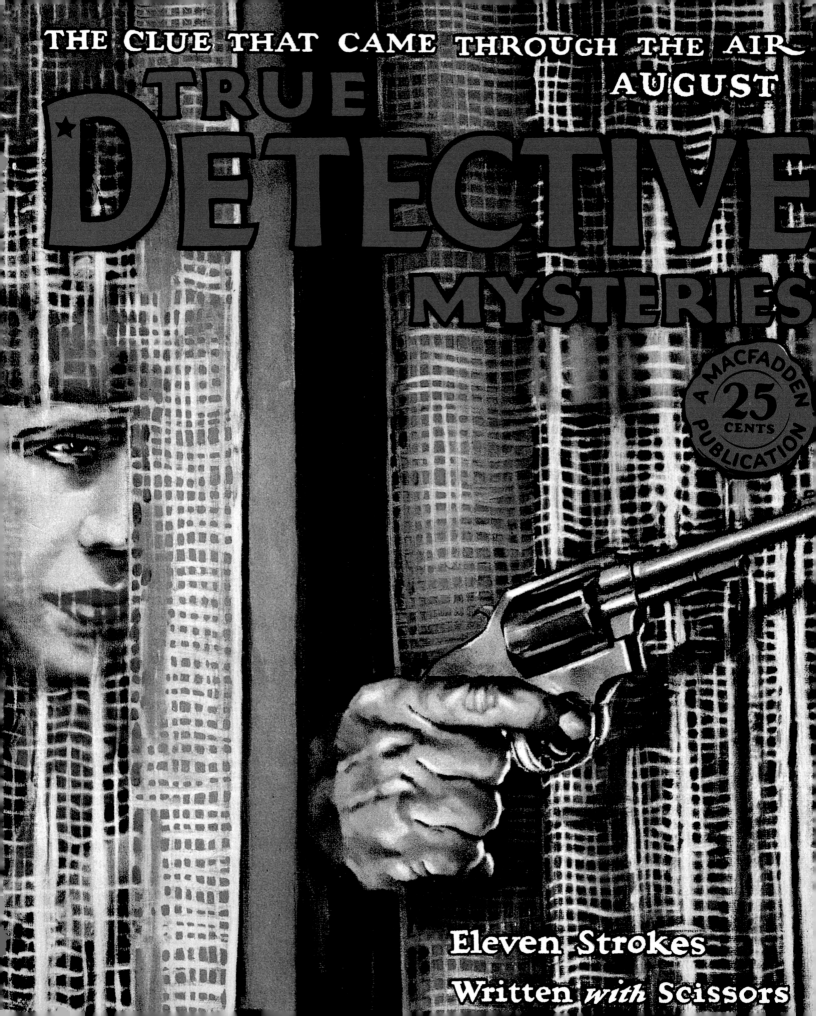

THE CLUE THAT CAME THROUGH THE AIR

AUGUST

TRUE
DETECTIVE
MYSTERIES

A MACFADDEN PUBLICATION

25 CENTS

Eleven Strokes
Written *with* Scissors

UNMORALISCHE GESCHICH-
TEN, RUCHLOSE SCHURKEN
von Eric Godtland

Die Magazine, die wahre Kriminalfälle zum ersten Reality-Format in der amerikanischen Unterhaltungsindustrie machen sollten, stellten nur ein neues Genre in der längst etablierten literarischen Tradition der Detektivgeschichten dar. Die ersten Detektive in der amerikanischen Literatur finden sich bei Edgar Allen Poe, der sich durch die Memoiren des französischen Abenteurers François Eugène Vidocq hatte inspirieren lassen. Vidocq hatte im frühen 19. Jahrhundert in Paris einen privaten Sicherheitsdienst betrieben. Allerdings war er in den USA kaum bekannt, daher wurde Poe das Verdienst zugeschrieben, mit seiner 1841 erschienenen Geschichte *Der Doppelmord in der Rue Morgue* den unfehlbaren Detektiv als archetypischen Helden erschaffen zu haben. Die Story war so erfolgreich, dass Poe seinen Detektiv in *Der entwendete Brief* (1844) und *Das Geheimnis der Marie Rogêt* (1850), eine Fortsetzung der *Rue Morgue*, erneut auftreten ließ. Poes Detektiv war eine alle überragende, edle Gestalt, ein Mann, der verblüffende analytische Fähigkeiten und subtile Menschenkenntnis einsetzte, um Verbrechen zu klären und die Täter ihrer gerechten Strafe zuzuführen. Motiviert durch den Erfolg von Poes Geschichten wagten sich auch andere Autoren an das Genre der Detektivgeschichten und des Kriminalromans. In Charles Dickens *Bleakhaus* geht es zum Beispiel um einen rätselhaften Mord, und als Dickens 1870 starb, saß er gerade an einer weiteren, unvollendet gebliebenen Kriminalgeschichte, *Das Geheimnis des Edwin Drood*.

Allerdings schrieben im 19. Jahrhundert nicht nur große Romanciers Kriminalgeschichten. Die ersten Dime Novels (Groschenromane) datieren zurück auf 1860, und die ersten Detektivgeschichten im Groschenheft-Format, *Old Cap Collier Library*, erschienen mit großem Erfolg ab 1883. Dies rief zwei Monate später die *New York Detective Library* auf den Plan, deren populärster Schnüffler Old King Brady war. 1885 folgte *Old Sleuth Library*, ebenfalls mit mehreren Geschichten in einem Heft, das auch auf den offenkundigen Charme der Vokabel „old" im Titel von Detektivheften setzte. Eigentlich waren die meisten Detektive in diesen Heften jedoch schneidige, junge Burschen, so auch Nick Carter, der 1886 erstmals erschien.

Nick Carter war der erste Dime Novel, der ausschließlich den Abenteuern eines einzelnen Detektivs gewidmet war. Als der prototypische, stürmische amerikanische Weltverbesserer verbrachte Nick seine Zeit zur Hälfte mit Detektivarbeit und zur Hälfte mit Abenteuern in aller Welt. Die Reihe war so populär, dass ihr Held bis 1936 überlebte und als *Nick Carter Library*, *Nick Carter Weekly*, *Nick Carter Stories* und schließlich *Nick Carter Magazine* von Verlag zu Verlag weitergereicht wurde. Während dieser 50 Jahre schrieben Dutzende von Autoren an Nicks Abenteuern, dennoch gelang es ihnen, ihren knallharten Helden verblüffend einheitlich zu zeichnen.

Das Bindeglied zwischen den literarischen Detektiven und denen der Dime Novels und frühen Magazine bildete die Sherlock-Holmes-Serie von Sir Arthur Conan Doyle. Nachdem er seinen Helden 1887 in *Eine Studie in Scharlachrot* eingeführt hatte, schrieb Doyle zwischen 1887 und 1927 über seinen Detektiv 60 Geschichten. Viele davon erschienen zunächst in dem Magazin *The Strand*, in dem Doyle mit einer neuen Holmes-Episode pro Heft den Fortsetzungsroman einführte. Sherlock Holmes war ein weitaus komplexerer Held als Nick Carter, ein Mann mit unglaublichen deduktiven Fähigkeiten, zugleich aber auch mit menschlichen Schwächen und durchaus Tendenzen zum Außenseiter. Diese Balance zwischen bewundernswertem

He came toward me with deadly intent

OPPOSITE *True Detective Mysteries*, August 1927

ABOVE *True Detective Mysteries*, January 1925

> **"Diesen wunderbaren Körper zersägen, der mir eine Tochter geschenkt hatte? Niemals! Ich stahl die Leiche der Mutter aus dem Obduktionssaal."**
> — *TRUE DETECTIVE MYSTERIES*, JANUAR 1925

I felt my last moment had arrived

OPPOSITE *True Detective Mysteries*, April 1927

ABOVE *True Detective Mysteries*, January 1925

Genie und Exzentrik fesselte die kollektive Vorstellungskraft des Lesepublikums so sehr, dass es zu Demonstrationen vor dem Verlagsgebäude kam, als Doyle seinen Helden sterben ließ, um mehr Zeit für seine „seriöseren" Arbeiten zu haben.

Doyles Schwager E. W. Hornung fügte diesem neuen, kultivierteren Teilbereich des Krimigenres weitere Nuancen hinzu. Um die Jahrhundertwende erschuf Hornung den ersten in Serie gehenden Antihelden, A. J. Raffles, einen unfehlbaren und beeindruckenden Kriminellen, das Gegenstück zu Doyles unfehlbarem Detektiv. Raffles war ein englischer Gentleman, Patriot und Kricketspieler, dessen Erbe nicht ausreichte, um ein standesgemäßes Leben zu führen. Daher sah er sich gezwungen, tollkühne Verbrechen zu begehen, bei denen er den Häschern stets nur um Haaresbreite entkam. Mit ihren Helden hatten Doyle und Hornung die frühen Vorbilder für James Bond und all die gewieften, aristokratischen Detektive, Spione und Diebe in den Hollywoodfilmen der 1950er- und 1960er-Jahre geschaffen.

1915 beschlossen die amerikanischen Verleger Street & Smith, ihre *Nick Carter Stories* um etwas englische Kultiviertheit à la Holmes zu bereichern. Das Heft wurde in *Detective Story Magazine* umbenannt, und Nick machte zwar weiter – das *Nick Carter Magazine* sollte erst noch kommen –, daneben standen jetzt jedoch englische Detektivgeschichten. Damit wollte man es sowohl den Anhängern der kultivierteren Detektive als auch denen der amerikanischen Draufgänger recht machen, und der Verkaufserfolg sprach für sich. Jeder wichtige Krimiautor dieser Zeit veröffentlichte in *Detective Story*, und schon bald stellten sich Konkurrenzblätter ein. Für das Krimigenre brach ein goldenes Zeitalter an, das auch die Inspiration für die ersten True Crime Magazines brachte.

Genau genommen erschienen die ersten True Crime Magazines 1924, als Macfadden in New York *True Detective Mysteries* auf den Markt brachte und eine mäßig erfolgreiche Pulp-Serie, *Detective Tales*, an einen Verlag in Chicago verkaufte und als *Real Detective Tales* relauncht wurde. Beide Titel veröffentlichten in den ersten vier Jahren ihres Erscheinens vorwiegend Fiction, denn sie sollten eigentlich den Konkurrenzblättern *Detective Story Magazine* und den jüngeren Titeln *Black Mask* und *Flynn's* Paroli bieten. Ironischerweise war *Flynn's*, das auflagenschwächste der drei, in dieser Phase das einzige Magazin, das überhaupt mit Berichten über wahre Kriminalfälle experimentierte.

EINBRUCH DER WIRKLICHKEIT

Um 1928 verabschiedeten sich sowohl die *True Detective Tales* wie auch die *Real Detective Tales* ganz von den fiktiven Krimigeschichten. Zwar hatten beide mitunter schon Storys gebracht, die auf realen Begebenheiten beruhten, dabei aber auf die wirklichen Namen, auf Fotos und nähere Details verzichtet. Nach und nach wagten sie jedoch immer öfter, neben der Fiction auch wahre Geschichten zu bringen. *True Detective* stellte 1929 auf das True-Crime-Format um. *Real Detective*, das 1927 den sperrigen Titel *Real Detective Tales & Mystery Stories* bekommen hatte, mischte noch bis 1931 fiktive und wahre Geschichten.

Warum diese Kursänderung? Möglicherweise war ja der Konkurrenzkampf um gute Autoren und Storys sehr verbissen, wahrscheinlicher ist jedoch, dass irgendjemand, Macfadden oder sein Chefredakteur John Shuttleworth, letztendlich registriert hatte, dass sich auf den Straßen und in den konzessionslosen Kneipen spannendere Dinge abspielten, als sie irgendein Autor erfinden konnte.

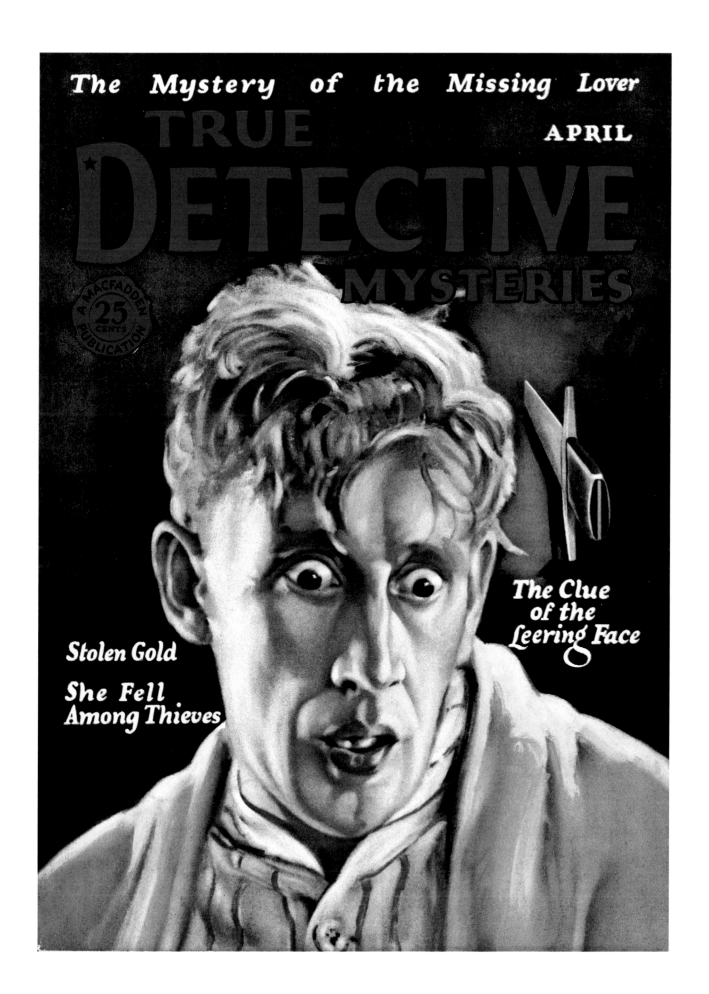

TRUE
December
DETECTIVE
MYSTERIES

A MACFADDEN PUBLICATION

PRICE
UNITED STATES
25¢
CANADA
30¢

The "Green Goods" Guy

Sleeping Death

LE GRAND THÉÂTRE DE L'IMMORALITÉ

Eric Godtland

Les magazines de faits divers criminels, qui allaient devenir le premier « divertissement réalité » de l'Amérique, n'étaient à l'origine que de nouveaux titres s'inscrivant dans une tradition bien installée, celle de la fiction. Les premiers détectives de la littérature américaine étaient apparus dans les nouvelles d'Edgar Allen Poe, elles-mêmes inspirées des mémoires de François Eugène Vidocq, un aventurier français qui devint chef d'une brigade de sûreté dans le Paris du début du XIXᵉ siècle. Les aventures de Vidocq n'étaient pas très connues aux États-Unis. C'est Edgar Poe que l'on considéra comme l'inventeur du détective infaillible, avec la publication, en 1841, de *Double assassinat dans la rue Morgue*. La nouvelle connut un tel succès populaire que Poe fit revivre son héros *dans La Lettre volée* en 1844, puis en 1850 dans *Le Mystère de Marie Roget*, la suite de *Double Assassinat dans la rue Morgue*. Le détective d'Edgar Poe était un personnage noble et imposant qui, grâce à ses étonnantes capacités d'intuition et d'analyse élucidait les énigmes criminelles et conduisait les coupables au châtiment qu'ils méritaient. Dans *Le Mystère de Marie Roget*, Edgar Poe inaugurait ce qui allait devenir une norme dans les premiers magazines policiers. Il romança un fait divers authentique : la disparition de Mary Rogers à New York, qu'il situa à Paris, en déguisant à peine le nom de l'héroïne. Le succès des nouvelles d'Edgar Poe créa un précédent que d'autres n'eurent plus qu'à affiner et à exploiter : le roman de détective et de mystère. *La Maison déserte* de Charles Dickens, par exemple, repose sur une énigme criminelle, et son auteur mourut en 1870, alors qu'il écrivait un autre roman de ce genre, *Le Mystère d'Edwin Drood*.

Tous les auteurs de romans policiers du XIXᵉ siècle n'étaient pas des écrivains du niveau d'Edgar Poe ou de Charles Dickens. Les premiers romans de gare datent de 1860 et le premier recueil de nouvelles policières, *Old Cap Collier Library*, obtint un grand succès en 1883. Old Cap n'apparaissait que dans quelques-unes de ces nouvelles, jouant surtout le meneur de jeu qui présentait d'autres héros. Cette réussite commerciale engendra deux mois plus tard *New York Detective Library*, où le fin limier s'appelait Old King Brady. Exploitant la magie que semblait opérer le mot « Old » dans les titres, *Old Sleuth Library* fit son apparition sur le marché, sous forme de recueil de nouvelles. Ces héros « Old » étaient en fait, pour la plupart, de fringants jeunes hommes, à l'instar de Nick Carter, qui fit ses débuts en 1886.

Nick Carter fut le premier détective à bénéficier d'un roman entier consacré à ses seuls exploits. Parfait prototype de l'Américain énergique et bonne âme, Nick partageait son temps entre son travail de détective et ses aventures à l'étranger. Son personnage fut tellement populaire qu'il survécut jusqu'en 1936, passant d'éditeurs en éditeurs sous des titres successifs : *Nick Carter Library* devint *Nick Carter Weekly*, puis *Nick Carter Stories*, et enfin *Nick Carter Magazine*. Au cours de ses cinquante années d'existence, ses aventures furent racontées par des dizaines d'auteurs, qui parvinrent à maintenir une étonnante cohérence chez ce vigoureux personnage.

C'est Sir Arthur Conan Doyle qui assura, avec la série des *Sherlock Holmes*, le passage de ces romans et magazines de gare vers un genre de qualité, la nouvelle. Après l'apparition du détective londonien dans un premier roman, *Une étude en Rouge*, Conan Doyle produisit 60 nouvelles entre 1887 et 1927 narrant les enquêtes de son héros. Nombre d'entre elles furent d'abord publiées dans *The Strand Magazine* à raison d'une aventure de Sherlock Holmes par numéro. Personnage plus

OPPOSITE *True Detective Mysteries*, December 1927

ABOVE *The Master Detective*, September 1929

BELOW *Real Detective Tales and Mystery Stories*, October 1929

> **«La pensée qu'on puisse découper cette superbe créature qui m'avait donné une fille m'était insupportable. Je volais le corps dans la salle de dissection.»**
> — *TRUE DETECTIVE MYSTERIES*, JANVIER 1925

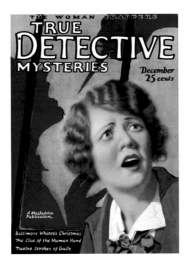

OPPOSITE *The Master Detective*, October 1929

ABOVE *True Detective Mysteries*, December 1924

BELOW *True Detective Mysteries*, June 1928

complexe que Nick Carter, l'enquêteur de Baker Street était un incroyable logicien avec des failles humaines et des habitudes d'«outsider». Ce génie admirable et excentrique, célibataire d'âge mûr et misogyne qui sniffait de la cocaïne et passait le plus clair de son temps en compagnie du Dr. Watson, vieux garçon comme lui, captivait tellement l'imagination de ses lecteurs que, lorsque Conan Doyle élimina son héros pour se consacrer à une littérature «plus sérieuse», des foules en colère se rassemblèrent devant les bureaux de son éditeur pour protester.

E. W. Hornung, beau-frère de Conan Doyle, avait pris le relais en étoffant ce nouveau genre d'enquêtes sophistiquées. Au début du XXe siècle, il inventa le premier anti-héros de feuilleton, A. J. Raffles, un fascinant cambrioleur aussi infaillible que le détective de Doyle. Raffles était un gentleman anglais, patriote et joueur de cricket, auquel son héritage ne suffisait pas à offrir les plaisirs de sa caste. Il était contraint de réaliser des cambriolages audacieux après un suspense palpitant. Doyle et Hornung avaient ébauché le prototype du futur James Bond et de tous les aristocrates cambrioleurs, espions et détectives du Hollywood des années 1950 et 1960. Les deux beaux-frères sont également à l'origine de l'intérêt du public pour les énigmes vécues avec un double point de vue, celui du criminel et du détective. Une ambivalence que devaient plus tard cibler les *detective magazines*.

En 1915, l'éditeur américain Smith & Street décida d'introduire la sophistication de Sherlock Holmes dans les *Nick Carter Stories*, qu'il rebaptisa *Detective Story Magazine*. On y trouvait les aventures de Nick Carter (*Nick Carter Magazine* n'était pas encore né), parallèlement à celles de détectives britanniques. L'idée étant de plaire autant aux fans de voyous américains qu'aux amateurs de détectives courtois. Les chiffres de vente confirmèrent que ce but était atteint. Tous les grands auteurs de thriller écrivaient dans *Detective Story* et l'essor de ses ventes suscita la création de magazines concurrents. La littérature criminelle entrait dans son âge d'or.

La naissance du genre date de 1924, lorsque le New-Yorkais Macfadden lança *True Detective Mysteries* et qu'un éditeur de Chicago racheta *Detective Tales*, un *pulp* médiocre qu'il intitula *Real Detective Tales*. La fiction y resta prédominante pendant les quatre premières années, car l'un et l'autre étaient conçus pour concurrencer *Detective Story Magazine* et ses rivaux *The Black Mask* et *Flynn's*. C'est d'ailleurs ce dernier qui se lança le premier dans la publication de faits divers criminels.

LA RÉALITÉ S'INSTALLE

C'est vers 1928 que *True Detective Tales* et *Real Detective Tales* abandonnèrent la fiction. Si l'un et l'autre avaient ouvert leurs colonnes à des histoires vraies, ils s'étaient abstenus de publier les noms et les photos des protagonistes. Ils s'enhardirent progressivement et *True Detective* sauta le pas de la réalité dès 1929, tandis que *Real Detective*, qui portait depuis 1927 le titre peu accrocheur de *Real Detective Tales & Mystery Stories*, continuait à mélanger fiction et réalité.

Pourquoi cette évolution? On pourrait avancer la compétition entre les magazines pour s'attacher les bons auteurs de fiction et dénicher les bonnes histoires. Mais il est plus probable que quelqu'un a fini par se rendre compte que ce qui se passait dans les rues et les bars clandestins de la prohibition était plus passionnant que la fiction.

OPPOSITE *True Detective Mysteries*, May 1928

ABOVE LEFT *True Detective Mysteries*,
November 1926

ABOVE RIGHT *True Detective Mysteries*, June 1925

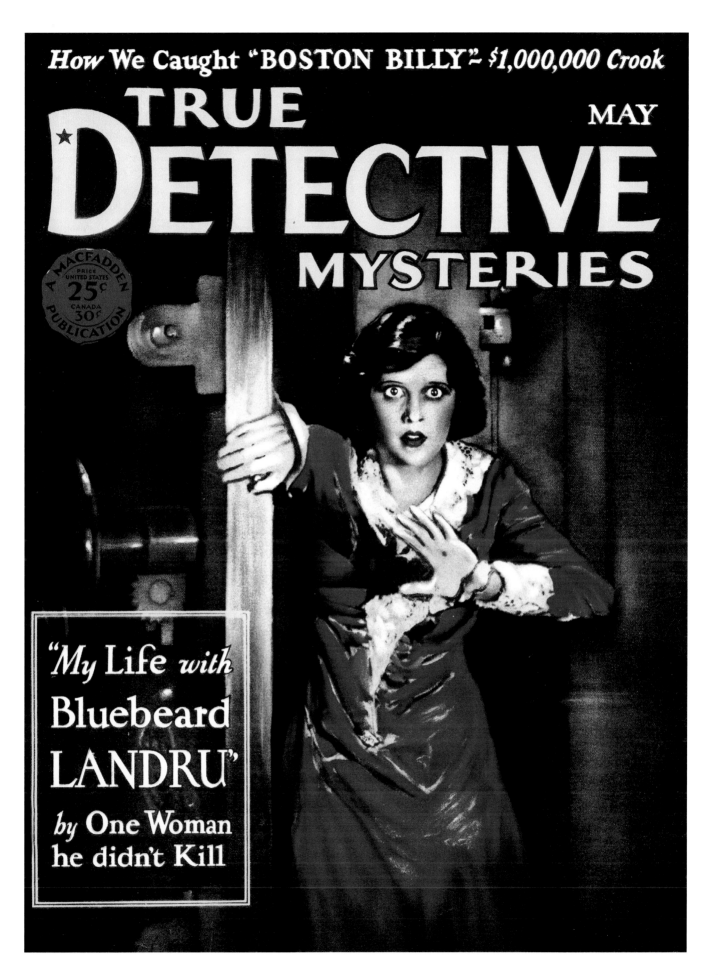

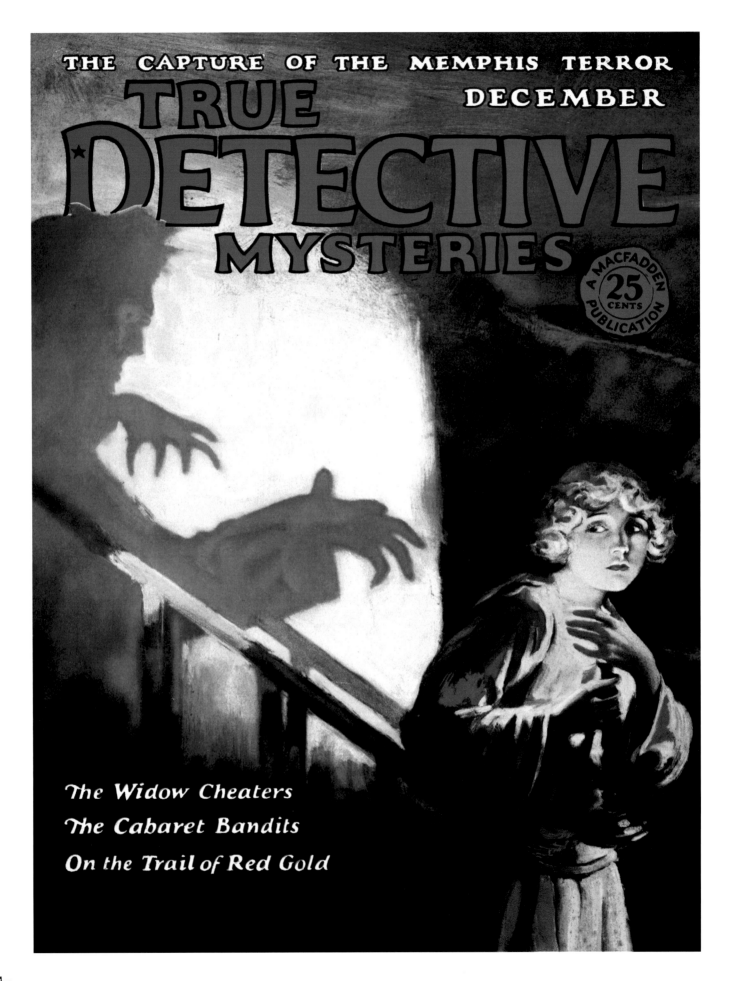

THE CAPTURE OF THE MEMPHIS TERROR
DECEMBER

TRUE
DETECTIVE
MYSTERIES

A MACFADDEN PUBLICATION
25 CENTS

The Widow Cheaters
The Cabaret Bandits
On the Trail of Red Gold

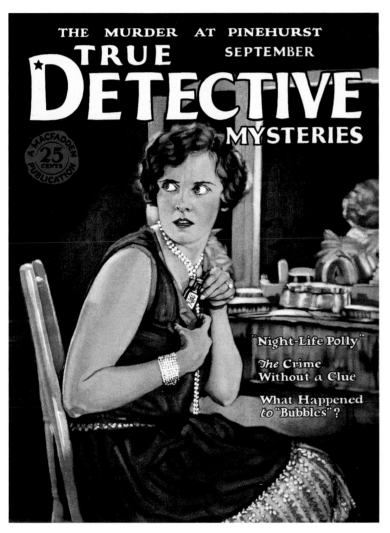

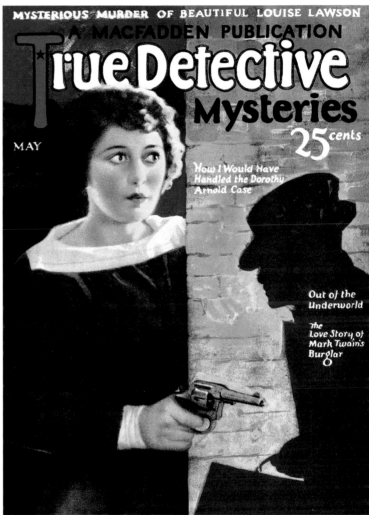

OPPOSITE *True Detective Mysteries*,
December 1925

ABOVE LEFT *True Detective Mysteries*,
September 1927

ABOVE RIGHT *True Detective Mysteries*,
May 1924

PAGES 56–57 *True Detective Mysteries*,
December 1924

more Whitey was in high spirits the night that he left Baltimore for the little Southern city where the mark was located.

ON the way down to the scene of the robbery neither Johnny nor his pals ceased preaching to Whitey.

"You're all wrong, old pal," they told him. "You ought to turn back before it's too late."

And he continued to laugh at them and belittle their timidity and retaliate with the same old statement:

"The citizens kept shooting at us until——

"I knocked 'em off for fifteen years wherever I found them, and how many times did I get a tumble? Just once in my life!"

They cited case after case of men who had been knocked off on the last job.

"The last job," Johnny told him, "has usually been the one on which the grifter has taken the jump over the border. I've known many a grifter that was killed on the last job, Whitey. Remember old 'Chi Jack'?"

OLD CHI JACK, to whom Johnny referred, was a pal of both Johnny and Baltimore Whitey, who had been killed while trying to hold up a bank.

"That happens once in a lifetime," he replied to Johnny's reference to the ending of old Chi Jack.

"And this may be your time," Johnny kept at him.

And Whitey came back again with the old fifteen-

year story and the one tumble in those fifteen years.

Then later on he got the wrong idea into his head. He thought that Johnny and his gang had reached the conclusion that he was yellow, that they were afraid of him. This turned him into a madman. He threatened to shoot the first one that made any more reference to his going out on the racket again.

"Nobody thinks you're yellow, Whitey," Johnny said to him. "We are only thinking of the wife and the kids and what a terrible sucker you are to come back into the game after you've been on the level for nine long years."

"Cut it out," he snarled. "I don't want to hear any more about the wife and the kids and my stretch along the straight and narrow. I know my own business best. I'm sick of listening to you mugs preaching."

Nothing was said to him after that except that Johnny and the rest of his gang had determined to leave him immediately after the bank had been robbed.

There was only one night officer in the town and this officer, incidentally, had the reputation of being a hard nut. On more than one occasion he had driven bank burglars away from the bank. It was said of him that he didn't know the meaning of the word fear. The bank had been much sought after by bank burglars, primarily because of the fact that it hadn't up-to-date equipment. The vault was an old-timer and so was the safe; the building was minus burglar alarms, and the location was ideal for a robbery. In addition to all these things it was rumored that it carried a large amount of cash.

THE night officer was an unusually suspicious man, due to the fact that a number of different gangs of bank burglars had made many efforts to "stick him up." After midnight when all the citizens had retired, if he saw anybody coming down the main street towards him he would step out in the middle of the road so that nobody could get to him to hold him up. If anybody came out in the middle of the road he would immediately command them to halt, and if they didn't halt he began to shoot at them. He was the kind to shoot first and inquire afterward.

He was the man who had killed old Chi Jack, of whom

have made mention. Jack was a member of a gang that
ad tried to hold him up one night. Jack went out in the
iddle of the road to shove his gun in the officer's face,
ad when he told Jack to halt and he didn't stop, he opened
re on him killing him in his tracks.

Now Johnny knew all about the timidity and the
eculiarities of this watchman, and he had devised a plan
• "get to him." It was arranged that Baltimore Whitey
as to pretend that he was terribly drunk when they reached
e main street. He was supposed to shout and swear with
•andon, and Johnny and Tommy Devlin and "Tennessee
utch," the other members of the gang, were to appear to
• making an effort to subdue Whitey. The purpose of all
is was to throw, or catch the night officer off his guard
• that they could get to him and hold him up to quiet him
id then burglarize the bank.

AROUND one in the morning they
started up-town. When they got
the edge of the main street Whitey
gan to do the drunken
an's act, while Tommy
evlin, Tennessee Dutch
id Johnny talked to
m as they would
ally talk to a drunken
iend whom they
ere trying to get
me.

Suddenly the big
ght officer hove
sight a block
two away.
'hitey was
Irsing and
rearing and
owling
e a real
runk.

When they got within a hundred yards or so of the officer
he stepped out in the middle of the street, and when they
finally got nearer to him he stopped and spoke to them:
"Making a lot of noise," the officer said.
"Yes," Johnny replied. "Trying to get our friend down
to the camp."

THE camp to which Johnny referred was a railroad camp
at the other end of the town.
Then Whitey became more boisterous than ever and
Johnny and his pals gave up in feigned disgust.
"To hell with him," Tennessee Dutch expostulated. "I'm
not going to fool with this mug any longer. Let him lie
where he is."
This was Whitey's signal to raise more disturbance and
he certainly raised
it, Johnny told me.
"He began to roar
and whoop like an
Indian," Johnny
(*Cont'd on page 66*)

——Tennessee Dutch passed out with a bullet through his heart"

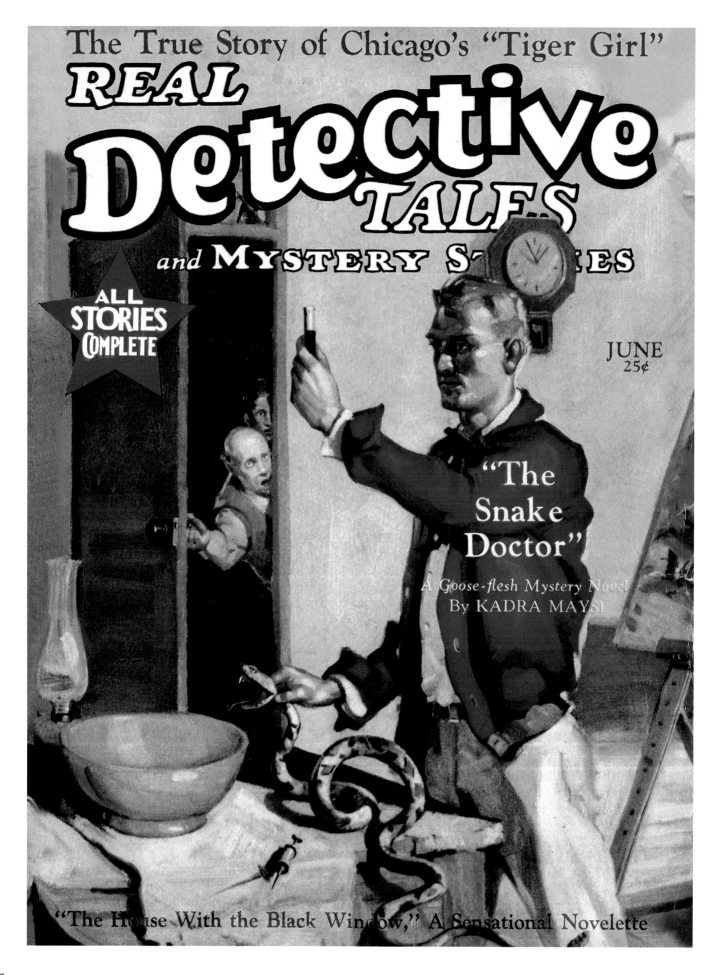

The True Story of Chicago's "Tiger Girl"

REAL Detective TALES

and MYSTERY STORIES

ALL STORIES COMPLETE

JUNE
25¢

"The Snake Doctor"

A Goose-flesh Mystery Novel
By KADRA MAYSI

"The House With the Black Window," A Sensational Novelette

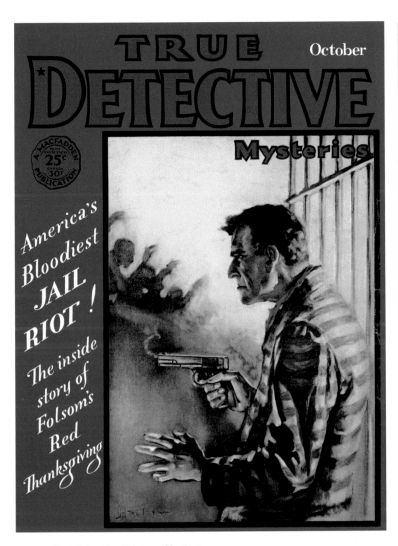

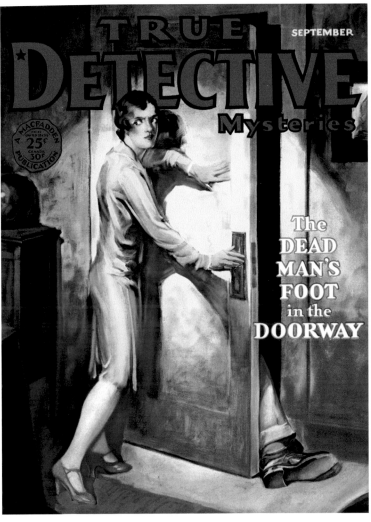

OPPOSITE *Real Detective Tales and Mystery Stories*, June 1929

ABOVE LEFT *True Detective Mysteries*, October 1929

ABOVE RIGHT *True Detective Mysteries*, September 1929

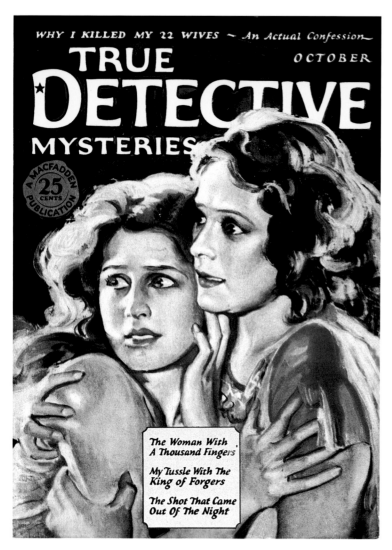

Cover text:

WHY I KILLED MY 22 WIVES ~ An Actual Confession

TRUE DETECTIVE MYSTERIES

OCTOBER

A MACFADDEN PUBLICATION

25 CENTS

The Woman With A Thousand Fingers

My Tussle With The King of Forgers

The Shot That Came Out Of The Night

"Half the crooks in this prison are here because they associated with some moll and confided in her. Never trust a woman, my boy."

— *TRUE DETECTIVE MYSTERIES*, MAY 1928

OPPOSITE *True Detective Mysteries*, May 1927

ABOVE *True Detective Mysteries*, October 1925

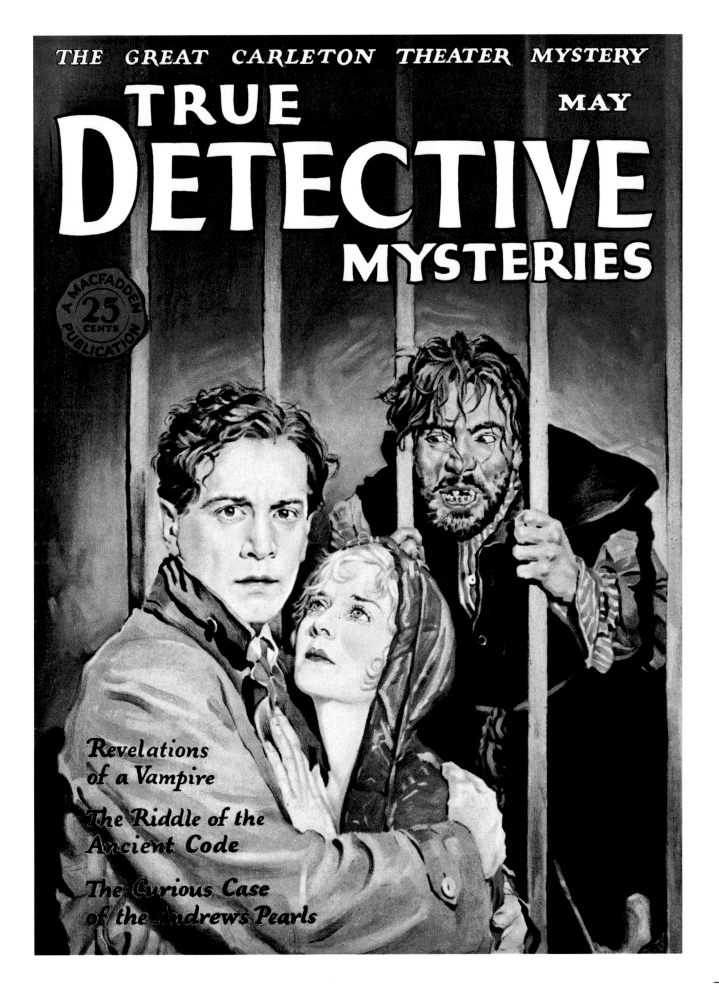

1930 - 1939

In the '30s the status of the magazines
was such that even FBI head J. Edgar
Hoover was eager to see his name in
their pages. During this golden age
the magazines were "star makers" in a
near-Hollywood sense for criminals
John Dillinger, Al Capone, Bonnie and
Clyde, Ma Barker, Pretty Boy Floyd,
Alvin Karpis, Machine Gun Kelly, and
Baby Face Nelson.

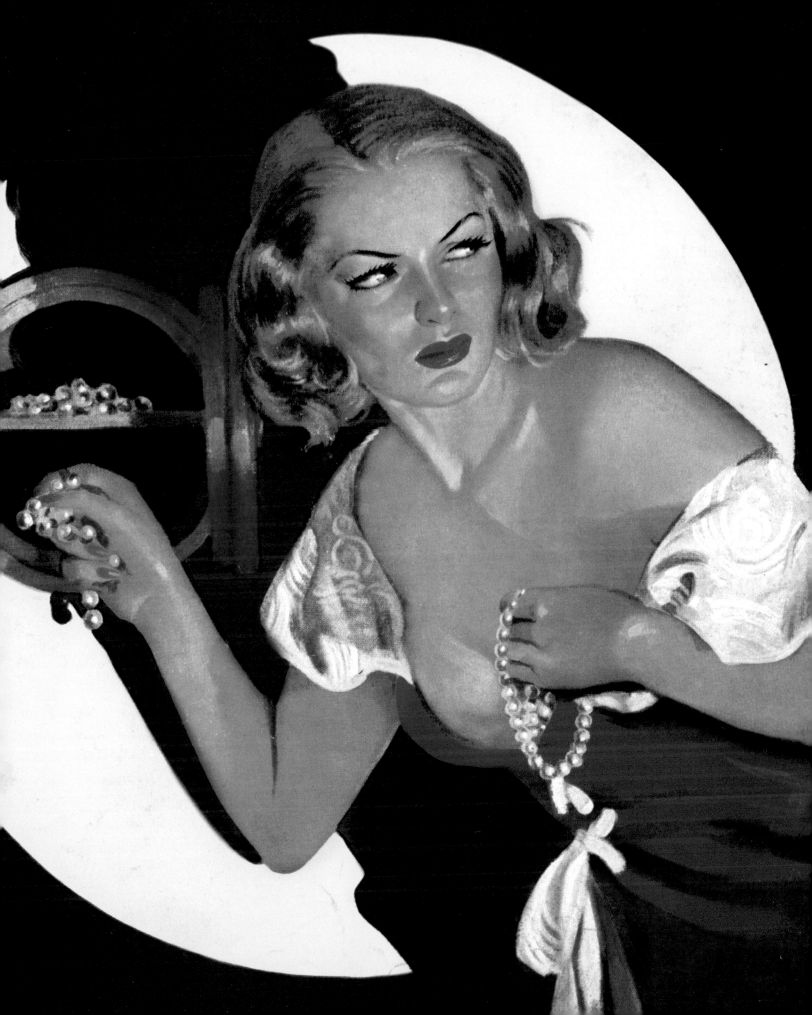

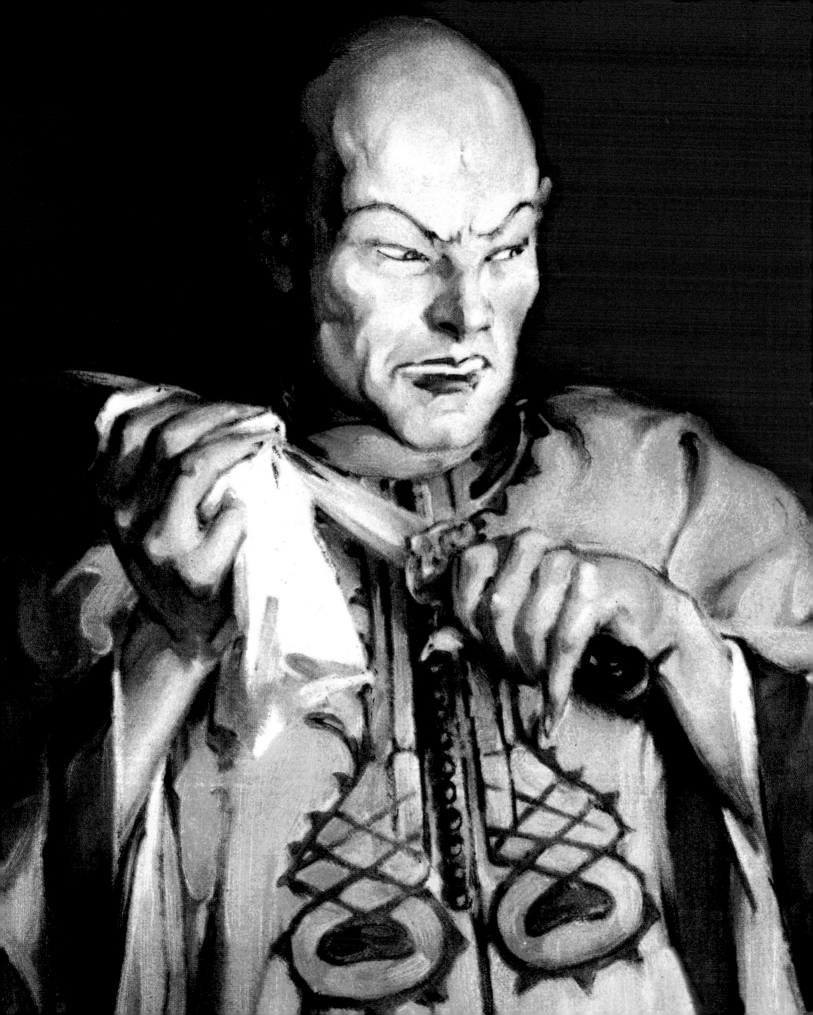

THE GOLDEN AGE OF CRIME

by Eric Godtland

Detective magazines exploded in popularity in the 1930s thanks to a synergistic triad of trends: the proliferation of home radio sets, the national crime wave generated by Prohibition, and the escapist yearnings of a public mired in the Great Depression. Radio had flowered in the 1920s and continued to blossom through the '30s, with 638 stations in 1930, growing to 909 by 1942. By the end of the decade more than 80% of American households owned a radio. This medium brought live news coverage to all parts of the country simultaneously, changing the idea of what "up on the news" meant. Radio transformed reporting, and especially crime reporting, into a form of entertainment. For the first time people could follow the exploits of bank robbers, gangsters, and other shadowy characters at work, at home, in barbershops and bars, with the exciting urgency of hour-by-hour reports.

At the same time, Prohibition had created a growth market of interesting crime since passage of the 18th Amendment in 1919. Murder alone was up by 77% between 1920 and 1933, and all crime was more spectacular with the emergence of the organized criminal families battling for bootlegging rights. Hearing radio broadcasts about these sensational events made the public curious to see pictures and to know more. The newspapers offered a taste, but not the more grisly crime photos or in-depth stories. Add to this the public's desire for distraction during the Depression. Unemployment and deflation worsened steadily through the '30s. It's well documented that entertainment thrives in periods of depression and this was, after all, the greatest depression of them all. For many, reading about murder victims and their grieving loved ones provided a reminder there were still things for which to be thankful. Alternately, tales of Old West-style bank robberies provided fantasies of

instant wealth at a time when 30 to 80 banks failed each year. For each bank that failed, hundreds of people lost their life savings, and detective magazine readers rooted for those daring enough to steal back from the perceived corporate villains. Not surprisingly, bank robberies were the most popular subject in the true crime magazines of the '30s. All this crime and chaos was a tremendous boon to the detective magazine publishers, mainly Macfadden, Real Detective Tales Inc., and Fawcett, who fell over themselves to provide the kind of photos, interviews, and illustrations that only crime magazines could provide.

From every perspective the 1930s were the pinnacle of true crime publishing. The magazines were of the highest quality during this era, all creamy rag paper interiors, sophisticated matte covers for best art reproduction, and squared-off, book-style perfect bindings. In the '30s the artists commissioned for detective cover illustrations were fine artists trained in the best schools. And most important for true crime fans, the magazines' crime coverage during this era was the best and most complete of any decade.

Macfadden in particular, publisher of *True Detective, Master Detective, American Detective, Famous Detective Cases, Inside Detective,* and others employed a large staff of investigators to comb newspapers for promising crimes. Stringers were then sent to the scene to cover the story first-hand, even to the most remote backwaters. The 5,000-word stories were thorough and professional, including interviews with family and friends of both victim and perpetrator. By 1930 Macfadden's photo re-creations had been replaced with real crime photos that were generally of far better quality than what the newspapers could manage. In the '30s actual detectives and other members of law

PAGE 63 *Inside Detective*, January 1938

OPPOSITE *True Detective Mysteries*, August 1930

ABOVE *Dynamic Detective*, June 1937

> **"It was my first look at nudism en masse. Venuses, floppy matrons, cows, athletes, pot-bellies, scarecrows. I joined the crowd, running right behind a swivel-hipped Venus."**
>
> — *REAL DETECTIVE*, JULY 1934

enforcement often contributed stories and the status of the magazines was such that even FBI head J. Edgar Hoover was eager to see his name in their pages.

During this Golden Age the magazines could confer instant fame on their featured criminals. They were "star makers" in a near Hollywood sense for John Dillinger, Al Capone, Bonnie Parker and Clyde Barrow, Ma Barker, Pretty Boy Floyd, Alvin Karpis, Machine Gun Kelly, and Baby Face Nelson, who rank among the most recognizable names in criminal history thanks to the detective magazines. Dillinger holds top honors as America's all-time most popular criminal, with Capone close behind. In their day they had as many fans as the film stars of the era, and Hollywood kept close tabs on the detective magazines for plot ideas. *Scarface* (1932), patterned after the career of Al Capone, went into production less than a year after the gangster's 1931 income tax evasion bust.

By the mid-'30s both cops and criminals viewed detective magazines as quasi-trade journals. For cops, a mention in an article — or, better, a heroic photo — was as career-validating as an aspiring actor seeing his face in *Variety*. Criminals wrote letters to the editors; when Ma Barker and one of her sons were finally gunned down in a farmhouse in 1935 police found piles of detective magazines, some with pages turned to coverage of their exploits.

The "Hollywood" nature of crime, and the criminal nature of Hollywood, were often openly acknowledged in the '30s. Actors played mobsters during the day and drank beside real gangsters in the clubs at night. Actress Virginia Hill took the symbiosis to the limit when she hooked up with Ben "Bugsy" Siegel. He was a gangster, she an actress. He tried to get into films, while she embezzled from him. Can anyone deny the detective magazines of the 1930s fueled this art-imitates-life-imitates-art scenario?

OPPOSITE *Real Detective*, January 1938

BELOW *True Detective Mysteries*, March 1930

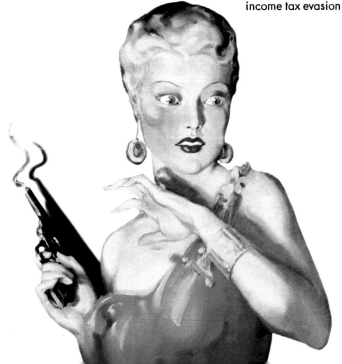

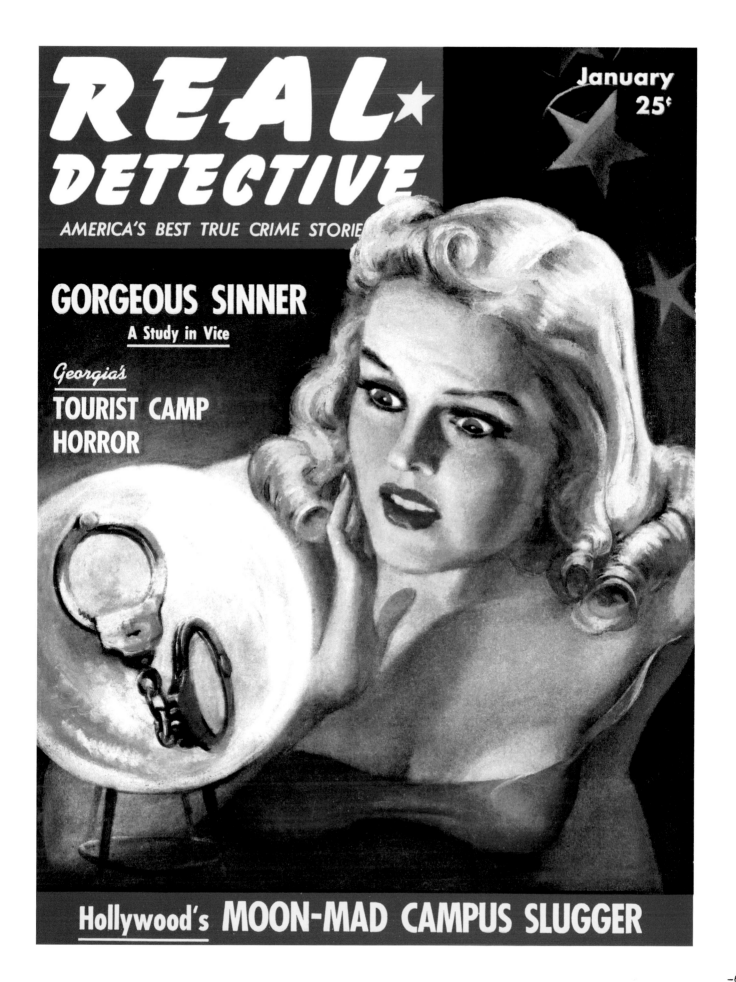

January
25¢

REAL ★ DETECTIVE

AMERICA'S BEST TRUE CRIME STORIES

GORGEOUS SINNER
A Study in Vice

Georgia's
TOURIST CAMP HORROR

Hollywood's MOON-MAD CAMPUS SLUGGER

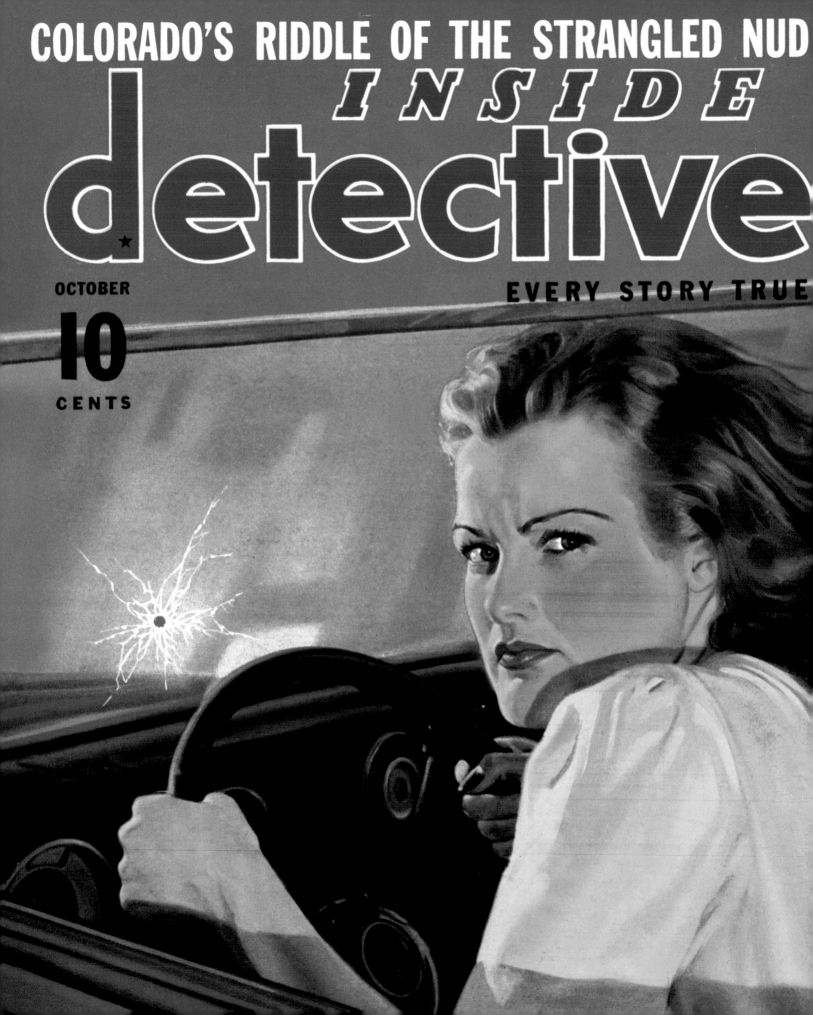

DAS GOLDENE ZEITALTER DES VERBRECHENS

von Eric Godtland

Der Synergieeffekt von drei Zeiterscheinungen ließ in den 1930er-Jahren die Popularität der Detective Magazines explosionsartig ansteigen: erstens die weite Verbreitung von Radiogeräten, dann die durch die Prohibition ausgelöste landesweite Verbrechenswelle und schließlich die realitätsfernen Sehnsüchte einer Nation, die im Würgegriff der Depression gefangen war. Das Radio war in den 1920ern schon ungemein populär geworden, und in den 1930ern setzte sich dieser Trend fort; bereits 1930 gab es 638 Sender, 1942 waren es 909. Am Ende des Jahrzehnts besaßen über 80 Prozent aller Haushalte in den USA ein Radio. Durch dieses Medium, das Nachrichten gleichzeitig in jeden Winkel des Landes brachte, bekamen Aktualität und Bekanntheit eine von Grund auf neue Bedeutung. Das Radio machte aus Berichterstattungen, insbesondere die Berichterstattungen über Verbrechen, eine Form des Entertainments. Zum ersten Mal konnten die Menschen das Tun von Bankräubern, Gangstern und anderen zwielichtigen Gestalten am Arbeitsplatz, zu Hause, beim Frisör oder in Bars verfolgen, mit der ganzen packenden Dramatik stündlich neuer Entwicklungen.

Zugleich war durch die Verabschiedung des 18. Verfassungszusatzes, die Prohibition, ein echter Wachstumsmarkt an interessanten Verbrechen entstanden. Allein die Mordrate stieg von 1920 bis 1933 um 77 Prozent, und mit dem Auftauchen der Gangs der organisierten Kriminalität, die um die Kontrolle über den Alkoholschwarzmarkt kämpften, wurden die Verbrechen insgesamt spektakulärer. Die Radionachrichten über diese packenden Ereignisse weckten im Publikum den Wunsch, Bilder zu sehen und nähere Einzelheiten zu erfahren. Die Zeitungen lieferten einen kleinen Vorgeschmack, brachten aber keine schockierenden Fotos von Verbrechensopfern oder ausführliche Hintergrundbe-

richte. Man denke sich noch die Sehnsucht nach ein wenig Ablenkung in Zeiten der Wirtschaftsmisere hinzu. Arbeitslosigkeit und Deflation verschlimmerten sich im Laufe der 1930er stetig. Es ist nichts Neues, dass die Unterhaltungsindustrie in Zeiten wirtschaftlicher Not prosperiert, und es war die größte Wirtschaftskrise aller Zeiten. Über Mordopfer und deren trauernde Hinterbliebene zu lesen, schenkte vielen den Trost, dass sie doch noch Dinge hatten, für die sie dankbar sein konnten. Auf der anderen Seite ließ es sich in Zeiten, in denen jährlich 30 bis 80 Banken pro Jahr die Schalter für immer dichtmachten, bei Geschichten über Banküberfälle à la Wildwest herrlich vom plötzlichen Reichtum träumen. Mit jeder Bank, die pleite ging, verloren Hunderte ihre gesamten Ersparnisse, und die Leser der Detective Magazines drückten jedem die Daumen, der es wagte, sich Geld von diesen vermeintlichen Gaunern in Nadelstreifen zurückzuholen. Es überrascht nicht, dass Banküberfälle das beliebteste Thema in den True Crime Magazines der 1930er-Jahre waren. Die chaotischen Zeitumstände waren ein Segen für die Verleger solcher Magazine, insbesondere für Macfadden, Real Detective Tales Inc. und Fawcett, die sich die Beine ausrissen, um an die Art von Fotos, Interviews und Illustrationen zu kommen, die nur Crime Magazines bieten konnten.

Wie man es auch betrachtet, die 1930er-Jahre waren der Höhepunkt in der Geschichte der True Crime Magazines. In diesem Jahrzehnt waren sie von exzellenter Qualität; die Innenseiten waren aus cremefarbenem Hadernpapier, sie hatten schicke matte Cover, damit die Illustrationen optimal zur Geltung kamen, und eine Klebebindung wie bei richtigen Büchern. Die Künstler, die in den 1930ern mit den Bildern für die Cover beauftragt wurden, kamen von den besten Kunstakademien. Und was

OPPOSITE *Inside Detective*, October 1939

ABOVE *Front Page Detective*, December 1937

"Es war meine erste Erfahrung mit Nudismus als Massenphänomen. Es gab Göttinnen, feiste Matronen, Kühe, Athletinnen und Schreckschrauben. Im Schlepptau einer hüftschwingenden Venus stürzte ich mich ins Getümmel."

— *REAL DETECTIVE*, JULI 1934

OPPOSITE, ABOVE & BELOW *Al Capone on the Spot*, 1931

am wichtigsten für den echten Fan des True Crime war, die Reportagen waren in keinem anderen Jahrzehnt so gut und gründlich recherchiert.

Vor allem Macfadden, der Verleger von *True Detective, Master Detective, American Detective, Famous Detective Cases, Inside Detective* und weiteren Blättern, beschäftigte einen riesigen Stab von Mitarbeitern, die die Zeitungen nach vielversprechend aussehenden Kriminalfällen durchkämmten. Dann wurden freiberufliche Korrespondenten an den Schauplatz des Verbrechens, wie entlegen auch immer, geschickt, um aus erster Hand berichten zu können. Die 5000-Worte-Storys waren solide und professionell gemacht und beinhalteten Interviews mit Angehörigen und Freunden der Opfer wie auch der Täter. 1930 lösten echte Tatortfotos, die in der Regel qualitativ wesentlich besser waren als Zeitungsfotos, bei Macfadden die nachgestellten Fotos ab. Zudem steuerten in den 1930ern echte Polizisten und andere Vertreter der Strafverfolgungsbehörden Storys für die Magazine bei, die solches Ansehen genossen, dass selbst FBI-Chef J. Edgar Hoover Wert darauf legte, seinen Namen darin gedruckt zu sehen.

In diesem goldenen Zeitalter konnten die Magazine die Verbrecher, über die sie berichteten, über Nacht zu Berühmtheiten machen. Sie bauten Stars auf, wie es sonst nur Hollywood konnte. John Dillinger, Al Capone, Bonnie Parker und Clyde Barrow, Ma Barker, Pretty Boy Floyd, Alvin Karpis, Machine Gun Kelly und Baby Face Nelson verdanken es den Detective Magazines, dass sie heute noch Größen in den Annalen des Verbrechens sind. Dillinger ist in den USA der populärste Kriminelle

aller Zeiten, dicht gefolgt von Al Capone. In ihrer Zeit hatten sie ebenso viele Fans wie die damaligen Hollywoodstars, und Hollywood, immer auf der Suche nach guten Storys, las die Detective Magazines mit großer Aufmerksamkeit. Der Film *Scarface* (1932), der auf der Lebensgeschichte Al Capones basiert, kam bereits ein Jahr nach der Verurteilung des Gangsters wegen Steuervergehens in die Kinos.

Mitte der 1930er betrachteten Cops wie Gangster die Detective Magazines als ihre Fachzeitschriften. Für einen Cop war eine Erwähnung oder noch besser ein Foto in heroischer Pose in einem der Hefte seiner Karriere so förderlich wie für einen aufstrebenden Schauspieler ein Foto in *Variety*. Kriminelle schrieben Briefe an die Herausgeber; als Ma Barker und einer ihrer Söhne 1935 schließlich doch erschossen wurden, fand die Polizei bei ihnen stapelweise Detective Magazines, manche bei den Berichten über ihre Schandtaten aufgeschlagen. Während der 1930er versuchte man gar nicht erst, den „hollywoodhaften" Charakter der Verbrechen und den kriminellen Charakter Hollywoods zu leugnen. Tagsüber spielten Schauspieler Gangsterrollen, und abends tranken sie in den Bars Seite an Seite mit echten Gangstern. Die Schauspielerin Virginia Hill trieb die Symbiose auf die Spitze, als sie sich mit dem Gangster Ben „Bugsy" Siegel einließ. Er versuchte, ins Filmgeschäft einzusteigen, sie veruntreute sein Geld. Will da jemand leugnen, dass die Detective Magazines in den 1930er-Jahren dieses Szenario von Kunst-imitiert-das-Leben und umgekehrt nährten?

L'ÂGE D'OR DE L'ENQUÊTE CRIMINELLE

Eric Godtland

La popularité des magazines policiers explosa dans les années 1930 grâce à trois facteurs conjugués : la prolifération des postes de radio dans les foyers, la vague de criminalité déclenchée par la prohibition, et la volonté d'évasion d'un public enlisé dans la Grande Dépression. La radio avait commencé à se développer dans les années 1920 et elle continua son ascension dans les années 1930, avec 638 stations en 1930, pour 909 en 1942. À la fin des années 1930, plus de 80 % des familles américaines étaient équipées d'un poste de radio. Ce média qui apportait simultanément des nouvelles toutes fraîches aux quatre coins du pays changea la notion d'informations ? La radio transforma le reportage et notamment le reportage criminel en une forme de distraction. Pour la première fois, les auditeurs pouvaient suivre les exploits des braqueurs de banques, des gangsters et autres malfrats, au travail, à domicile, chez le coiffeur ou dans un bar, vivant dans l'urgence excitante d'une évolution, heure par heure.

Au même moment, la prohibition avait créé un marché du crime en pleine croissance depuis l'adoption du XVIIIe amendement en 1919. Le délit de meurtre à lui tout seul avait progressé de 77 % entre 1920 et 1933, et toutes les catégories de délinquance devinrent plus spectaculaires avec le déclenchement d'une guerre entre les différentes bandes de gangsters pour le contrôle du trafic d'alcool. Le public était de plus en plus désireux de voir des images et d'en savoir plus. Les journaux offraient un avant-goût de ces crimes, mais ils ne publiaient ni les photos les plus horribles ni les comptes rendus détaillés des événements. En outre, la Grande Dépression suscita une très forte demande de divertissement du public. Les études ont montré que c'est en période de crise que la demande de divertissement est la plus forte et la

crise de 1929 fut la pire de toutes. Ces récits de meurtres, la vision des victimes et de leurs proches terrassés de chagrin, tout cela rappelait à beaucoup de lecteurs qu'il y avait encore plus malheureux qu'eux. Dans un autre genre, les récits de braquages de banque dans le vieux style western leur faisaient miroiter une fortune immédiate à une époque où les faillites de banques étaient légion. Et chacune de ces faillites entraînait la ruine de petits épargnants qui y avaient déposé les économies d'une vie entière. De ce fait, les lecteurs des magazines policiers soutenaient souvent dans leur for intérieur les types assez audacieux pour récupérer le butin dont s'étaient emparés les arnaqueurs en cols blancs. Dans un tel contexte, il n'est pas étonnant que les braquages de banques aient été les sujets les plus populaires des magazines d'enquêtes criminelles des années 1930. Cette atmosphère de crimes et de bouleversements sociaux constitua une fantastique aubaine pour les éditeurs de magazines policiers, notamment Macfadden, Real Detective Tales Inc. et Fawcett, qui se démenèrent pour fournir à leurs lecteurs les photos, les interviews et les illustrations que seuls des magazines criminels étaient en mesure de leur offrir.

À tous égards, les années 1930 représentèrent le zénith de l'enquête criminelle. À cette époque la qualité des magazines policiers atteignit son apogée, avec des illustrations sur beau papier chiffon d'un beige crémeux, des couvertures mates sophistiquées assurant des reproductions parfaites et des reliures d'une qualité qui n'avait rien à envier à celles des livres. Dans les années 1930, les illustrateurs qui réalisaient ces couvertures de magazines policiers étaient des artistes formés dans les meilleures écoles d'art. Et, ce qui est plus important encore, pour les adeptes de ces magazines, la couverture des crimes, à l'époque, fut la

> **« C'était ma première expérience de nudisme de masse. Des vénus, des matrones flasques, des athlètes, des bedaines avachies et autres épouvantails. Je rejoignis la foule, marchant derrière une vénus balançant ses hanches. »**
>
> — *REAL DETECTIVE*, JUILLET 1934

meilleure et la plus complète de toute l'histoire du magazine policier.

Macfadden, éditeur entre autres de *True Detective, Master Detective, American Detective, Famous Detective Cases* et *Inside Detective*, employait notamment une équipe d'enquêteurs nombreux, chargés de dépouiller la presse pour dénicher les crimes les plus prometteurs. On envoyait ensuite des correspondants locaux sur les lieux du délit, même dans les régions les plus reculées, pour obtenir un reportage de première main sur les faits. Dans ces récits comportant 5 000 mots, fouillés et d'une rigueur toute professionnelle, on trouvait notamment des interviews de la famille, des amis de la victime et du meurtrier. Vers 1930, les reconstitutions photo de Macfadden avaient été remplacées par d'authentiques photos de scènes du crime généralement de bien meilleure qualité que ce que les quotidiens pouvaient offrir. Dans les années 1930, les véritables inspecteurs et les autres membres des forces de police proposaient souvent des récits et le prestige de ces magazines était tel que même le chef du FBI, John Edgar Hoover, ne ratait pas l'occasion de voir son nom imprimé dans l'un d'eux.

Durant cet âge d'or, les magazines avaient le pouvoir de rendre célèbres les criminels dont ils parlaient. Ils créèrent des stars dans un sens proche de celui d'Hollywood avec John Dillinger, Al Capone, Bonnie Parker et Clyde Barrow, Ma Barker, Pretty Boy Floyd, Alvin Karpis, Machine Gun Kelly et Baby Face Nelson, lesquels doivent aux magazines policiers d'avoir laissé un souvenir dans l'histoire criminelle. C'est Dillinger qui arrive en tête du hit-parade des criminels les plus popu-laires d'Amérique toutes époques confondues, suivi de près par Capone. À leur époque, ils comptaient autant de fans que les stars de cinéma et les scénaristes à l'affût de bonnes idées lisaient attentivement les *detective magazines*. C'est ainsi que le tournage de *Scarface* (1932), s'inspirant de la carrière d'Al Capone, fut lancé moins d'un an après la condamnation du gangster pour fraude fiscale.

Au milieu des années 1930, les flics comme les criminels considéraient les magazines policiers comme des revues professionnelles. Une mention dans un article ou, mieux encore, une photo d'eux au cours d'une action héroïque était aussi utile pour leur carrière que le fait pour un aspirant acteur d'obtenir la publication d'un portrait dans *Variety*. Les criminels eux-mêmes écrivaient des lettres aux patrons de ces magazines. Quand Ma Barker et l'un de ses fils furent finalement abattus dans une ferme en 1935, la police y trouva des piles de magazines policiers, certains ouverts aux pages relatant leurs exploits. La nature « hollywoodienne » d'un crime et la nature criminelle de Hollywood étaient souvent ouvertement acceptées dans les années 1930. Les acteurs jouaient des gangsters le jour et, le soir venu, buvaient en compagnie de véritables gangsters dans les cabarets. L'actrice Virginia Hill poussa cette osmose à son comble quand elle se mit en ménage avec Ben « Bugsy » Siegel. Lui était un gangster, elle, une actrice. Il essayait de s'immiscer dans les milieux du cinéma, tandis qu'elle le délestait de son argent. Les magazines policiers des années 1930 ont sans aucun doute alimenté ce scénario d'imitation réciproque de la vie et de l'art.

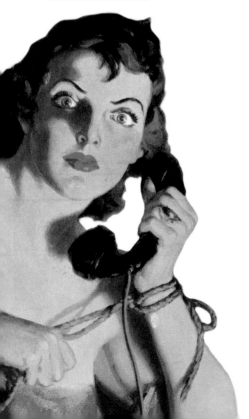

OPPOSITE *Real Detective*, August 1933

BELOW *Master Detective*, February 1938

PAGE 76 *Startling Detective Adventures*, August 1938

PAGE 77 *Startling Detective Adventures*, April 1938

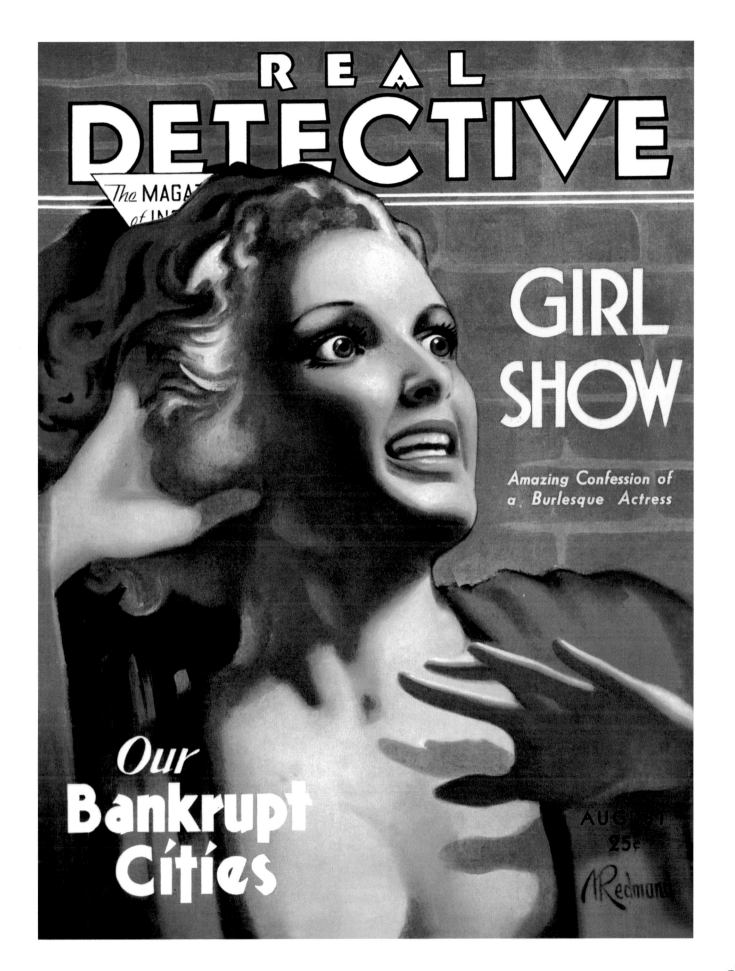

STARTLING
Detective
ADVENTURES
(Reg. U. S. Pat. Off.)

AUG

Arkansas'
TRAGIC RIDDLE
of the
BOTTLED
HORROR

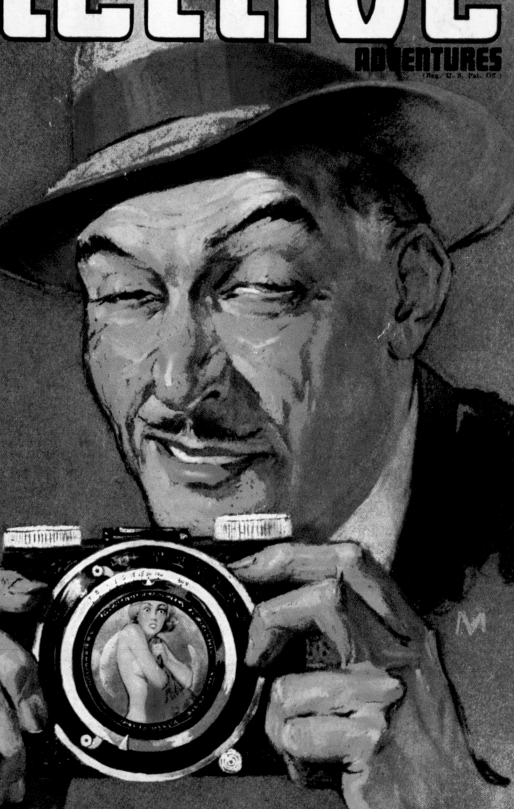

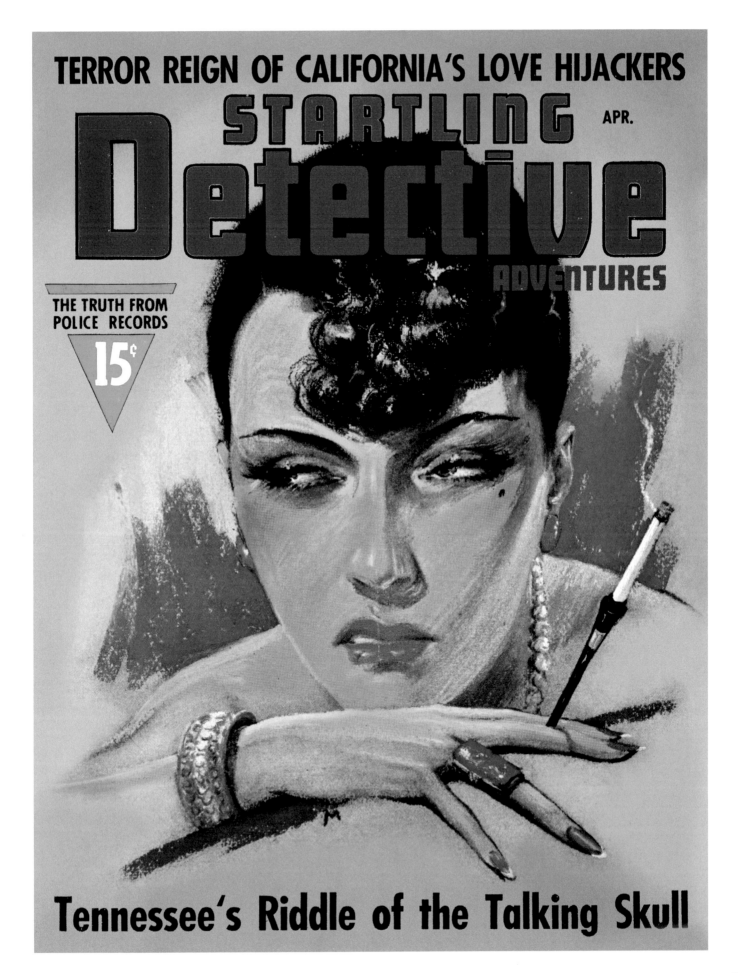

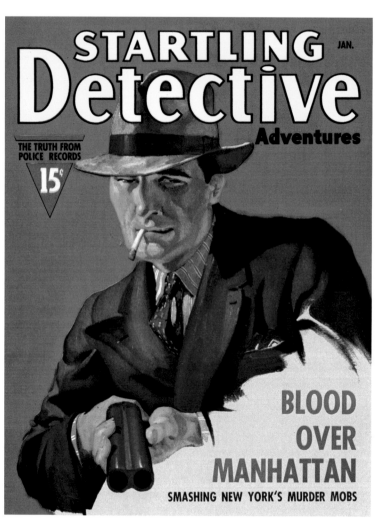

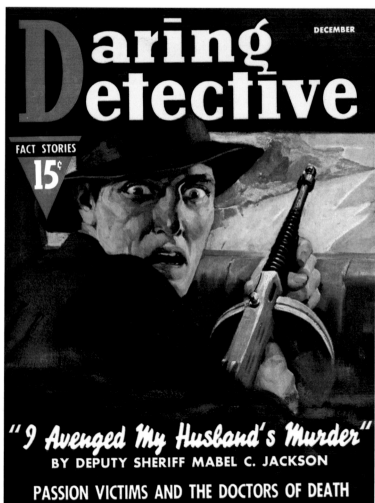

OPPOSITE *Real Detective*, June 1937

ABOVE LEFT *Startling Detective Adventures*,
January 1938

ABOVE RIGHT *Daring Detective*, December 1937

Poker-Face Gussie's Lethal Love

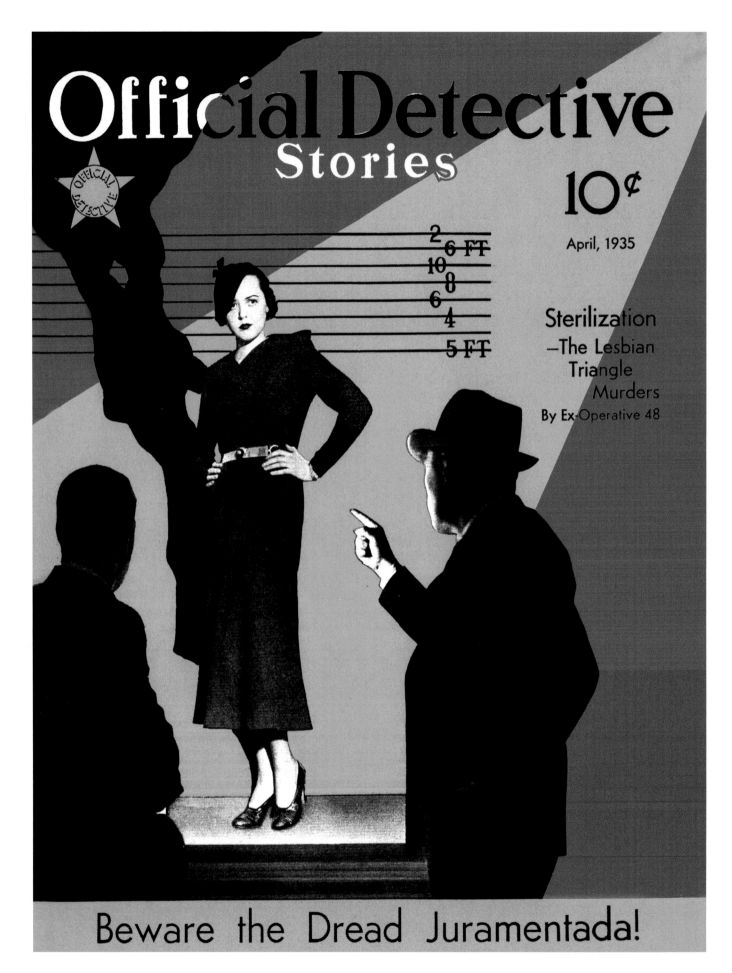

"Sex crimes! The acts of men who are lower than beasts! An aroused public demands to know the cause and the cure."

— *REAL DETECTIVE*, JULY 1934

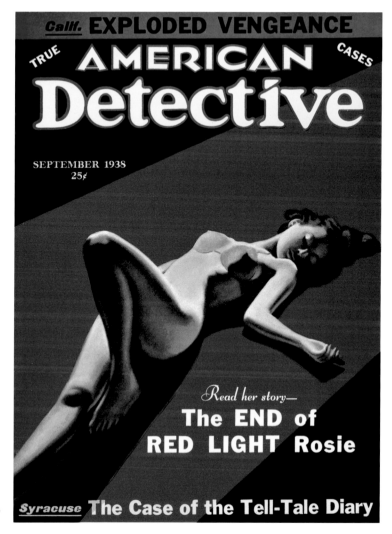

OPPOSITE *Official Detective Stories*, April 1935

RIGHT *True American Detective Cases*, September 1938

"Spencer planned to use his dupes as the nuclei of a series of nude cult chapters...unwitting inmates of a chain of 'peep houses.'"

— *REAL DETECTIVE*, NOVEMBER 1932

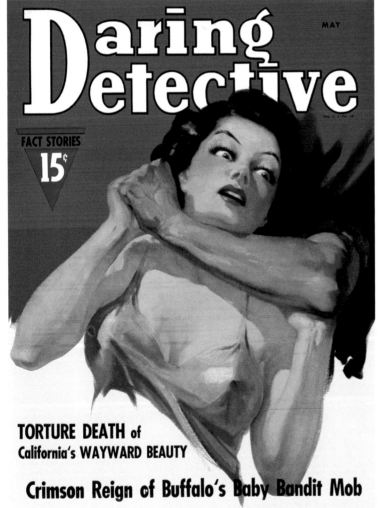

OPPOSITE *Master Detective*, December 1939

LEFT *Daring Detective*, May 1938

PAGE 84 *Front Page Detective*, January 1938

PAGE 85 *Inside Detective*, August 1938

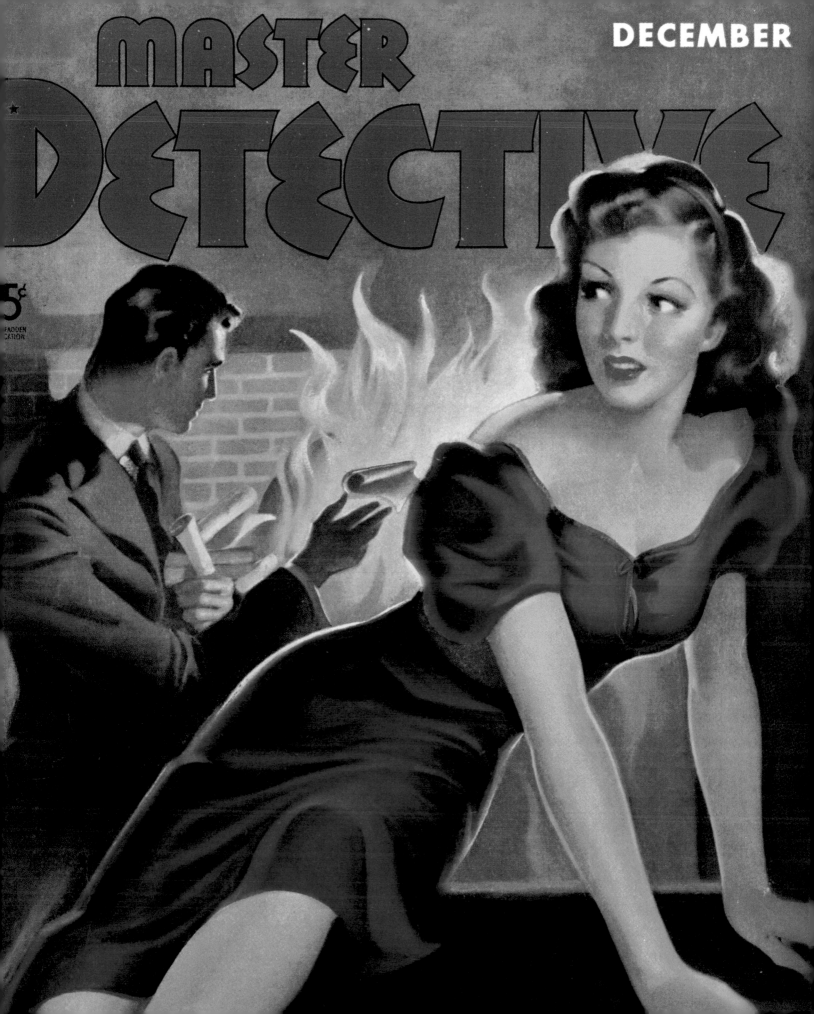

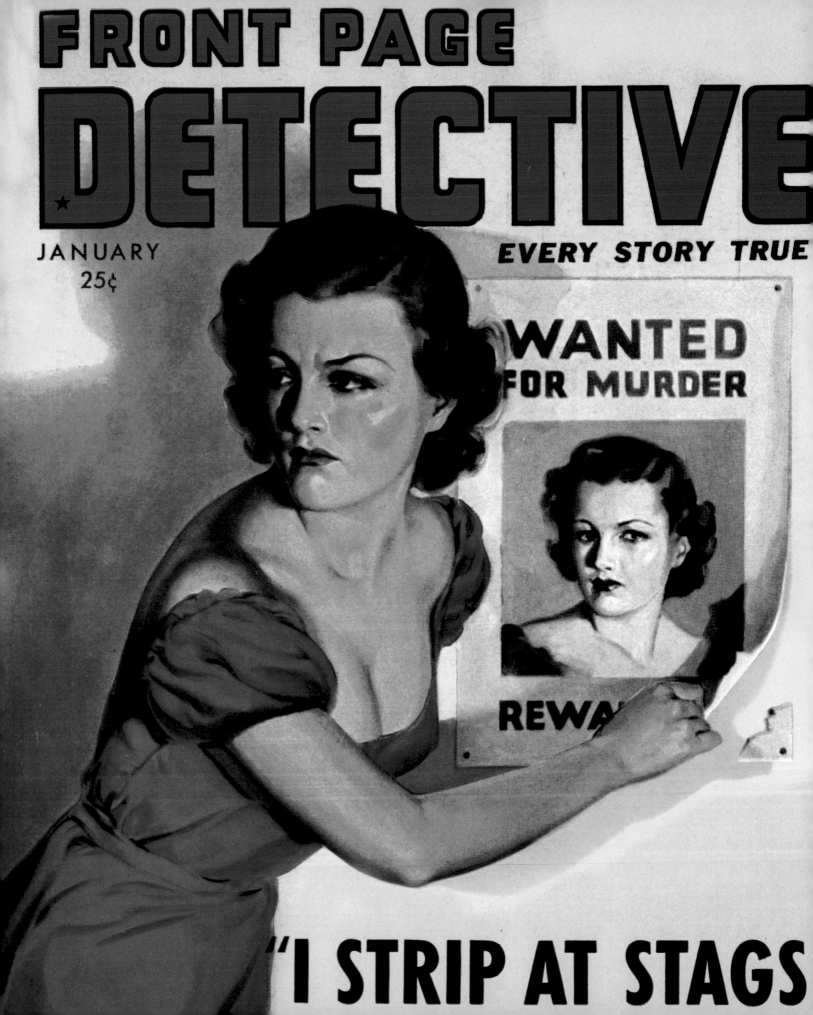

BRANDED BY DEATH! —Texas' Mystery of Illicit Love

INSIDE
detective

AUGUST
10¢

EVERY
STORY
TRUE

MURDER
on the
**BATHING
PARTY**

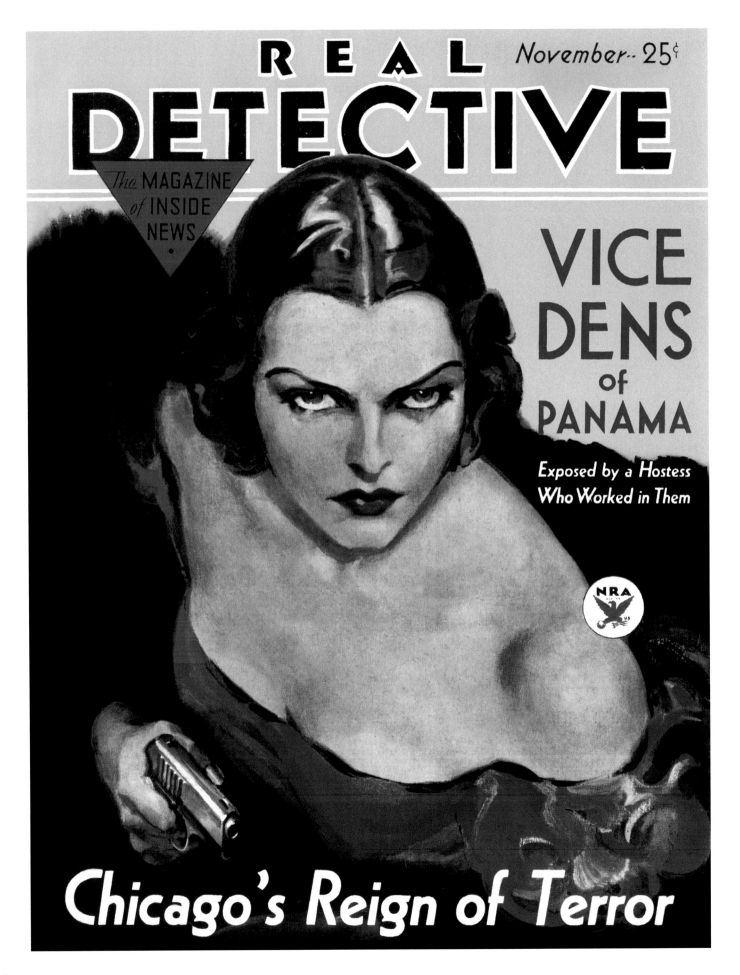

OPPOSITE *Real Detective*, November 1933

ABOVE LEFT *American Detective Fact Cases*, August 1936

ABOVE RIGHT *American Detective Fact Cases*, July 1936

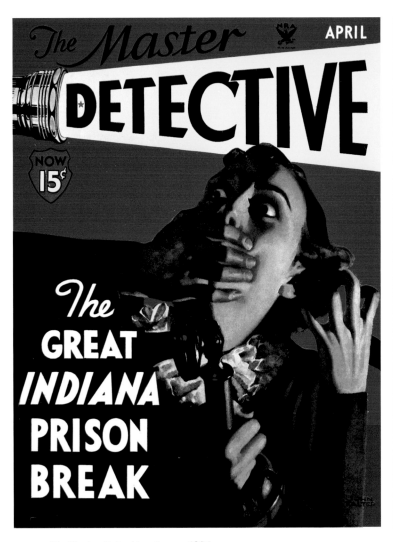

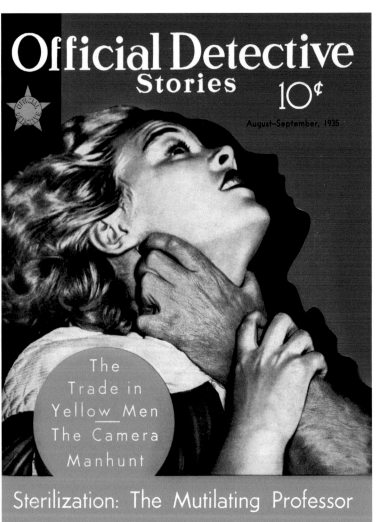

OPPOSITE *The Master Detective*, January 1934

ABOVE LEFT *The Master Detective*, April 1934

ABOVE RIGHT *Official Detective Stories*,
August – September 1935

PAGES 90–91 *Real Detective*, August 1936

PAGE 92 *Startling Detective Adventures*, July 1930

PAGE 93 *Startling Detective Adventures*,
April 1930

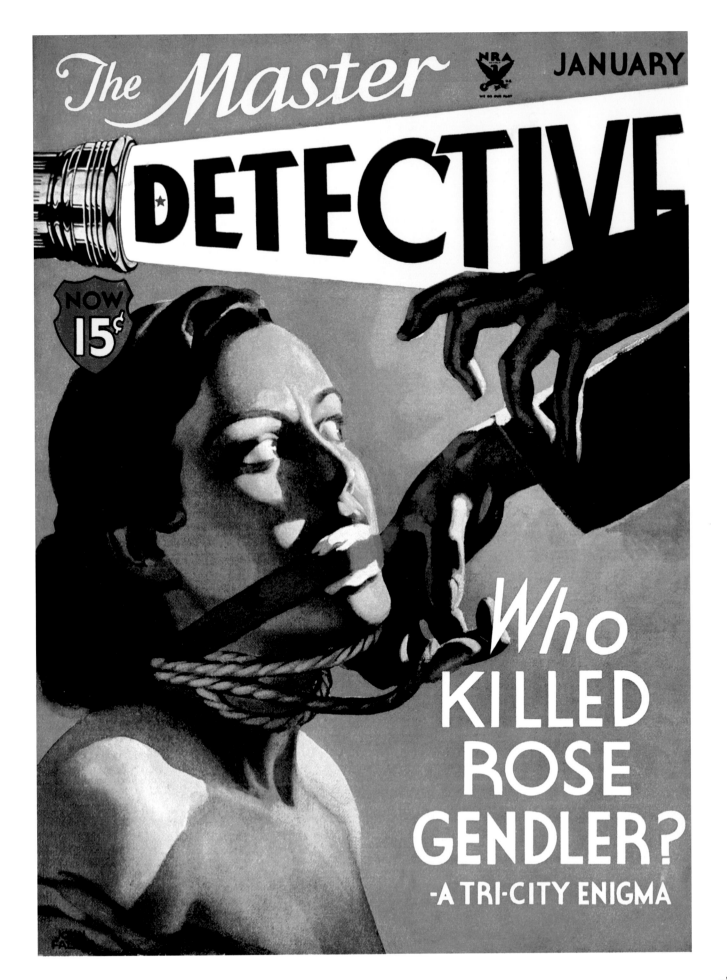

by RICHARD EDWARDS

(Special Investigator for Real Detective)

SHOWING UP

California's

NUDIST PEEP-SHOWS

MY GIRL STEPPED out of her peach panties and tossed them over the low hanging branch of a tree. A second later her wisp of a bra had followed them. Then, a white nymph in the sunshine, she ran with swinging hips to join a nearby group of a dozen men and women who, naked like herself, were playing at leapfrog with many a grosteque fall and roll upon the soft grass.

Newspaperman as I am and veteran of many a police raid into the tenderloins of large cities, whose inmates are not particularly noted for modesty, I was shocked, to say the least. Human anatomy in postures and displays that leave nothing to the imagination is not a pleasant sight. Here, in this northern California nudist camp, hidden away in Jack London's celebrated Valley of the Moon, the spectacle was little short of revolting. The thought came as I watched, that a week-end spent in any hogstye picked at random, would leave one feeling cleaner than this adventure which I had voluntarily undertaken.

The purpose of my being in this camp was purely commercial. I had agreed to write the facts about Pacific coast nudism and nudist "Peep Shows" for REAL DETECTIVE. To get these facts, or at least some of them, I must go into a nudist stockade and see conditions for myself.

I was surprised at how easily I had been able to conclude the necessary arrangements. I merely made a few inquiries and picked the camp whose literature made it seem the most representative. Then I called at the San Francisco booking office of this camp, was told the small price of admission and how to get there.

One stumbling block, at first, did threaten. I was informed that no male could visit this camp alone. Each man must have a woman companion. Where was I to find a girl brazen enough to go with me, I wondered? Seeing my hesitation, the camp's smirking booking agent came to my rescue. He would be glad to introduce me to a girl for the trip, if I wished. Parenthetically, let me say, I learned afterward that these booking agents, when possible, obtain the names and addresses of girls who have visited the camp before, to meet just such emergencies as mine.

But, as I thought over the matter, I had another idea. I would "go the whole horse" on this proposition and get a companion of my own. Checking over in my mind the girls of my acquaintance whom I might approach with such an invitation, I settled upon Sadie M——, a young woman of the burlesque stage. When Sadie's show had received a little unfavorable newspaper mention a short time before, I had given Sadie a "good break" in the story and I

What really goes on where large groups of men and women, without clothes and without shame, frolic together in disgraceful exhibitions under the sham banners of the naked cult

The high-salaried nudists in San Diego's Z o r o Gardens (above) spend their time lolling about on imitation fur rugs—to the delight and edification of the paying spectators.

knew she felt she had reason to do me a favor.

Sadie, surely, would not share the average woman's reluctance to take off her clothes in the presence of others of the opposite sex. Sadie did practically this very thing each night in her stage performance. She was what is commonly known as a "stripper." The high spot of her act arrived when, to seductive music, she undulated her body in suggestive dance, the meanwhile flinging aside first one bit of apparel then another until, for a brief instant, she stood before her audience a gleaming white and naked Salome without a single glittering bead of concealment.

Leaving the booking agent's office, I hunted up Sadie and propositioned her. She thought a Sunday in the country might do her good.

Thus it was Sadie who so blithely stepped out of her dainty underthings up there that warm morning, in the nudist Valley of the Moon playground and who so readily joined the other unclad men and women in their games.

I am not going to describe the scenes in that naked cult stockade during the balance of the day. I doubt if a caress-starved convict ever conjured up in his cell more purple dreams than the disgusting actualities I witnessed. Tugs of war in which grunting men and women nestled flesh against flesh. Swimming parties in which the squeals of the girls located the masculine underwater playsters. Pseudo-athletes of both sexes attempting hand-stands and cartwheels. Twosomes sprawled in grotesque abandon beside rocks and tree trunks. Couples entwined in hammocks. Couples picnicking in attitudes that would destroy the normal appetite. And everywhere, couples with prying eyes, eyes that probed and missed nothing of what decent civilization thinks it so necessary to conceal.

In the literature which the San Francisco booking agent for this camp had given me, I had read nudism's justification for this decadent practice imported from the old world. In a nutshell, it is this: The mingling of naked men and women

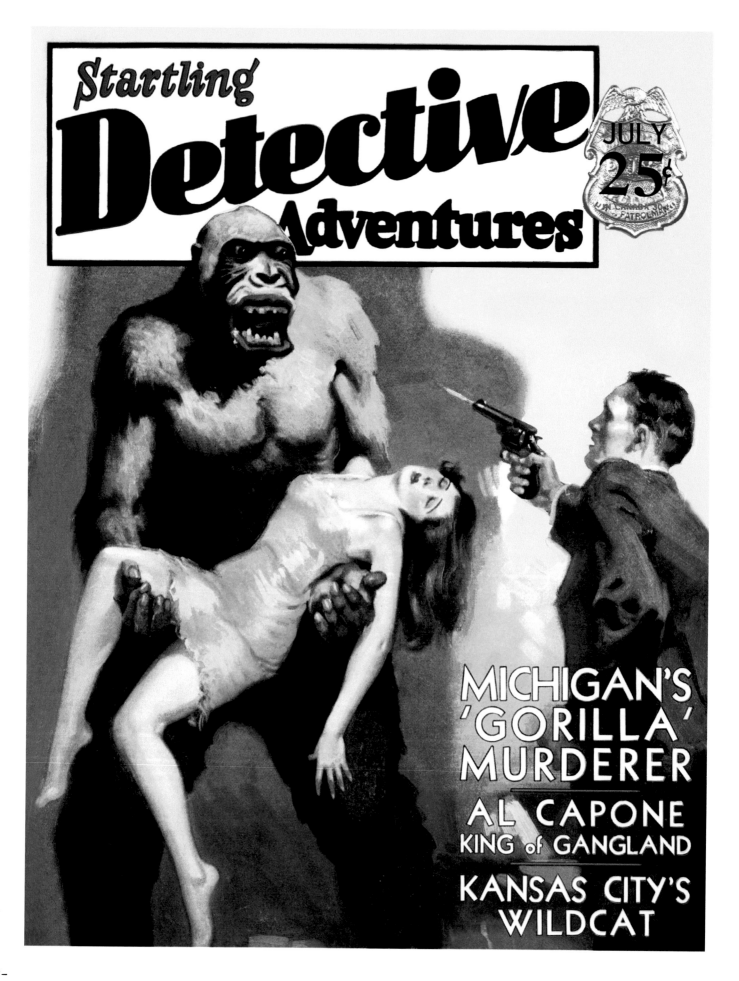

Startling **Detective** Adventures

JULY 25¢

MICHIGAN'S 'GORILLA' MURDERER

AL CAPONE KING of GANGLAND

KANSAS CITY'S WILDCAT

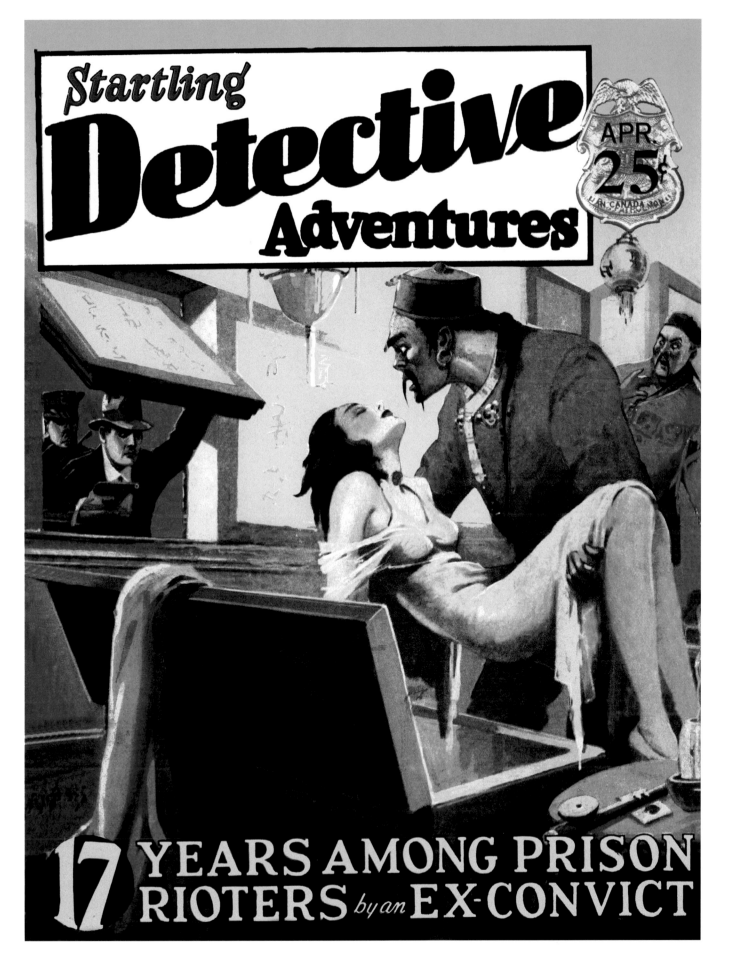

Startling Detective Adventures

APR. 25¢

17 YEARS AMONG PRISON RIOTERS *by an* EX-CONVICT

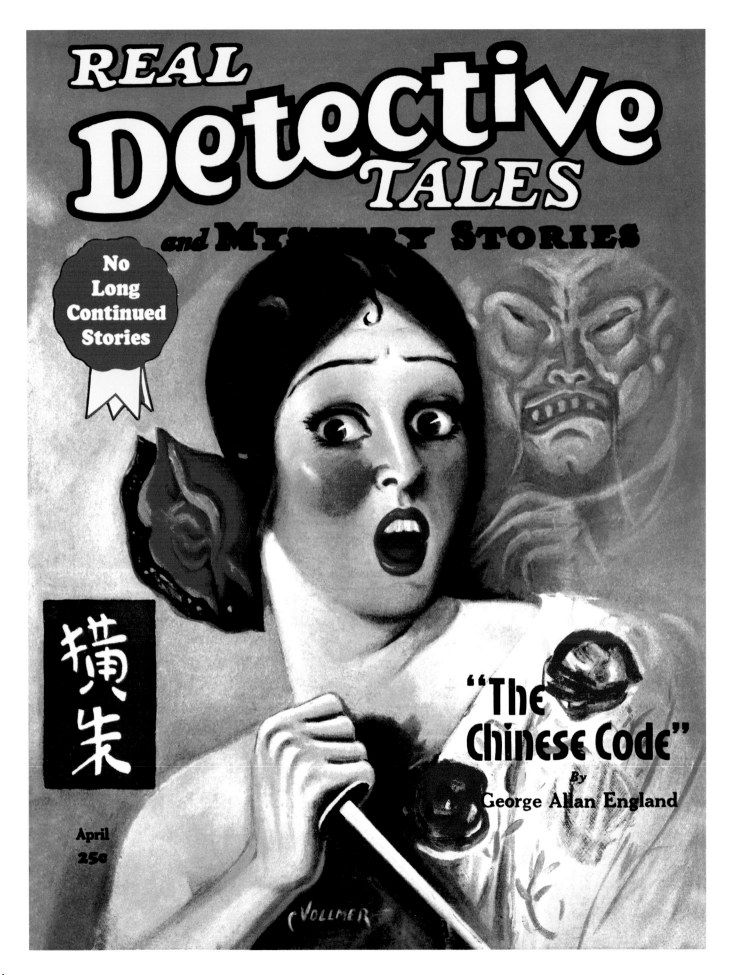

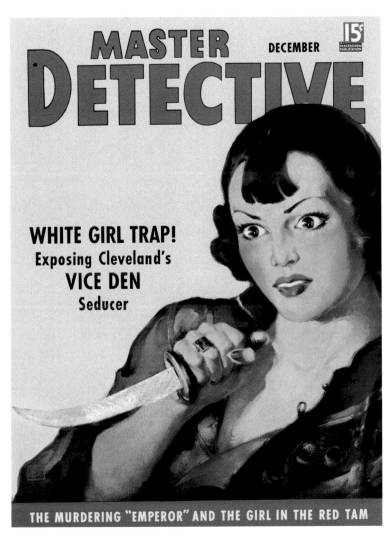

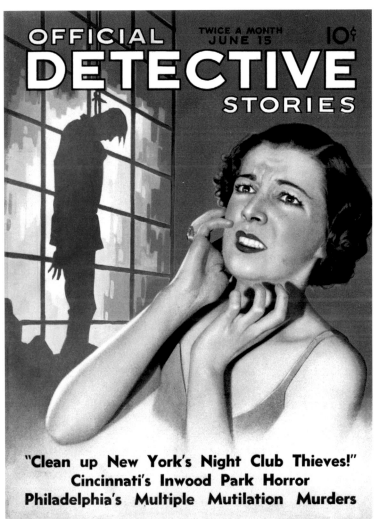

OPPOSITE *Real Detective Tales and Mystery Stories*, April 1930

ABOVE LEFT *Master Detective*, December 1937

ABOVE RIGHT *Official Detective Stories*, June 15, 1937

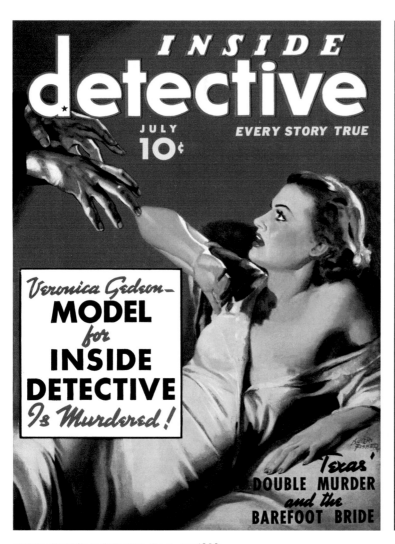

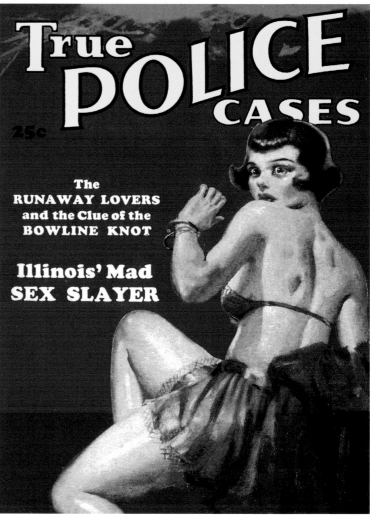

OPPOSITE *Front Page Detective*, December 1939

ABOVE LEFT *Inside Detective*, July 1937

ABOVE RIGHT *True Police Cases*, 1936

PAGE 98 *Official Detective Stories*, January 15, 1937

PAGE 99 *American Detective Fact Cases*, August 1937

PAGES 100–101 *Real Detective*, April 1935

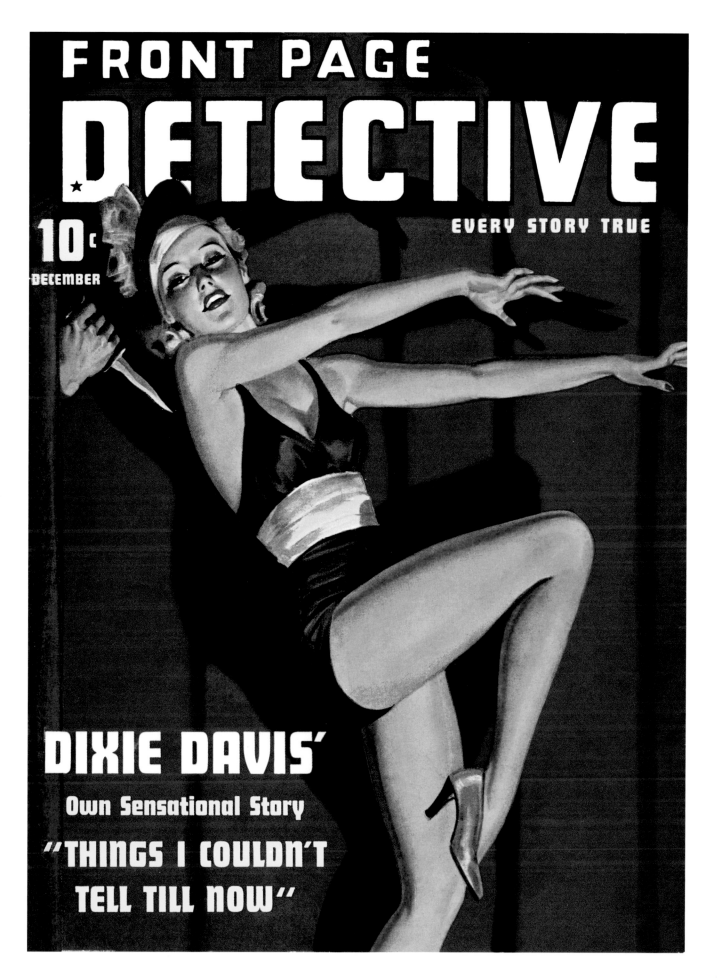

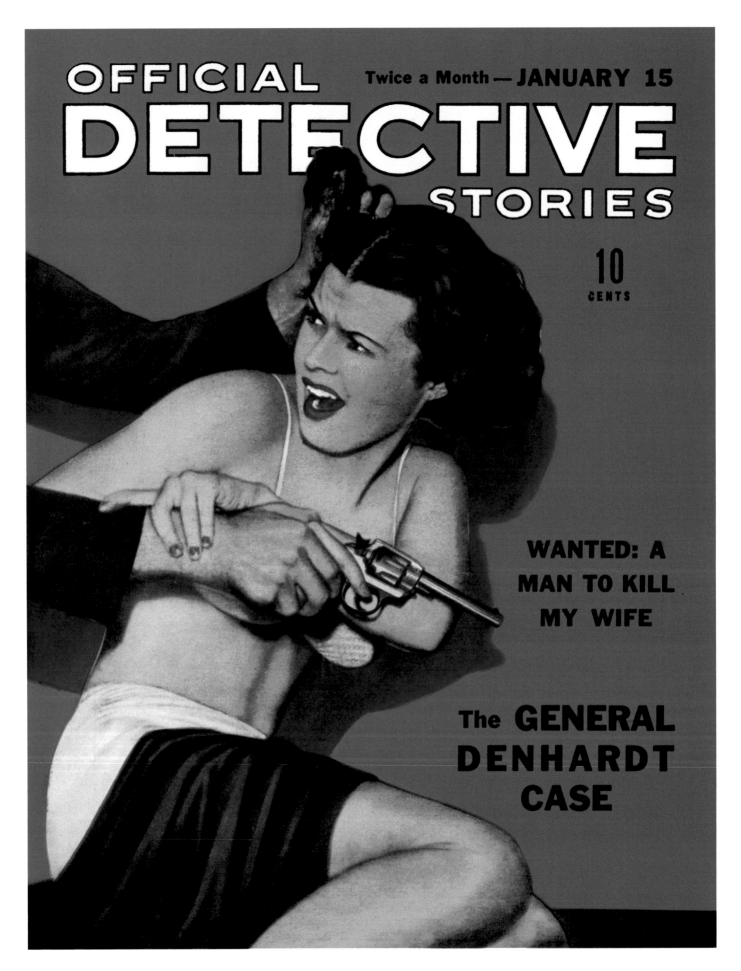

OFFICIAL DETECTIVE STORIES

Twice a Month — JANUARY 15

10 CENTS

WANTED: A MAN TO KILL MY WIFE

The GENERAL DENHARDT CASE

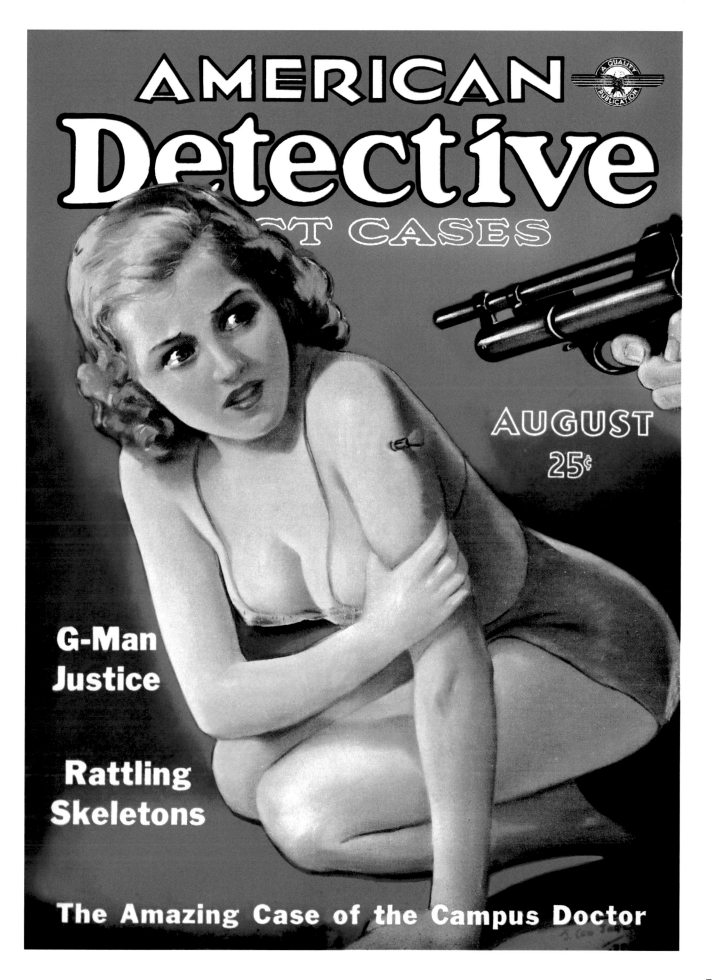

AMERICAN

Detective

ST CASES

A QUALITY PUBLICATION

AUGUST
25¢

G-Man
Justice

Rattling
Skeletons

The Amazing Case of the Campus Doctor

the Fight Against
MARIJUANA..th

WHAT ABOUT YOUR sons and daughters, Mr. and Mrs. America? Have they succumbed to the diabolical Marijuana cigarette? Or don't you know?

Are their eyes red-rimmed? Are they out-of-sorts constantly? Are they keeping company with a coterie of other boys and girls about whose morals you are inquisitive?

You'd better find out! You'd better save them from this frightful new menace to youth, if you would prevent in your own family the sex orgies, the sanguinary fits of insanity, the murder to which the use of this cigarette ultimately leads!

Look at them—examine them carefully! Shadow them, if need be, to find out what they are doing. For like a snake crawling through deep grasses, this awful curse of the East—the blood kindred of the drug hashish—has made its way into schools and colleges, into the homes of the finest families of the country.

You don't read much about individual cases until an affair like that which rocked a mid-western city last December becomes the denouement of a Marijuana cigarette-inspired orgy. The police keep names out of the newspapers. In fact, ninety per cent of the cases are handled by the juvenile courts! Nevertheless, the astounding and shocking condition prevails, everywhere!

Tulsa, Oklahoma; St. Louis, Missouri; Denver, Colorado; Marquette, Michigan; Eureka, California; Tampa, Florida, and the reeking records of New York City's Harlem, with its sin sinks of iniquity kept alive by the unmoral pens of New York columnists, testify to the spread of this new thrill, this new and deadly form of drug, which is probably the most powerful aphrodiziac ever used by those of Occidental birth.

It prolongs the sex thrill sixty times; it makes a second seem a minute, a minute an hour, an hour two and one-half days! And if it doesn't lead to murder, during a fit of drug-inspired insanity, it paints in the minds of its addicts visions, such as those seen by the fanatics of Hassan, the murderous Ishmaelite cult leader who held dominion over his small but powerful empire by rewarding his killers with endless hours in the harem, while under the influence of the terrible drug hashish, a product of hemp, which is the root stock of Marijuana! So vile were the practices of these men, that from their sanguinary

activities comes the English word "Assassin," which springs directly from the Arabic word "Hashshashin" or hashish eater.

Yes, months of investigation by the writer have revealed the startling truth that with prohibition gone, and bootleg drinking no longer a thrill, boys and girls, from puberty to adolescence, have embraced the use of the Marijuana cigarette. And in their orgies one sees again the blood and lust and rapine of the days of Peter the Hermit, when Christian crusaders, seeking to rescue from the Saracen the ground made holy by the feet of Jesus, encountered the opposition of deadly knives which, drunk with hashish, knew no mercy!

THROUGHOUT the country sex orgies, as exotic and as devilish as any reported written with blood into the secret archives of Mohammedan licentiousness, are in progress among the youth of the most respectable communities.

Picture this scene!

A "room upstairs" over one of the hot

Boys and girls of high school and college age meet in a "club" room. Eagerly they light the "sex" cigarettes. The girls strip. The boys photograph them in the nude. Later, these photographs are passed about school corridors and campuses, to be snickered at by the whole student body. Sometimes, they are even used to blackmail the parents of the young women whose figures are so unconventionally revealed. Thus does the deadly Marijuana break down the finer feelings of our youth. If you would know the full story of degredation and death that follow in Marijuana's wake, read this frank and startling exposé.

SEX" CIGARETTE

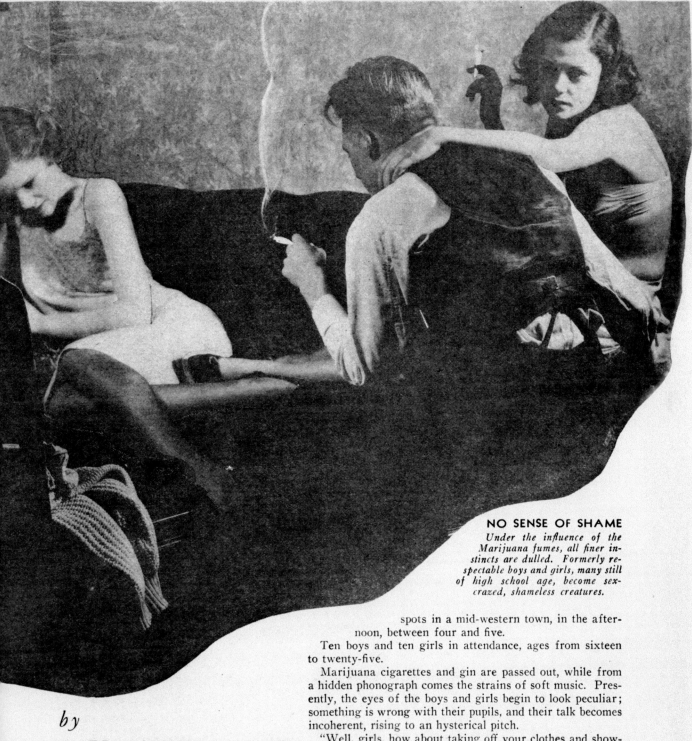

NO SENSE OF SHAME

Under the influence of the Marijuana fumes, all finer instincts are dulled. Formerly respectable boys and girls, many still of high school age, become sex-crazed, shameless creatures.

by

OSEPH H APPELGATE

Staff Investigator For
REAL DETECTIVE

spots in a mid-western town, in the afternoon, between four and five.

Ten boys and ten girls in attendance, ages from sixteen to twenty-five.

Marijuana cigarettes and gin are passed out, while from a hidden phonograph comes the strains of soft music. Presently, the eyes of the boys and girls begin to look peculiar; something is wrong with their pupils, and their talk becomes incoherent, rising to an hysterical pitch.

"Well, girls, how about taking off your clothes and showing us what you really look like?"

Without an argument, without any effort to prevent the unsolicited assistance from the boys, the girls, with the movements such as are reported by a slow-motion camera, begin to disrobe. Their frocks are removed; they stand

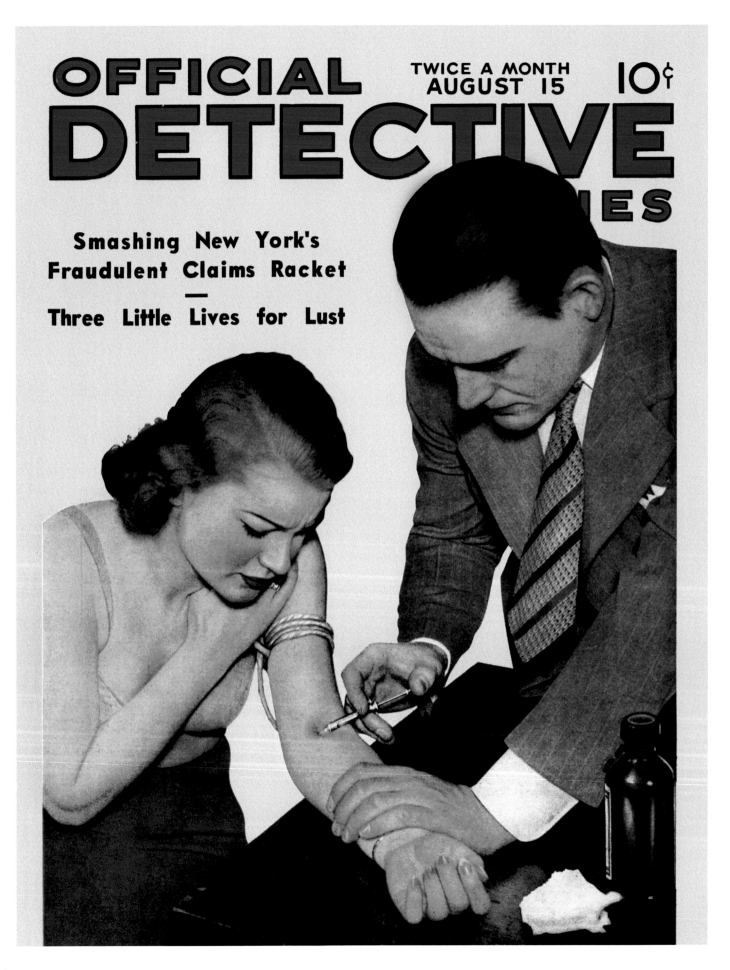

OFFICIAL
DETECTIVE
IES

TWICE A MONTH
AUGUST 15

10¢

Smashing New York's
Fraudulent Claims Racket
—
Three Little Lives for Lust

"Lurid stories of deep-dyed villains, white slavery and dope dens flashed before me. We were on the books as two flossies willing to join any party."

— *FRONT PAGE DETECTIVE*, JUNE 1937

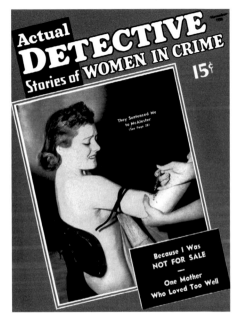
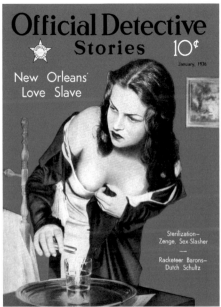
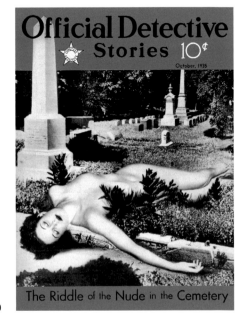
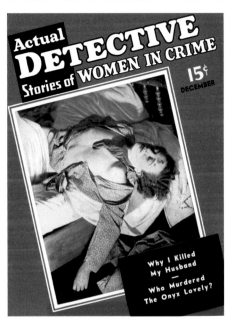

OPPOSITE *Official Detective Stories*, August 15, 1937

CLOCKWISE FROM ABOVE LEFT *Actual Detective Stories of Women in Crime*, November 1938; *Official Detective Stories*, January 1936; *Actual Detective Stories of Women in Crime*, December 1937; *Official Detective Stories*, October 1935

PAGE 104 *The Confessions of a Stool Pigeon*, August 1931

PAGE 105 *Confessions of a Federal "Dick,"* circa 1930

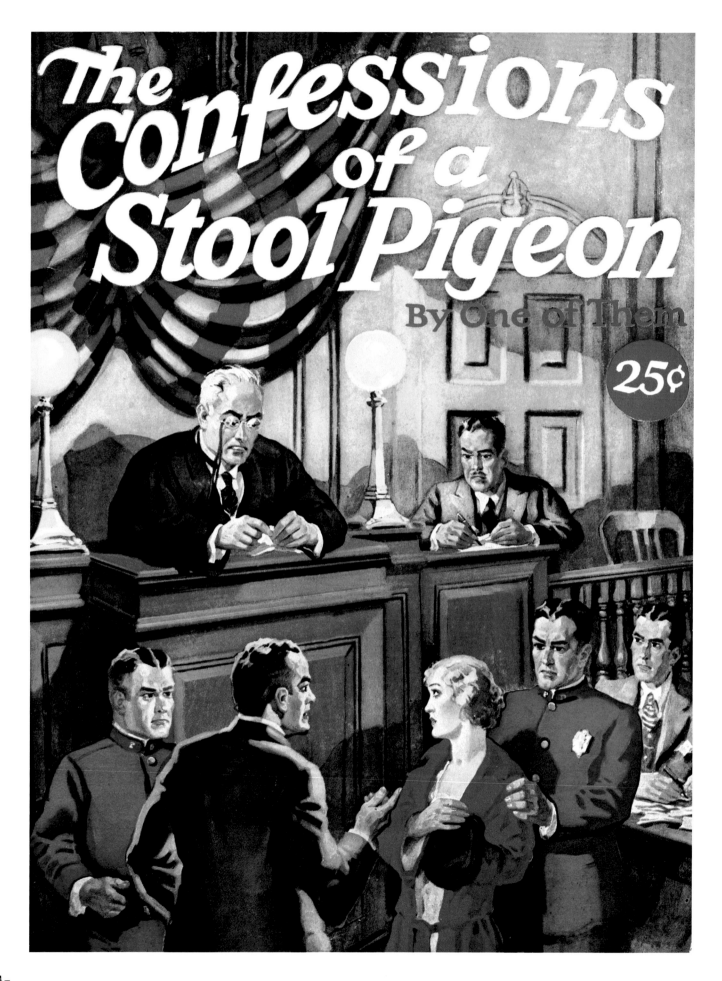

The Confessions of a Stool Pigeon

By One of Them

25¢

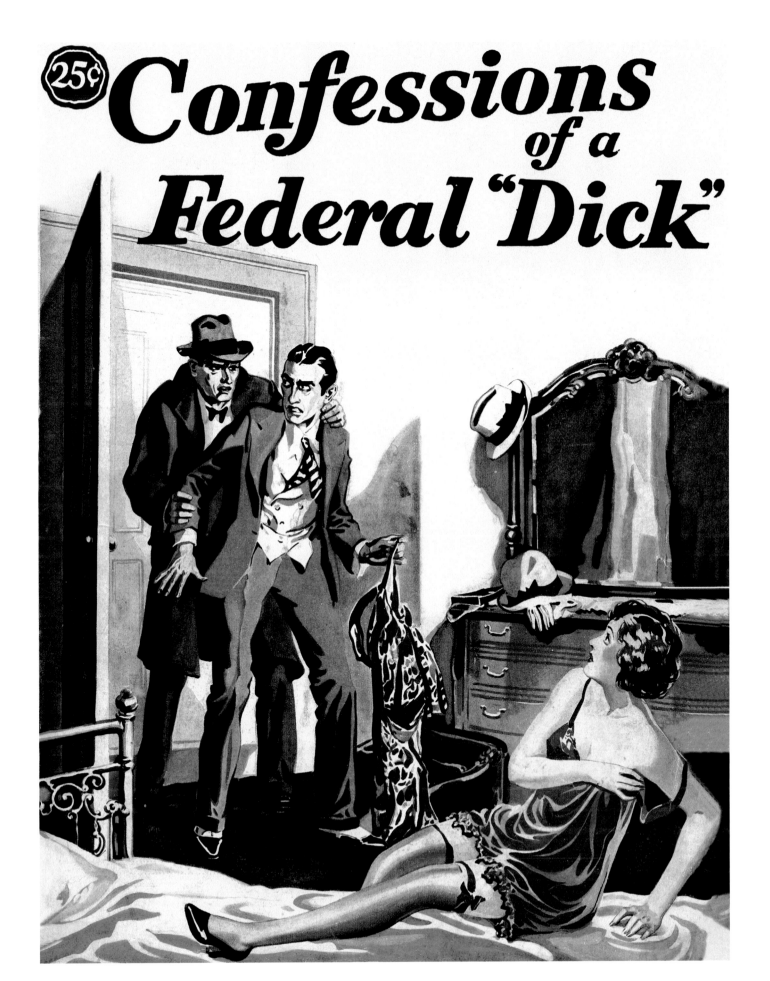

25¢

Confessions of a Federal "Dick"

OPPOSITE *Real Detective*, June 1938

BELOW *American Detective Fact Cases*, July 1936

PAGES 108–109 *Real Detective*, June 1938

HONKY-TONK MURDER

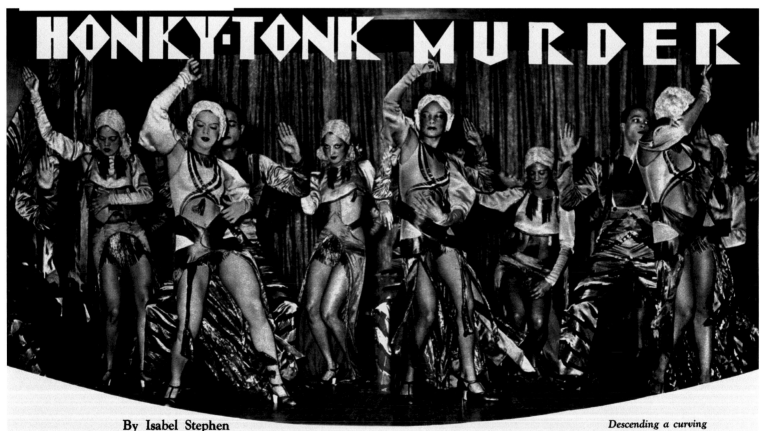

By Isabel Stephen
and Featuring
New York Police Department's Undercover Squad

Descending a curving stoop that led to the grilled door of a speakeasy, Achille Mirner, diamond merchant of Paris, London and Vienna, went to keep his rendezvous with death—dead at 39 because of a night of folly

N⁰ FLASHING Neon sign beckoned nocturnal adventurers to Eleanor Thompson's honky-tonk. Like a rattlesnake's den, it nested in darkness on the ground floor of a red stone mansion in Seventy-fourth Street, within earshot of mournful sirens of fog-bound rivercraft plying the nearby Hudson.

At three-fifteen in the morning of the last Sunday in October, 1932, a battered taxicab slunk up to the curb before its door. The driver reached round, turned a handle. "Easy now, gents," he warned two hilarious pas-

sengers. "Don't forget your password . . . and pipe down till you git inside."

A plump man in well-fitting dinner clothes got out first, a man in his late thirties. "We know our p's and q's," he said with exaggerated caution, speaking with the precise accents of a foreigner. "Keep the change—" he shoved a bill into the man's paw and turned to his companion. "Come, Jerry—and pipe down!"

Goose-stepping, the pair descended a curving stoop that led to a grilled door of the sunken entrance. Thus blithely,

Achille Mirner, diamond merchant of Paris, London and Vienna, went to keep his rendezvous with Death.

The taxi-driver's password admitted them to a spacious hall into which seeped the tinkle of ice against glass through the throbbing strains of a blues orchestra. A blonde in slinky pink chiffon fluttered toward them.

"I'm Eleanor," she chirped, girlishly extending a slender hand flashing with stones. "Welcome! *Our* night is just

starting."

She led them to a room where built-in benches faced tables which skirted two walls. A cigarette girl and a waiter were skittering between livid blotches that were faces glazed with drink, in clouds of tobacco smoke.

"It's too damned stuffy," Mirner complained in a whisper to his companion, Jerome Bernheim. "We'll just have a round and make our exit." But within fifteen minutes

54 55

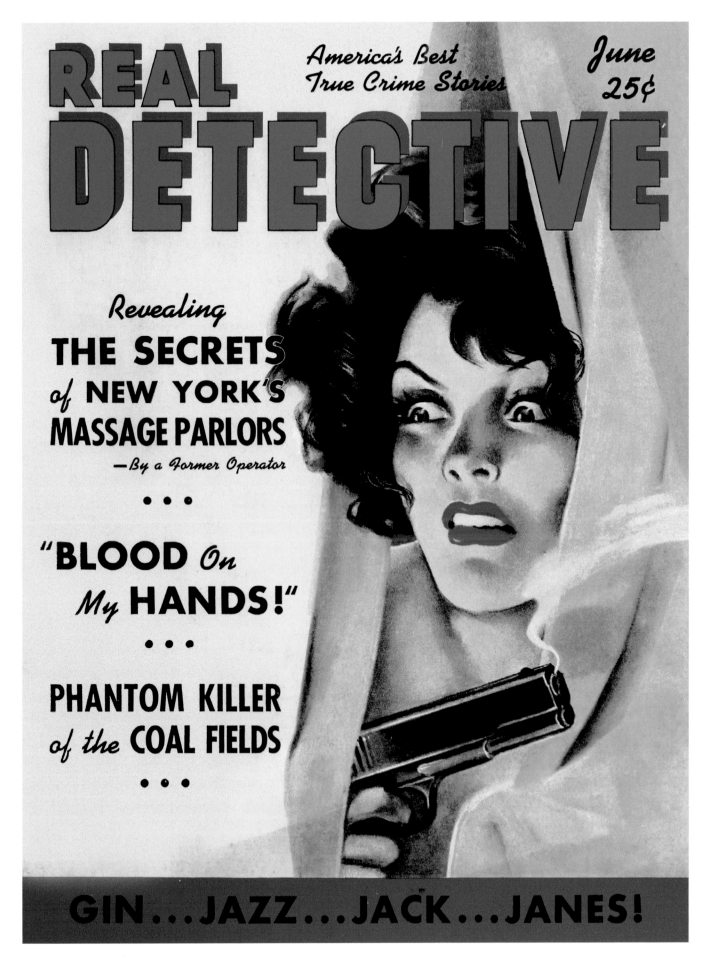

REAL DETECTIVE

America's Best True Crime Stories

June 25¢

Revealing
THE SECRETS
of **NEW YORK'S**
MASSAGE PARLORS
—By a Former Operator

• • •

"BLOOD *On*
My **HANDS!"**

• • •

PHANTOM KILLER
of the **COAL FIELDS**

• • •

GIN...JAZZ...JACK...JANES!

GIN, JAZZ

"The cheap, tawdry dance halls of Boston, with their pleasure-mad girls and villainous liquor, are to blame... He was a good boy until he got in with those dance hall sheik and sirens..."

PORTLY JAMES A. MONAGLE stood before the meat block in his provision store at Medford, Massachusetts, dressing a chicken with a cleaver. Across the shop, his fourteen-year-old daughter, Mary, counted the day's receipts. A lone electric bulb, hanging from the ceiling's center, threw their forms into yellowed relief and cast flickering shadows on the whitewashed walls.

"Time to close up, Father," the girl called, as she turned the key in the register and tucked a roll of bills into her apron pocket.

"Sure, I'll be right with you," the butcher replied, "But first I must fix this chicken for your mother. Tomorrow is Sunday. She told me not to forget the dinner. This bird is a beauty!"

His merry chuckle was suddenly stilled by a scraping foot on the doorstep. His still sparkling Irish eyes began to narrow with disbelief, roving quickly to where his daughter stood in terror-stricken alarm. Anger surged up in him, his face growing purplishly red, his hand tightening its grip on the cleaver as a sharp command reached his ears:

"Stick up your hands!"

The speaker, Monagle saw in the half-gloom, was a youth of not more than twenty, dressed in a tight-fitting black coat and brown felt hat pulled well down over his eyes. Back of him stood another, shorter youth, seemingly less audacious, apparently a trifle nervous. In the hands of each were pistols, held low but menacingly uptilted toward

JACK, JANES!

by
John S. Thorp

For this (top), a boy turned killer. Mrs. James Monagle (below), widowed by the "Baby-faced" murderer. (Right) Mary Monagle, daughter of the slain butcher. Her camera-like mind retained all the details of the tragedy, which was of invaluable aid to the police. Detectives followed blood trail through the alley and knew without a doubt the slayer scaled the fence (right), to safety.

Angela Federini spied a gun in her yard. A hurried telephone call to the police brought them to the spot marked by arrow. It proved to be the weapon which killed James A. Monagle.

the pair behind the counter.

"I said get them up," came the second command. "This is a stickup."

Mary Monagle thought quickly. By dropping behind the counter, she realized, she could scamper animal-like to the rear door and the yard and give the alarm. Silently, she slid out of sight.

Taken unawares, the tall bandit uttered an oath and pressed his finger on the trig-

27

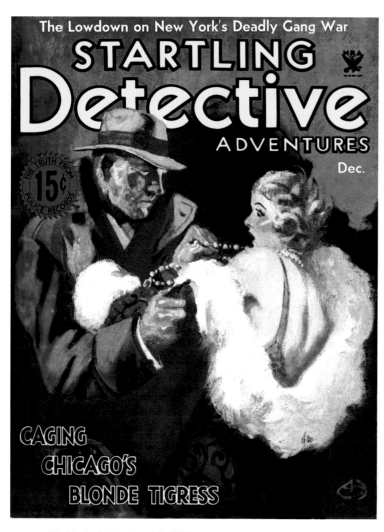

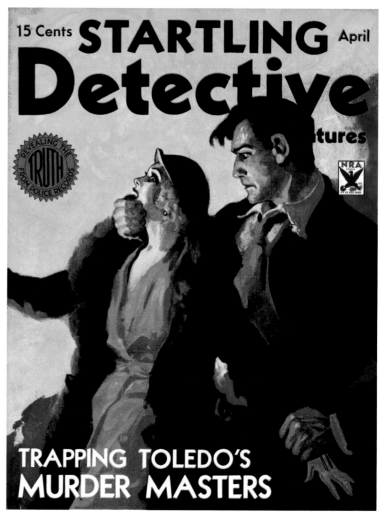

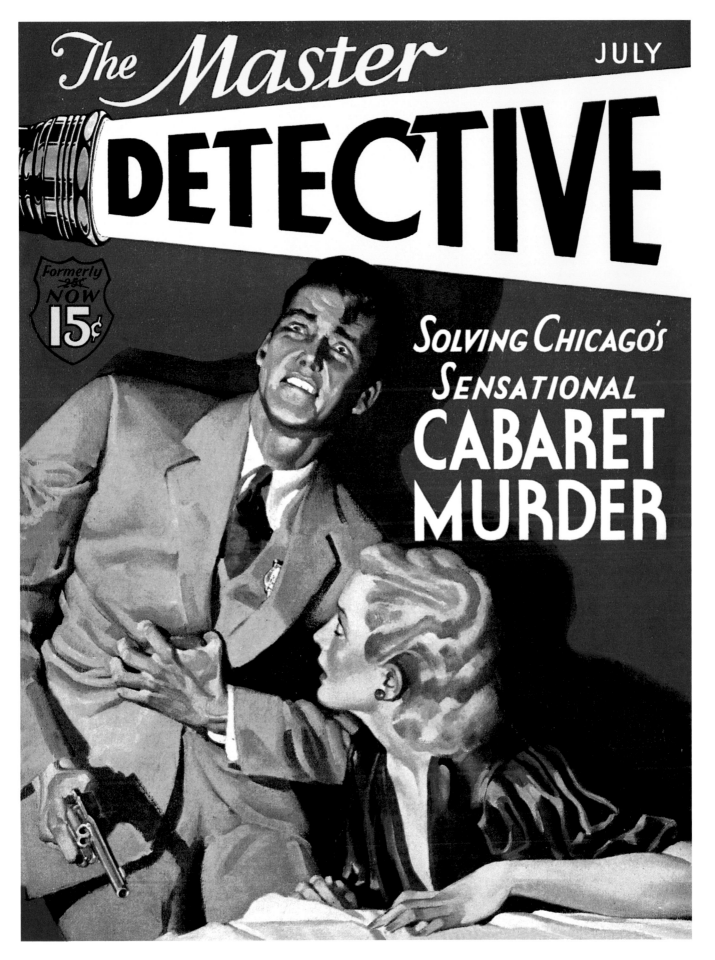

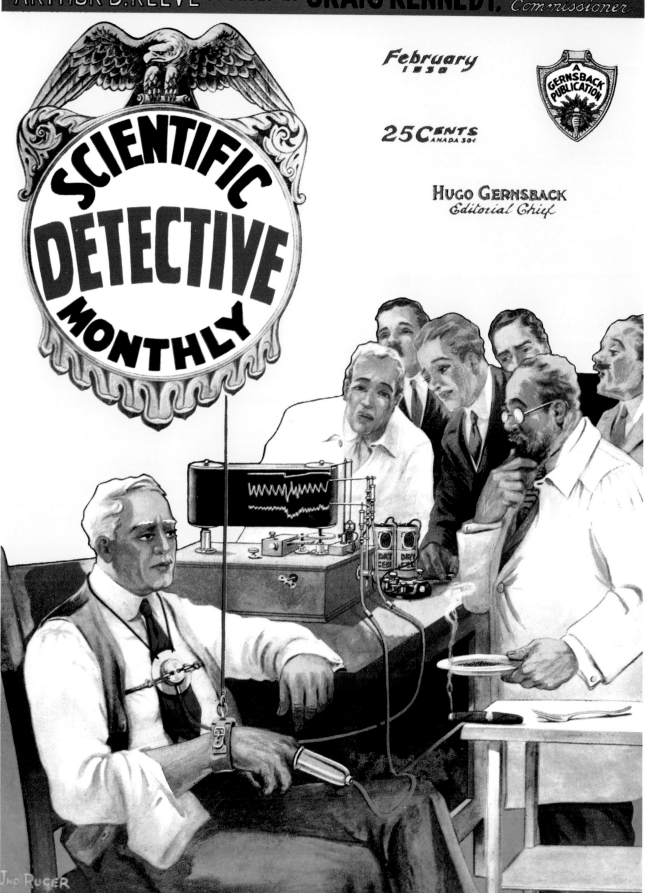

ARTHUR B. REEVE Creator of CRAIG KENNEDY, Editorial Commissioner

February 1930

25 CENTS CANADA 30¢

A GERNSBACK PUBLICATION

SCIENTIFIC DETECTIVE MONTHLY

HUGO GERNSBACK
Editorial Chief

Jno Ruger

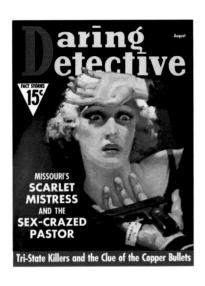

Daring Detective

August

FACT STORIES 15¢

MISSOURI'S
SCARLET
MISTRESS
AND THE
SEX-CRAZED
PASTOR

Tri-State Killers and the Clue of the Copper Bullets

OPPOSITE *Real Detective*, September 1939

ABOVE LEFT *Daring Detective*, August 1937

BELOW *Real Detective*, August 1934

PAGE 116 *Real Police Story Magazine*, 1937

PAGE 117 *True Gang Life*, November 1936

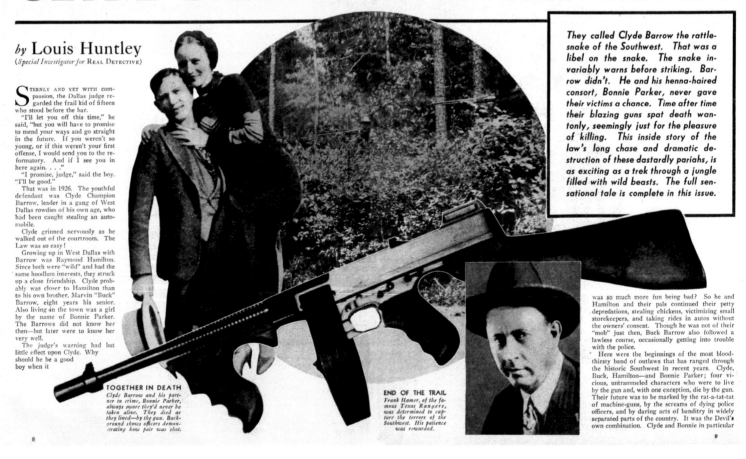

Twelve Murders Avenged When Texas Rangers Kill

CLYDE BARROW AND HIS MOLL

by Louis Huntley

(*Special Investigator for* REAL DETECTIVE)

STERNLY AND YET WITH compassion, the Dallas judge regarded the frail kid of fifteen who stood before the bar.

"I'll let you off this time," he said, "but you will have to promise to mend your ways and go straight in the future. If you weren't so young, or if this weren't your first offense, I would send you to the reformatory. And if I see you in here again. . . ."

"I promise, judge," said the boy. "I'll be good."

That was in 1926. The youthful defendant was Clyde Champion Barrow, leader in a gang of West Dallas rowdies of his own age, who had been caught stealing an automobile.

Clyde grinned nervously as he walked out of the courtroom. The Law was so easy!

Growing up in West Dallas with Barrow was Raymond Hamilton. Since both were "wild" and had the same hoodlum interests, they struck up a close friendship. Clyde probably was closer to Hamilton than to his own brother, Marvin "Buck" Barrow, eight years his senior. Also living in the town was a girl by the name of Bonnie Parker. The Barrows did not know her then—but later were to know her very well.

The judge's warning had but little effect upon Clyde. Why should he be a good boy when it

They called Clyde Barrow the rattlesnake of the Southwest. That was a libel on the snake. The snake invariably warns before striking. Barrow didn't. He and his henna-haired consort, Bonnie Parker, never gave their victims a chance. Time after time their blazing guns spat death wantonly, seemingly just for the pleasure of killing. This inside story of the law's long chase and dramatic destruction of these dastardly pariahs, is as exciting as a trek through a jungle filled with wild beasts. The full sensational tale is complete in this issue.

TOGETHER IN DEATH
Clyde Barrow and his partner in crime, Bonnie Parker, always swore they'd never be taken alive. They died as they lived—by the gun. Background shows officers demonstrating how pair was shot.

END OF THE TRAIL
Frank Hamer, of the famous Texas Rangers, was determined to capture the terrors of the Southwest. His patience was rewarded.

was so much more fun being bad? So he and Hamilton and their pals continued their petty depredations, stealing chickens, victimizing small storekeepers, and taking rides in autos without the owners' consent. Though he was not of their "mob" just then, Buck Barrow also followed a lawless course, occasionally getting into trouble with the police.

Here were the beginnings of the most bloodthirsty band of outlaws that has ranged through the historic Southwest in recent years. Clyde, Buck, Hamilton—and Bonnie Parker; four vicious, untrammeled characters who were to live by the gun and, with one exception, die by the gun. Their future was to be marked by the rat-a-tat-tat of machine-guns, by the screams of dying police officers, and by daring acts of banditry in widely separated parts of the country. It was the Devil's own combination. Clyde and Bonnie in particular

8

9

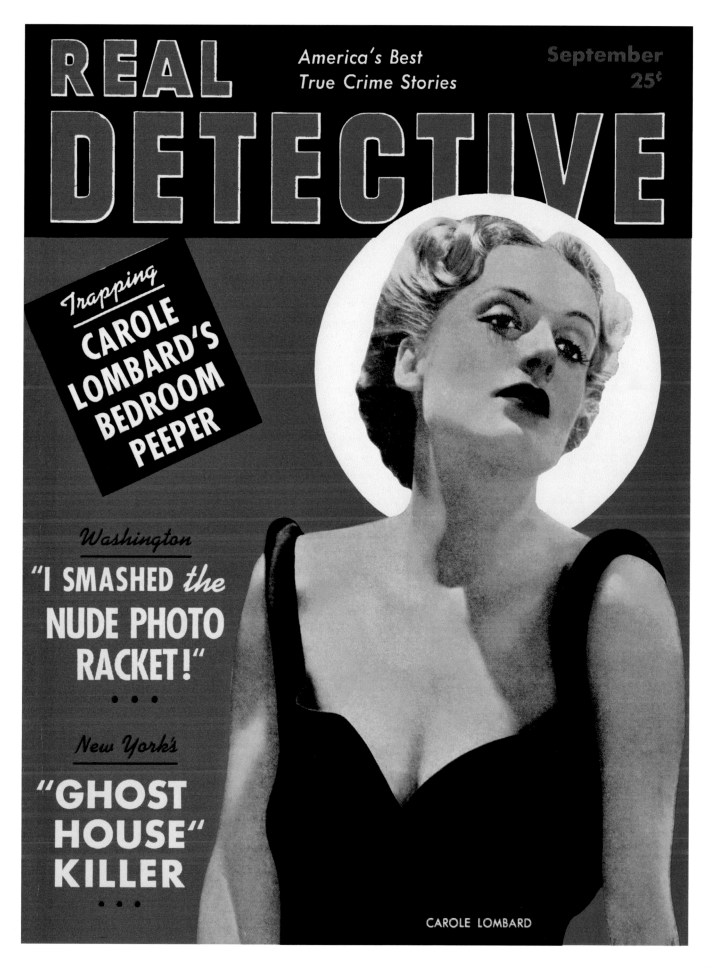

REAL DETECTIVE

America's Best
True Crime Stories

September
25¢

Trapping
CAROLE
LOMBARD'S
BEDROOM
PEEPER

Washington
"I SMASHED *the*
NUDE PHOTO
RACKET!"
• • •

New York's
"GHOST
HOUSE"
KILLER
• • •

CAROLE LOMBARD

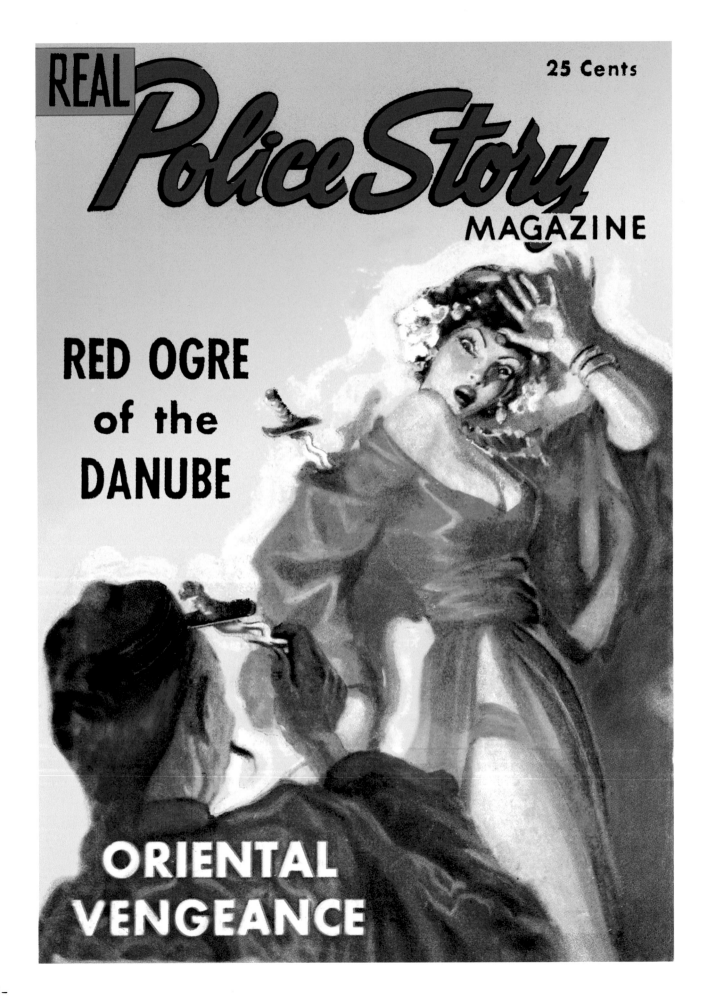

REAL
Police Story
MAGAZINE

25 Cents

RED OGRE
of the
DANUBE

ORIENTAL
VENGEANCE

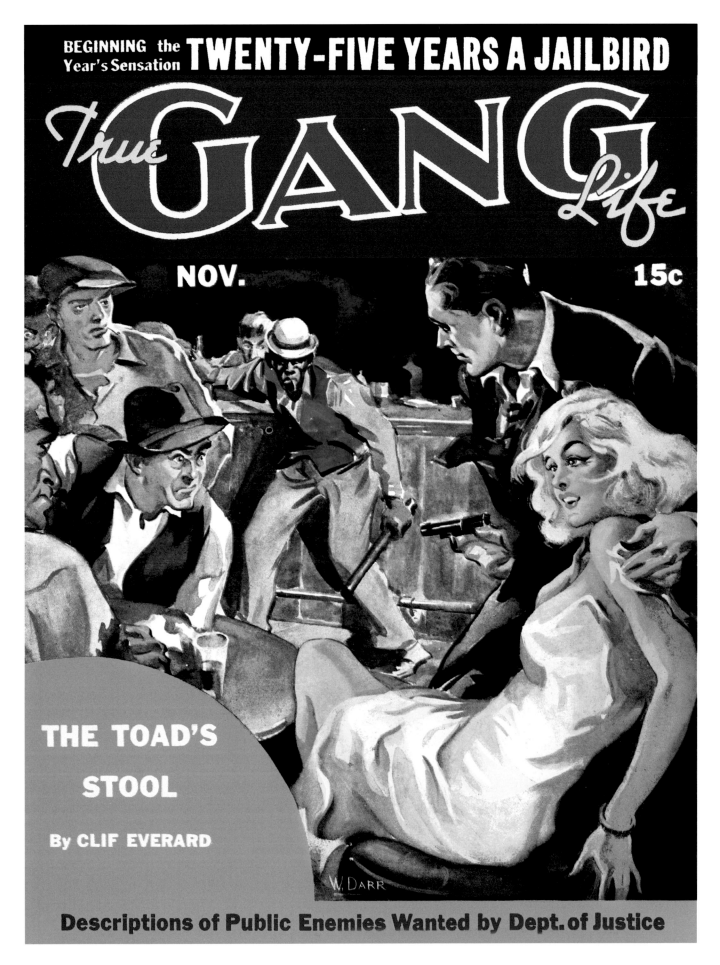

THE TOAD'S STOOL

By CLIF EVERARD

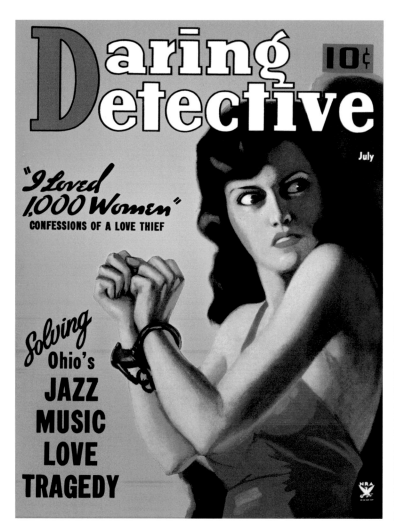

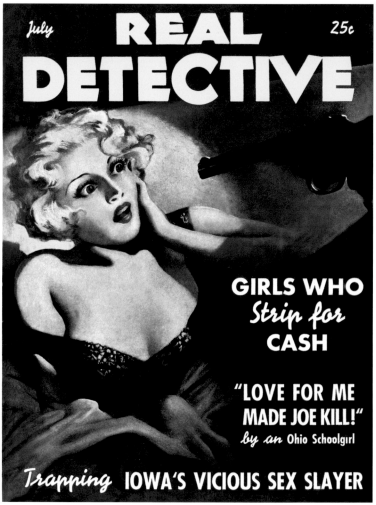

OPPOSITE *Official Detective Stories*, April 1, 1937

ABOVE LEFT *Daring Detective*, July 1935

ABOVE RIGHT *Real Detective*, July 1937

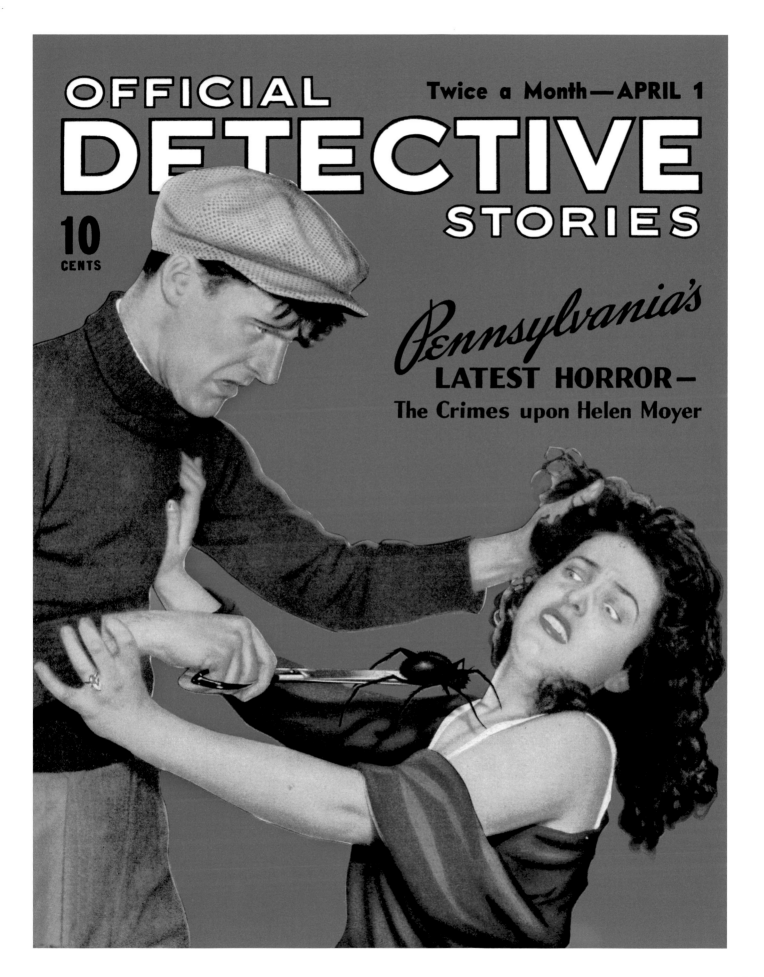

OFFICIAL DETECTIVE STORIES

Twice a Month—APRIL 1

10 CENTS

Pennsylvania's LATEST HORROR—
The Crimes upon Helen Moyer

1940 - '1949

In January of 1947 a crime occurred
that foreshadowed the direction of
detective magazines for the remainder
of their lifespan. The Black Dahlia
murder case, involving the mutilation
of a beautiful Hollywood starlet,
riveted the detective world. Horrible
as it all was, the obvious sex appeal
lurking in the back story was not lost
on publishers struggling to hold a
shrinking readership.

Best True Fact
DETECTIVE

THRILLING CASES FROM POLICE FILES!

PDC

SEEING THE POLICEMAN,
THE SCARLET TEMPTRESS
TURNED AND FLED!

25¢

CRIMSON CRIMES OF
THE LUSTFUL LADIES!

SEX REARS
ITS HEAD
by Eric Godtland

The detective magazines entered the 1940s flush with success and optimism, not knowing they were just two years from the end of their golden reign. With the bombing of Pearl Harbor and America's entrance into World War II they confronted two insurmountable obstacles that would bring about great change.

First, domestic crime lost its sparkle. Prohibition was repealed at the end of 1933, and when organized crime's cash cow dried up the sensational turf battles, hits, and general corruption began winding down. By 1940 the mob was rarely front-page news. Then the Great Depression ended as the war sent Americans back to work. All the celebrity criminals were either dead or behind bars and with government stabilization the bank robberies slacked off.

The magazines were left with only garden-variety murders and robberies to cover, and even these were occurring with less frequency in the '40s. One can imagine that after 1942 many a wild young man with the potential for a lone-wolf crime spree vented his homicidal impulses fighting Nazis or island-hopping in the Pacific. As if all this weren't disastrous enough for the detective titles, publishers joined in the war effort, either shelving their crime magazines in favor of war-related titles (such as Lionel White's wonderful *War* magazine) or integrating spy, black-marketeer, and other propaganda stories into their true crime coverage, diluting its purity.

The second blow was wartime paper rationing, which would forever change detective magazines for the worse. Government-mandated rationing forced many titles to cease publishing for the duration, and in some cases for good. *Startling Detective* suspended publication midway through 1944, not to return until 1946. *Actual Detective* was cut down in 1943 and absorbed into *Official Detective*. *Official Detective* continued, but its page count was cut in half.

The most ruinous decision the publishers made was to stick with the pulp after the rationing ended. You can see the logic: Pulp was far cheaper, giving the perception of increased profits, but this lowering of quality contributed to a downward spiral that would prove deadly to the genre. As publishers became accustomed to the savings of cheap paper they looked for other ways to economize. Less was spent on crime research and the magazines became not only less attractive but less relevant. This in turn attracted fewer readers, causing more need to cut costs. It was during this time that the photo cover became as prevalent as the painted. Commissioned art was expensive; photos were relatively cheap. While photo covers had been used to some extent in the 1930s, during the 1940s they accounted for more than half of all covers. In the decades to follow the balance would tip sharply.

By the end of 1946 the war was well over, but the detective magazines showed no sign of recovering their pre-war glory. Then, in January of 1947, a crime occurred that foreshadowed the direction of the genre for the remainder of its life span. The Black Dahlia murder case, in which the naked and mutilated body of a beautiful Hollywood starlet was found in a vacant lot in Los Angeles, riveted the detective readership. Horrible as it all was, the obvious sex appeal lurking in the back story of this case was not lost on publishers struggling to hold a shrinking readership. New publisher Skye Publications was the most aggressive at playing the sexy-death hand in *Best True Fact Detective* and *Women in Crime*, but before the decade ended most titles had switched to stories with prurient fascination and were playing up the sexual angle in every possible crime. It was a line that, once crossed, could never be retraced.

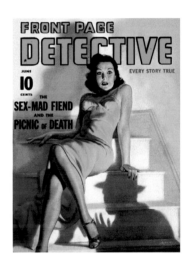

PAGE 120 *Police Detective Cases*, February 1948

OPPOSITE *Best True Fact Detective*, January 1948

ABOVE *Front Page Detective*, June 1940

BELOW *Crime Detective*, September 1940

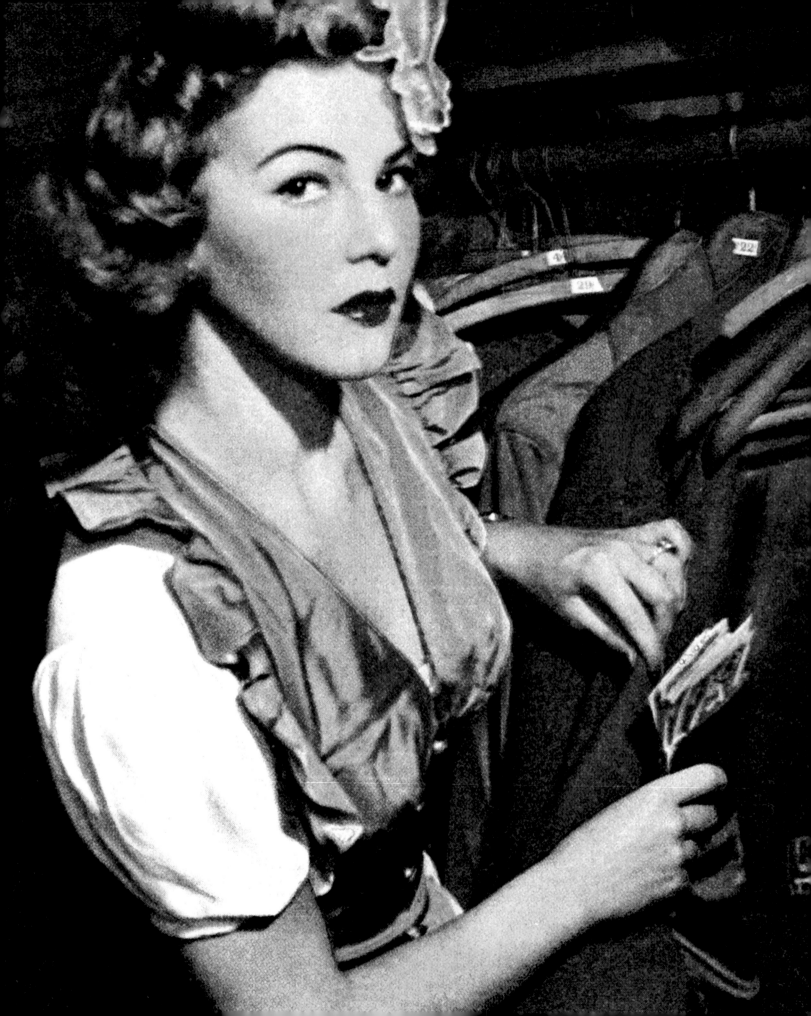

SEX ERHEBT SEIN HÜBSCHES HAUPT

von Eric Godtland

Optimistisch und erfolgsverwöhnt gingen die Detective Magazines in die 1940er-Jahre, doch ihr goldenes Zeitalter neigte sich bereits dem Ende zu. Der Angriff auf Pearl Harbor und der darauf folgende Kriegseintritt der USA veränderten die Welt.

Der Kriminalität im eigenen Land ging ihre glanzvolle Aura verloren. Die Prohibition, der Goldesel des organisierten Verbrechens, war schon Ende 1933 aufgehoben worden, und die Anzahl der Morde, der Bandenkriege und die allgemeine Korruption gingen zunehmend zurück. Die berühmten Gangster waren entweder tot oder hinter Schloss und Riegel, und mit der Stabilisierung der staatlichen Ordnung flaute auch die Welle spektakulärer Banküberfälle ab. Die Magazine konnten nur noch über langweilige Feld-Wald-und-Wiesen-Morde oder Raubüberfälle berichten, und selbst die geschahen in den 1940ern nicht mehr so häufig. Von 1942 an hat wahrscheinlich mancher ungebärdige junge Mann seine Mordgelüste lieber im Kampf gegen die Nazis oder die Japaner im Pazifik ausgetobt. Und als wäre das alles nicht schon katastrophal genug für die Detective Magazines gewesen, leisteten auch die Verleger ihren Beitrag zum Krieg und ersetzten ihre Detective-Titel entweder durch Titel mit militärischer Thematik – wie etwa Lionel Whites grandioses Magazin *War* – oder verwässerten ihre True-Crime-Titel, indem sie Spionage-, Schwarzmarkt- oder andere propagandataugliche Themen einbauten.

Ein weiterer schwerer Schlag war die Papierrationierung im Krieg. Viele Magazine mussten ihr Erscheinen vorübergehend einstellen, und für einige war es das endgültige Aus. *Startling Detective* stellte Mitte 1944 sein Erscheinen ein und war erst 1946 wieder zu haben. *Actual Detective* wurde 1943 von *Official Detective* geschluckt.

Official Detective erschien weiterhin, jedoch nur noch mit dem halben Umfang.

Nach dem Ende der Papierrationierung beim holzhaltigen Pulp-Papier zu bleiben, war jedoch die folgenschwerste Entscheidung der Verleger. Dieses Material war weitaus billiger als gutes Papier und versprach größere Gewinnspannen. Doch das leitete einen allgemeinen Qualitätsverlust ein, der letztendlich das Ende des Genres bedeutete. Man investierte nicht mehr so viel in die Nachforschungen, und damit wurden die Magazine für den Leser nicht nur unattraktiver, sondern auch weniger aussagekräftig. Folglich sank die Leserzahl, was wiederum weitere Einsparungen notwendig machte. In dieser Zeit tauchten immer mehr Fototitel neben den gemalten auf. Cover, die eigens gemalt werden mussten, waren teuer, Fotos dagegen relativ preiswert.

1946 war der Krieg Geschichte, aber nichts deutete darauf hin, dass die Detective Magazines an die goldenen Vorkriegszeiten anknüpfen würden. Dann, im Januar 1947, geschah ein Verbrechen, das die Ausrichtung der Magazine für die restliche Zeit ihres Bestehens bestimmen sollte. Der Mordfall *Black Dahlia*, in dem der nackte und verstümmelte Körper eines Starlets aus Hollywood gefunden wurde, fesselte die Leser der Detective Magazines. So schrecklich das Verbrechen war, den Verlegern, die um ihre schrumpfende Leserschaft kämpften, entging nicht, dass in dieser Story viel Sexappeal steckte. Der junge Verlag Skye Publications reizte mit seinen Heften *Best True Fact Detective* und *Women in Crime* diese Sexy-Tod-Karte am schamlosesten aus, doch noch vor Ende des Jahrzehnts waren auch die meisten anderen Magazine auf schlüpfrige Geschichten umgeschwenkt und betonten bei jeder Art von Verbrechen deren sexuelle Aspekte. Damit war eine Linie überschritten, hinter die es kein Zurück gab.

OPPOSITE *National Detective Cases*, February 1947

ABOVE *Inside Detective*, December 1945

JANUARY

NATIONAL
DETECTIVE

15¢
IN CANADA

CASES

MAD GUNMAN
of MANHATTAN

Death on Delivery

LE SEXE REDRESSE LA TÊTE

Eric Godtland

Les magazines policiers abordent les années 1940 avec l'optimisme de la réussite, sans se douter qu'ils ne sont qu'à deux ans de la fin de leur âge d'or. Avec l'entrée en guerre de l'Amérique, ils sont confrontés à deux obstacles insurmontables qui vont entraîner un changement majeur.

Tout d'abord, aux États-Unis, le crime ne fait plus recette : la prohibition a été abrogée en 1933. La vache à lait du crime organisé ayant cessé d'alimenter les caisses, les sensationnelles guerres des gangs, les braquages et la corruption en général commencèrent à décliner. Et puis avec la guerre, les chômeurs de la Grande Dépression retrouvent le chemin du travail. Toutes les grandes figures du crime sont mortes ou sous les barreaux et avec la stabilisation politique, on assiste à une baisse sensible des hold-up.

La presse n'a plus que des affaires criminelles de second ordre ou des attaques de banques banales à relater. On peut imaginer qu'en 1942, nombre de jeunes gens sur le point de débuter une carrière de criminel ont canalisé leurs pulsions homicides en abattant des nazis ou en combattant dans les îles du Pacifique. Comme si tout cela n'était pas assez désastreux pour les magazines policiers, les éditeurs ont soutenu l'effort de guerre, soit en suspendant leurs titres en faveurs de périodiques explicitement liés à la guerre (comme le magnifique magazine *War* de Lionel White) ou en intégrant dans leurs magazines d'enquêtes criminelles des histoires d'espionnage et de marché noir, altérant ainsi leur pureté.

Le second coup porté à cette industrie est lié au rationnement du papier. Le rationnement décidé par le gouvernement contraint de nombreux titres à cesser de paraître pour la durée de la guerre. *Startling Detective* suspend sa parution en 1944 pour ne reparaître qu'en 1946. *Actual Detective* est supprimé en 1943 et absorbé par *Official Detective*, lequel continue à paraître mais avec une pagination réduite de moitié.

Mais la décision la plus néfaste des éditeurs fut celle de s'en tenir au papier *pulp* après la fin du rationnement. Ce type de papier étant beaucoup moins cher, les marges escomptées étaient beaucoup plus importantes. Mais ce blocage sur la qualité entraîna une chute fatale au genre. Car les éditeurs, habitués à économiser sur le papier, fonctionnèrent sur des budgets resserrés : les enquêtes se firent plus superficielles et les magazines perdirent en attrait et en pertinence. La baisse du nombre de lecteurs entraîna une nouvelle réduction des coûts de fabrication. Les photos de couverture firent peu à peu jeu égal avec les illustrations plus onéreuses que les photos bon marché. Les photos de couverture devaient s'arroger la moitié du marché dans les années 1940. Et les décennies suivantes allaient confirmer la suprématie de la photo.

Fin 1946, la guerre était terminée, mais les magazines policiers semblaient loin de retrouver leur éclat d'avant-guerre. En 1947, un crime défraya la chronique : l'affaire du Dahlia Noir. On avait retrouvé le cadavre dénudé et mutilé d'une starlette hollywoodienne dans un appartement de Los Angeles. Ce crime tint l'opinion publique en haleine. Si atroce fut ce meurtre, sa dimension sexuelle évidente ne laissa pas indifférents les éditeurs de magazines policiers qui surent l'utiliser pour regagner un lectorat déclinant. Et c'est un nouveau venu sur le marché, Skye Publications, qui fut le plus agressif dans l'exploitation du polar à connotations sexuelles avec *Best True Fact Detective* et *Women in Crime*. Mais dès la fin de la décennie, la plupart des titres jouaient avec l'angle sexuel dans toutes les affaires criminelles. Cette ligne une fois franchie, il fut impossible de revenir en arrière.

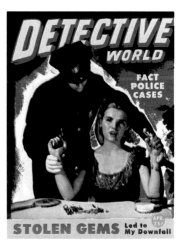

OPPOSITE *National Detective Cases*, January 1945

ABOVE *Detective World*, April 1946

PAGE 128 *True Cases of Women in Crime*, July 1949

PAGE 129 *True Stories of Women in Crime*, January 1949

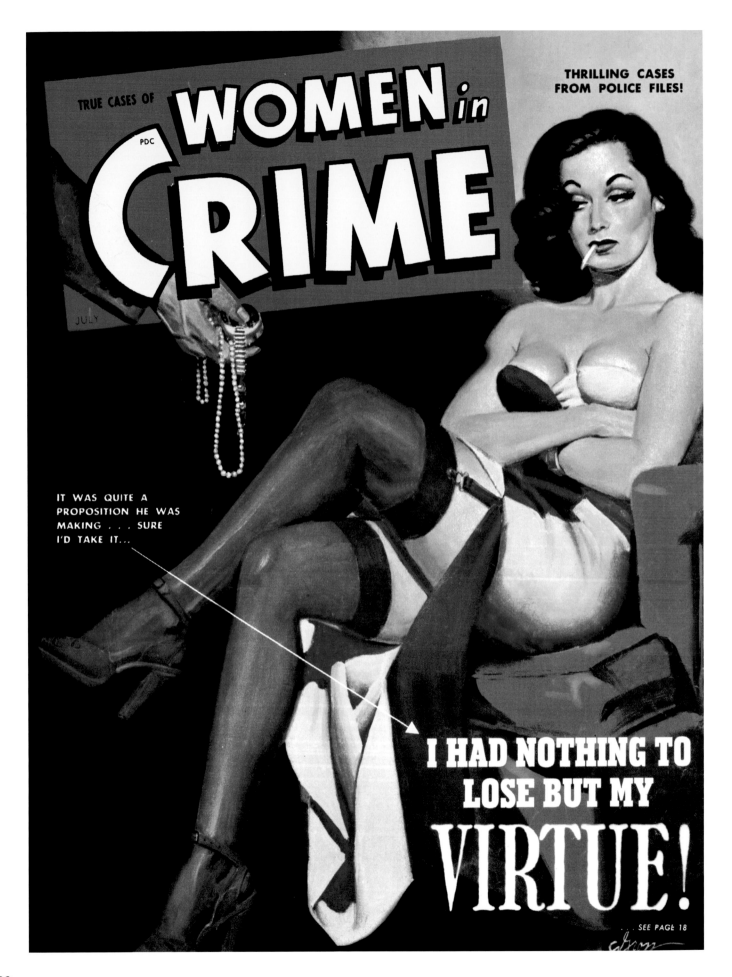

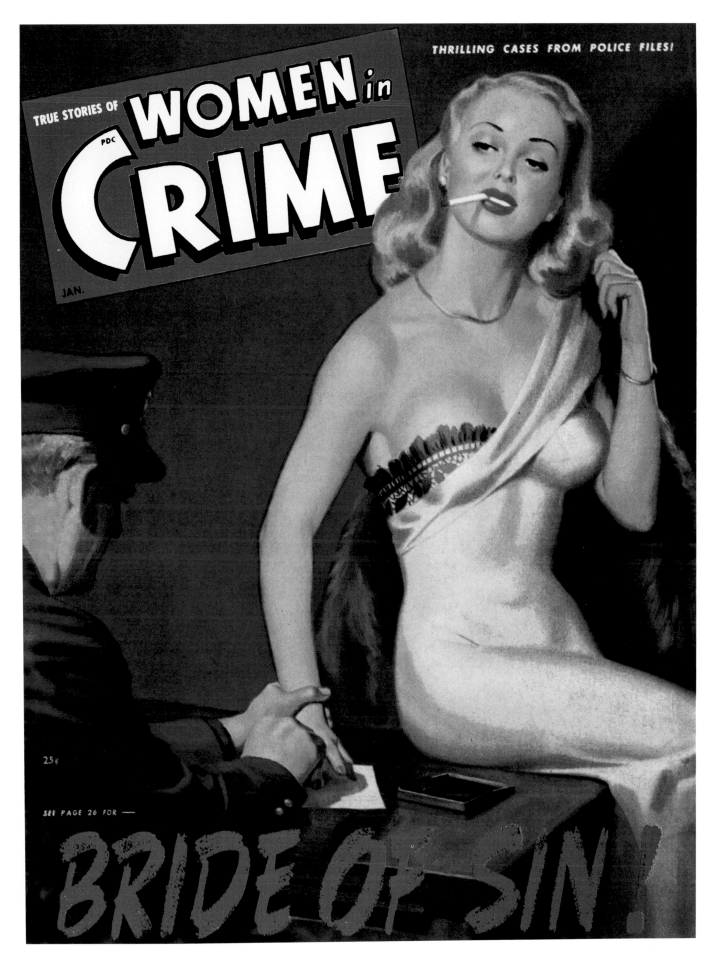

True Stories of WOMEN in CRIME

THRILLING CASES FROM POLICE FILES!

PDC

JAN.

25¢

SEE PAGE 26 FOR —

BRIDE OF SIN!

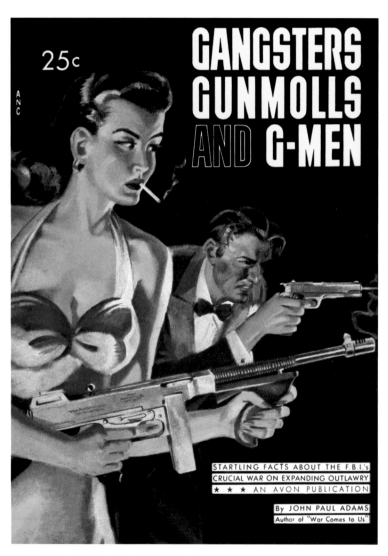

"Something has to happen before the rosy-fingered dawn steals over the city and rouses it to another day of the ceaseless battle of living. And that something is full of death and destruction."

— *DARE DEVIL DETECTIVE*, JUNE 1946

OPPOSITE *Women in Crime True Fact Detective Cases*, March 1948

ABOVE *Gangsters Gunmolls and G-Men*, 1949

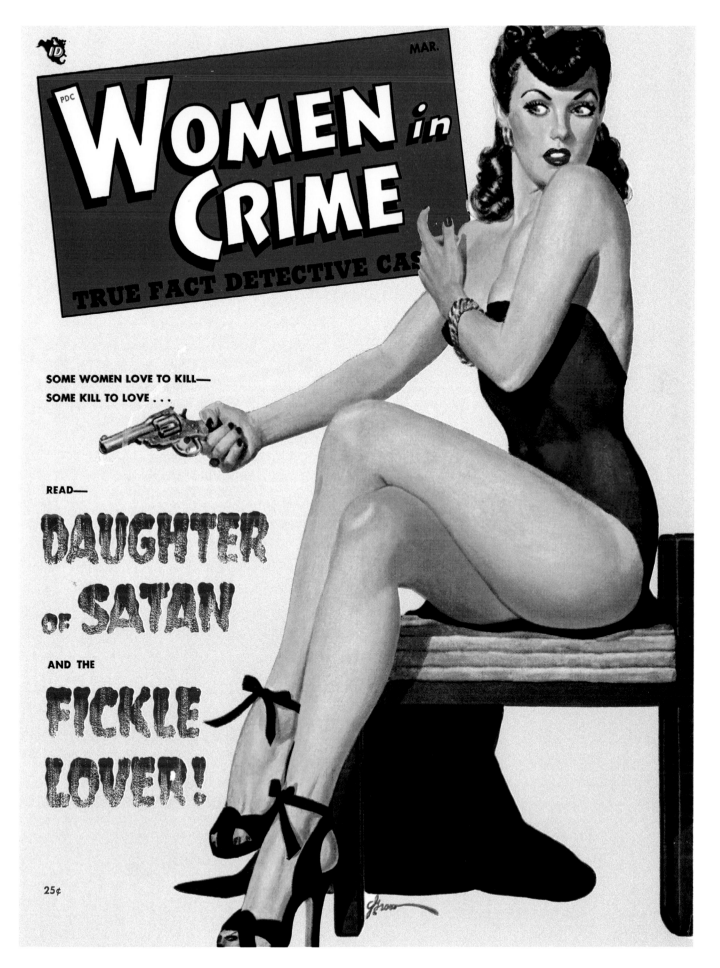

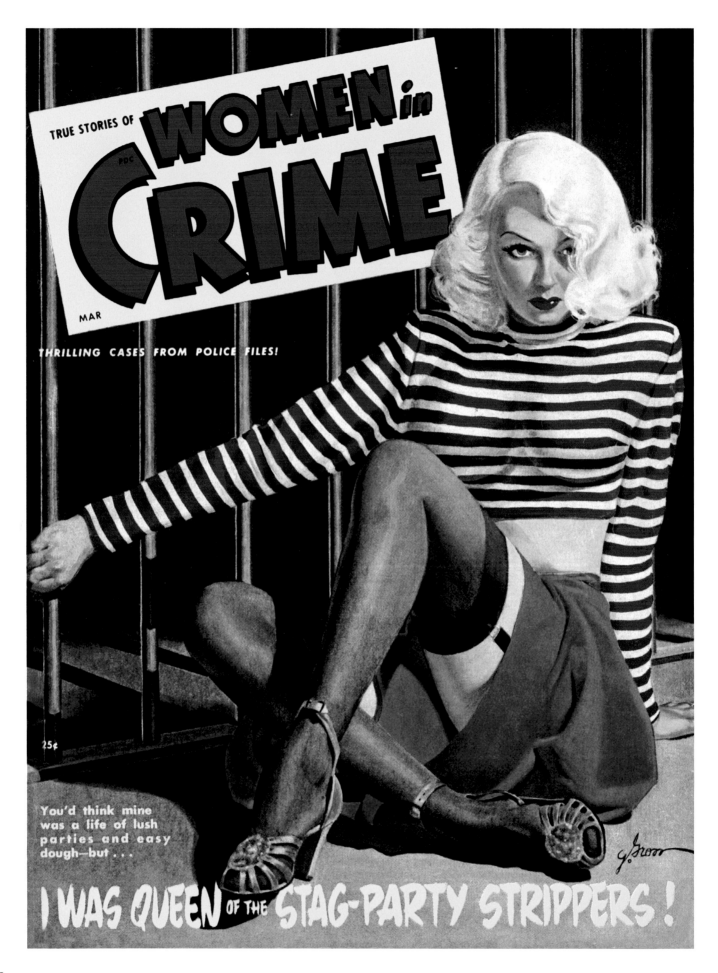

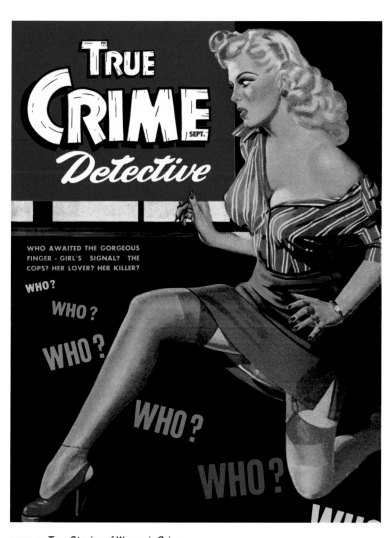

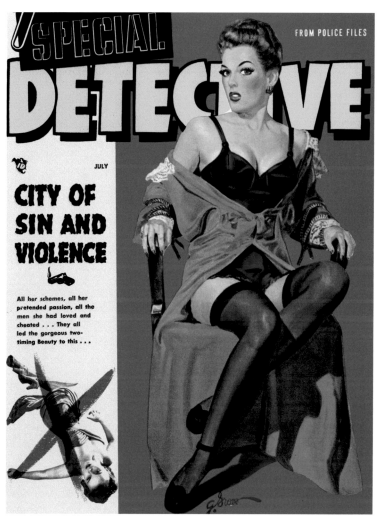

OPPOSITE *True Stories of Women in Crime*,
March 1949

ABOVE LEFT *True Crime Detective*,
September 1947

ABOVE RIGHT *Special Detective*, July 1948

PAGES 134–135 *Crime Detective*, September 1940

I MADE A RACKET

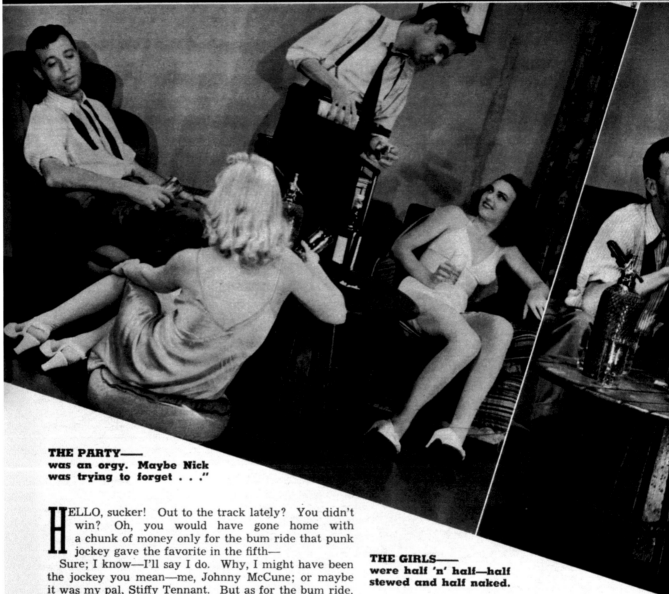

THE PARTY——
was an orgy. Maybe Nick
was trying to forget . . ."

THE GIRLS——
were half 'n' half—half
stewed and half naked.

HELLO, sucker! Out to the track lately? You didn't win? Oh, you would have gone home with a chunk of money only for the bum ride that punk jockey gave the favorite in the fifth—

Sure; I know—I'll say I do. Why, I might have been the jockey you mean—me, Johnny McCune; or maybe it was my pal, Stiffy Tennant. But as for the bum ride, perhaps that was part of the set-up. Did it occur to you that the odds against the horse might have been too short for the owner to do any betting on him or that the trainer figured the horse needed a race under his belt and considered the race as only an exercise gallop? Perhaps they were losing purposely just to get the nag into a spot where he could be raced against cheaper horses—that happens, too.

Racing ain't a dirty business; it's the people in it and I guess me and Stiffy are among 'em. Sure, I've "pulled" enough favorites to earn the nick-name "strong arm"; I've ridden ringers, too, and bangtails so full of dope they was running store-houses of the stuff. And I've put little sponges up their noses to make their breathing difficult. In fact, I got so bold that I had few mounts there wasn't something queer about. Few trainers, except guys like the Deacon, who's crooked as a horse's hind leg, would trust me. But then, even fixed races don't always stay fixed. One race at Aqueduct this year proved that for me at a cost of $50 of my own money. And Stiffy rode the nag, too.

Nick Rosson, the gambler, was supposed to be bettin[g] a wad for me and Stiffy and the Deacon on the hea[t]

Nightside, the nag Stiffy was riding, was hopped u[p] to out-run Man-o'-War, if necessary. It was a mile an[d] a sixteenth event and the last race on the card and [I] wanted to see it run off. So I stayed at the rail by th[e] course. I didn't see the Deacon until he spoke.

"This race is off, as far as Nightside is concerned," h[e] said. "Somebody sprung a leak and some gambler go[t] a tip on the fix. So much betting's been done in th[e] mutuel machines the horse ain't hardly even money[.] Opened at ten-to-one, too. Rosson's give orders to pul[l] Nightside back and keep him from winning. Say, it'[s] getting so you can't trust nobody."

My $50 already was bet in a handbook downtown an[d] I couldn't draw it down so, instead of winning mayb[e] $500 as I had expected, I stood to be loser. Was I sore[?] The Deacon wise-cracked:

"Racing luck, Johnny!"

Luck my eye, I thought to myself.

OUT OF RACING

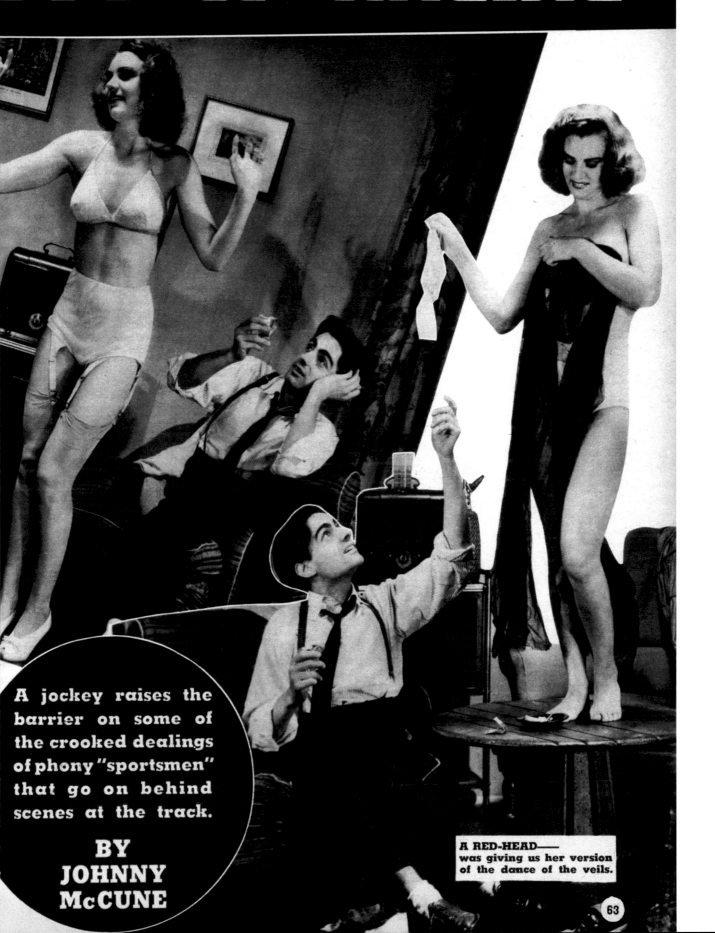

A jockey raises the barrier on some of the crooked dealings of phony "sportsmen" that go on behind scenes at the track.

BY JOHNNY McCUNE

A RED-HEAD—— was giving us her version of the dance of the veils.

63

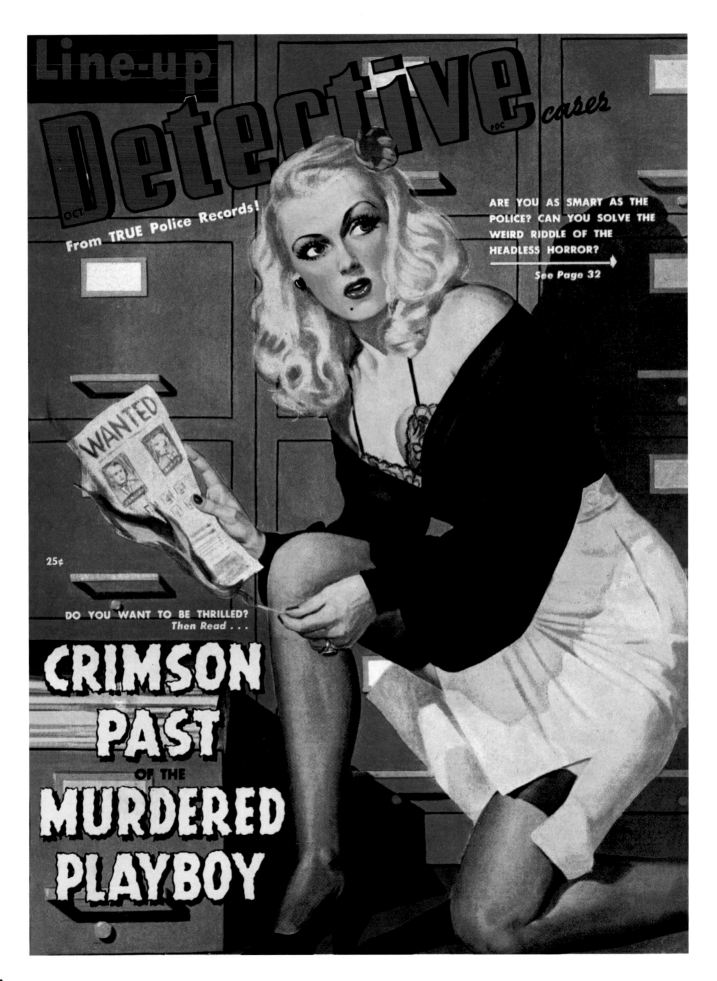

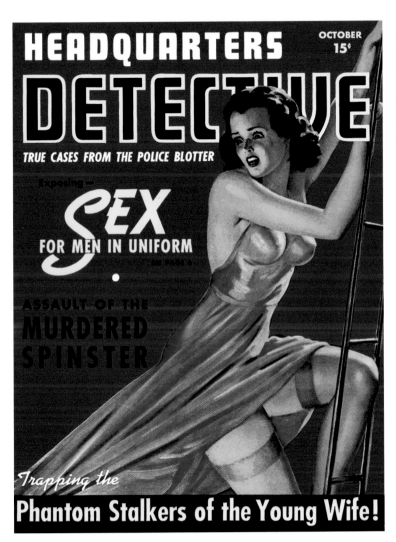

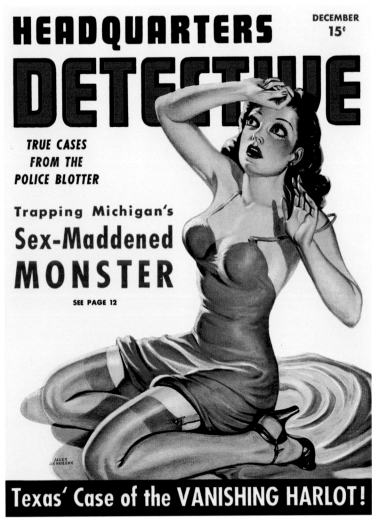

OPPOSITE *Line-up Detective,*
October 1948

ABOVE LEFT *Headquarters Detective,*
October 1940

ABOVE RIGHT *Headquarters Detective,*
December 1940

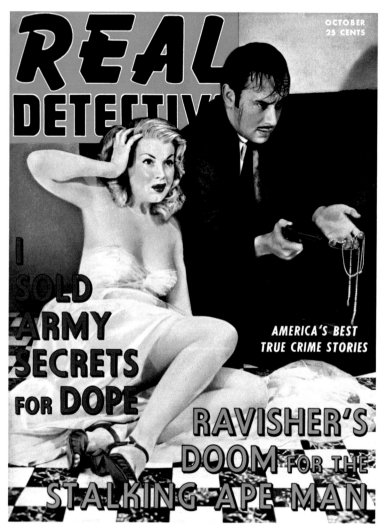

OPPOSITE *Hello Sucker Gay Life Easy Money*,
April – May 1944

ABOVE *Real Detective*, October 1941

"I'm not trying to tell you I'm lily white. Plenty of men have fallen for my line. And plenty of men have paid the bills. Such men are saps."

— *TRUE THRILLS*, 1942

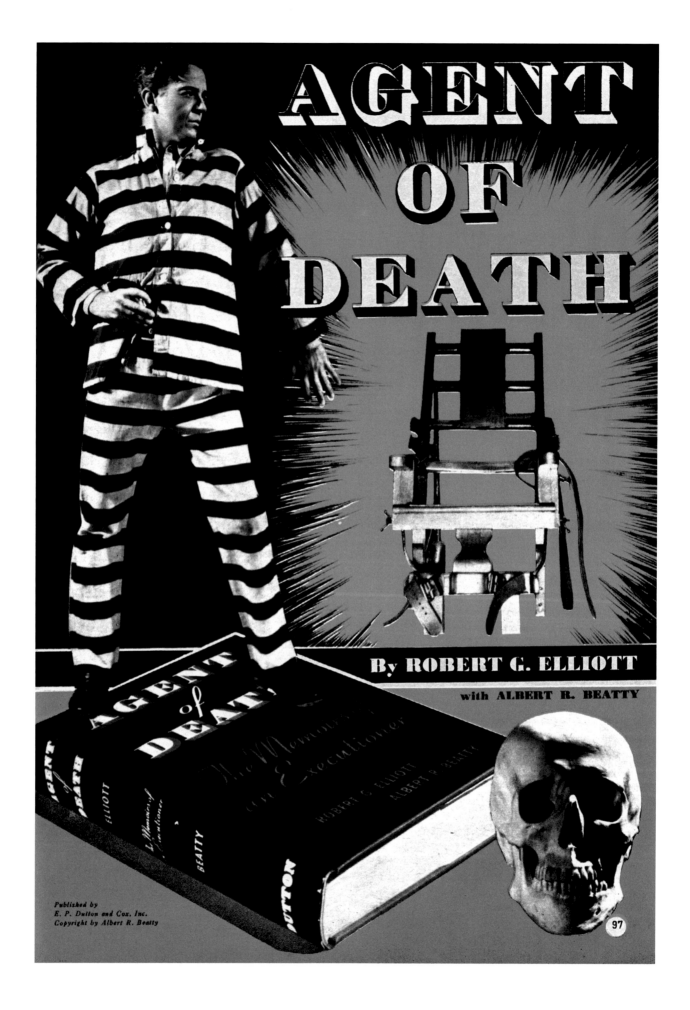

AGENT OF DEATH

By ROBERT G. ELLIOTT

with ALBERT R. BEATTY

Published by
E. P. Dutton and Cox, Inc.
Copyright by Albert R. Beatty

97

"How I wept and cried in my room that night! What had happened to my once beautiful dreams?"

— *HOMICIDE DETECTIVE*, 1948

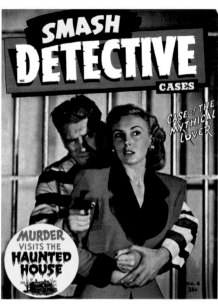

OPPOSITE *Sensation*, February 1942

CLOCKWISE FROM ABOVE LEFT *Exclusive Detective Cases*, September 1948; *True Crime Detective*, September 1949; *Smash Detective Cases*, 1945; *Expose Detective Cases*, November 1946

"Night was made for death, but even killers sometimes become impatient."
— *CONFIDENTIAL DETECTIVE CASES*, JANUARY 1948

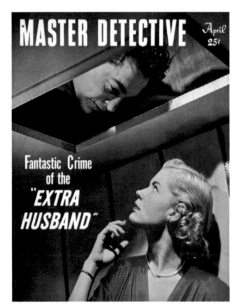

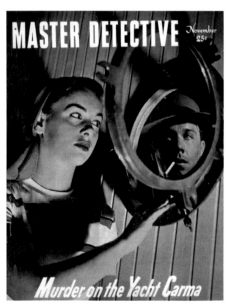

OPPOSITE *All-Fact Detective*, March 1943

CLOCKWISE FROM ABOVE LEFT *Master Detective*, April 1949; *Sensation*, Summer 1943; *Master Detective*, November 1948; *Complete Detective Cases*, March 1949

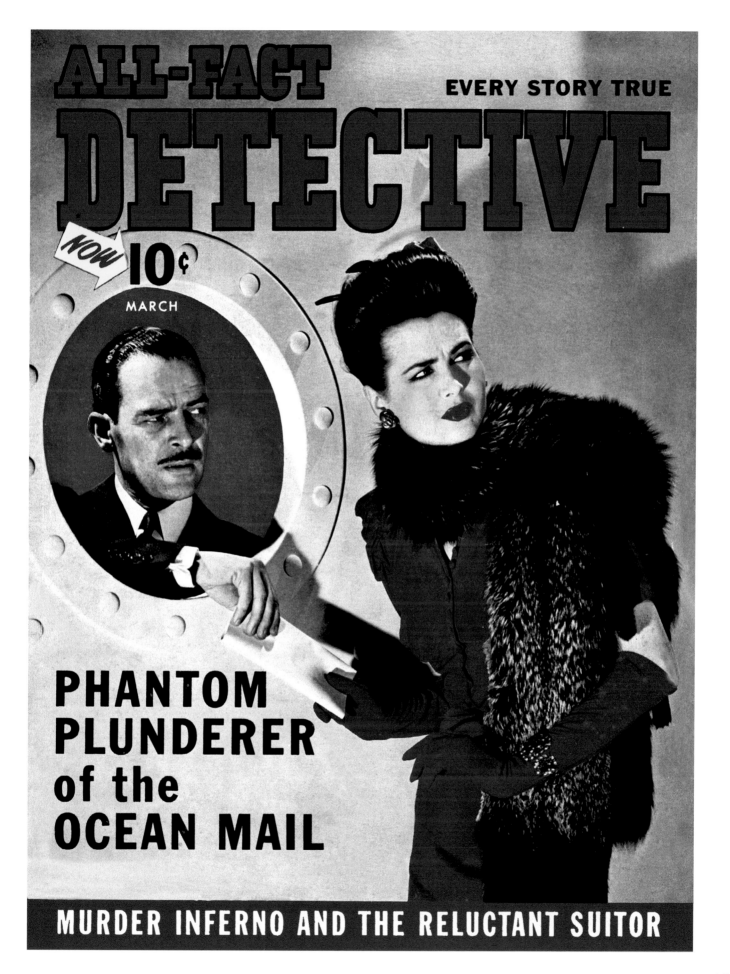

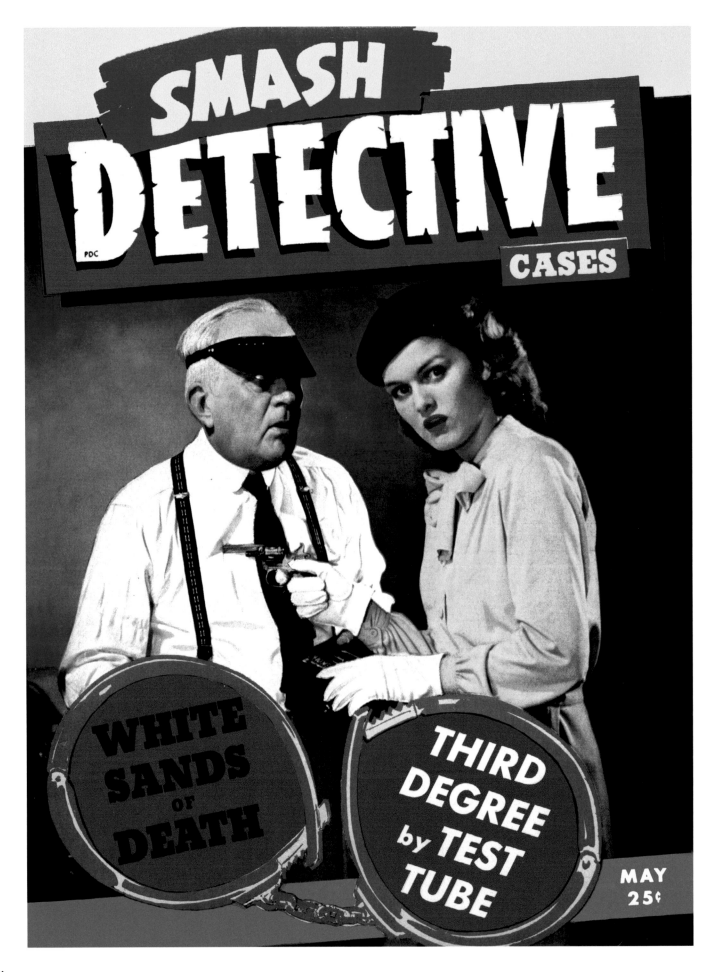

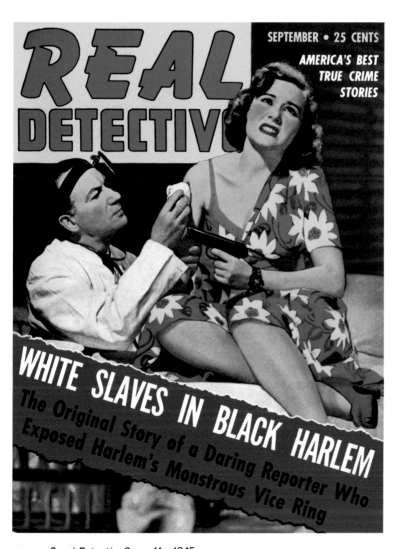

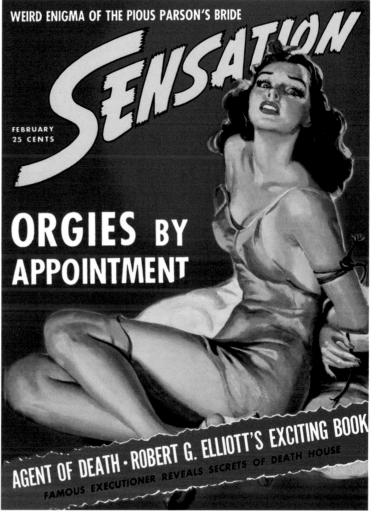

OPPOSITE *Smash Detective Cases*, May 1945

ABOVE LEFT *Real Detective*, September 1942

ABOVE RIGHT *Sensation*, February 1942

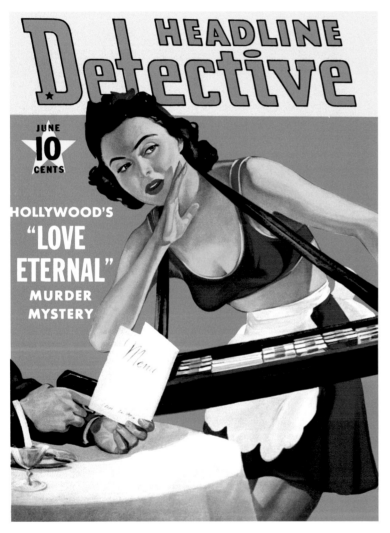

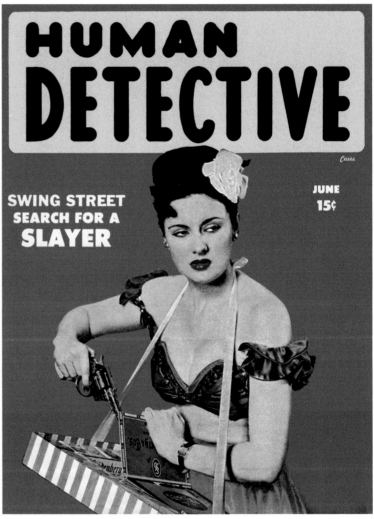

OPPOSITE *Exposé Detective True Crime Cases,*
April 1942

ABOVE LEFT *Headline Detective,* June 1940

ABOVE RIGHT *Human Detective Cases,* June 1941

PAGE 148 *Real Detective,* January 1941

PAGE 149 *Crime Detective,* April 1943

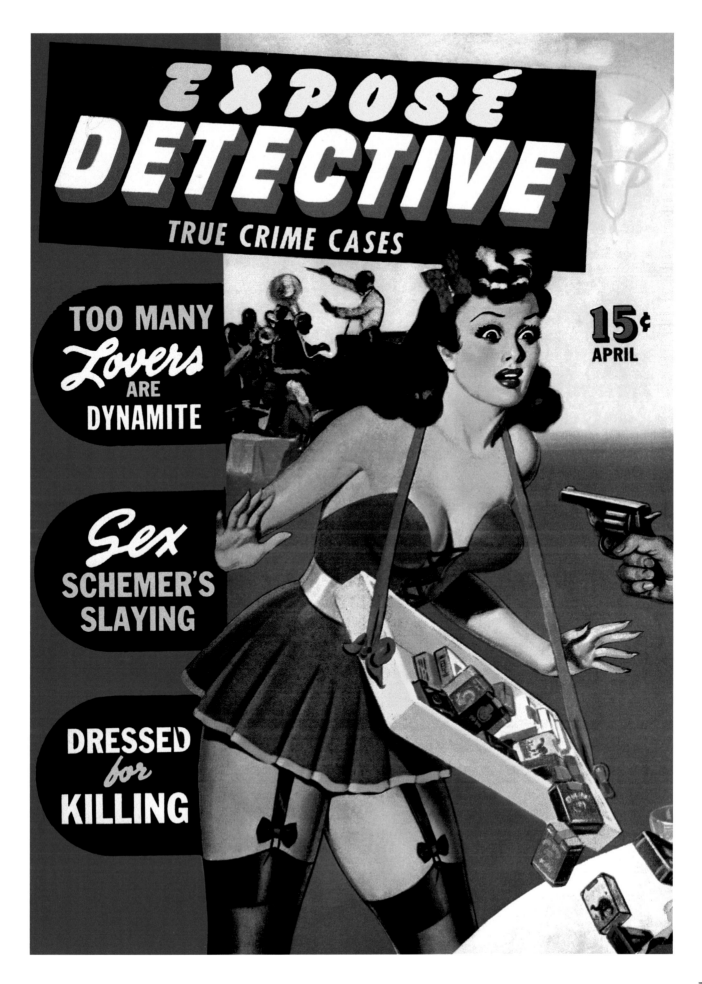

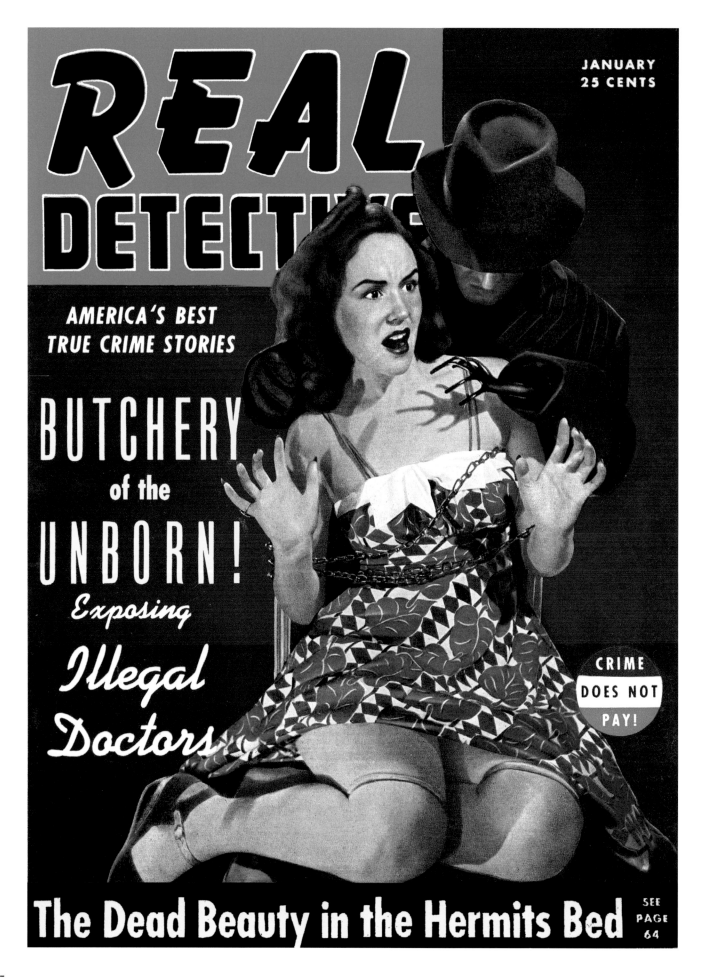

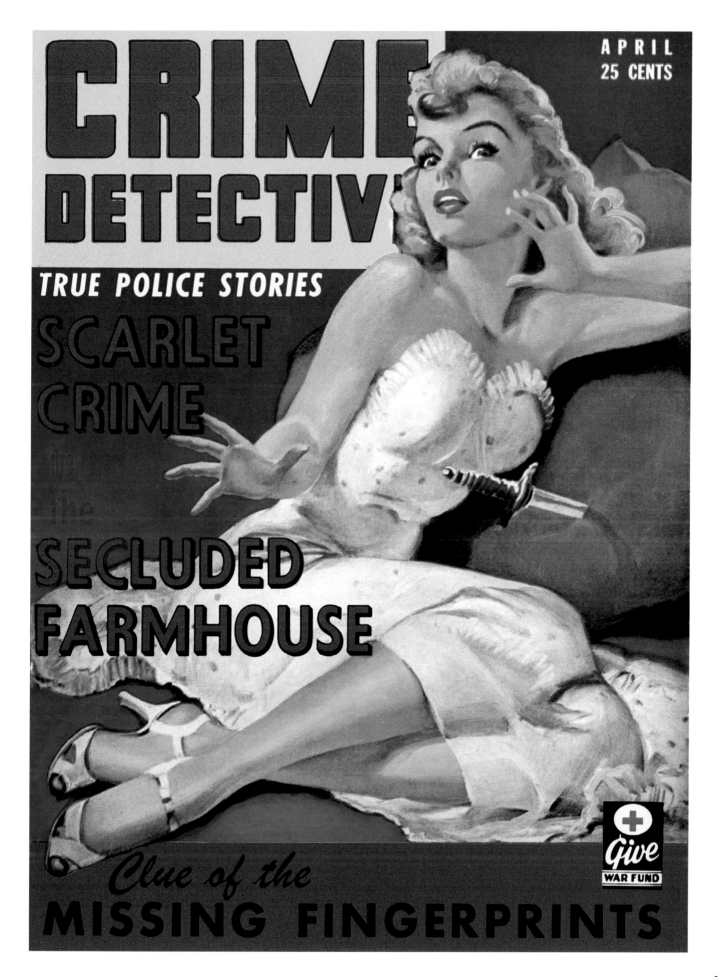

CRIME
DETECTIVE

APRIL
25 CENTS

TRUE POLICE STORIES

SCARLET
CRIME
in
the

SECLUDED
FARMHOUSE

Clue of the
MISSING FINGERPRINTS

Give
WAR FUND

"In a subtle manner, bred of long
practice, she opened a vial in her
handbag and poured half its contents
in the highball she handed him."
— LINE-UP DETECTIVE CASES, AUGUST 1947

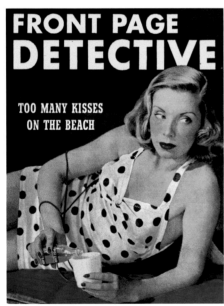

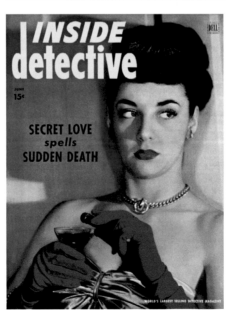

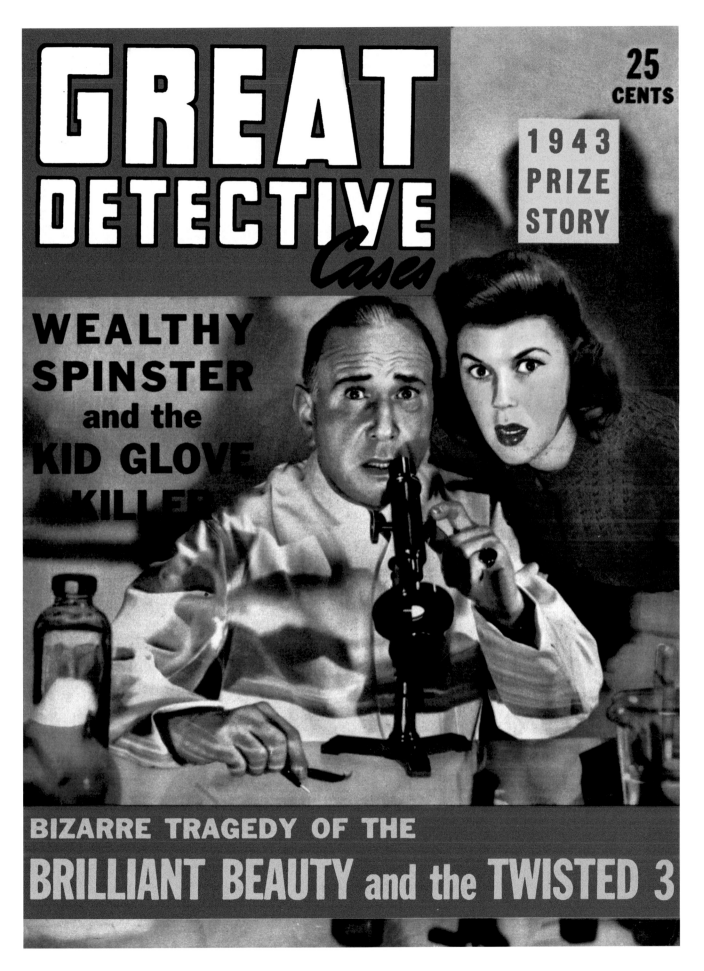

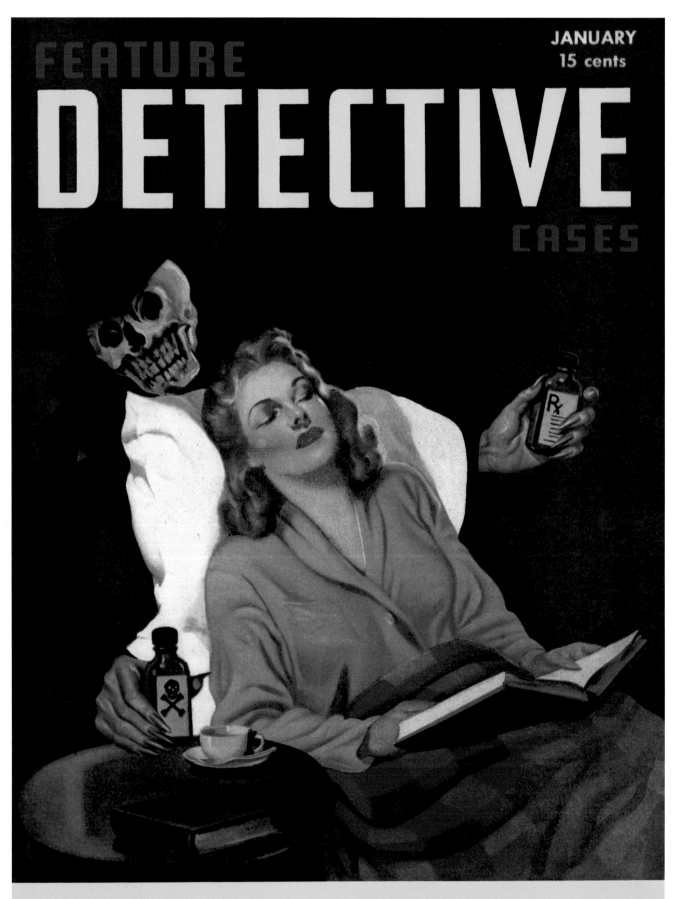

FEATURE
DETECTIVE
CASES

JANUARY
15 cents

CAPSULES OF DOOM • BOSTON'S SLASHING ROMEO

"Silently the poisoner mixed deadly potions, the potions that killed in secret; silently the poisoner plotted more murder."

— *OFFICIAL DETECTIVE TALES,*
SEPTEMBER 1947

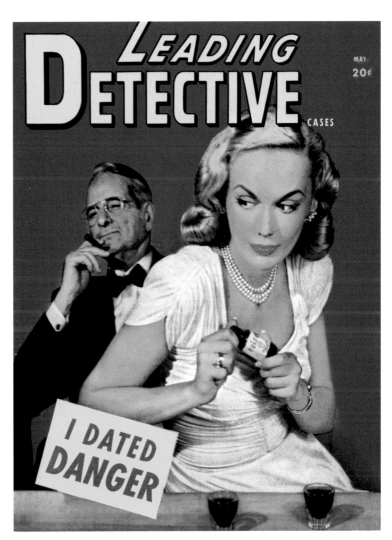

OPPOSITE *Feature Detective Cases*, January 1941

ABOVE *Leading Detective Cases*, May 1947

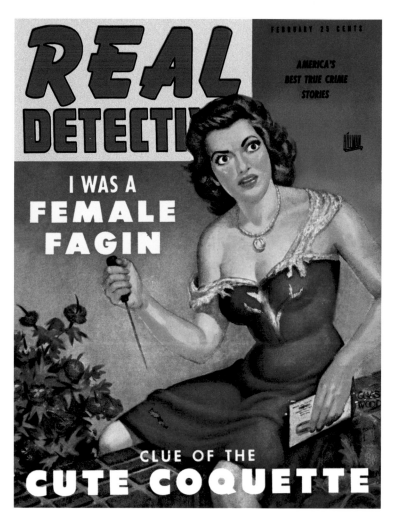

"There was an interesting postscript. 'I live 300 miles south of Hell. I'm the original Hellcat and I shoot to kill.'"

— *FRONT PAGE DETECTIVE,*
OCTOBER 1948

OPPOSITE *True Detective Mysteries*, July 1940

ABOVE *Real Detective*, February 1948

PAGE 156 *Official Detective Stories*, February 1945

PAGE 157 *Confidential Detective Cases*, January 1948

PAGES 158–159 *True Detective Mysteries*, April 1940

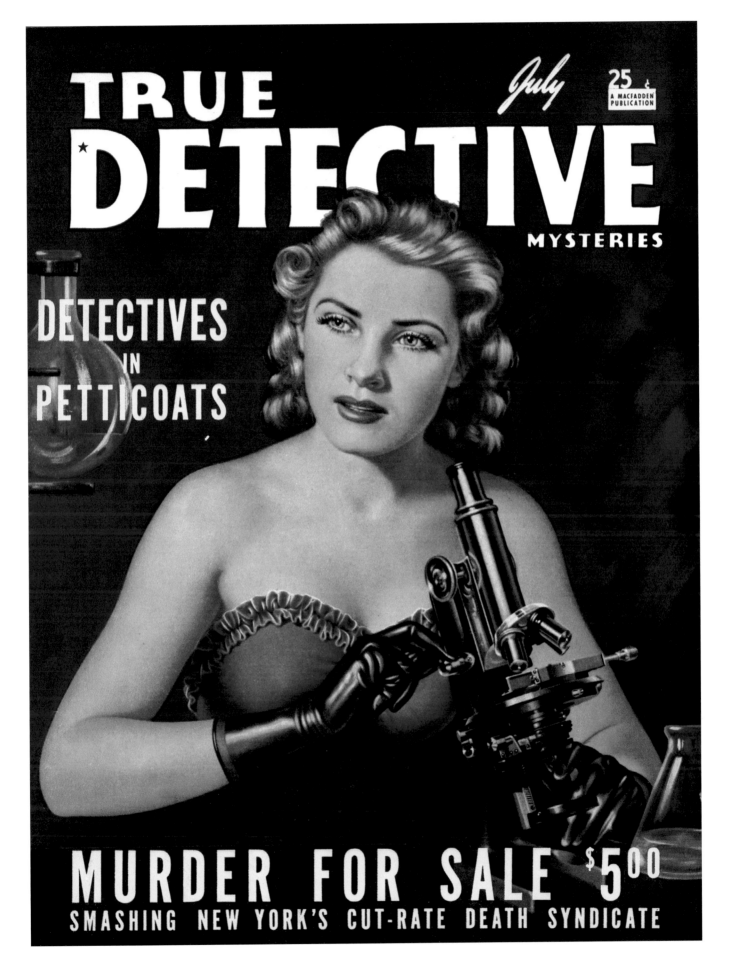

OFFICIAL
DETECTIVE
STORIES

Combined with Actual Detective

February, 1945

The Truth Behind
My Clairvoyant Years
With Gipsy Liz

25¢

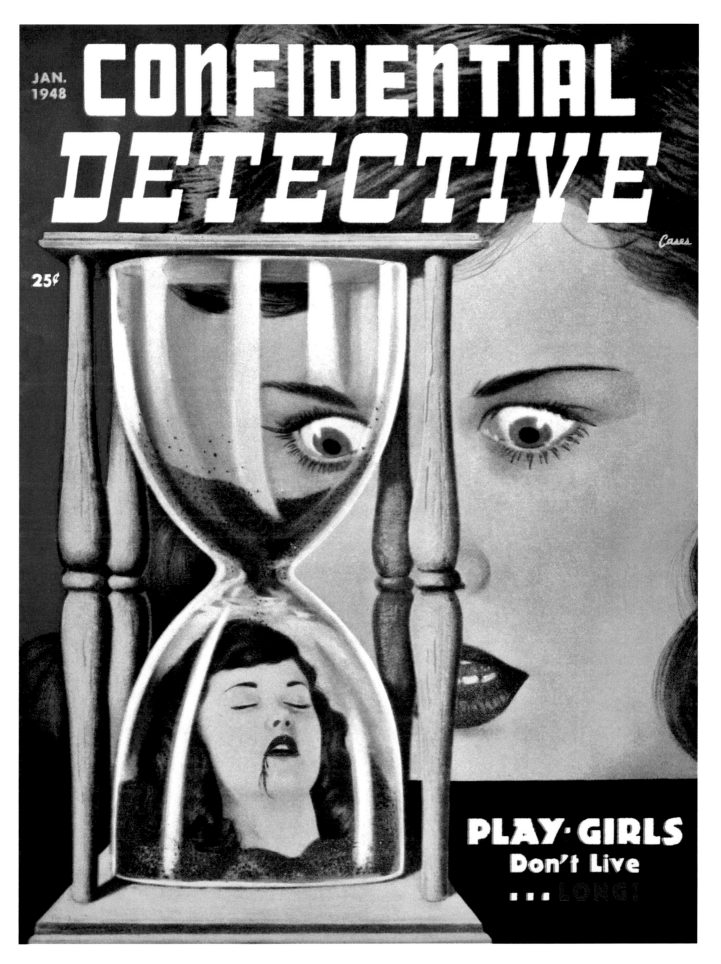

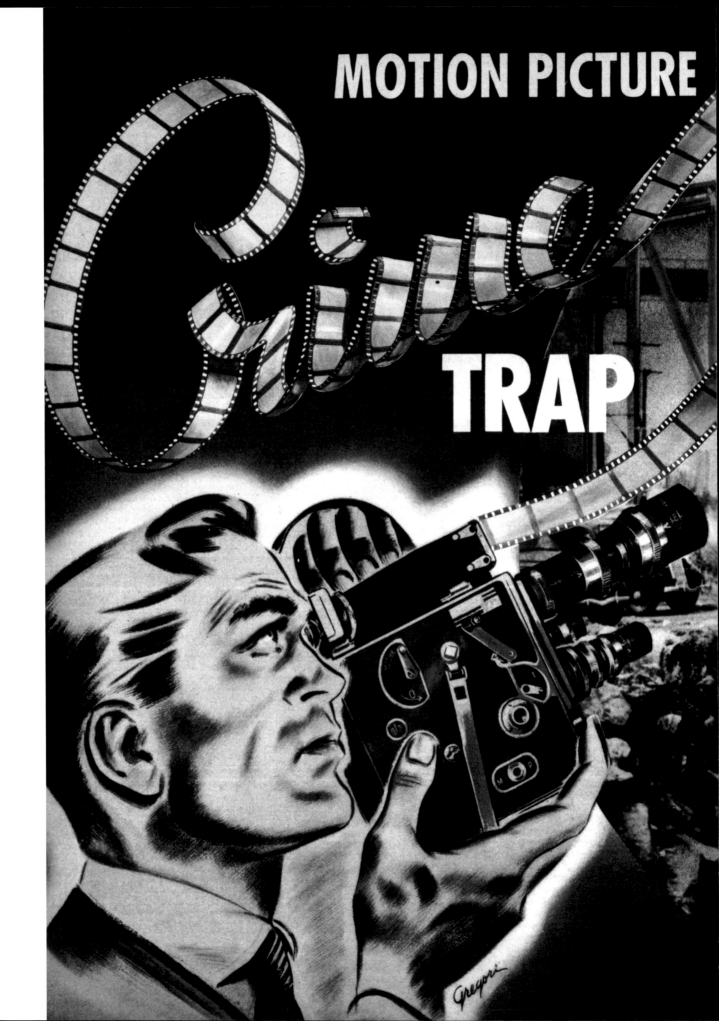

MOTION PICTURE

Crime

TRAP

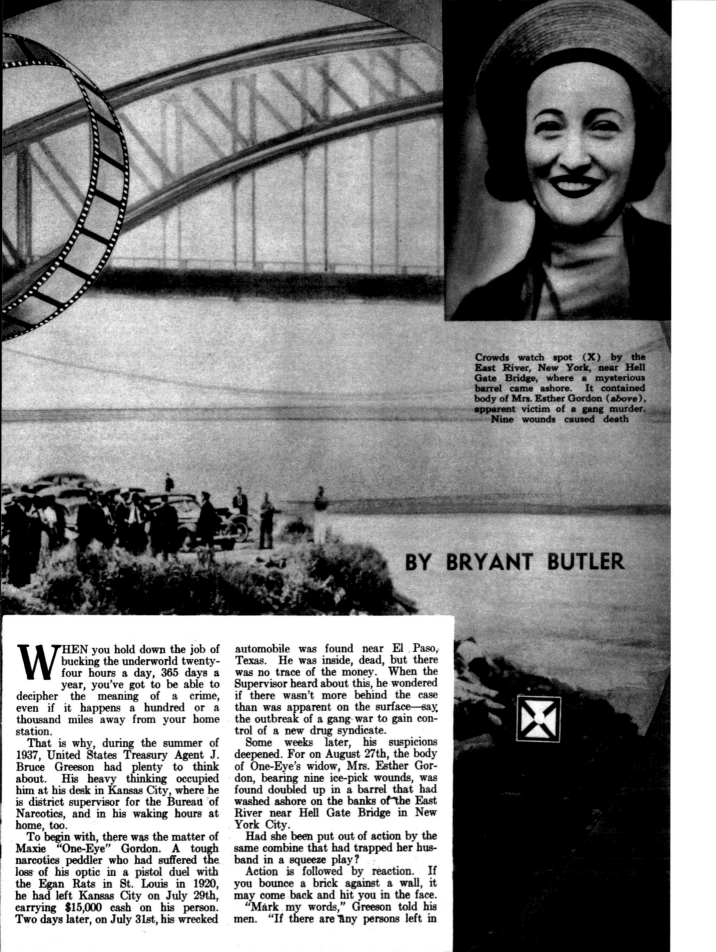

Crowds watch spot (X) by the East River, New York, near Hell Gate Bridge, where a mysterious barrel came ashore. It contained body of Mrs. Esther Gordon (*above*), apparent victim of a gang murder. Nine wounds caused death

BY BRYANT BUTLER

WHEN you hold down the job of bucking the underworld twenty-four hours a day, 365 days a year, you've got to be able to decipher the meaning of a crime, even if it happens a hundred or a thousand miles away from your home station.

That is why, during the summer of 1937, United States Treasury Agent J. Bruce Greeson had plenty to think about. His heavy thinking occupied him at his desk in Kansas City, where he is district supervisor for the Bureau of Narcotics, and in his waking hours at home, too.

To begin with, there was the matter of Maxie "One-Eye" Gordon. A tough narcotics peddler who had suffered the loss of his optic in a pistol duel with the Egan Rats in St. Louis in 1920, he had left Kansas City on July 29th, carrying $15,000 cash on his person. Two days later, on July 31st, his wrecked

automobile was found near El Paso, Texas. He was inside, dead, but there was no trace of the money. When the Supervisor heard about this, he wondered if there wasn't more behind the case than was apparent on the surface—say, the outbreak of a gang war to gain control of a new drug syndicate.

Some weeks later, his suspicions deepened. For on August 27th, the body of One-Eye's widow, Mrs. Esther Gordon, bearing nine ice-pick wounds, was found doubled up in a barrel that had washed ashore on the banks of the East River near Hell Gate Bridge in New York City.

Had she been put out of action by the same combine that had trapped her husband in a squeeze play?

Action is followed by reaction. If you bounce a brick against a wall, it may come back and hit you in the face.

"Mark my words," Greeson told his men. "If there are any persons left in

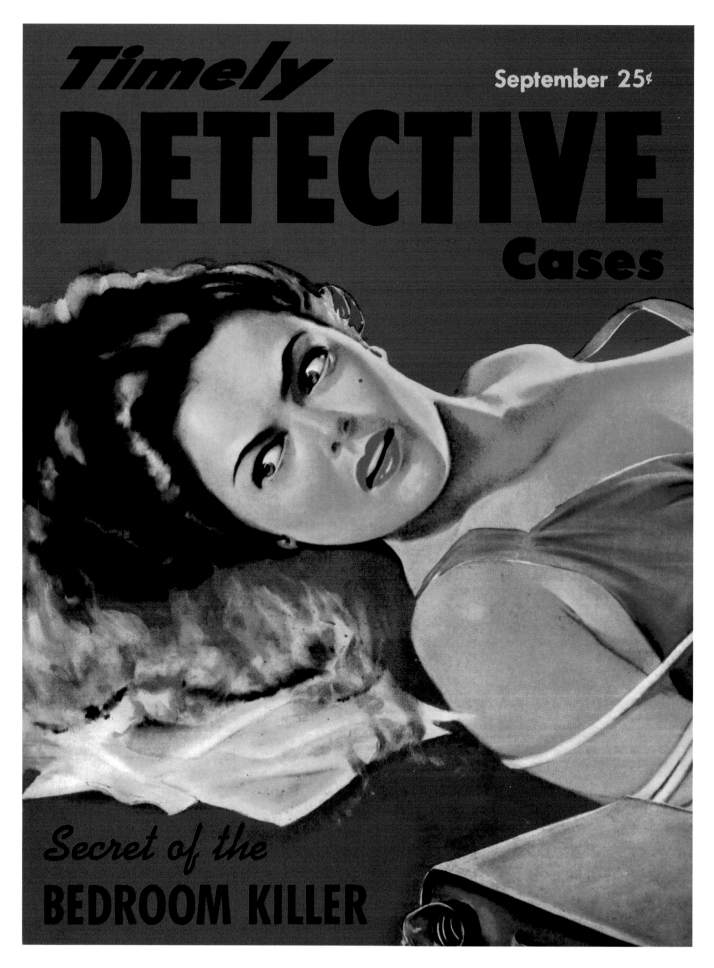

Timely
DETECTIVE
Cases

September 25¢

Secret of the
BEDROOM KILLER

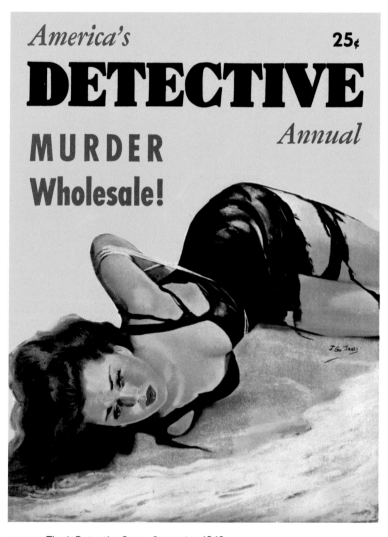

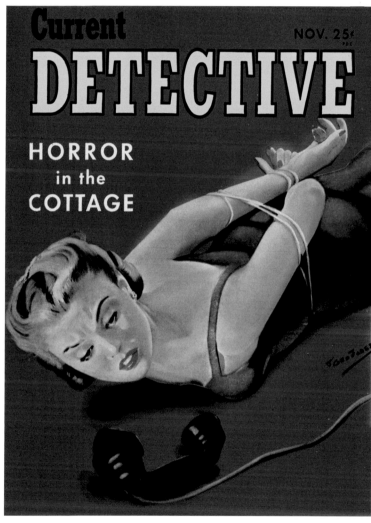

OPPOSITE *Timely Detective Cases*, September 1943

ABOVE LEFT *America's Detective Annual*, 1944

ABOVE RIGHT *Current Detective*, November 1944

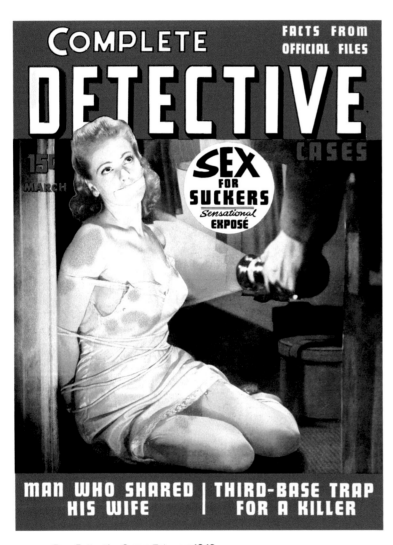

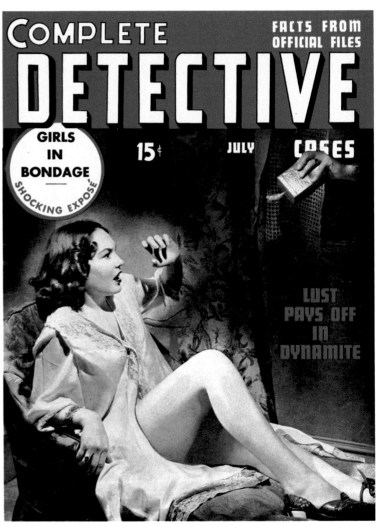

OPPOSITE *Rare Detective Cases*, February 1943

ABOVE LEFT *Complete Detective Cases*, March 1941

ABOVE RIGHT *Complete Detective Cases*, July 1940

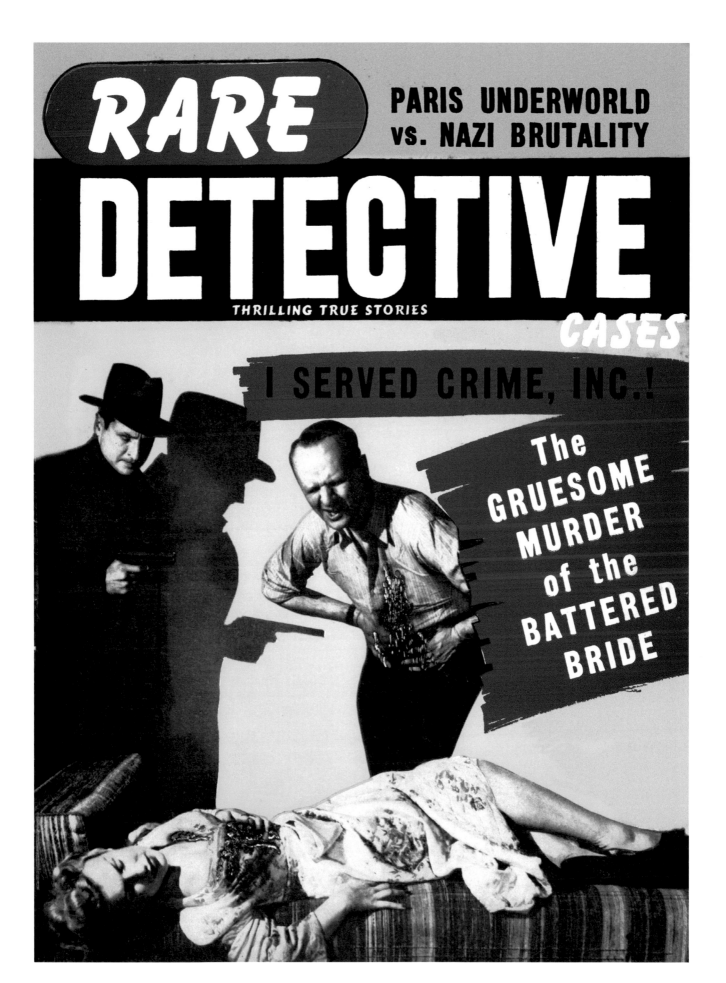

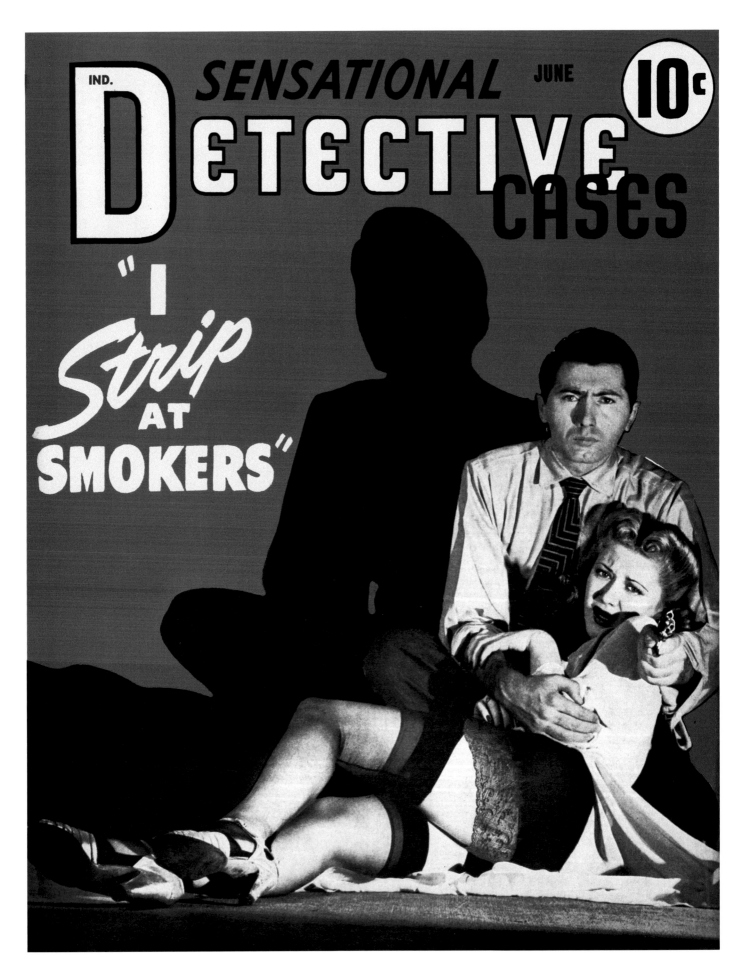

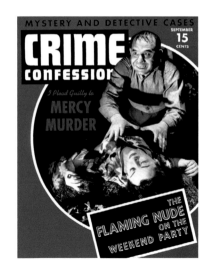

OPPOSITE *Sensational Detective Cases*, June 1942

ABOVE RIGHT *Crime Confessions*, September 1942

BELOW *Master Detective*, January 1943

PAGE 166 *Real Detective*, July 1941

PAGE 167 *Exposé Detective Cases*, October 1947

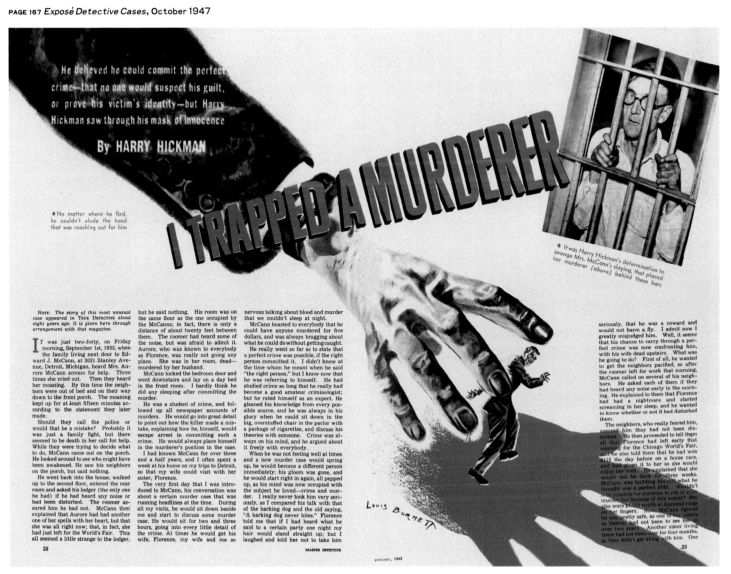

He believed he could commit the perfect crime—that no one would suspect his guilt, or prove his victim's identity—but Harry Hickman saw through his mask of innocence

By HARRY HICKMAN

♦ No matter where he fled, he couldn't elude the hand that was reaching out for him

I TRAPPED A MURDERER

♦ It was Harry Hickman's determination to avenge Mrs. McCann's slaying, that placed her murderer (above) behind these bars

NOTE: *The story of this most unusual case appeared in* TRUE DETECTIVE *about eight years ago. It is given here through arrangement with that magazine.*

IT was just two-forty, on Friday morning, September 1st, 1933, when the family living next door to Edward J. McCann, at 3031 Stanley Avenue, Detroit, Michigan, heard Mrs. Aurore McCann scream for help. Three times she cried out. Then they heard her moaning. By this time the neighbors were out of bed and on their way down to the front porch. The moaning kept up for at least fifteen minutes according to the statement they later made.

Should they call the police or would that be a mistake? Probably it was just a family fight, but there seemed to be death in her call for help. While they were trying to decide what to do, McCann came out on the porch. He looked around to see who might have been awakened. He saw his neighbors on the porch, but said nothing.

He went back into the house, walked up to the second floor, entered the rear room and asked his lodger (the only one he had) if he had heard any noise or had been disturbed. The roomer assured him he had not. McCann then explained that Aurore had had another one of her spells with her heart, but that she was all right now; that, in fact, she had just left for the World's Fair. This all seemed a little strange to the lodger,

but he said nothing. His room was on the same floor as the one occupied by the McCanns; in fact, there is only a distance of about twenty feet between them. The roomer had heard some of the noise, but was afraid to admit it. Aurore, who was known to everybody as Florence, was really not going any place. She was in her room, dead—murdered by her husband.

McCann locked the bedroom door and went downstairs and lay on a day bed in the front room. I hardly think he did any sleeping after committing the murder.

He was a student of crime, and followed up all newspaper accounts of murders. He would go into great detail to point out how the killer made a mistake, explaining how he, himself, would escape arrest in committing such a crime. He would always place himself in the murderer's position in the case.

I had known McCann for over three and a half years, and I often spent a week at his home on my trips to Detroit, so that my wife could visit with her sister, Florence.

The very first day that I was introduced to McCann, his conversation was about a certain murder case that was running headlines at the time. During all my visits, he would sit down beside me and start to discuss some murder case. He would sit for two and three hours, going into every little detail of the crime. At times he would get his wife, Florence, my wife and me so

nervous talking about blood and murder that we couldn't sleep at night.

McCann boasted to everybody that he could have anyone murdered for five dollars, and was always bragging about what he could do without getting caught.

He really went so far as to state that a perfect crime was possible, if the right person committed it. I didn't know at the time whom he meant when he said "the right person," but I know now that he was referring to himself. He had studied crime so long that he really had become a good amateur criminologist; but he rated himself as an expert. He gleaned his knowledge from every possible source, and he was always in his glory when he could sit down in the big, overstuffed chair in the parlor with a package of cigarettes, and discuss his theories with someone. Crime was always on his mind, and he argued about it freely with everybody.

When he was not feeling well at times and a new murder case would spring up, he would become a different person immediately; his gloom was gone, and he would start right in again, all pepped up, as his mind was now occupied with the subject he loved—crime and murder. I really never took him very seriously, as I compared his talk with that of the barking dog and the old saying, "A barking dog never bites." Florence told me that if I had heard what he said to a certain party one night my hair would stand straight up; but I laughed and told her not to take him

seriously, that he was a coward and would not harm a fly. I admit now I greatly misjudged him. Well, it seems that his chance to carry through a perfect crime was now confronting him, with his wife dead upstairs. What was he going to do? First of all, he wanted to get the neighbors pacified, so after the roomer left for work that morning, McCann called on several of his neighbors. He asked each of them if they had heard any noise early in the morning. He explained to them that Florence had had a nightmare and started screaming in her sleep, and he wanted to know whether or not it had disturbed them.

The neighbors, who really feared him, assured him they had not been disturbed. He then proceeded to tell them all that Florence had left early that morning for the Chicago World's Fair, and he also told them that he had won $115 the day before on a horse race, and had given it to her so she would enjoy her visit. He explained that she would not be back for three weeks. McCann was building himself what he thought was a perfect alibi. Wouldn't it be possible for someone to rob or even murder her because of this money? She also wore $1,400 worth of diamond rings on her fingers. Now, McCann figured he was pretty safe, as one of her sisters in Detroit had not been to see her over two years. Another sister living there had not been over for four months, as they didn't get along with him. One

LOUIS BURMETT

28 MASTER DETECTIVE JANUARY, 1943 29

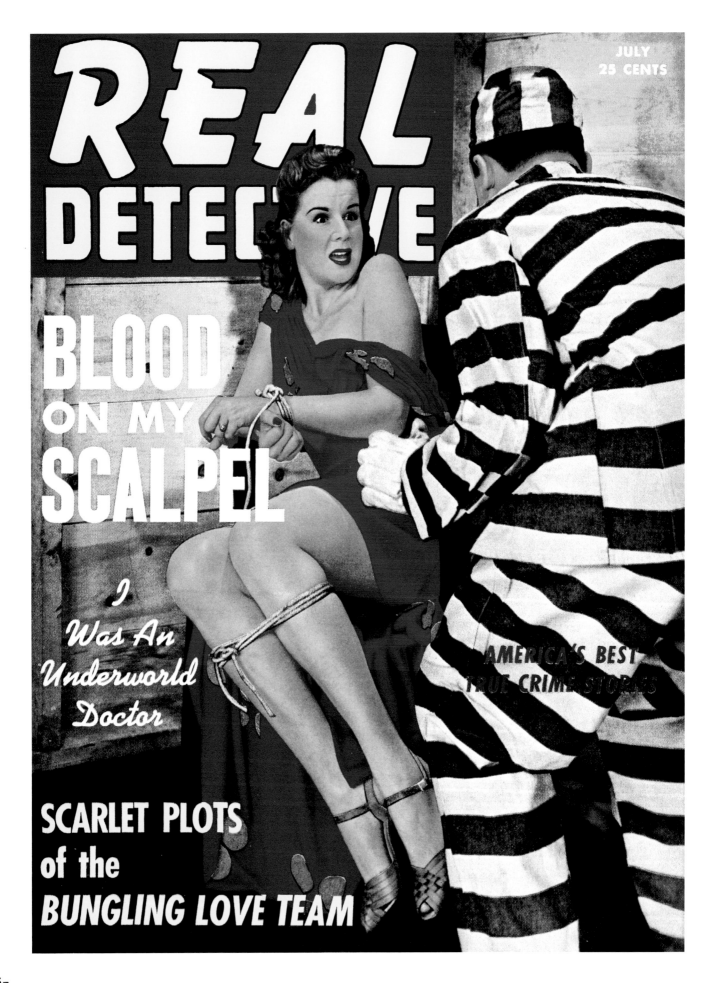

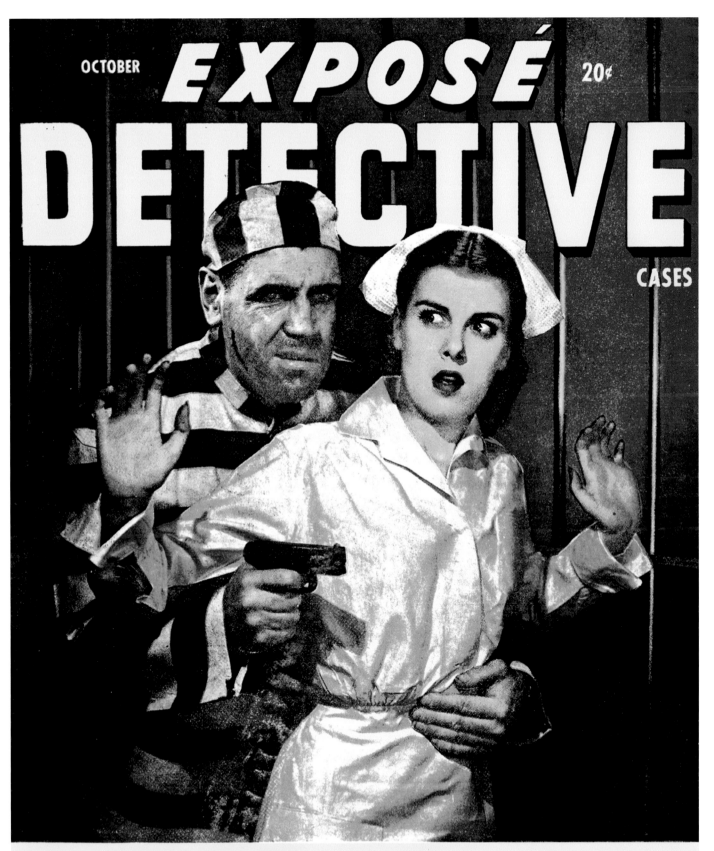

OCTOBER **EXPOSÉ** 20¢

DETECTIVE

CASES

BLONDE SIREN *and her Frightened Sugar Daddy*

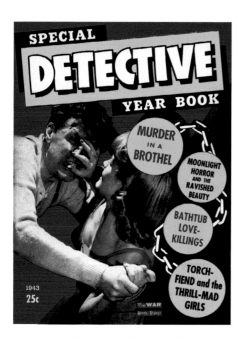

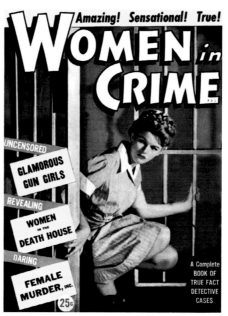

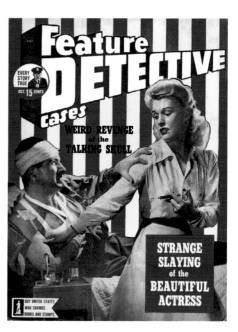

OPPOSITE *Special Detective Cases*, May 1943

ABOVE LEFT *Special Detective Year Book*, 1943

ABOVE CENTER *Women in Crime*, 1945

ABOVE RIGHT *Feature Detective Cases*, October 1942

PAGES 170–171 *True Thrills*, 1942

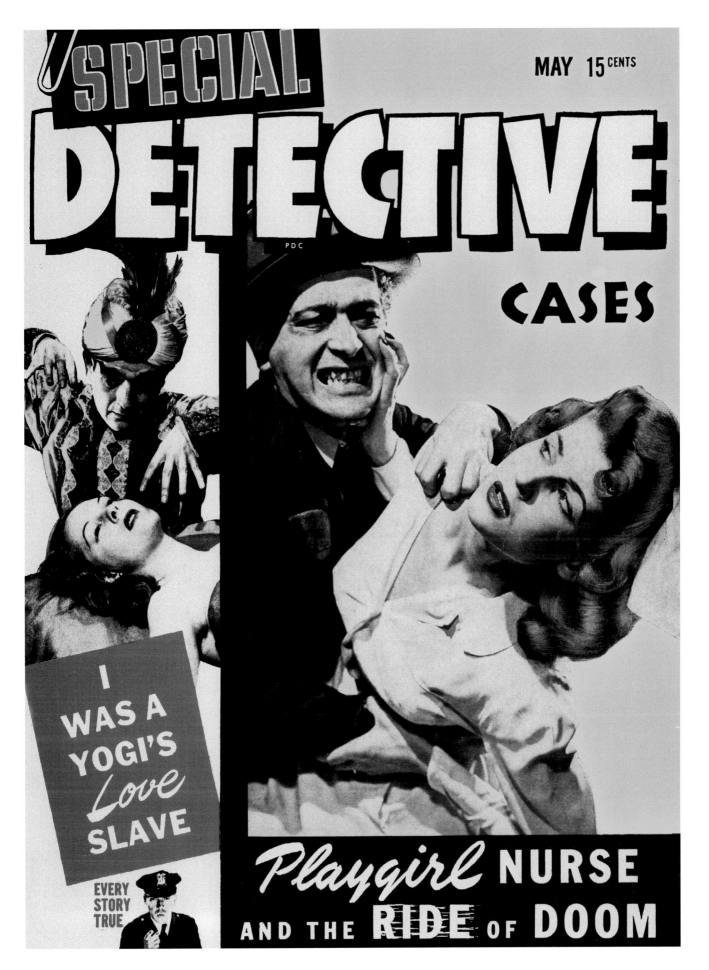

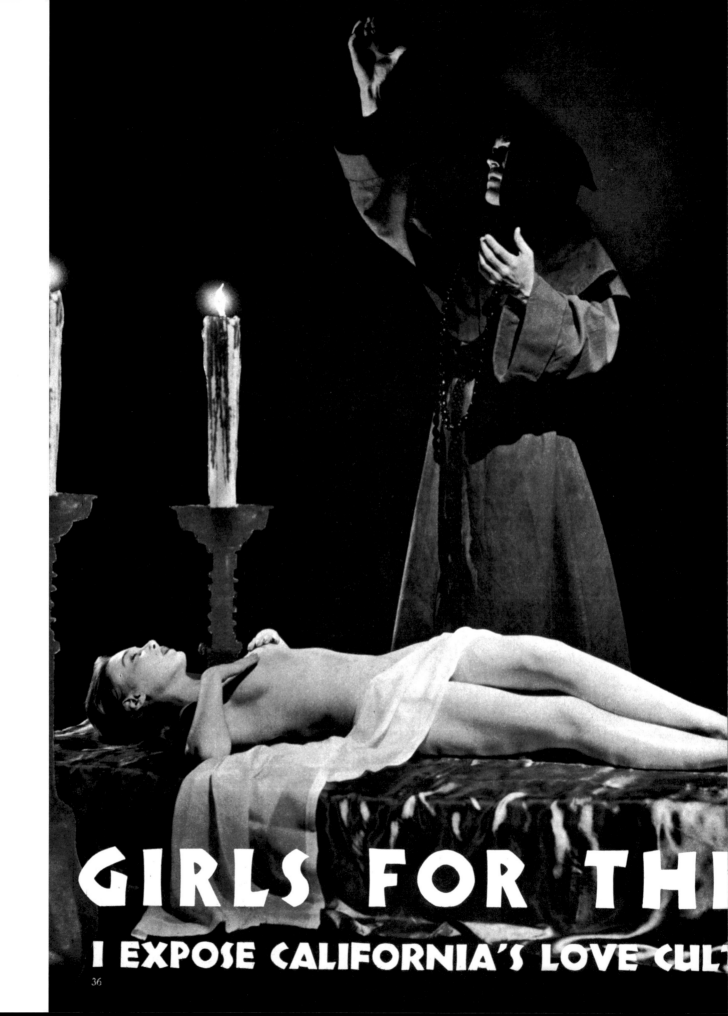

GIRLS FOR THE

I EXPOSE CALIFORNIA'S LOVE CULT

36

by ANSON GERBER
Adopted Son of Rev. Dr. Otoman Zar-Adusht Ha'nish

IN LOS ANGELES, CALIFORNIA, not long ago, a young girl named Irma Weber, brought suit for $1,000,000 damages, claiming that when she was 11 years old she was violated in a weird orgy arranged by the "Master" of Mazdaznan, an Oriental sex cult. As I arrived in California only a few days before announcement of this suit appeared in the Los Angeles newspapers, I went immediately to see the girl and her parents. My interest in Rev. Dr. Otoman Zar-Adusht Ha'nish and his international cult of perversion and bestiality was even greater than that of the unfortunate girl who brought the suit. For I came to America with the sole purpose of murdering this perverted "Master" and all of his "cardinals" before the law intervened. My own life has been ruined. My parents were destroyed by Dr. Otoman Zar-Adusht Ha'nish, the California fakir; master of bestiality; who, posing as the founder of a new religious thought, has spread a foul lie over all of Europe and America.

I found Irma Weber to be a mild and naive young lady still in high school. Pressing upon her mind is the memory of that frightful hour of orgiastic ritual conducted at Norco, California, six years ago, in the name of Holy Faith and of God. The girl is beautiful. typically American, but the shadow of a terrible fear is in her eyes. She feels that she has been ruined for life by the Mazdaznan cult to which her Swiss parents once subscribed.

BUT Irma Weber is only one girl. I have talked to fifty who have been seared with the scarlet brand of Mazdaznan in Switzerland, where I was born, in Germany, France, Austria, England and America. As an intended "cardinal" and high priest of the cult, I took part in the very orgies which this girl and her parents describe in the suit they have brought.

The girl's father, a Swiss landscape gardener, and her mother, followed what they believed was the torch of a new and sustaining religious faith when they came to America after hearing the "Master" preach in Switzerland. Six years ago Irma's violation under the direction of the man they had all but worshipped, convinced them that the teachings of Mazdaznan formed a screen of religion to hide the bestial orgies of the "Master" and his "cardinals." The family withdrew from the organization, but the girl could not forget. She told her pitiful story to Mrs. Fay Galen, a clear thinking, crusading attorney in Los Angeles. Mrs. Galen brought the suit to expose Mazdaznan and to save other girls from destruction at the hands of this monstrous cult.

But there is very little aside from the actual instance of one child's violation that these innocent Swiss people can tell about the "inner circle" sessions of the cultists.

It is my intention here to reveal in detail what only the "inner circle" of Mazdaznan can possibly know. I have been cheated of my revenge by the death of the high priest of Mazdaznan, whose body was legally cremated in Los Angeles in 1936. But there are still the "cardinals" of the cult. In revealing these secrets my work has just begun.

Before I tell in detail the various inhuman practices of this mad group, let me explain that Mazdaznan is not one of the tin can religious cults so numerous in Los Angeles. It has temples and "health" resorts all over America; also in Liverpool, London, Leipzig, Paris, Brussels, Prague, Hamburg, Amsterdam, Rotterdam and Vienna, to name only a few. Its membership exceeds 20,000 in California alone.

The man who called himself Rev. Dr. Otoman Zar-Adusht Ha'nish, and who adopted me

DEVILS OF LUST
AND THE CHAMBER OF HORRORS

37

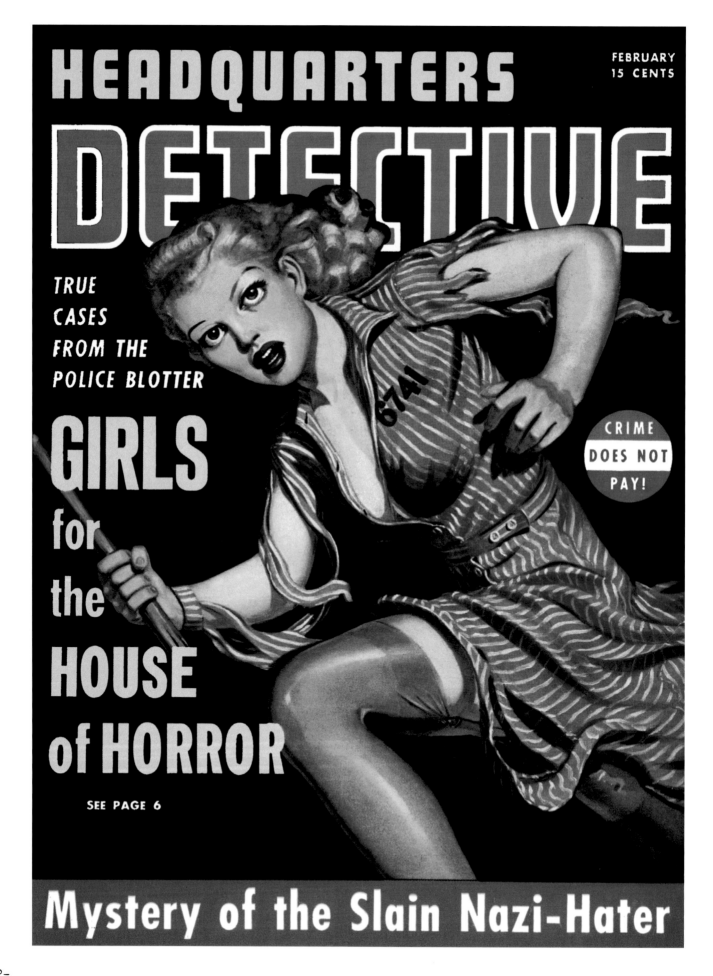

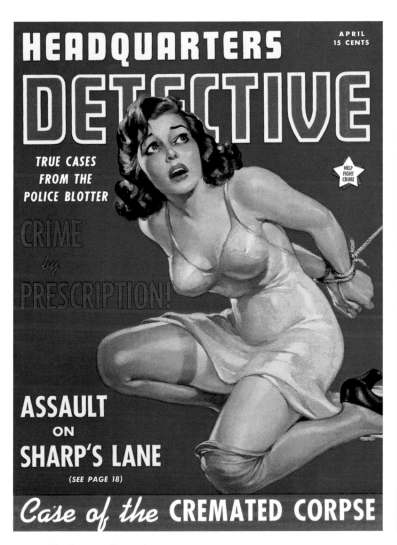

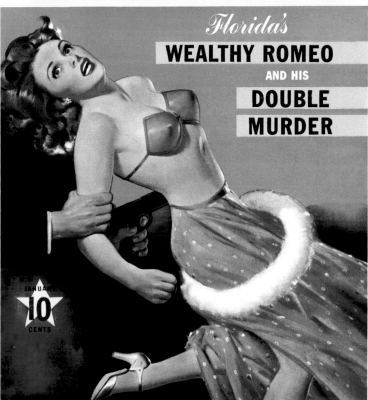

OPPOSITE *Headquarters Detective*, February 1941

ABOVE LEFT *Headquarters Detective*, April 1941

ABOVE RIGHT *Headline Detective*, January 1942

PAGE 174 *Real Detective*, July 1940

PAGE 175 *Crime Detective*, August 1941

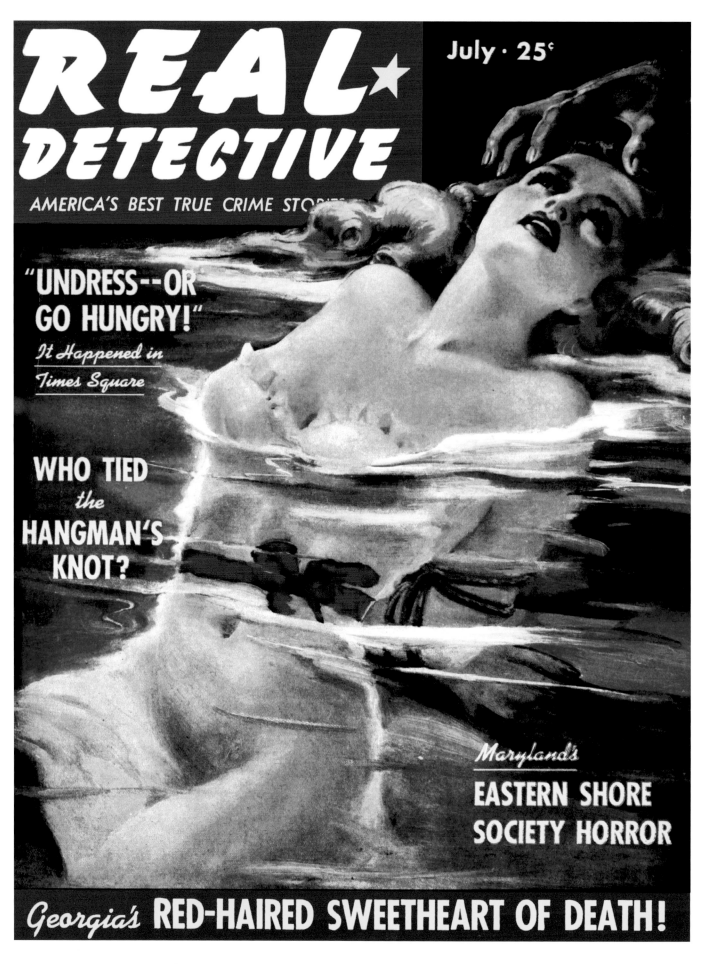

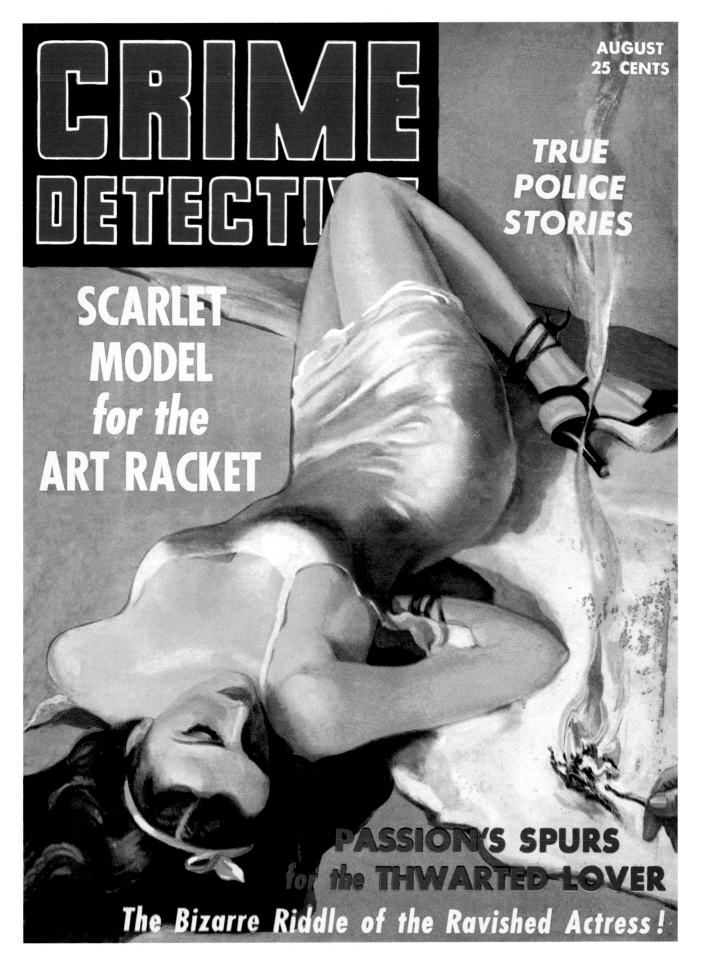

CRIME DETECTIVE

AUGUST
25 CENTS

TRUE POLICE STORIES

SCARLET MODEL for the ART RACKET

PASSION'S SPURS for the THWARTED LOVER

The Bizarre Riddle of the Ravished Actress!

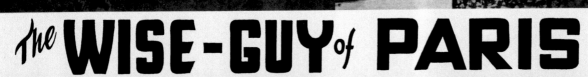

The WISE-GUY of PARIS

by Joseph Fulling Fishman

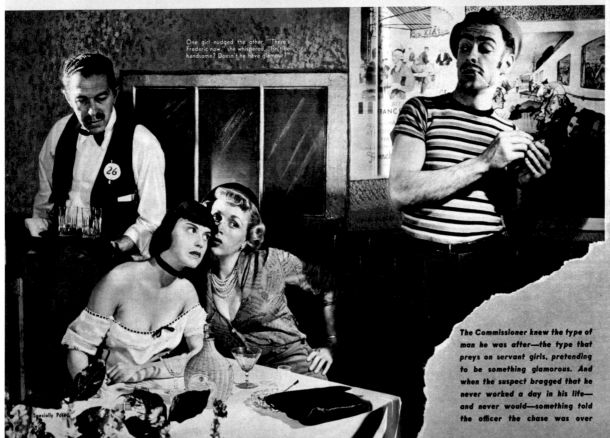

One girl nudged the other. "There's Frederic now," she whispered. "Isn't he handsome? Doesn't he have glamour?"

The Commissioner knew the type of man he was after—the type that preys on servant girls, pretending to be something glamorous. And when the suspect bragged that he never worked a day in his life— and never would—something told the officer the chase was over

Specially Posed.

"YOU know where the Choisy-le-Roe Road intersects the Paris-Versailles Highway?" The voice over the thin wire was nervous, upset.

"Of course," impatiently answered Magistrate De Girard, of the little town of Antony, a suburb of Paris. "What of it?"

"Well, if you will look alongside the intersection on the right going toward Paris you will find—something terrible."

The Magistrate straightened up in his chair. "What is it?" he demanded.

The only answer was a dull snap. Excitedly, the Magistrate called the operator and demanded that the connection be restored. But the girl, with the maddening impersonality of phone girls everywhere, said calmly, "Sorry, sir, the other party is no longer there."

The Magistrate replaced the combination receiver and transmitter in its socket and called the Chief of Police. He and two of his men hurried to the road intersection which the mysterious caller had designated. They spread out to comb the underbrush on the right side.

And then they found it!

If this was a joke, it was as grisly and macabre a one as they had ever known. Lying in the soaking wet ground, with the rain beating against it with sickening smacks, was the body of a youth of about fifteen or sixteen, entirely nude except for a pair of worn and battered shoes!

The body was doubled up, with the head to one side lying against a bit of shrubbery. From the head to the knees the decomposing flesh showed a mass of bruises and welts. The skull itself gave surface indications of a fracture, while numerous bruises on the body showed that the youth had been mercilessly beaten.

"Spread around, boys," the chief directed, "and see if you can find any clues." In a few moments one of his subordinates came hurrying to the chief with a raincoat. It was the youth's size, and well worn. Eagerly the chief examined it. It was full of grease and dirt. On it in indelible ink was lettered:

"Ploukinez 172"

"It may be a valuable lead," the chief commented. "Looks like an orphan asylum uniform. Maybe Ploukinez is the boy's name and

(Continued on page 33)

19

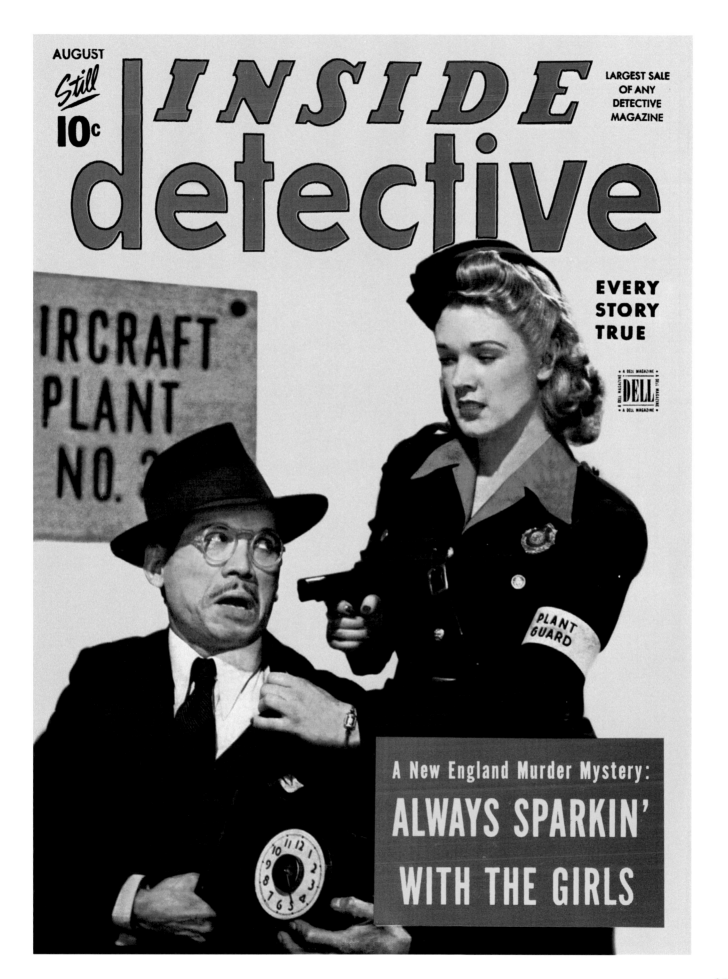

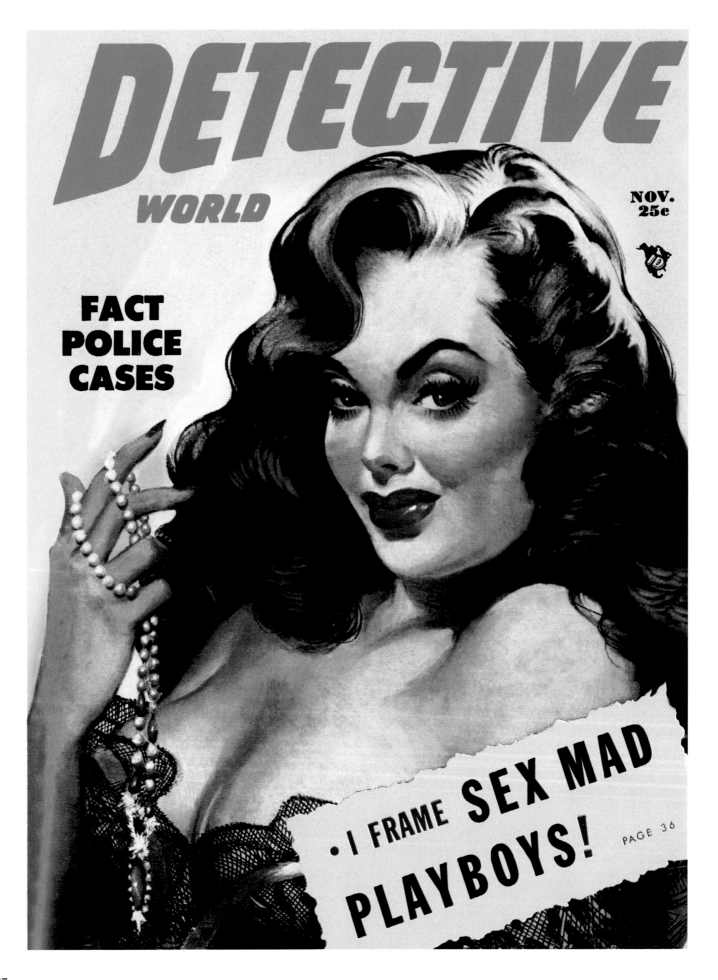

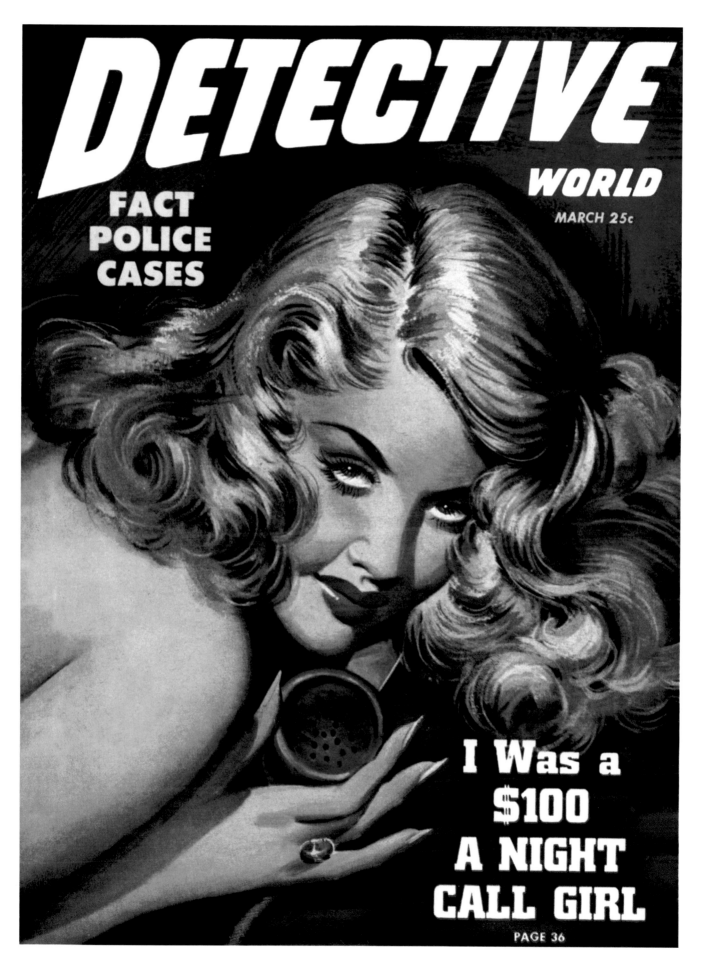

DETECTIVE WORLD

WORLD

MARCH 25c

FACT POLICE CASES

I Was a $100 A NIGHT CALL GIRL

PAGE 36

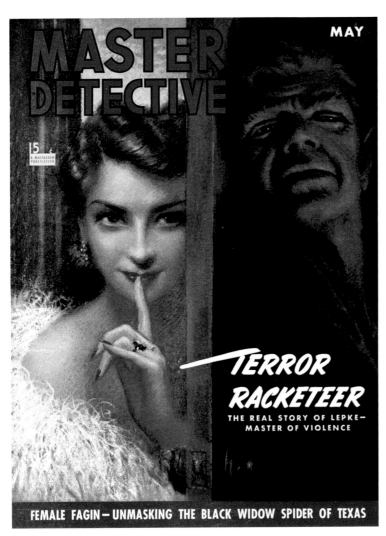

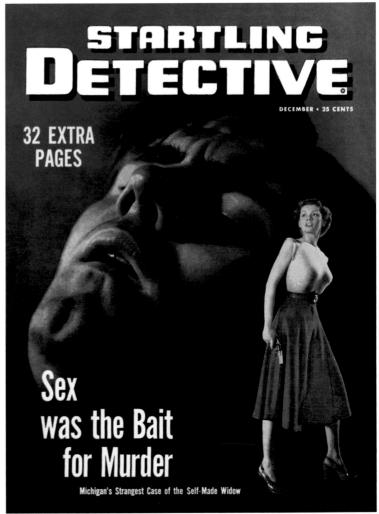

OPPOSITE *Master Detective*, December 1942

ABOVE LEFT *Master Detective*, May 1940

ABOVE RIGHT *Startling Detective*, December 1948

MASTER DETECTIVE

DECEMBER

25c

Main Street Blackmailer

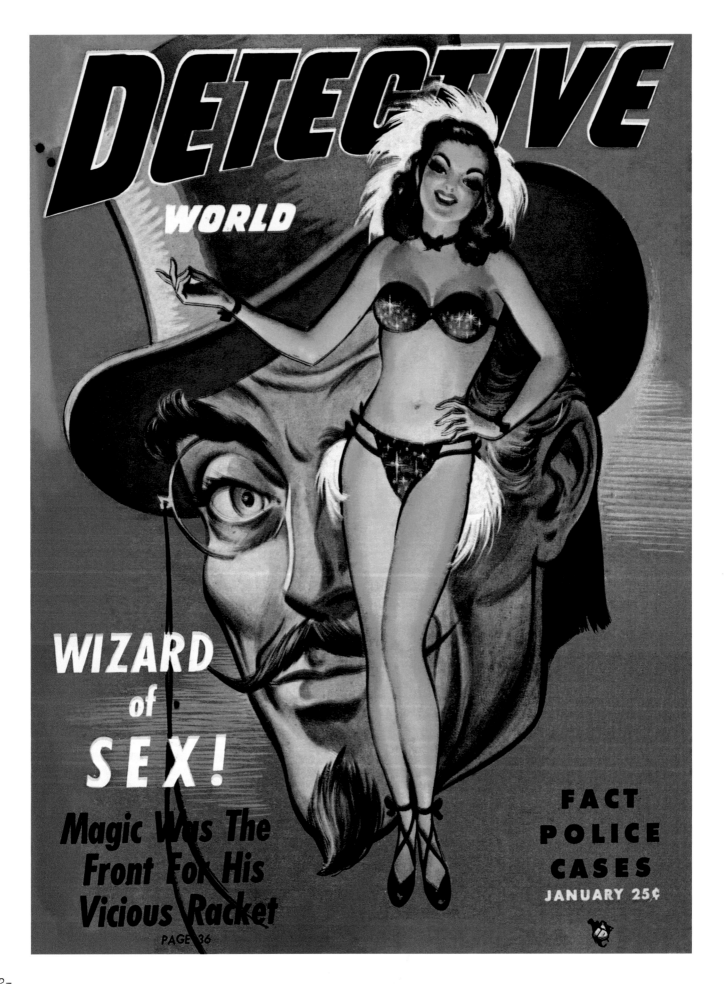

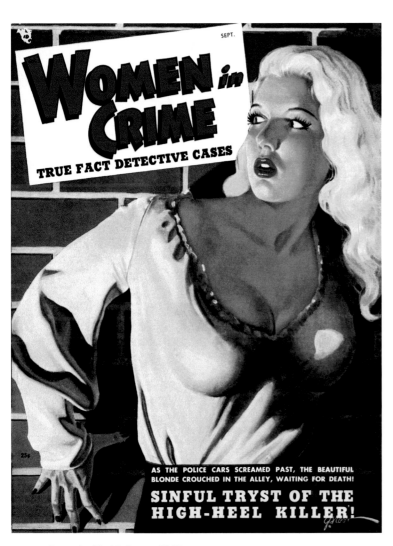

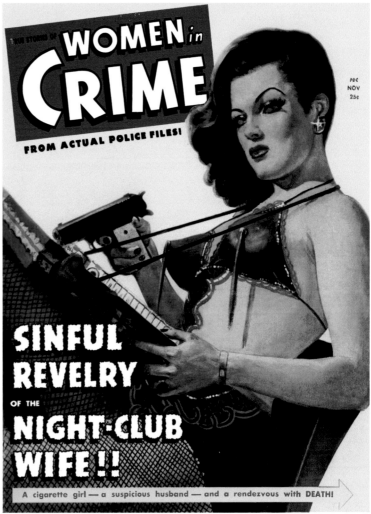

OPPOSITE *Detective World*, January 1949

ABOVE LEFT *Women in Crime True Fact Detective Cases*, September 1948

ABOVE RIGHT *True Stories of Women in Crime*, November 1948

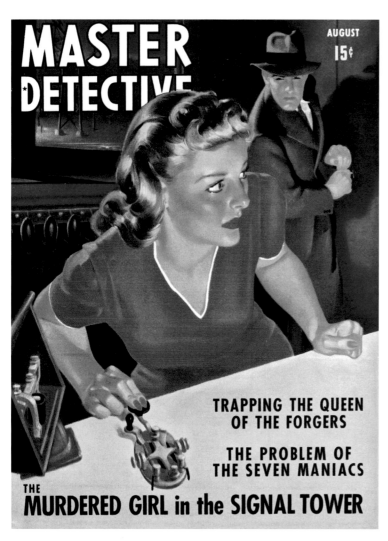

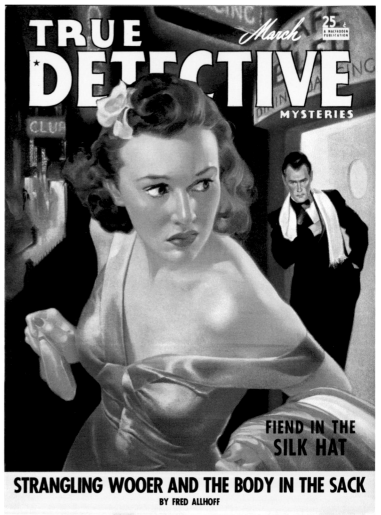

OPPOSITE *Detective World*, September 1949

ABOVE LEFT *Master Detective*, August 1941

ABOVE RIGHT *True Detective Mysteries*, March 1941

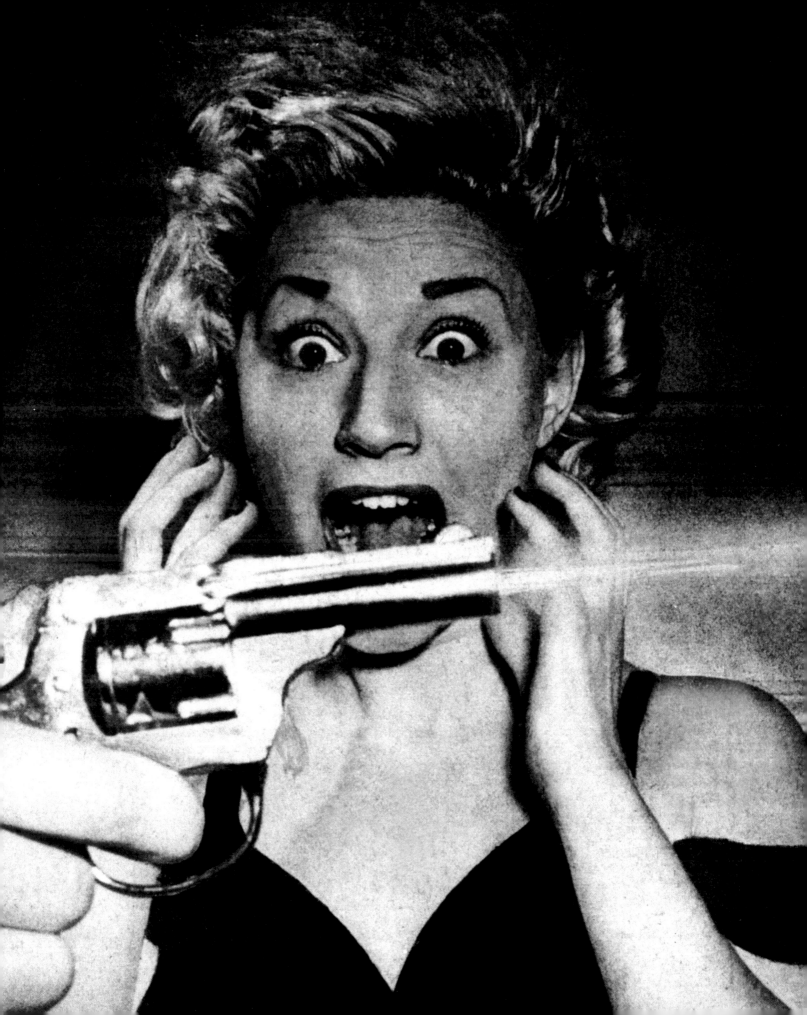

1950-195 9

In 1950 the vision of a smoking, wise-
cracking, gorgeous whore in a slit skirt
and breast-hugging sweater spelled
major trouble. Women in Crime, Crime
Girls, Women on Trial, and Ladies of
the Underworld were just a few of the
femme fatale-baited titles drilling
home the concept of woman as temptress.

SHE PLAYED ME FOR A SUCKER!

by Eric Godtland

The 1950s were, if not the aesthetic heyday, then the height of the detective's camp appeal. There were more new oddball and spin-off titles created during this period than in previous decades, as well as greater experimentation with the format. Unfortunately, this broadening of the genre was borne more of desperation than public demand.

The proliferation of television in the 1950s dealt the magazines a serious blow. Unlike the mutually beneficial relationship detective titles enjoyed with radio, television was clearly a competitor, and a stiff one at that. The long-popular detective theme was a natural for early television content, and detective and crime mysteries were amongst the first and most popular TV shows. For the already-anemic detective fiction field these shows delivered the coup de grace. For true crime it was a one-two punch of the dramas combined with television's daily crime news coverage that wore down the magazine market to a smaller, older demographic.

The resulting financial squeeze led many of the aging old-guard publishers to sell their detective titles to girlie magazine companies. The best example was *True Police Cases*, started by Fawcett in 1946 as a serious, scholarly crime journal, then sold to Robert Harrison of *Eyeful, Titter, Wink* fame in the mid-'50s. Harrison was single-handedly inventing the scandal genre at this time with his *Confidential* magazine. Under him *True Police Cases* turned equally tawdry.

True Police was not the only case of a comparatively respectable detective title mutating overnight after sale to a girlie or scandal publisher. All the newcomers had a more "colorful" take on what would make a detective magazine move copies, with covers featuring scantily clad, whorish sexpots at the top of their sales-generating idea lists.

It wasn't just the girlie publishers who changed the detectives, though. In the '50s even the old-guard publishers experimented with their formats, with occasionally disastrous results. Most notable was *Master Detective*, which shrank to digest size in the early 1950s in an attempt to replicate the success of *The Reader's Digest*. After a purported 70% drop in sales the executives realized their mistake and changed back to large format, but *MD* would never fully recover from their misjudgment. Several titles tried to integrate general interest topics such as sports, fishing and men's fashion with the crime in the hope of gaining new fans, while others thought crime fiction would turn the trick. All of this tinkering further alienated the core readership.

Inevitably, under the new owners, the magazines' writing began to suffer. For true crime aficionados the 1950s titles represented a degeneration of the magazines from well-written, respectable reality to sleazy, sensationalistic truth-stretching fish wrapper. They are right, but there were those who preferred the scent of fish. The Cold War and drug-themed articles were especially preposterous, but also wildly entertaining in an "I Was a Teenage Dope Fiend" way. By 1955 the journalistic integrity across the entire genre had taken a decided back seat to hot dames and potboiler scenarios.

So the true crime purist's loss was the trash lover's gain. For the collector of over-the-top, flagrantly sexual imagery the late 1940s through the 1950s represent the pinnacle for the detective titles. Earlier magazines were more beautifully printed, better written, and featured cover art by fine artists, but not until the 1950s was the Bad Girl detective archetype refined to an icon.

PAGE 187 *Women in Crime*, July 1954

OPPOSITE *True Crime Cases*, April 1952

ABOVE *Detective World*, June 1951

BELOW *True Mystery*, August 1954

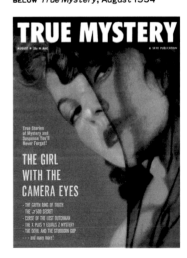

"You can't pick your money out of a dirty gutter without getting your skirts dirty, and you can't indulge in gin and sin without sinking to the bottom of the cesspool."

— SMASH DETECTIVE CASES, AUGUST 1950

Women in Crime, Crime Girls, Women on Trial, Ladies of the Underworld, Crime Confessions, Girl Spies, Sensational Exposes and Vice Squad were just a few of the femme fatale-baited '50s titles drilling home the concept of woman as temptress. In 1950 the vision of a smoking, wise-cracking, gorgeous whore in a slit skirt and breast-hugging sweater (or, better yet, a taxi dancer's striped Bohemian leotard!) spelled major trouble. With full, flowing hair and the occasional beatnik beret, this tart and her pals glared defiantly from police line-ups, conned suckers in seamy bars, and brandished the just-fired pistol at countless murder scenes. Even when she morphed into a teenage delinquent late in the decade she was all too alluring in her dungarees and leather jacket, lip curled with disdain, bouffant jutting skyward as the cops led her away.

What was her crime? You name it, Joe. These dolls were guilty of everything from hanging around with JD hot rod rumblers to swinging hard at hop-head parties. And don't even bother to ask why a beautiful former choirgirl would be drawn to this degenerate underworld of crime and depravity. A mature man of the '50s, the typical detective magazine reader, knew the answer all too well. If not held tight in a restraining moral grip, if not penned at home by marriage, children, and church, if not hogtied with girdles and aprons and single strands of ladylike pearls, any woman was capable of anything. One slip of the moral order and we'd be right back in Eden, one snake hiss away from disaster. Just ask the preacher man, my friend— all women are bad.

OPPOSITE *Police Detective Cases*, June 1950

BELOW *True Detective*, November 1959

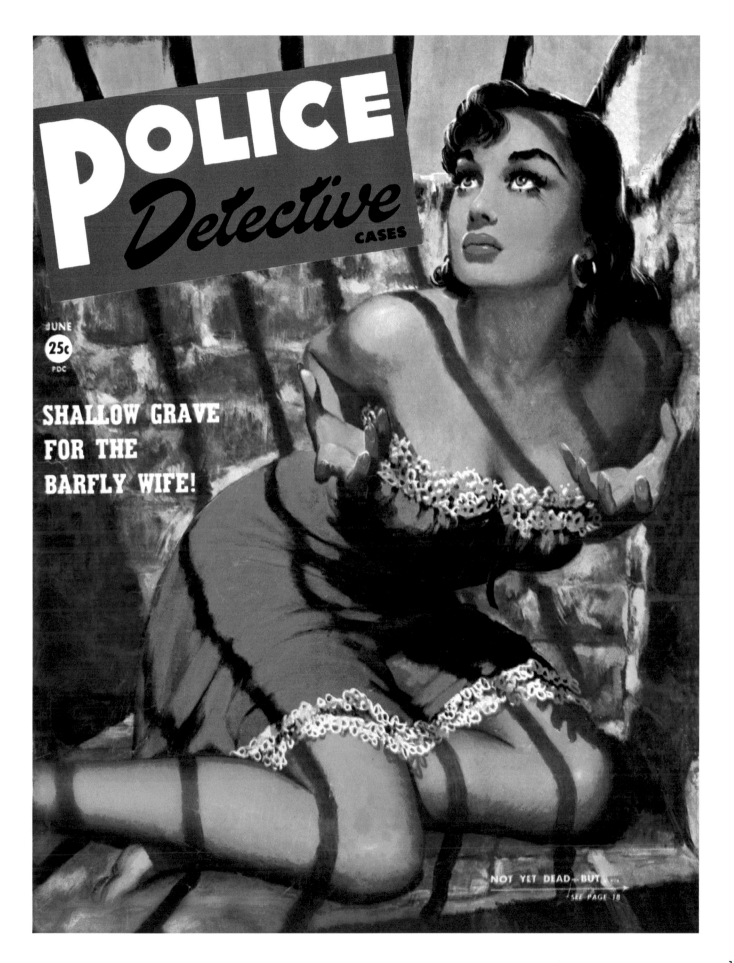

POLICE *Detective* CASES

JUNE
25¢
PDC

SHALLOW GRAVE
FOR THE
BARFLY WIFE!

NOT YET DEAD - BUT ...
SEE PAGE 18

INSIDE detective

WORLD'S LARGEST SELLING
DETECTIVE MAGAZINE

MARCH 15c

THE WALL OF EYES

.. no es

. no escape...

..no escap

..no escape...

DIE SCHLAMPE HAT MICH REINGELEGT!

von Eric Godtland

Die 1950er-Jahre waren vielleicht nicht die ästhetischen Glanzzeiten der Detective Magazines, doch sie zeigten sie auf dem Gipfel ihres Camp-Appeals. In bislang ungekanntem Ausmaß experimentierte man mit skurrilen neuen oder Spin-off-Formaten. Unglücklicherweise war diese Verbreiterung des Genres eher eine Verzweiflungstat als eine Reaktion auf Publikumswünsche.

Der unaufhaltsame Vormarsch des Fernsehens versetzte den Magazinen einen ernsthaften Schlag. Hatten die Detective Magazines und das Radio noch wechselseitig voneinander profitiert, war mit dem Fernsehen ein echter Konkurrent erwachsen, der nicht zu unterschätzen war. Die schon so lange beliebten Kriminalgeschichten waren ein naheliegendes Thema für das junge neue Medium, und Krimiserien zählten zu den ersten und beliebtesten TV-Formaten. Den ohnehin schon kränkelnden Magazinen versetzten diese Serien den Todesstoß. Die Serien und die aktuelle Berichterstattung über Verbrechen in den Fernsehnachrichten verdrängten die Heftchen in einen Nischenmarkt mit ausschließlich älterem Leserpublikum.

Die sich daraus ergebenden finanziellen Einbußen bewogen viele Verleger alter Schule, ihre Detective-Titel an Verlage zu verkaufen, die vornehmlich Girlie Magazines vertrieben. Das beste Beispiel war *True Police Cases*, das 1946 von Fawcett als seriöses, wissenschaftliches Journal begründet und Mitte der 1950er an Robert Harrison, den legendären Verleger von *Eyeful*, *Titter* und *Wink*, verkauft worden war. Harrison erfand zu dieser Zeit mit seinem Magazin *Confidential* gerade höchstpersönlich das Genre der Skandalblätter. Unter seiner Regie wurde *True Police Cases* ebenso halbseiden.

True Police war nicht das einzige verhältnismäßig respektable Detective Magazine, das durch den Verkauf an einen Verleger von Girlie- oder Skandalblättern schlagartig umgekrempelt wurde. Die Neueinsteiger in diesem Metier hatten eine sehr viel handfestere Vorstellung davon, wie man den Absatz der Detective Magazines ankurbeln konnte, und leicht bekleidete, nuttig aussehende Sexbomben auf dem Titel standen ganz oben auf ihrer Liste.

Aber es waren nicht nur diese neuen Verleger, die das Genre veränderten. In den 1950er-Jahren experimentierte auch die alte Garde der Verlage mit dem Format, mit gelegentlich katastrophalen Folgen. Am denkwürdigsten war der Fall von *Master Detective*, das Anfang der 1950er-Jahre bei dem Versuch, den Erfolg von *The Reader's Digest* zu wiederholen, auf Oktavformat schrumpfte. Nach einem Rückgang der Verkaufszahlen um 70 Prozent sahen die Verantwortlichen ihren Fehler ein und kehrten zum größeren Format zurück, doch *Master Detective* sollte sich nie mehr von den Folgen dieser Fehlentscheidung erholen. Einige True-Crime-Blätter versuchten, neue Leserkreise zu erschließen, indem sie Themen von allgemeinem Interesse wie Sport, Angeln oder Herrenmode aufgriffen, andere setzten auf fiktive Krimigeschichten. All diese schlecht beratenen Experimente vergraulten nur noch mehr von den Stammlesern.

Unter den neuen Besitzern litt zwangsläufig auch die journalistische Qualität. Für wahre True-Crime-Aficionados stellen die Titel der 1950er-Jahre einen Niedergang dar: Waren die Magazine früher gut geschrieben und der Wahrheit verpflichtet, waren sie mittlerweile zu schlüpfrigen, sensationsgeilen, verlogenen Schmierblättern verkommen, in die man bestenfalls noch Fisch einwickeln konnte. Unrecht hatten sie damit nicht, doch es gibt auch Menschen, die den Fischgeruch vorziehen. Artikel, die sich um den Kalten Krieg oder Drogen drehten, waren oft besonders grotesk, aber auch extrem unterhaltsam, à la „Ich war ein minderjähriges Drogenwrack".

> **"Man kann sein Geld nicht im Rinnstein verdienen, ohne sich schmutzig zu machen, und man kann nicht durch einen Sumpf aus Gin und Sünde waten, ohne darin zu versinken."**
> — *SMASH DETECTIVE CASES*, AUGUST 1950

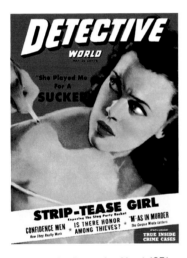

PAGE 192 *Inside Detective*, March 1951

PAGE 193 *True Detective Cases from Police Files*, August 1965

OPPOSITE *Detective World*, September 1950

ABOVE *Detective World*, May 1953

BELOW *True Detective*, December 1953

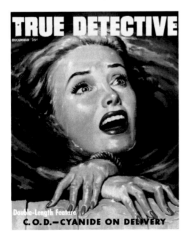

1955 spielte journalistische Integrität im gesamten Genre unverkennbar nur noch die zweite Geige neben den scharfen Miezen und der reißerischen Sensationsmache.

Der herbe Verlust für den True-Crime-Puristen war ein Gewinn für den Liebhaber von Schund. Für den Sammler von knalliger, sexuell expliziter Bildsprache stellen die späten 1940er- und die 1950er-Jahre den Höhepunkt in der Geschichte der Detective Magazines dar. Frühere Hefte hatten eine bessere Druckqualität, waren besser geschrieben, und die Titelbilder wurden von ausgebildeten Künstlern gemalt, doch erst in den 1950er-Jahren wurde das für solche Magazine archetypische Bad Girl zur Ikone stilisiert.

Women in Crime, Crime Girls, Women on Trial, Ladies of the Underworld, Crime Confessions, Girl Spies, Sensational Exposes und *Vice Squad* sind nur einige der Titel aus den 1950ern, die mit Femmes fatales lockten und das Bild von der Frau als Verführerin zementierten. In den 1950er-Jahren stand das Bild einer rauchenden, schlagfertigen, umwerfend aussehenden Schlampe in geschlitztem Rock oder brustbetontem, hautengem Pullover – oder noch besser im gestreiften engen Top eines Taxigirls – für alles, woran man sich die Finger verbrennen konnte. Mit vollem, wallendem Haar, vielleicht noch mit Baskenmütze im Stil der Beatniks, starrten einen diese Flittchen und ihre Freundinnen

trotzig von Polizeifotos an, zogen naiven Trotteln in zwielichtigen Bars das Geld aus der Tasche oder fuchtelten wild an zahllosen Tatorten mit gerade abgefeuerten Knarren herum. Selbst als sie gegen Ende des Jahrzehnts die Metamorphose zum kriminellen Teenager vollzogen, sahen sie in Nietenhose und Lederjacke, mit verächtlich verzogenem Mund und wippenden, hochtoupierten Haaren nur allzu hinreißend aus, wenn sie schließlich im Polizeigriff abgeführt wurden.

Was sie ausgefressen hatten? Such dir was aus, Joe. Diese Herzchen haben so ziemlich alles angestellt, vom Herumtreiben mit Halbstarken bis zu wilden Drogenpartys. Und mach dir nicht die Mühe, nachzufragen, wie ein so entzückendes ehemaliges Mitglied des Schulchors in diesen Sumpf von Verbrechen und Unzucht geraten konnte. In den 1950ern kannte der Mann in den besten Jahren, der typische Leser der Detective Magazines, die Antwort nur zu gut. Wenn man sie nicht hart an der moralischen Kandare hielt, durch Kinder, Küche und Kirche ans Haus fesselte und mit Hüftgürteln, Schürzen und damenhaften Perlenketten einschnürte, war jeder Frau jederzeit alles zuzutrauen. Nur eine kleine Unachtsamkeit der Moralwächter, und schon sind wir wieder im Garten Eden und nur einen Biss in den Apfel vom Sündenfall entfernt. Frag den nächsten Prediger, mein Freund – alle Frauen sind schlecht.

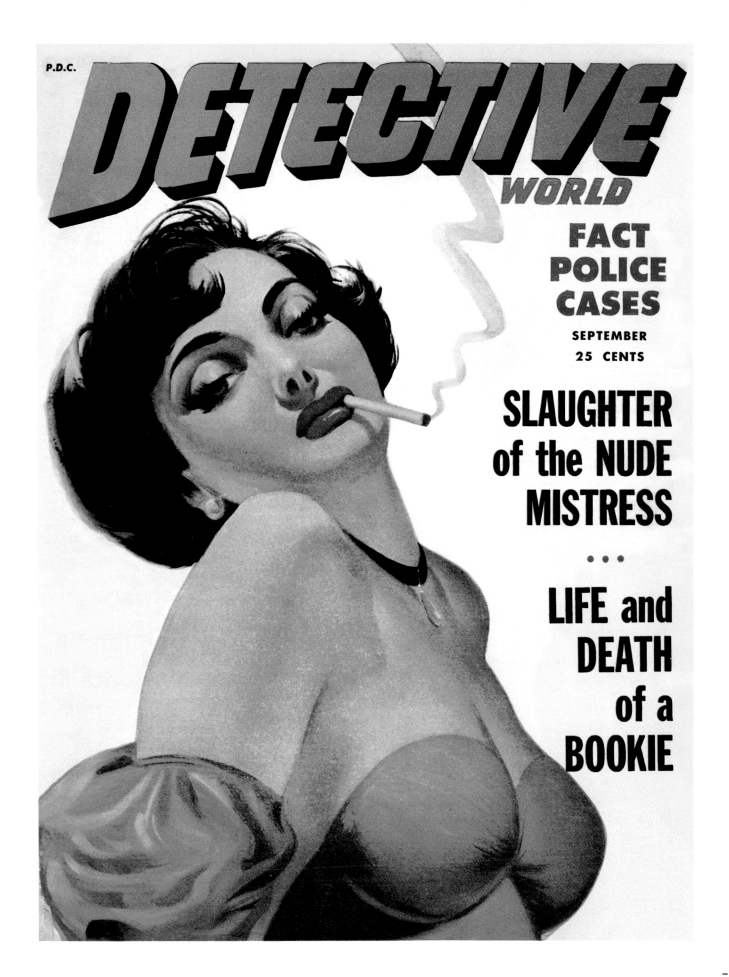

P.D.C.

DETECTIVE WORLD

FACT POLICE CASES

SEPTEMBER
25 CENTS

SLAUGHTER of the NUDE MISTRESS

. . .

LIFE and DEATH of a BOOKIE

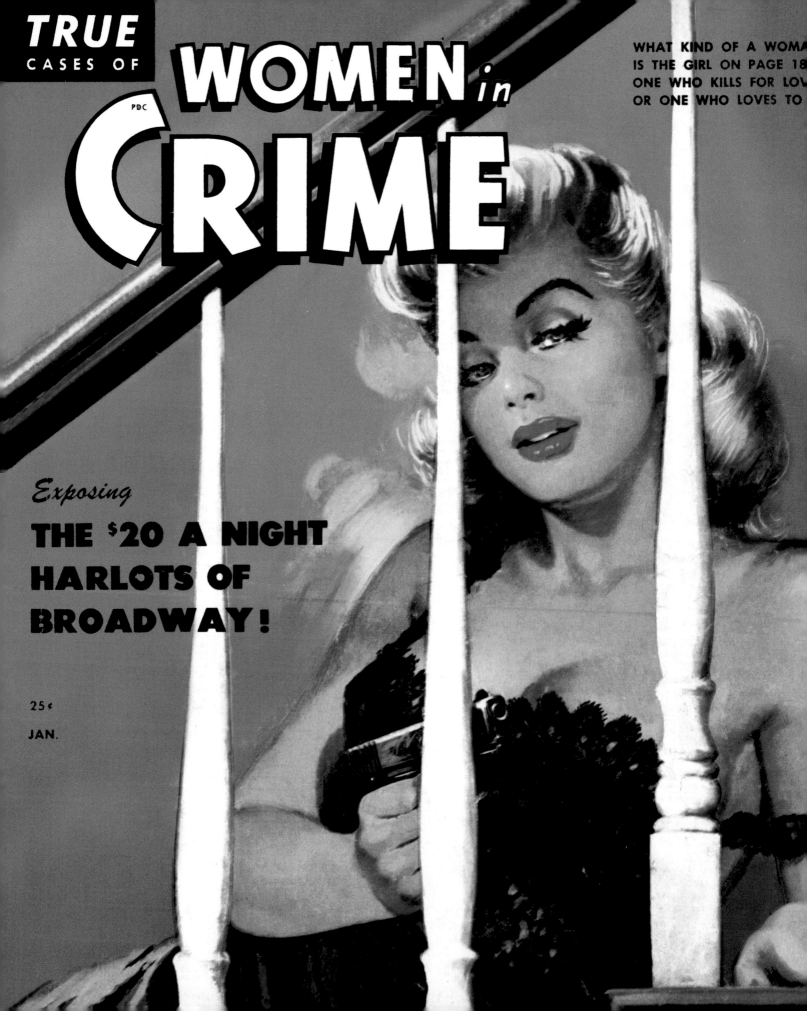

TRUE
CASES OF
WOMEN in
CRIME

PDC

WHAT KIND OF A WOMA
IS THE GIRL ON PAGE 18
ONE WHO KILLS FOR LO
OR ONE WHO LOVES TO

Exposing

THE $20 A NIGHT
HARLOTS OF
BROADWAY!

25¢

JAN.

ELLE M'A PRIS
POUR UNE POIRE !

Eric Godtland

Les années 1950 furent sinon l'âge d'or esthétique, en tout cas l'apogée du style kitsch des magazines policiers. Il y eut plus de titres loufoques et inattendus créés durant cette décennie que durant les précédentes. Plus d'expérimentations sur les formats aussi. Malheureusement, cet élargissement du genre reflétait davantage un secteur aux abois qu'une véritable attente du public. L'essor de la télévision dans les années 1950 porta un coup sévère aux magazines. À la différence des relations mutuellement bénéfiques que les magazines policiers entretenaient avec la radio, le petit écran était clairement un concurrent et un concurrent très rude. Le policier avec sa popularité déjà ancienne était un ingrédient obligé de la télévision naissante et les enquêtes policières et criminelles furent parmi les premières et les plus appréciées des émissions de télévision. Un succès qui porta le coup de grâce aux magazines policiers déjà exsangues. Pour les faits divers criminels, ce furent les fictions policières et les bulletins d'informations quotidiens proposés par la télévision qui entraînèrent un déclin du marché pour des magazines dont le lectorat perdit ses membres les plus jeunes.

La chute des recettes qui s'ensuivit amena nombre des éditeurs vieillissants de la première heure à vendre leurs titres à des groupes spécialisés dans les magazines sexy. Le meilleur exemple est celui de *True Police Cases*, créé par Fawcett en 1946 et qui se voulait alors un magazine de faits divers criminels sérieux, analytique, et qui fut revendu à Robert Harrison, alors propriétaire de *Eyeful, Titter, Wink*... Harrison était l'inventeur du magazine à scandales avec *Confidential*. Sous son impulsion *True Police Cases* ne tarda pas à rivaliser dans le sordide avec ce dernier.

True Police n'était pas le seul exemple d'un magazine policier plutôt respectable, dont la

métamorphose s'opérait du jour en lendemain, après avoir changé de mains, se transformant en feuille à scandales ou en magazine de pin up. Tous les nouveaux venus sur le marché avaient une vision plus « pittoresque » de ce qui pouvait faire remonter le tirage : le principe de couvertures exhibant des bombes sexuelles semi-déshabillées était évidemment l'axiome numéro un de leur programme marketing.

Mais les éditeurs de magazines sexy ne furent pas les seuls responsables de la mutation des *detective magazines*. Dans les années 1950, les éditeurs d'avant-guerre, eux aussi, essayaient de nouveaux formats, avec des résultats parfois désastreux. Le plus célèbre fut *Master Detective*, qui rétrécit jusqu'au format d'un livre de poche dans une tentative d'imiter le succès du *Reader's Digest*. Après une chute de 70 % des ventes, les responsables comprirent leur erreur et revinrent au grand format mais *Master Detective* ne devait jamais se remettre complètement de cette erreur de jugement. Plusieurs titres essayèrent de mêler polar et sujets d'intérêt général comme le sport, la pêche ou la mode masculine dans l'espoir de capter de nouveaux adeptes, tandis que d'autres décidaient de proposer des fictions à côté des faits divers criminels. Ces rafistolages ne serviront qu'à éloigner un peu plus les aficionados du genre.

Inévitablement, avec les nouveaux propriétaires, la qualité des textes déclina. Pour les amateurs des magazines d'enquêtes criminelles, les titres des années 1950 traduisent une décadence : on passe d'articles bien écrits au contenu respectable, à un style sensationnaliste et sordide bien loin de la vérité pour vendre du papier. Ils ont raison, mais il y avait des amateurs pour ce genre « visqueux ». Les articles sur la Guerre Froide et la drogue étaient particulièrement grotesques, mais aussi

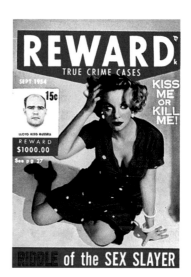

OPPOSITE *True Cases of Women in Crime*, January 1950

ABOVE *Reward True Crime Cases*, September 1954

BELOW *True Detective*, January 1956

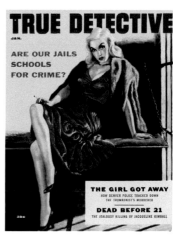

-197-

> **«Tu ne peux pas ramasser les pièces tombées dans le caniveau sans te salir. Tu ne peux pas d'adonner au gin et au péché sans sombrer dans un cloaque.»**
> — *SMASH DETECTIVE CASES*, AOÛT 1950

extrêmement divertissants pour les adeptes du genre : « J'étais accro à la dope à quinze ans. » En 1955, l'intégrité journalistique de tous ces périodiques avait effectué une retraite en bon ordre et s'était rabattue sur les filles faciles et les scénarios les plus racoleurs.

Le naufrage d'un certain purisme du polar se traduisit par un bénéfice pour les adeptes du « trash ». Pour le collectionneur d'images sexuelles explicites, les magazines policiers de la fin des années 1940 et des années 1950 représentent l'apogée du genre. Les magazines antérieurs étaient plus joliment imprimés, mieux écrits et les couvertures étaient signées de grands noms, mais il fallut attendre les années 1950 pour que l'archétype de la fille de mauvaise vie atteigne des sommets.

Women in Crime, Crime Girls, Women on Trial, Ladies of the Underworld, Crime Confessions, Girl Spies, Sensational Exposes et *Vice Squad* sont quelques-uns des titres accrocheurs des années 1950 qui exploitent le thème de la femme fatale et tentatrice. En 1950, la vision d'une pulpeuse prostituée, clope au bec et rictus ironique en jupe ajustée et chandail moulant (ou, mieux encore, en body rayé de stripteaseuse !) met le lecteur mâle en transes. Sous le béret beatnik, la chevelure flotte librement, et cette fille à voyous jette des regards défiants aux

cordons de flics, arnaque les gogos dans les bars mal famés et brandit un pistolet encore fumant sur d'innombrables scènes du crime. Même métamorphosée en adolescente délinquante, à la fin de la décennie, elle a un sacré chien en salopette et blouson de cuir, la lippe dédaigneuse, les cheveux drus hérissés, alors que les flics l'entraînent avec eux.

Mais qu'est-ce qu'on lui reproche, au juste ? Tout, ou peu s'en faut. Ces nanas-là sont coupables de traîner avec des « blousons noirs », de distribuer des pains dans des bastons et de s'éclater dans des fêtes démentes. Et ne vous avisez pas de demander comment une ex-enfant de chœur a fini dans ce bourbier de crime et de dépravation. Tout homme mûr des années 1950, le lecteur type des *detective magazines*, connaissait la réponse par cœur : si elle n'est pas soumise au code strict d'une morale sévère, si elle n'est pas clouée chez elle par sa vie d'épouse, par ses enfants, intimidée par l'Église aussi, si elle n'est pas enserrée dans des gaines, des cordonnets de tablier de cuisinière, de stricts colliers de perles, la femme est capable du pire. Une légère défaillance de l'ordre moral et nous voilà retournés au paradis, à un doigt (ou un serpent) du désastre. Demandez-donc son avis au prêtre de votre quartier… Toutes les femmes sont mauvaises !

OPPOSITE *Line-up Detective Crime*, April 1953

BELOW *True Detective*, April 1957

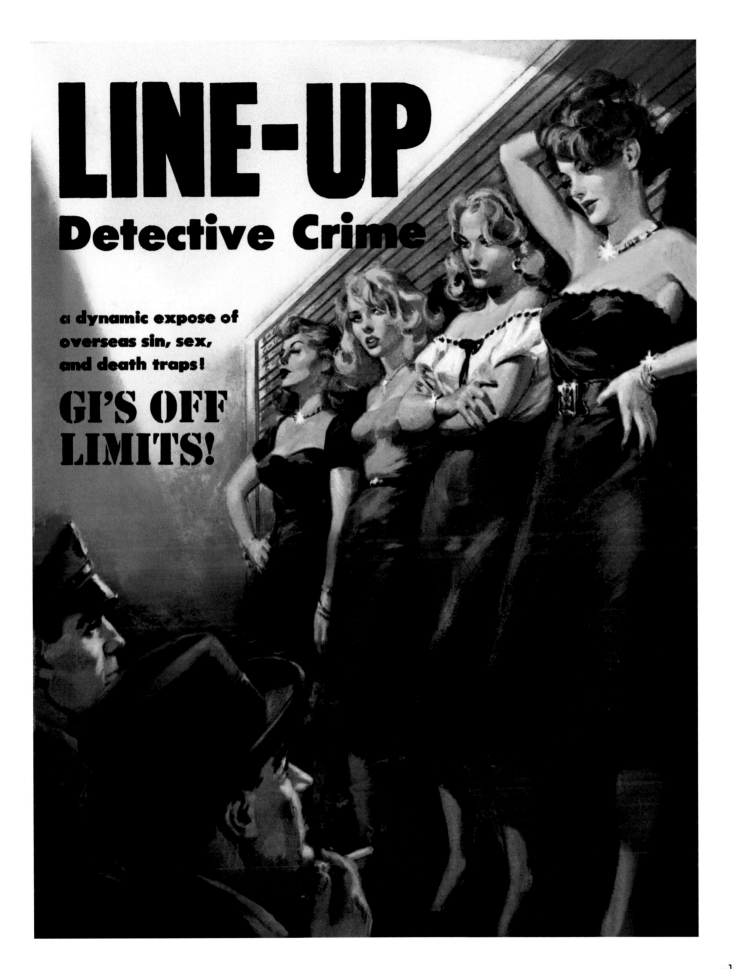

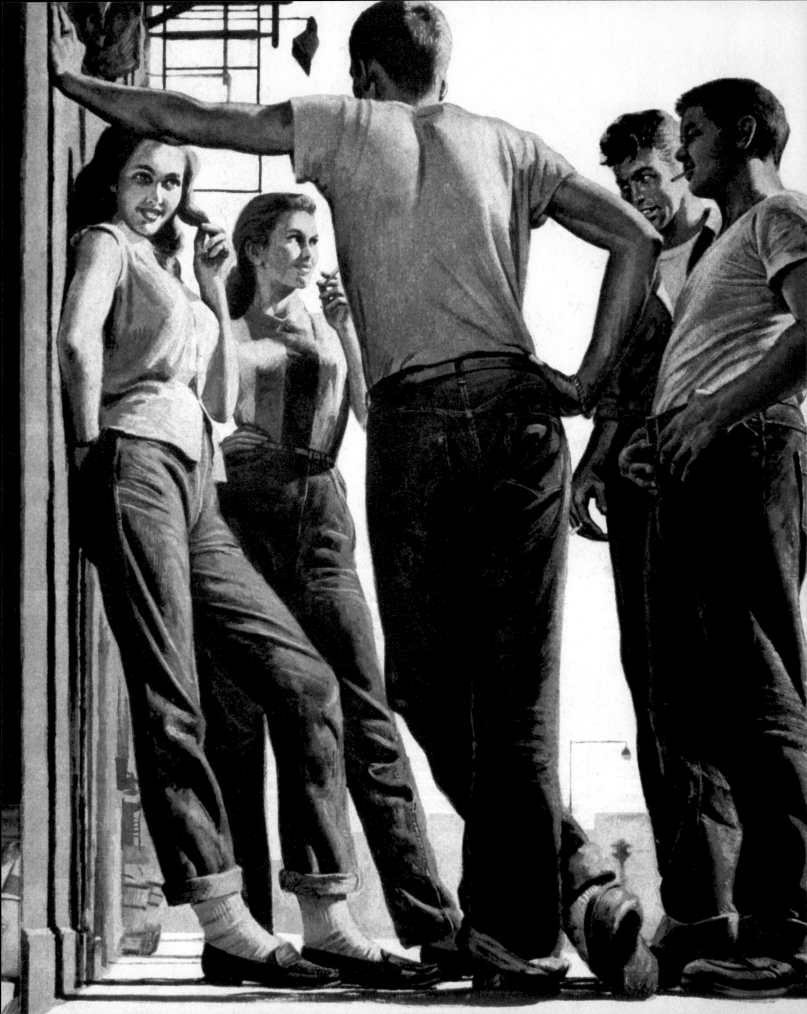

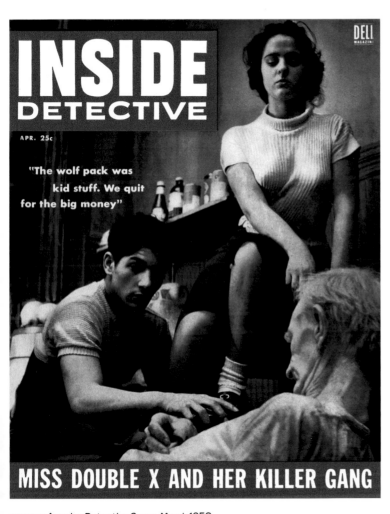

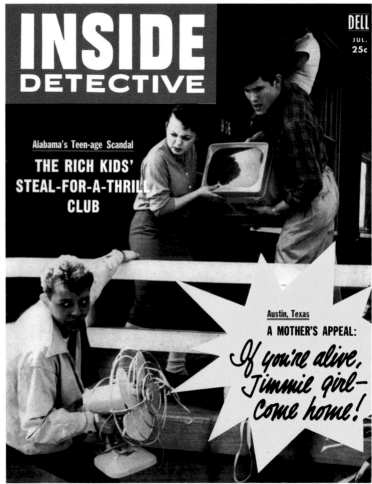

OPPOSITE *Amazing Detective Cases*, March 1958

ABOVE LEFT *Inside Detective*, April 1955

ABOVE RIGHT *Inside Detective*, July 1957

PAGES 202–203 *Special Detective*, February 1951

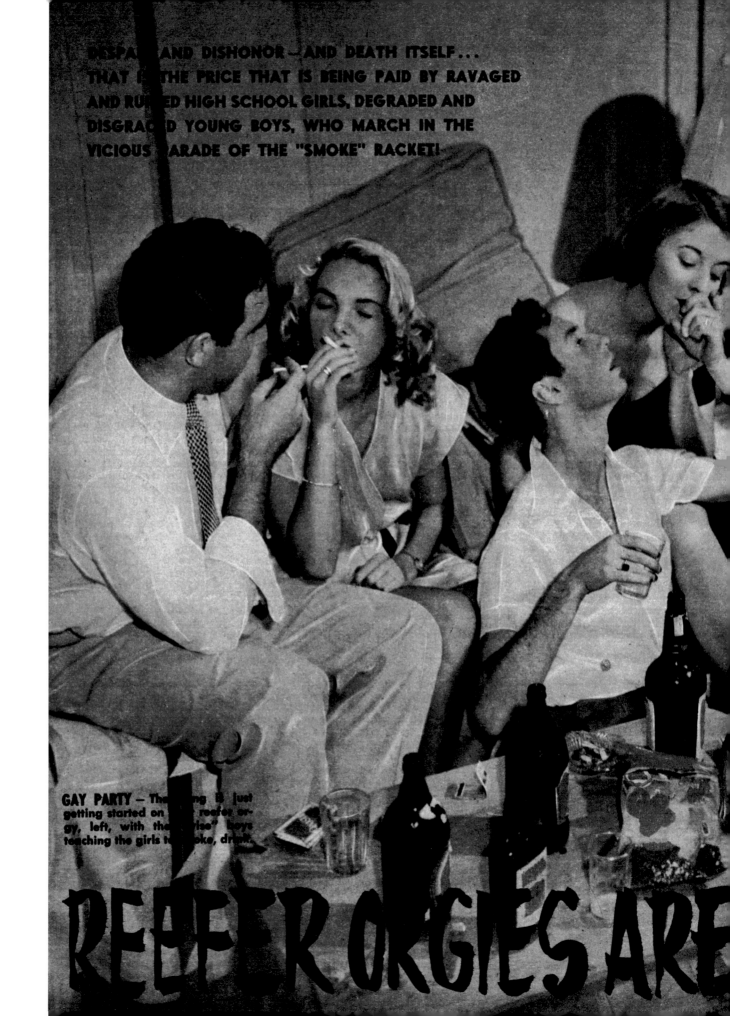

DESPAIR AND DISHONOR — AND DEATH ITSELF . . .
THAT IS THE PRICE THAT IS BEING PAID BY RAVAGED
AND RUINED HIGH SCHOOL GIRLS, DEGRADED AND
DISGRACED YOUNG BOYS, WHO MARCH IN THE
VICIOUS PARADE OF THE "SMOKE" RACKET!

GAY PARTY — The thing is just
getting started on this reefer or-
gy, left, with the "wise" boys
teaching the girls to smoke, drink.

REEFER ORGIES ARE

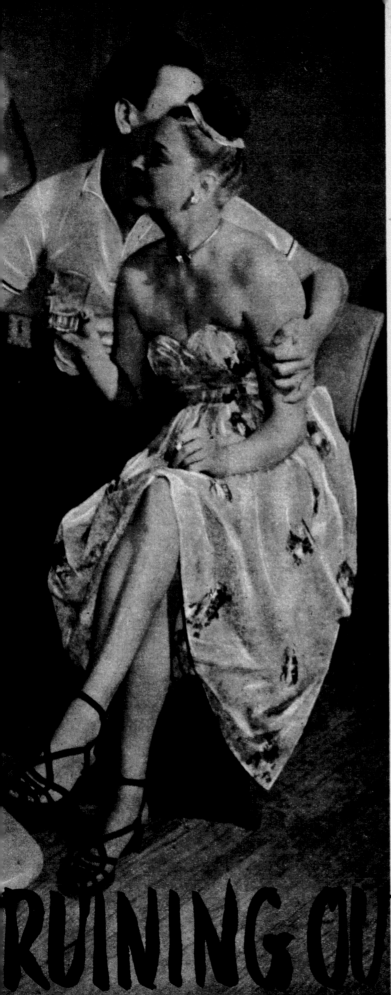

(Specially posed by professional models)

LIKE a creeping scourge, the shame and degradation of the reefer racket spreads among American youth. Young lives are being ruined, innocent youngsters are being seduced to join the circles of the depraved addicts . . . and the vicious marihuana racketeers are raking in their profits in ever-growing amounts. Law enforcement agencies have tried to stop the secret spread of this body and soul-consuming disease, but they are virtually helpless without the help of an informed public. ONLY AN AWARE AND ALERT PUBLIC CAN HELP STOP THIS RACKET!

There is hardly a youth group, a high school or college in the land that has not smelled the stench of this cesspool beneath the surface of American life. Yet, too many of us still know nothing about it . . . and our ignorance and indifference have given a green light to the drug racketeer who festers and grows not only on the business of supplying the drug to present addicts, but in deliberately creating new victims, in luring unwary youngsters, and starting them on the road to depravity, delinquency and often a miserable, untimely death.

RUINING OUR YOUTH!

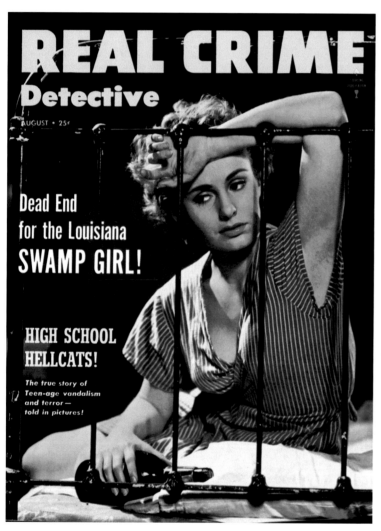

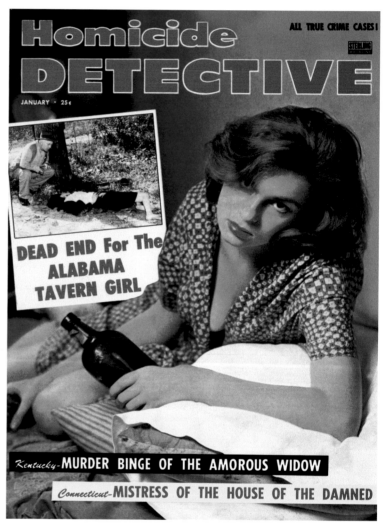

OPPOSITE *True Police Cases*, March 1954

ABOVE LEFT *Real Crime Detective*, August 1954

ABOVE RIGHT *Homicide Detective*, January 1957

True Police Cases

Cases

MARCH • 25 CENTS

**ALAN HYND'S
*STRANGEST
MURDER STORY***

**STRANGLE
AMBUSH
for the
MADCAP MODEL**

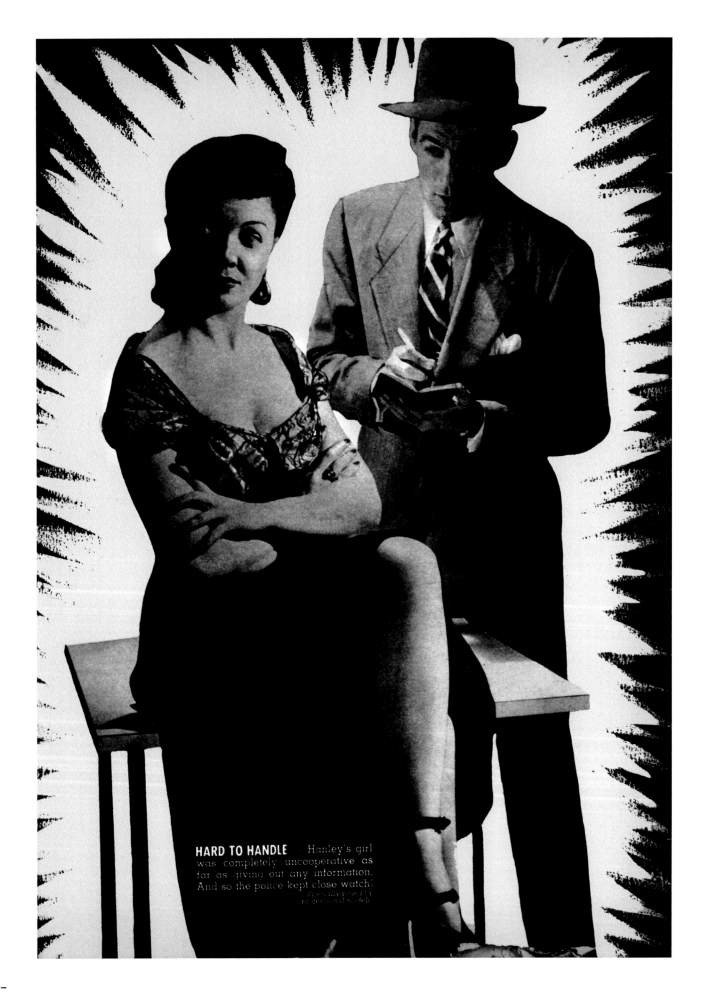

HARD TO HANDLE Hanley's girl was completely uncooperative as far as giving out any information. And so the police kept close watch!

OPPOSITE *All True! Police Detective Cases*,
October 1951

ABOVE LEFT *Crime*, January 1953

ABOVE RIGHT *True Cases of Women in Crime*,
March 1953

"She was a gorgeous and gallivanting gal ... she liked a good time with a gay guy but always preferred a one-night stand ... "

— *POLICE DETECTIVE CASES*, FEBRUARY – MARCH 1951

OPPOSITE *Detective Cases*, July 1958

ABOVE *Police Detective*, August 1957

PAGES 210–211 *True Crime*, July 1952

PAGE 212 *Homicide Detective*, November 1956

PAGE 213 *Inside Detective*, September 1958

DETECTIVE CASES

THE COMPLETE CRIME MAGAZINE

JULY 25c PDC

STRIPTEASER

TRAPPED TEMPTRESS

PROSTITUTE

GIRLS PRICED TO SELL

SEX VICTIM

RAPED AND STRANGLED

MODEL MURDERESS

BEAUTY IS DANGER

EXPOSING!

The games, the dames and the hard-boiled yeggs who went West to give the Hollywood merry-go-round a whirl—their slick swindles and assorted vices!

VIEW!

The big parade of hard men and easy wome[n] adventurers, race track touts, gamblers, fakers, crooks, gunmen—all come to cut themselves a fat slice o[f] movieland's tasty, loot-filled pie!

DYNAMITE!

To blast the disguise[s] slicksters whose super-collossa[l] on the Hollywood backdrop . . . whos[e] inflated egos and willing wom[en] all-powerful potenta[tes]

CRIME, VICE and

By Jack Duffy
(West Coast Investigator for
TRUE CRIME CASES)

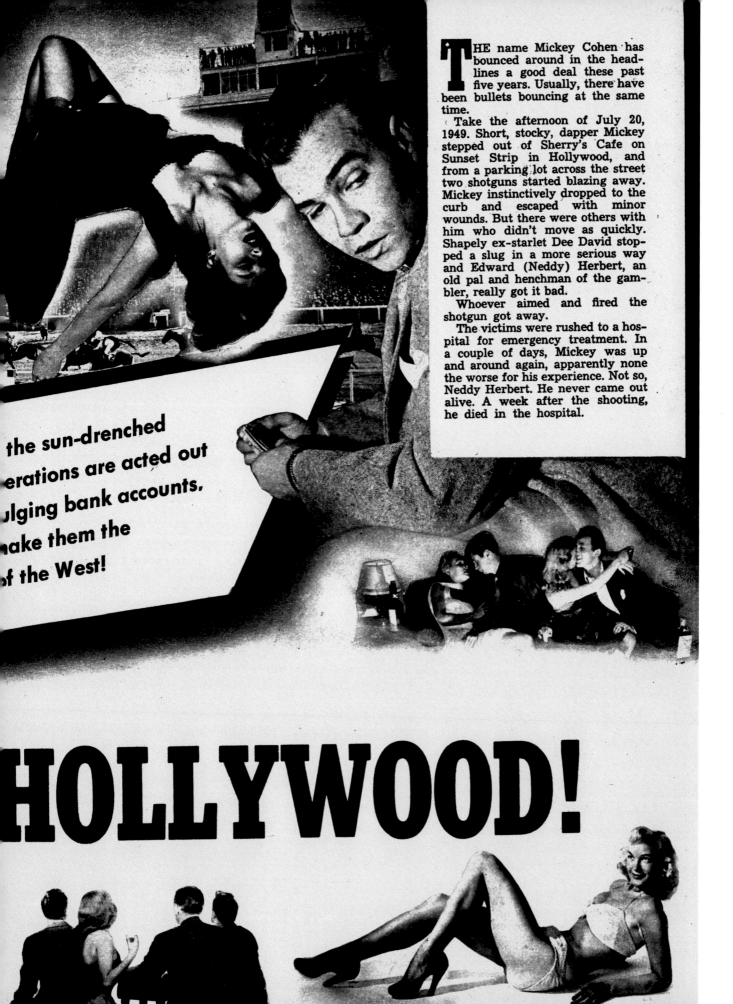

THE name Mickey Cohen has bounced around in the headlines a good deal these past five years. Usually, there have been bullets bouncing at the same time.

Take the afternoon of July 20, 1949. Short, stocky, dapper Mickey stepped out of Sherry's Cafe on Sunset Strip in Hollywood, and from a parking lot across the street two shotguns started blazing away. Mickey instinctively dropped to the curb and escaped with minor wounds. But there were others with him who didn't move as quickly. Shapely ex-starlet Dee David stopped a slug in a more serious way and Edward (Neddy) Herbert, an old pal and henchman of the gambler, really got it bad.

Whoever aimed and fired the shotgun got away.

The victims were rushed to a hospital for emergency treatment. In a couple of days, Mickey was up and around again, apparently none the worse for his experience. Not so, Neddy Herbert. He never came out alive. A week after the shooting, he died in the hospital.

the sun-drenched
erations are acted out
ulging bank accounts,
ake them the
f the West!

HOLLYWOOD!

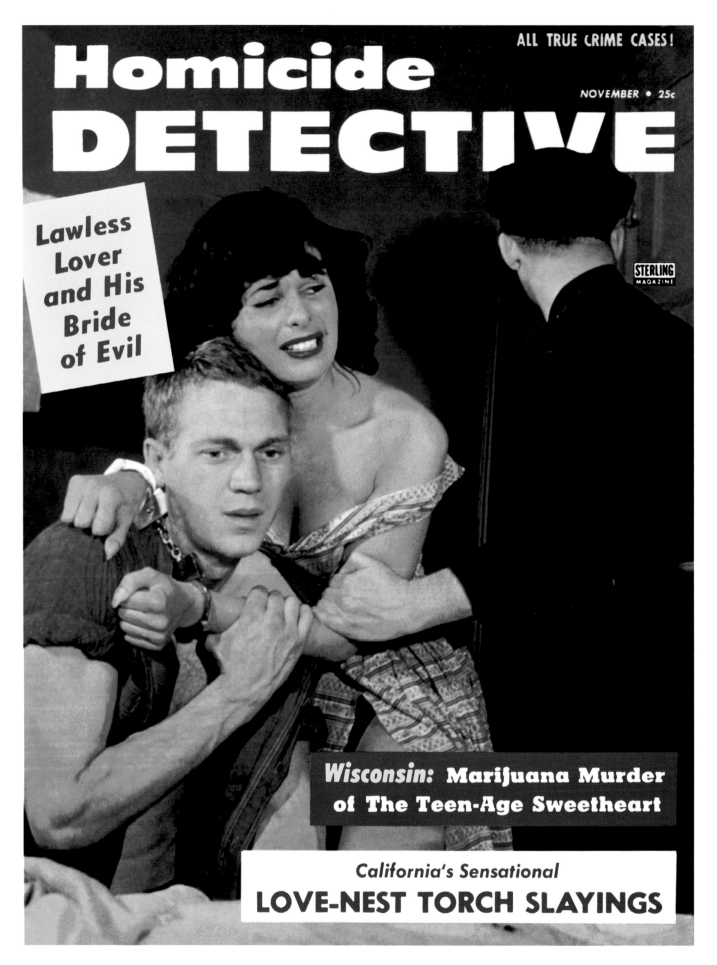

Homicide
DETECTIVE

ALL TRUE CRIME CASES!

NOVEMBER • 25c

STERLING MAGAZINE

Lawless Lover and His Bride of Evil

Wisconsin: Marijuana Murder of The Teen-Age Sweetheart

California's Sensational
LOVE-NEST TORCH SLAYINGS

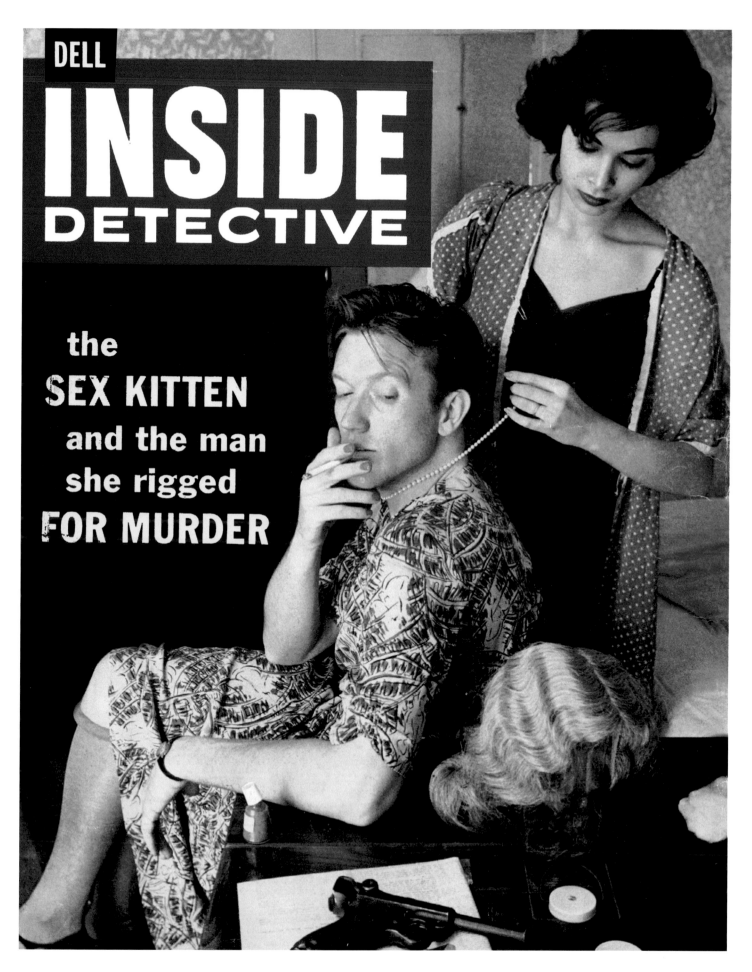

DELL

INSIDE
DETECTIVE

the
SEX KITTEN
and the man
she rigged
FOR MURDER

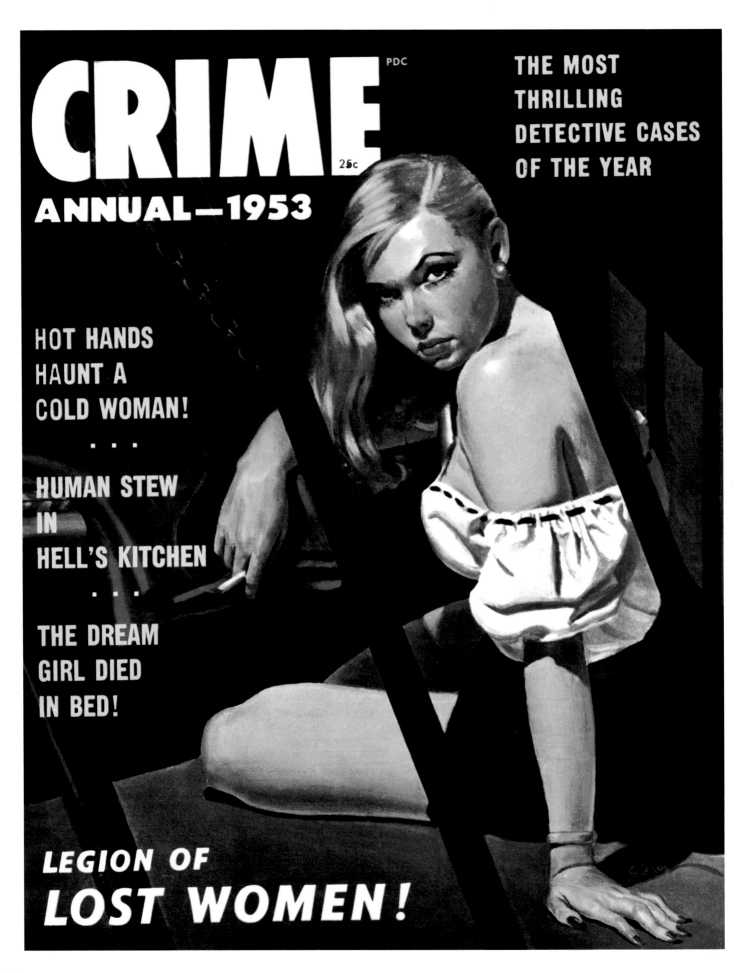

CRIME

PDC

25c

ANNUAL—1953

THE MOST THRILLING DETECTIVE CASES OF THE YEAR

HOT HANDS
HAUNT A
COLD WOMAN!

. . .

HUMAN STEW
IN
HELL'S KITCHEN

. . .

THE DREAM
GIRL DIED
IN BED!

LEGION OF LOST WOMEN!

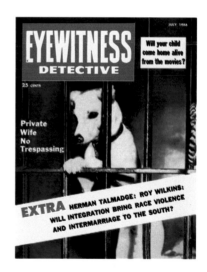

OPPOSITE *Crime Annual*, 1953

ABOVE RIGHT *Eyewitness Detective*, July 1956

BELOW *All True Fact Crime Cases*, April 1951

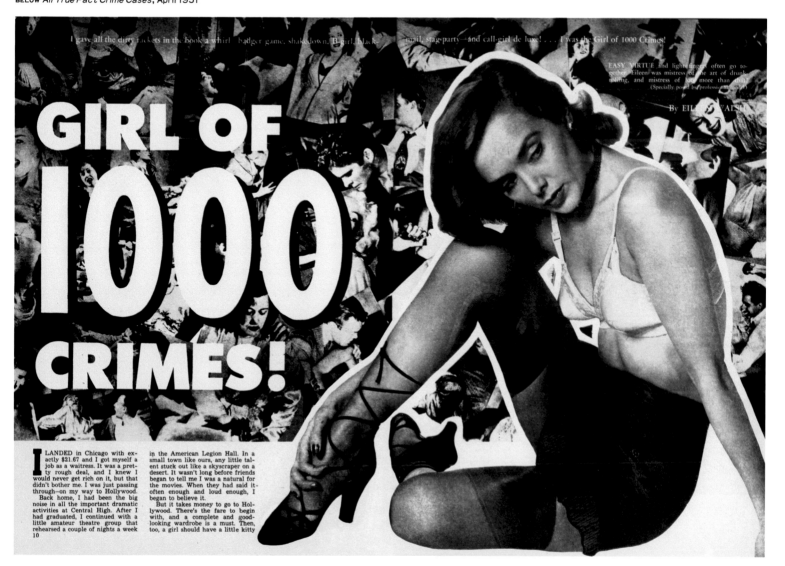

I gave all the dirty rackets in the book a whirl—badger game, shakedown, B-girl, black mail, stag-party—and call-girl de luxe! . . . I was the Girl of 1000 Crimes!

EASY VIRTUE and light fingers often go to-
gether. Eileen was mistress of the art of drunk-
rolling, and mistress of lots more than that!
(Specially posed by professional models)

By EILEEN WALSH

GIRL OF 1000 CRIMES!

I LANDED in Chicago with ex-
actly $21.67 and I got myself a
job as a waitress. It was a pret-
ty rough deal, and I knew I
would never get rich on it, but that
didn't bother me. I was just passing
through—on my way to Hollywood.

Back home, I had been the big
noise in all the important dramatic
activities at Central High. After I
had graduated, I continued with a
little amateur theatre group that
rehearsed a couple of nights a week
10

in the American Legion Hall. In a
small town like ours, any little tal-
ent stuck out like a skyscraper on a
desert. It wasn't long before friends
began to tell me I was a natural for
the movies. When they had said it—
often enough and loud enough, I
began to believe it.

But it takes money to go to Hol-
lywood. There's the fare to begin
with, and a complete and good-
looking wardrobe is a must. Then,
too, a girl should have a little kitty

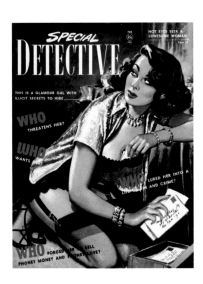

OPPOSITE & BELOW *Line-up Detective Crime*,
December 1951

ABOVE LEFT *Special Detective*, February 1951

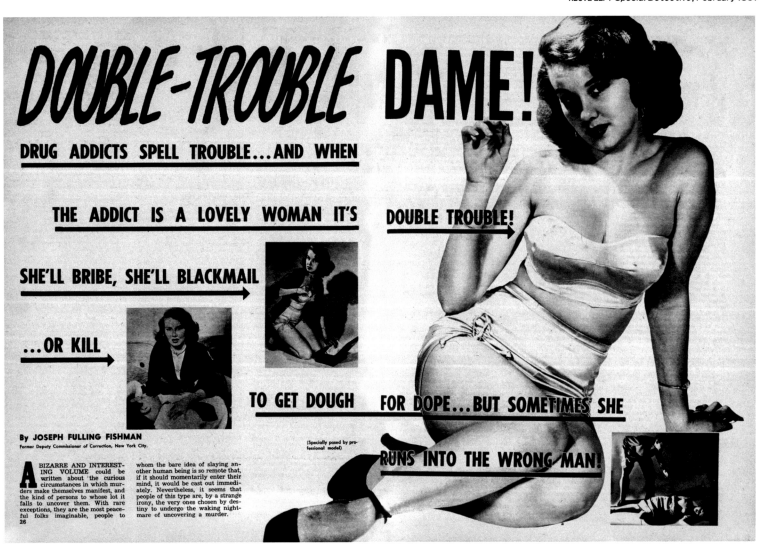

DOUBLE-TROUBLE DAME!

DRUG ADDICTS SPELL TROUBLE...AND WHEN

THE ADDICT IS A LOVELY WOMAN IT'S

DOUBLE TROUBLE!

SHE'LL BRIBE, SHE'LL BLACKMAIL

...OR KILL

TO GET DOUGH FOR DOPE...BUT SOMETIMES SHE

RUNS INTO THE WRONG MAN!

By **JOSEPH FULLING FISHMAN**
Former Deputy Commissioner of Correction, New York City.

(Specially posed by professional model)

A BIZARRE AND INTEREST-ING VOLUME could be written about the curious circumstances in which murders make themselves manifest, and the kind of persons to whose lot it falls to uncover them. With rare exceptions, they are the most peaceful folks imaginable, people to whom the bare idea of slaying another human being is so remote that, if it should momentarily enter their mind, it would be cast out immediately. Nevertheless, it seems that people of this type are, by a strange irony, the very ones chosen by destiny to undergo the waking nightmare of uncovering a murder.

26

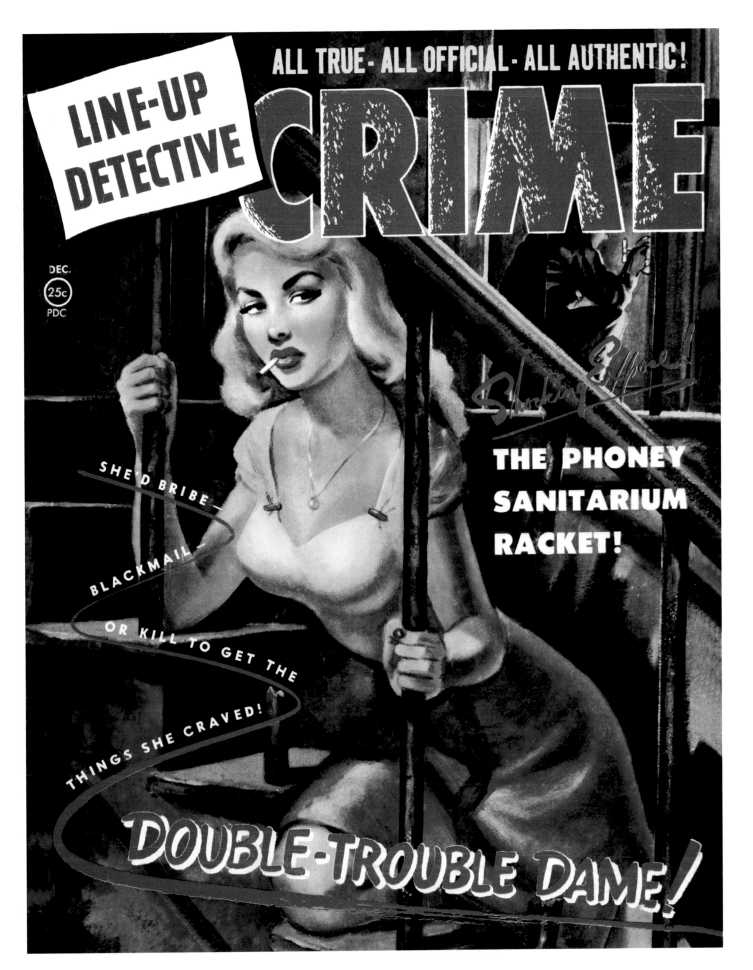

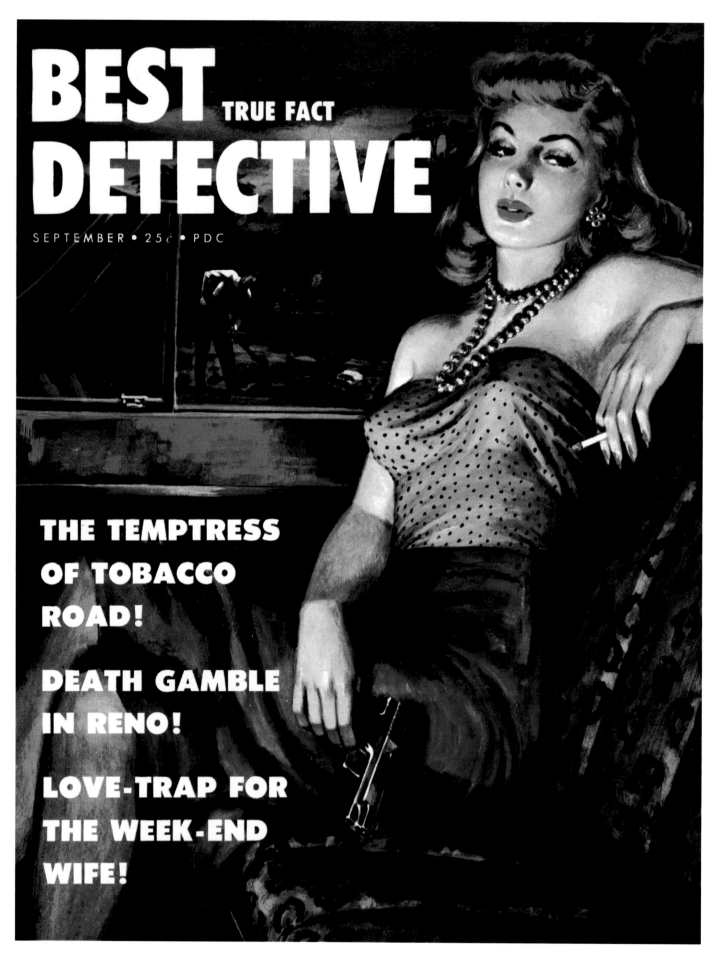

BEST TRUE FACT
DETECTIVE

SEPTEMBER • 25¢ • PDC

THE TEMPTRESS
OF TOBACCO
ROAD!

DEATH GAMBLE
IN RENO!

LOVE-TRAP FOR
THE WEEK-END
WIFE!

"She looked like a decent girl who had a lot of fun; a girl who laughed easily. But she wasn't laughing now. She was dead."

— *INSIDE DETECTIVE*, DECEMBER 1952

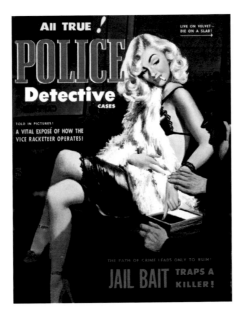
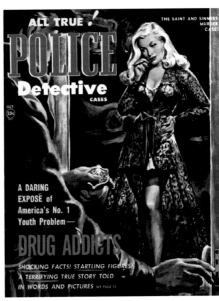
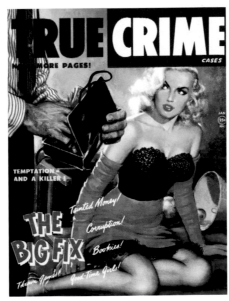
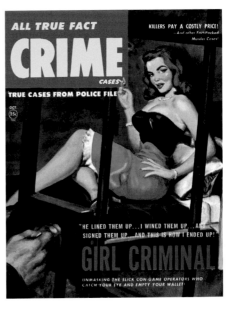

OPPOSITE *Best True Fact Detective*, September 1953

CLOCKWISE FROM ABOVE LEFT *All True! Police Detective Cases*, March 1951; *All True! Police Detective Cases*, October 1951; *All True Fact Crime Cases*, October 1951; *True Crime Cases*, January 1952

PAGE 220 *Smash Detective-Crime Cases*, January 1950

PAGE 221 *All True Fact Crime Cases*, February 1952

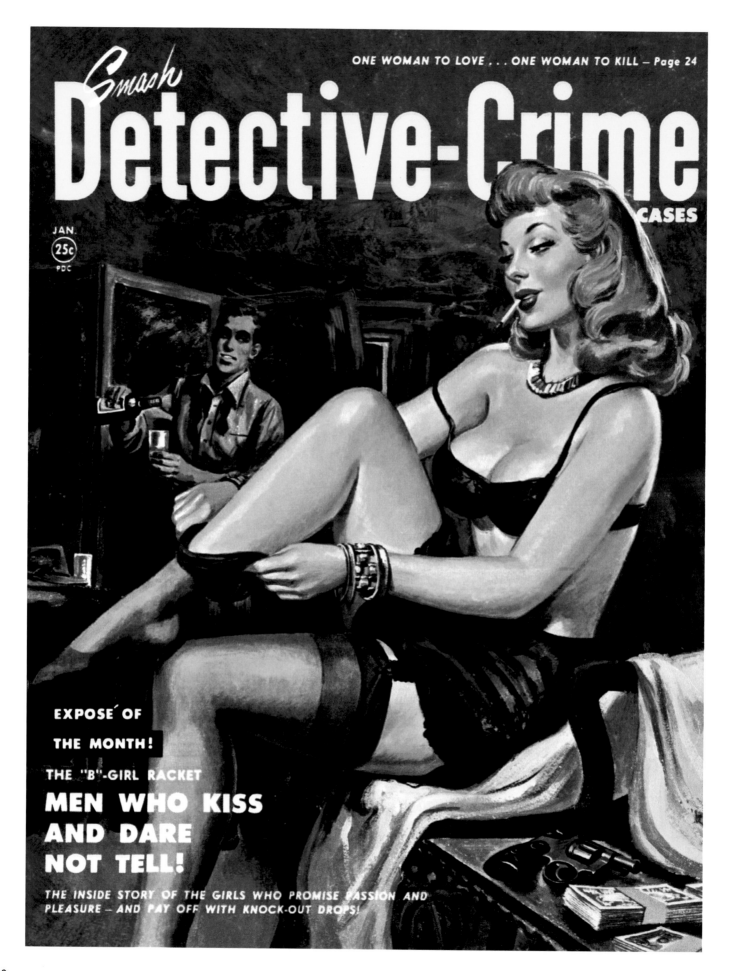

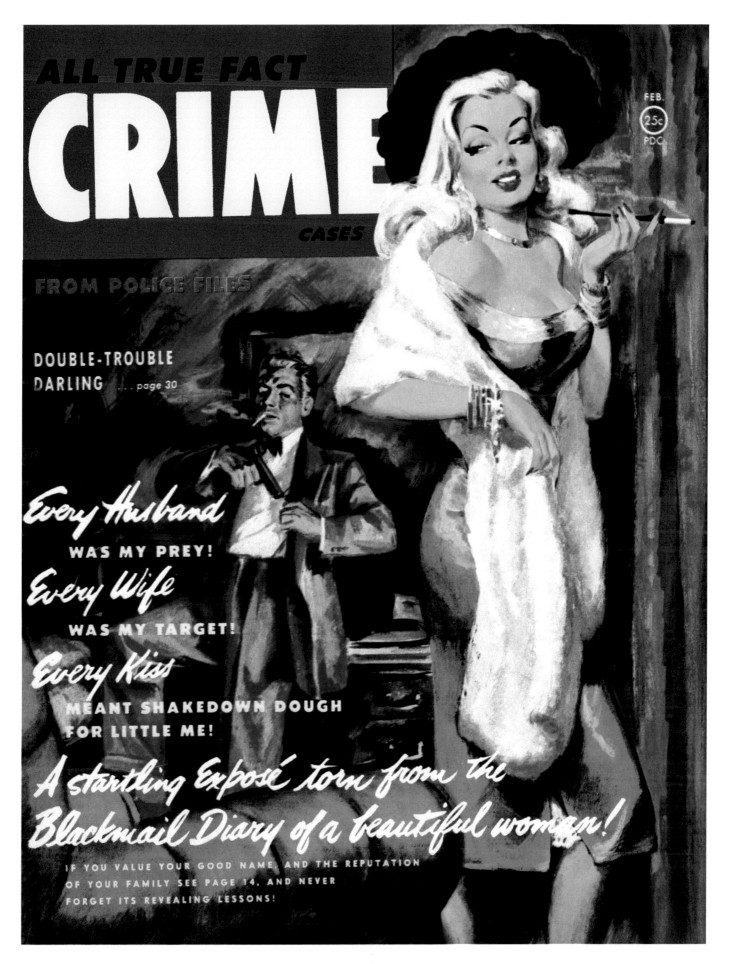

ALL TRUE FACT

CRIME

CASES

FEB.
25c
PDC

FROM POLICE FILES

DOUBLE-TROUBLE
DARLING ... page 30

Every Husband
WAS MY PREY!
Every Wife
WAS MY TARGET!
Every Kiss
**MEANT SHAKEDOWN DOUGH
FOR LITTLE ME!**

*A startling Exposé torn from the
Blackmail Diary of a beautiful woman!*

IF YOU VALUE YOUR GOOD NAME, AND THE REPUTATION
OF YOUR FAMILY SEE PAGE 14, AND NEVER
FORGET ITS REVEALING LESSONS!

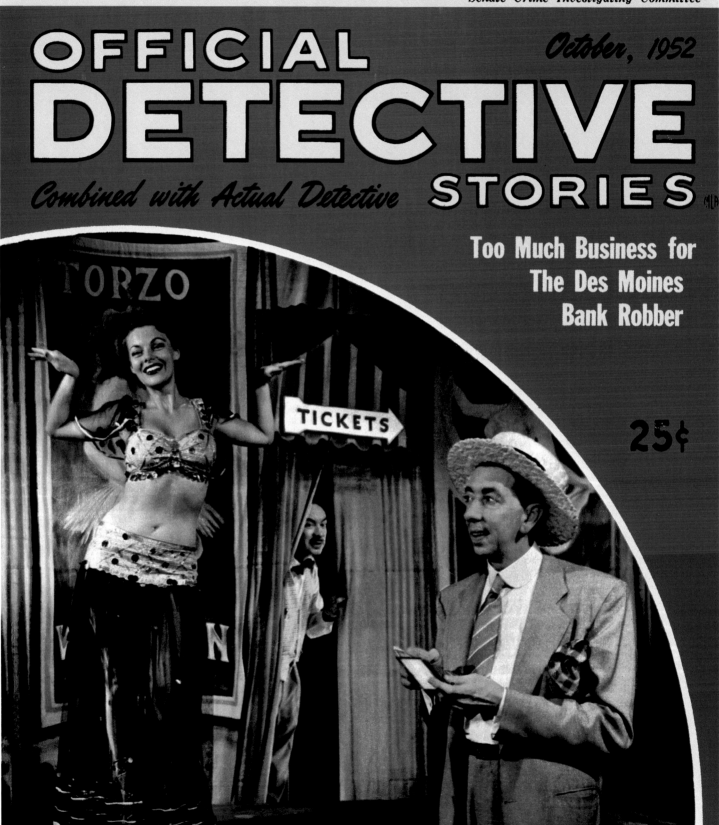

Behind the $100,000,000 Gold Racket

By Alfred M. Klein
Former Associate Counsel,
Senate Crime Investigating Committee

OFFICIAL DETECTIVE STORIES

October, 1952

Combined with Actual Detective

Too Much Business for
The Des Moines
Bank Robber

25¢

"Dr. Alfred Kinsey, the authoritative Mr. Sex Statistics, said that there's no such thing as a sex crime wave today in America. Yeah, right."
— *DETECTIVE CASES*, JUNE 1956

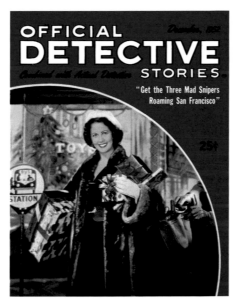

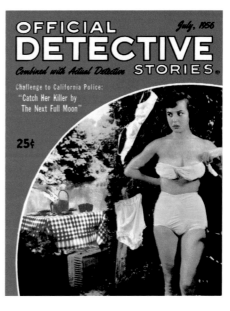

OPPOSITE *Official Detective Stories*, October 1952

CLOCKWISE FROM ABOVE LEFT *Official Detective Stories*, December 1952; *Official Detective Stories*, February 1954; *Official Detective Stories*, July 1956; *Official Detective Stories*, June 1951

PAGE 224 *True Crime Cases*, May 1951

PAGE 225 *Line-up Detective Cases*, June 1950

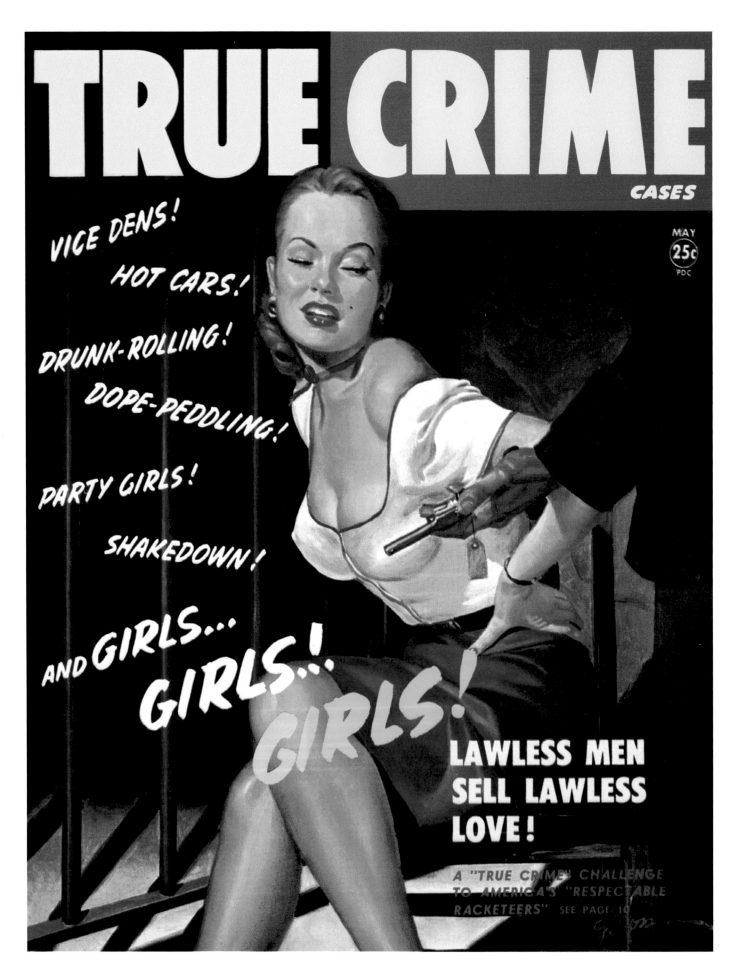

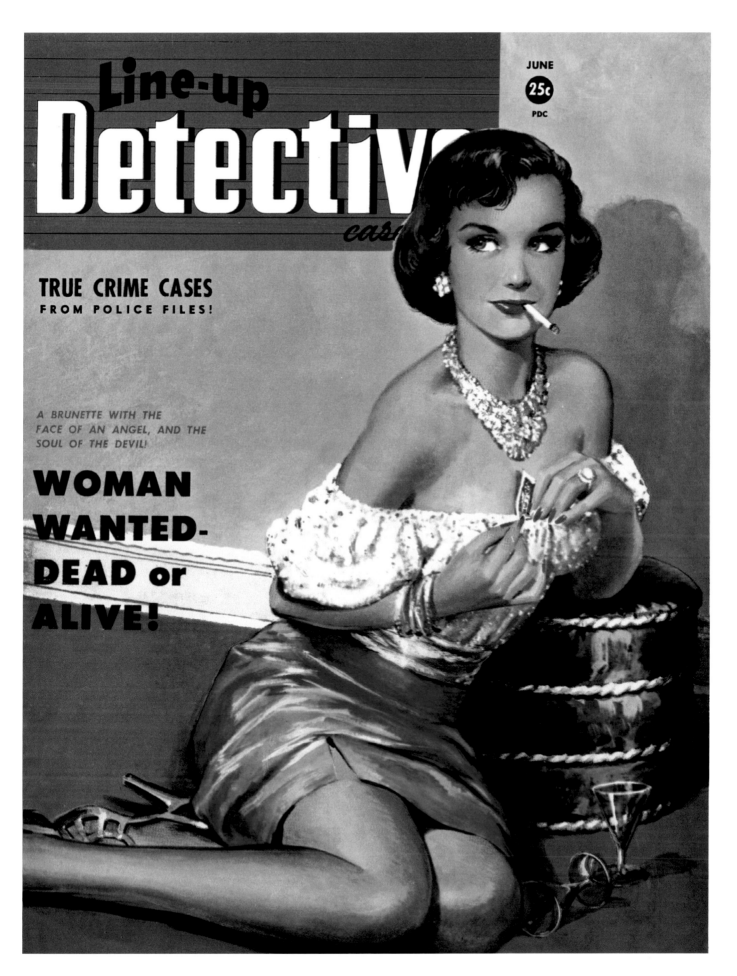

Line-up **Detective** cases

JUNE
25c
PDC

TRUE CRIME CASES
FROM POLICE FILES!

A BRUNETTE WITH THE
FACE OF AN ANGEL, AND THE
SOUL OF THE DEVIL!

WOMAN WANTED- DEAD or ALIVE!

"A girl will do absolutely anything that the gang decrees she must do—whether it is swiping pennies from newsstands or indulging in public sex acts to prove that she's 'hip.'"

— *CRIME*, MAY 1953

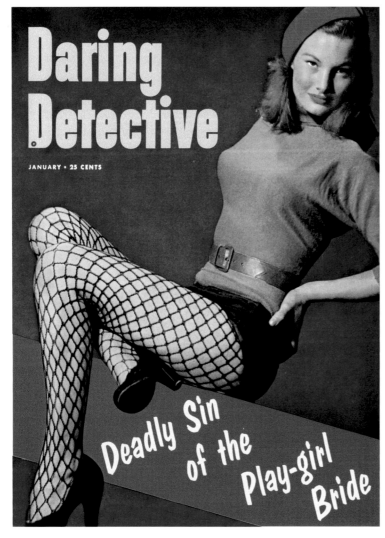

OPPOSITE *Exposé Detective*, November 1958

LEFT *Daring Detective*, January 1953

WOMEN BOUGHT AND SOLD LIKE CATTLE!

96 PAGES!

exposé detective

NOVEMBER • 35 CENTS • K

SEX HABITS OF WOMEN KILLERS
a daring exposé

ARSON KILLER
and the
INNOCENT VICTIM

THE KILLER WHO HAD A TIGER BY THE TAIL *by Alan Hynd*

True Police

CASES

4

8

5

FEBRUARY · 25 CENTS

SWEET **16** →
AND ALREADY
A WAYWARD QUEEN

A policewoman reveals the diary of a teen-ager who dared to defy the law!

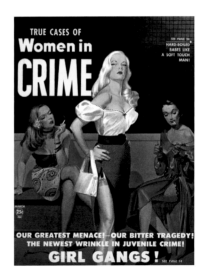

OPPOSITE *True Police Cases*, February 1959

ABOVE RIGHT *True Cases of Women in Crime*, March 1950

BELOW *Amazing Detective Cases*, March 1958

PAGE 230 *Detective Year Book*, 1950

PAGE 231 *Authentic Detective Cases*, July 1952

They're the hottest thing since Mamie Stover and the deadliest since the A-Bomb. And any swabbie who suckers for their dough and cars is asking to end up in a ditch with a split skull.

By D. L. WOOD

▶ On a rainy, chilly night last December, an incredible thing happened to a special guard working the night watch on a windswept pier in Los Angeles harbor.

Four very pretty girls got out of their sedan and walked across the dock to him. He stepped out to intercept them. "I'm sorry," he said, "but you girls can't come on here. What are you doing down here at this time of night anyway?"

"Sorry, mister," one of them, a blonde in a tight-fitting skirt and a snug leather jacket said, "but we're looking for something and we need you to help us find it."

"Sure," he said. "I'd be glad to help you."

"That's nice," the blonde said, "because if you didn't, I'd have to use this."

He felt something poke into his middle and looked down. It was a shiny, short-bladed knife, and he could feel the point of it pricking his skin through his clothes. He backed off, stammering, "If this is a robbery, you're crazy. There's nothing here that you'd want."

"Yes there is," she said. "You."

With that, the four shoved him into the shadows, and prodding him with the knife, forced him to submit to them.

When they left, he stumbled to the phone and told the authorities the amazing story. To prove it, the respectable, middle-aged father of two bore deep cuts made by the sadistic girls in their frenzy.

While he had trouble explaining the episode to his disbelieving wife, police were wont to give full credence to his tale. It wasn't the first time that the "Gull Girls"—so called because of the way they hung around ships and docks—had struck along the waterfront.

Already notorious in San Diego, the Gull Girls had now turned up at Los Angeles Harbor because the Navy fleets had pulled out of San Diego for the Middle East.

An able seaman (Continued on page 61)

28

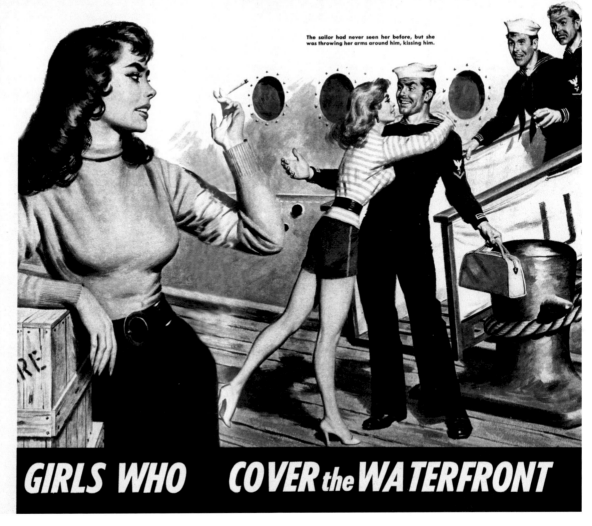

The sailor had never seen her before, but she was throwing her arms around him.

GIRLS WHO COVER the WATERFRONT

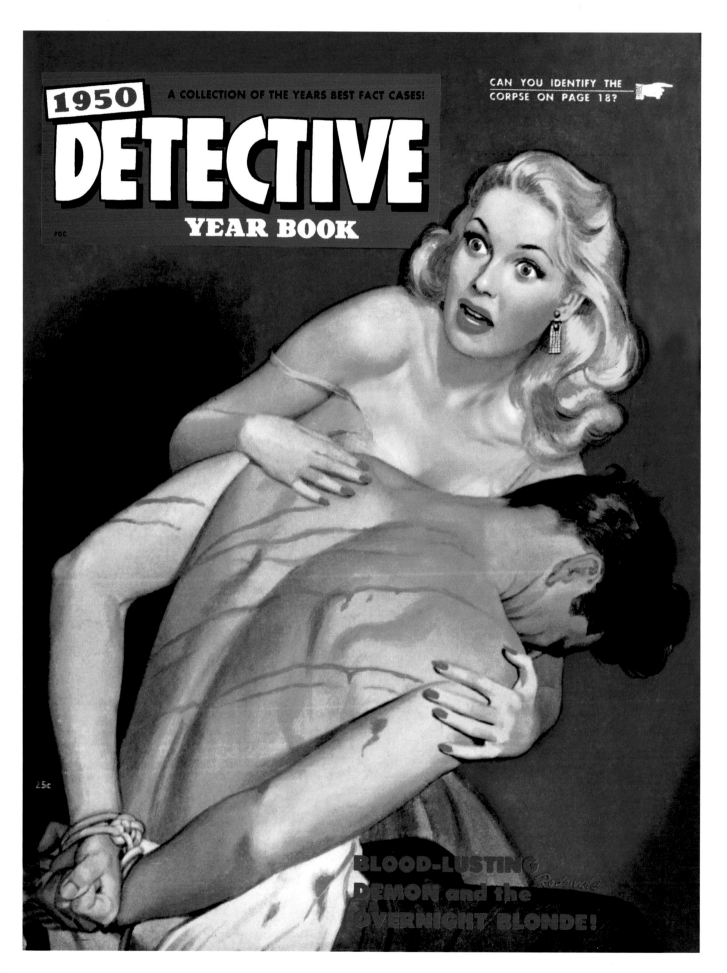

JULY
25¢

Authentic
DETECTIVE
Cases

WHITE SLAVE
CASE of the
CAPTIVE BRIDE

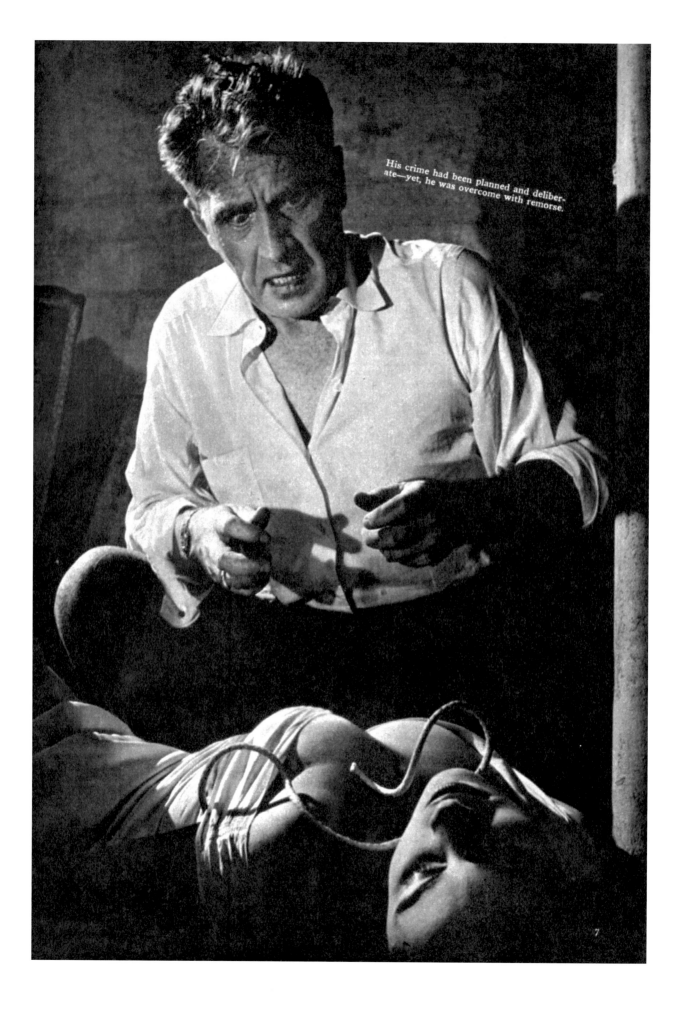

His crime had been planned and deliberate—yet, he was overcome with remorse.

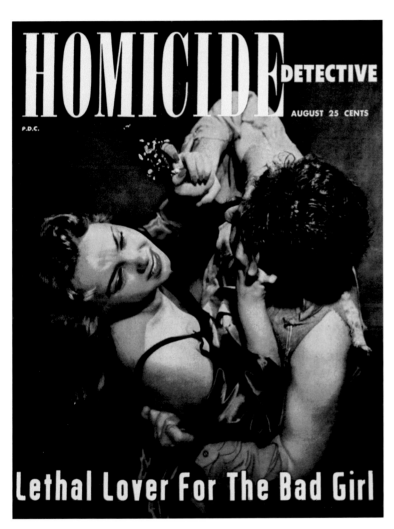

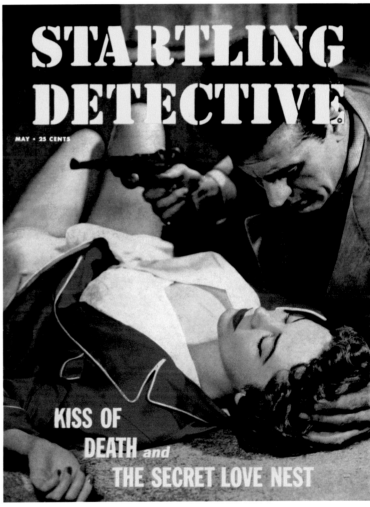

OPPOSITE *Daring Detective*, January 1953

ABOVE LEFT *Homicide Detective*, August 1951

ABOVE RIGHT *Startling Detective*, May 1955

PAGE 234 *Detective World*, September 1951

PAGE 235 *Detective World*, December 1951

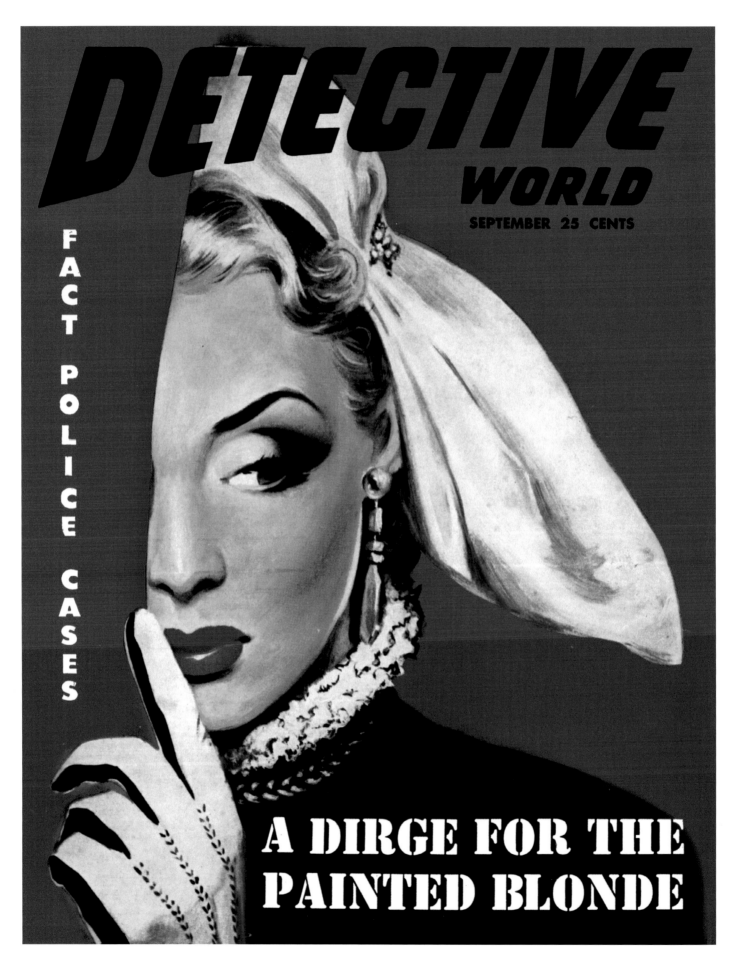

DETECTIVE WORLD

SEPTEMBER 25 CENTS

FACT POLICE CASES

A DIRGE FOR THE PAINTED BLONDE

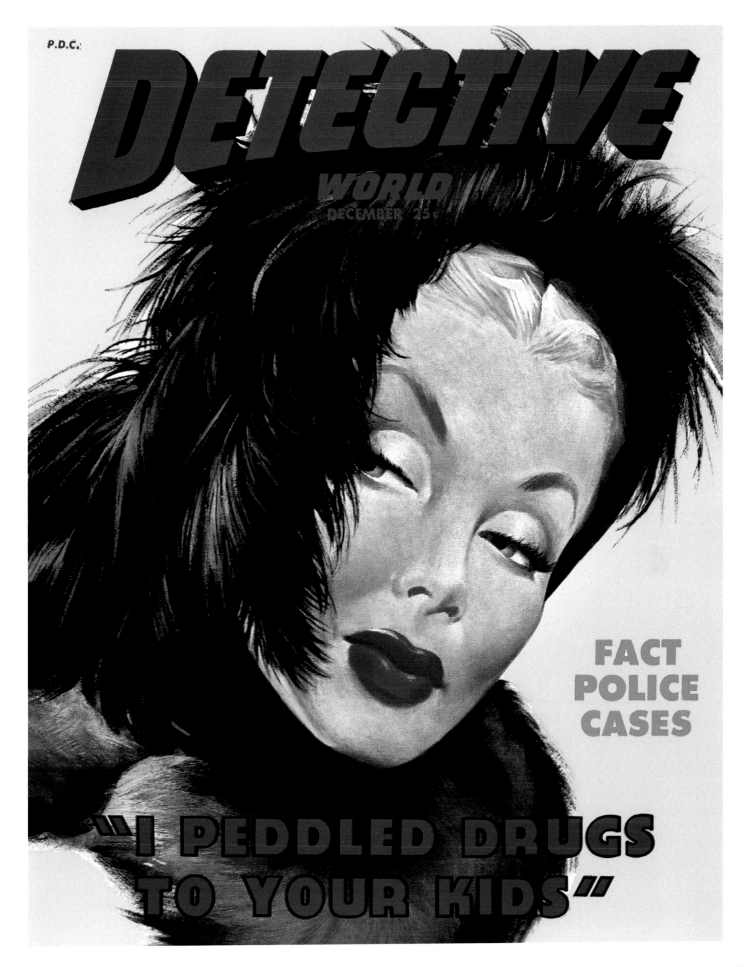

DETECTIVE
WORLD
DECEMBER 25¢

FACT
POLICE
CASES

"I PEDDLED DRUGS
TO YOUR KIDS"

1960-1969

By the mid-'60s the magazines started exploring television's taboo topics. Extreme violence, deviant crime, drug use, serious antisocial behavior, and especially violence combined with sex were all skirted by TV. Naturally, these topics were not new to detective titles, but the magazines had previously shied away from the most prurient elements.

THE SKID
INTO SLEAZE
by Eric Godtland

The degenerative path taken by the detective titles through the 1960s is starkly apparent when looking at them today. If you were a typical older American man during the 1960s, with the conservative moral and political views seemingly held by most detective magazine readers, the change in your magazines would have exactly mirrored your perception that the world was "going to hell in a handbasket."

The decade started innocently enough, carrying through with the common '50s themes of Bad Girls and dungaree-clad gang girls caught up in homicide, robbery, or prostitution. By the mid-'60s the world was changing rapidly, though, and what once provoked moral outrage now looked pretty staid.

In 1960 the birth control pill was invented. In 1963 President Kennedy was assassinated. The same year Betty Friedan kicked off the women's liberation movement with publication of *The Feminine Mystique*. In 1964 Congress passed the Civil Rights Act. To back it up, The Rev. Martin Luther King was awarded the Nobel Peace Prize. With 1967 came the Summer of Love, and by '68 those scary Black Panthers were everywhere. The cute little mop-topped Beatles who arrived in '63 turned out to be the precursors of a threatening horde of tight-pants anarchic long-hairs who would overrun America. And bad as it was in the Heartland, out in California nudism had escaped the camps and was jaybirding in the streets and whole cities like San Francisco seemed to be going crazy, hippie, and commie all at the same time. The conservative older American man hated all this societal deconstruction with a primordial intensity — and couldn't read enough about it.

Meanwhile, the detective magazines were also seeing radical change. The old guard of publishers was now geriatric. Those who had not already sold off their titles chose this time to retire. The new,

younger publishers and editors had no problem with pushing the envelope, and as television continued its relentless drag on all magazine sales, they examined their options.

Since television was the most dangerous enemy, great attention was paid to what that medium was restricted from covering. It is no coincidence that *Playboy* joined the top five best-selling magazine titles during this time when television couldn't even show a husband and wife sharing the same bed. Dozens of new girlie magazines sprang up between 1955 and 1965, making this period the heyday of the men's magazine, a golden era before the competition of cable television and adult video. Naturally, the new detective editors took notice of the sex magazines' success and once again increased the sexuality in their own titles.

By the mid-'60s the magazines started exploring television's other taboo topic. Extreme violence, deviant crime, drug use, serious antisocial behavior, and especially violence combined with sexuality were all skirted by TV. Naturally, these topics were not new to detective titles, but the magazines had previously played around the edges, shying away from the most prurient elements. From the 1920s through the mid-'60s detective magazines reported sexual crime from an unquestionably moral vantage point, and always with a degree of restraint. They could afford to dictate how sex crime was delivered to the public, as for 40 years true crime magazines had enjoyed a near-monopoly of this topic. Then in 1964 a slew of new and much more direct competitors emerged.

In 1952 Generoso Pope Jr. purchased the failing *New York Enquirer* and with editor Carl Grothman revamped it into *The National Enquirer*, a celebrity scandal and crime exploitation weekly — the first of its kind. The paper steadily gained popularity

PAGE 237 *Front Page Detective*, July 1969

OPPOSITE *True Detective*, May 1963

ABOVE *Did Justice Triumph?*, January 1967

BELOW *All True Real Detective*, November 1962

> **"While she detested the opposite sex, her hatred was greater for women— women who were normal."**
> — *TRUE DETECTIVE*, MAY 1963

through the 1950s and, when it increased its sensationalism in the early '60s, experienced a circulation explosion, reaching 1.1 million in 1964. The stench of this success drew other publishing scavengers to start cheap tabloids of their own, and to throw themselves into a head-on contest to outdo each other with violence, sex, and depravity. The mild, celebrity-oriented tabloids published today carry only the faintest whiff of the grisly gore-fest that assaulted shoppers at the checkout stands from 1965 to 1975. The last in the spirit was *The Weekly World News*, which ceased publishing in 2007. Nothing in print today can prepare you for a survey of *Candid Press*, *Close-up Extra*, *Flash*, *It's*

Happening, *Midnight*, or *Peeping Tom* — all titles from the 1965 – '75 period. These titles and at least 30 others splashed America's newsstands and grocery stores with sensational crime and bare boobies (on the cover!) beyond anything the detectives ever dared exhibit in their 40-year history.

To survive, the detective magazines had to respond to this left flank assault. Thus it was a combination of what television couldn't show, and what the tabloids were showing all too vividly, that pushed the detectives further into the sewer in the '60s, rather than back into insightful crime coverage. The detectives had still not reached the bottom of the pit, however.

OPPOSITE *Master Detective*, May 1962

BELOW *True Detective*, November 1961

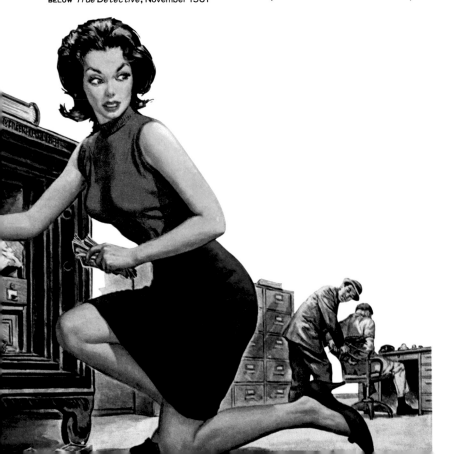

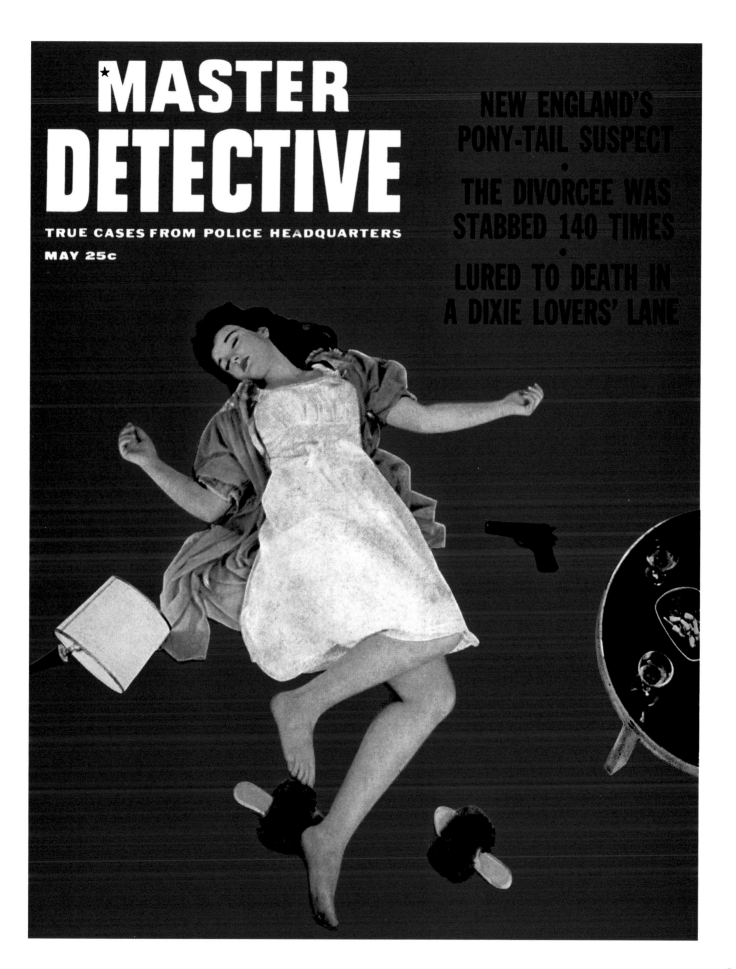

MASTER DETECTIVE

TRUE CASES FROM POLICE HEADQUARTERS

MAY 25c

NEW ENGLAND'S PONY-TAIL SUSPECT

•

THE DIVORCEE WAS STABBED 140 TIMES

•

LURED TO DEATH IN A DIXIE LOVERS' LANE

INSIDE
DETECTIVE

JAN. 50c

D.D. 19-190-901

THROUGH
HELL
ON A
BLUE PILL

ACHTUNG, ES WIRD SCHLÜPFRIG

von Eric Godtland

Wenn man sie heute betrachtet, wird deutlich, dass es mit den Detective-Titeln seit den 1960er-Jahren stetig bergab ging. Wäre man in den 1960ern der prototypische Leser dieser Hefte gewesen, ein Mann in mittleren Jahren mit konservativen Moralvorstellungen und ebenso konservativen politischen Ansichten, dann hätte der Richtungswechsel in den Magazinen genau das widergespiegelt, was man ohnehin in der Welt um sich herum zu beobachten glaubte: Dass alles zum Teufel ging.

Das Jahrzehnt fing eigentlich ganz unschuldig an, mit den gewohnten Bad Girls und den halbstarken Gang Girls in Nietenhosen, die in Mord, Raub oder Prostitution verwickelt waren. Aber gegen Mitte der 1960er änderte sich die Welt rapide, und was einst moralische Entrüstung ausgelöst hatte, wirkte jetzt nur noch altmodisch.

1960 wurde die Antibabypille erfunden. 1963 wurde Kennedy ermordet. Im selben Jahr gab Betty Friedan mit der Veröffentlichung von *Der Weiblichkeitswahn oder Die Selbstbefreiung der Frau* das Startzeichen für die moderne Frauenbewegung. 1964 verabschiedete der Kongress den Civil Rights Act und sah sich darin durch die Verleihung des Friedensnobelpreises an Martin Luther King Jr. bestätigt. 1967 erlebte den Summer of Love, und 1968 waren diese unheimlichen Black Panthers allgegenwärtig. Die Beatles von 1963 mit ihren putzigen Pilzköpfen entpuppten sich als Vorboten einer erschreckenden Horde langhaariger Anarchisten in engen Hosen, die über das ganze Land herfielen. Und als wäre das alles nicht schon schlimm genug, brach in Kalifornien die Nudistenbewegung aus ihren Camps aus und trieb ihr Unwesen auf offener Straße, und ganze Städte wie San Francisco schienen Verrückten, Hippies und Kommunisten in die Hände zu fallen. Dem konservativen älteren Amerikaner waren die gesellschaftlichen Veränderungen

allesamt zutiefst widerwärtig – und zugleich konnte er nicht genug darüber lesen.

Währenddessen zeichnete sich auch bei den Detective Magazines eine radikale Umwälzung ab. Die Verleger der Gründerjahre waren mittlerweile reif fürs Altersheim. Diejenigen von ihnen, die ihre Blätter noch nicht verkauft hatten, entschlossen sich nun, in den Ruhestand zu gehen. Die neuen jüngeren Herausgeber und Redakteure hatten keine Probleme damit, neue Wagnisse einzugehen, und da das Fernsehen weiterhin die Verkaufszahlen der Magazine in den Keller drückte, überprüften sie ihre Möglichkeiten.

Da das Fernsehen der gefährlichste Konkurrent der Printmedien war, registrierte man genau, was bei der Berichterstattung in diesem Medium nicht möglich war. Es ist sicher kein Zufall, dass der *Playboy* in dieser Zeit, in der das Fernsehen nicht einmal zeigen durfte, wie Ehemann und Ehefrau ein Bett teilten, zu einem der fünf bestverkauften Zeitschriftentitel aufstieg. Zwischen 1955 und 1966 kamen Dutzende neuer Girlie Magazines auf den Markt und machten diese Epoche zu einer goldenen Ära der Männermagazine, lange bevor Kabelfernsehen und Pornovideos ihnen das Wasser abgruben. Natürlich entging auch den Machern der Detective Magazines nicht, wie erfolgreich die Sextitel waren. So steigerten sie ein weiteres Mal den Sexanteil in ihren Heften.

Mitte der 1960er begannen die Magazine, auch andere Themen verstärkt aufzugreifen, die im Fernsehen noch tabu waren: extreme Brutalität, kriminelle Geisteskranke, Drogenmissbrauch, sozialethisch desorientiertes Verhalten und insbesondere die Kombination von Sex und Gewalt. Diese Themen waren für die Detective Magazines zwar nichts Neues, doch bislang hatte man sich nur vorsichtig von außen herangewagt und sich immer gescheut,

OPPOSITE *Inside Detective*, January 1969

ABOVE *National Informer*, January 1967

BELOW *Rampage*, May 1971

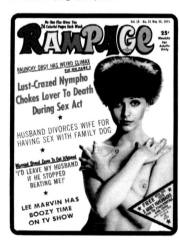

"Männer verabscheute sie, doch Frauen hasste sie – Frauen, die nicht ihren abnormen Trieb teilten!"
— *TRUE DETECTIVE*, MAI 1963

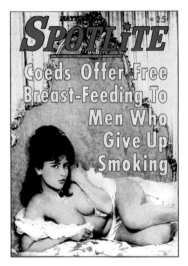

ihre allzu anstößigen Aspekte auszuschlachten. Von den 1920er-Jahren bis Mitte der 1960er-Jahre war über Sexualdelikte immer aus einer unangreifbaren Position moralischer Überlegenheit und stets mit einer gewissen Zurückhaltung berichtet worden. Die Detective Magazines konnten diktieren, wie Sexualverbrechen der Öffentlichkeit präsentiert wurden, denn rund 40 Jahre lang hatten sie praktisch das Monopol auf diese Themen. Dann, 1964, erwuchs ihnen eine ganze Schar neuer und weitaus unverblümterer Konkurrenten.

1952 hatte Generoso Pope Jr. den kränkelnden *New York Enquirer* aufgekauft und mithilfe des Chefredakteurs Carl Grothman als *National Enquirer* relauncht, ein wöchentliches Skandalblatt über Promis und Verbrechen, das erste Blatt seiner Art. Das Blatt gewann in den 1950ern beständig an Popularität, und als der Sensationsjournalismus in den frühen 1960ern hemmungsloser denn je wurde, erlebte es mit 1,1 Millionen verkauften Exemplaren 1964 geradezu eine Auflagenexplosion. Der faulige Geruch dieses Erfolgs motivierte andere Zeitungsaasgeier, Revolverblättchen gleicher Machart zu gründen, die sich gegenseitig bei der Darstellung von Sex, Gewalt und Verdorbenheit zu übertrumpfen versuchten. Die harmlosen Promi-

Klatschblätter von heute sind nur noch ein fader Abklatsch der schauerlichen Blutbäder, die Zeitungskäufer von 1965 bis 1975 an den Kiosken erwarteten. Am ehesten entsprach ihnen noch die *Weekly World News*, die 2007 eingestellt wurde. Nichts, was man heute am Kiosk kaufen kann, vermag einen auf das vorzubereiten, was *Candid Press*, *Close-up Extra*, *Flash*, *It's Happening*, *Midnight* oder *Peeping Tom*, allesamt Titel aus der Zeit von 1965 bis 1975, für einen bereithielten. Diese und mindestens 30 weitere Titel besudelten die amerikanischen Zeitungsstände und Lebensmittelgeschäfte mit reißerisch aufbereiteten Verbrechen und nackten Brüsten – auf dem Cover! –, mit Dingen, die weit über das hinausgingen, was sich die Detective Magazines in den 40 Jahren ihrer Existenz je herausgenommen hatten.

Um zu überleben, mussten die Detective Magazines diesen Angriff parieren. Weil das Fernsehen sie nicht zeigen durfte und die Boulevardblätter sie nur zu üppig ausschlachteten, widmeten sich in den 1960er-Jahren auch die Detective Magazines noch intensiver den Lustmorden, anstatt zu einer seriösen Kriminalberichterstattung zurückzukehren. Aber noch war ihre Talfahrt nicht am tiefsten Punkt angelangt.

STARTLING DETECTIVE

JANUARY 1966 • 35 CENTS

A shocking documentary dealing with homosexuality, incest, rape, abortion and murder!

SEX and CRIME

From the amazing book
by **WARDEN CLINTON T. DUFFY** *of San Quentin, With Al Hirshberg*

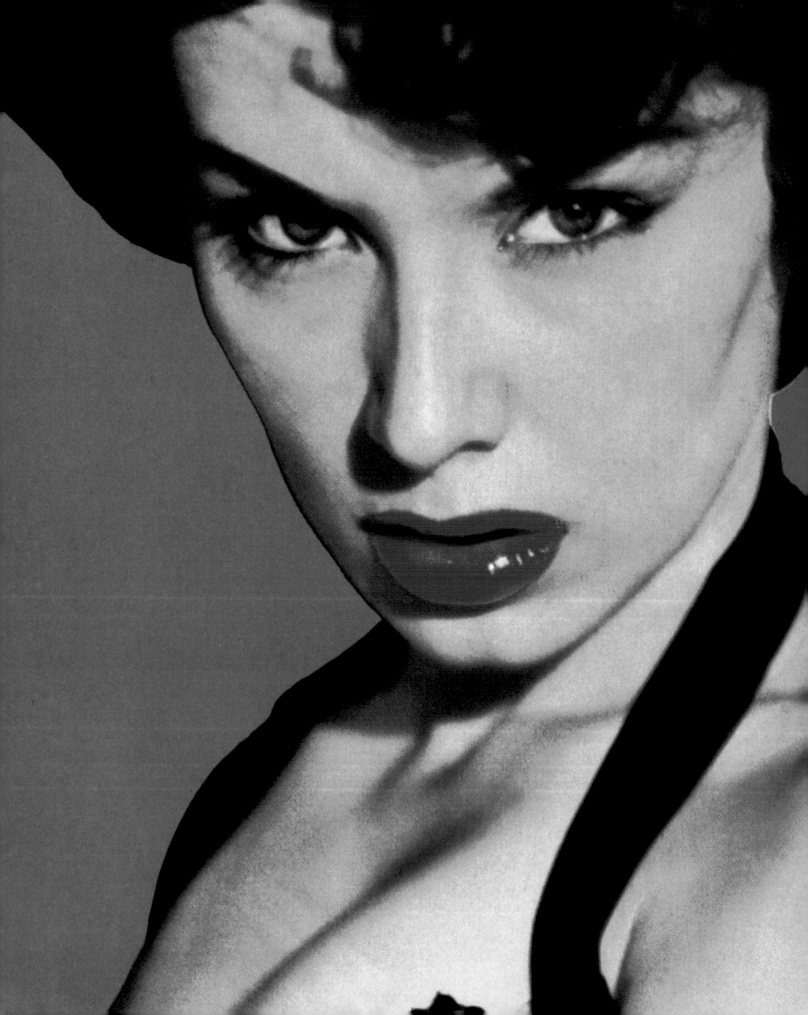

LE DÉRAPAGE DANS LE SORDIDE
Eric Godtland

La dégradation dans les années 1960 du contenu des magazines de faits divers criminels est particulièrement évidente quand on les examine aujourd'hui. Pour un Américain d'âge mûr typique des années 1960, avec les opinions morales et politiques conservatrices de la plupart des lecteurs de magazines de ce genre, la mutation de ces magazines devait refléter sa conviction que le monde ne tournait décidément plus très rond.

La décennie avait pourtant commencé assez innocemment ; elle puisait toujours dans l'imagerie des filles de mauvaise vie et des maîtresses de caïds compromises dans des affaires d'homicide, de cambriolage ou de prostitution. Au milieu des années 1960, cependant, le monde changea rapidement et ce qui était considéré comme une transgression insupportable aux bonnes mœurs quelque temps auparavant parut désormais assez anodin.

En 1960, la pilule contraceptive était inventée. En 1963, le président Kennedy était assassiné. La même année, Betty Friedan lançait le MLF en publiant *La Femme mystifiée*. En 1964, le Congrès américain votait la loi sur les droits civiques abolissant toute ségrégation entre Blancs et Noirs et Martin Luther King, incarnation de cette nouvelle ère, devenait prix Nobel de la paix. En 1967 naissait le Summer of Love et, en 1968, les Black Panthers se répandaient partout. Les Beatles, ces très fréquentables jeunes gens à frange apparus en 1963, s'avéraient soudain les précurseurs d'une véritable nuée de chevelus débraillés en jeans moulants sur le point de submerger l'Amérique. Et alors que le pays traversait une mauvaise passe, là-bas, en Californie, le nudisme s'était échappé des camps où il avait été autorisé pour se répandre dans les rues des grandes villes. On aurait dit que San Francisco était en train de devenir folle, hippie et communiste, tout cela en même temps. Les vieux

Américains conservateurs exécraient du fond du cœur cette révolution des mœurs, exécration qu'une certaine presse alimentait sans relâche.

Les magazines de faits divers criminels évoluaient, eux aussi, à grands pas : les éditeurs de la première heure étaient maintenant arrivés à un âge très avancé. Ceux qui n'avaient pas déjà vendu leurs titres choisirent de se retirer. Les nouveaux éditeurs et rédacteurs en chef plus jeunes étaient disposés à repousser les limites du genre et, devant l'hémorragie des tirages provoquée par la montée en puissance de la télévision, ils se virent forcés de faire le point.

La télévision était leur pire ennemi. Les patrons de magazines recensèrent donc les sujets que la télé ne pouvait pas couvrir. Ce n'est pas une coïncidence si *Playboy* figurait parmi les cinq plus forts tirages de magazines à une époque où même l'image d'un couple côte à côte dans le lit conjugal était prohibée. Des dizaines de nouveaux magazines de charme apparurent entre 1955 et 1965, on était à l'apogée des périodiques masculins, un âge d'or avant la concurrence du câble et des vidéos pour adultes. Évidemment, les nouveaux responsables des magazines policiers notant le succès de la presse érotique ne cessèrent de renforcer la part du sexe dans leurs propres titres.

Au milieu des années 1960, les magazines commencèrent à explorer les autres sujets tabous à la télévision. La violence extrême, les crimes hors normes, la toxicomanie, les comportements fortement déviants, notamment ceux associant violence et sexualité, n'étaient pas autorisés à la télévision. Évidemment, ces sujets n'étaient pas nouveaux pour les magazines policiers ; ceux-ci avaient déjà flirté avec ces marges, en excluant les ingrédients les plus scabreux. Des années 1920 jusqu'au milieu des années 1960, les *detective magazines*

> «Elle détestait le sexe opposé et elle n'aimait pas les femmes, les femmes qui ne partageaient pas ses instincts démesurés.»
> — *TRUE DETECTIVE*, MAI 1963

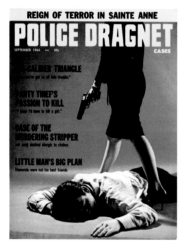

OPPOSITE *Lady-Killers*, 1964

ABOVE *Police Dragnet Cases*, September 1965

PAGE 250 *Real Detective*, October 1963

PAGE 251 *Police Dragnet Cases*, September 1961

avaient publié des enquêtes sur les crimes sexuels en adoptant un point de vue indéniablement moral et toujours avec un certain degré d'autocensure. Ils pouvaient donc se permettre d'édicter les règles selon lesquelles les crimes sexuels devaient être présentés au public, dans la mesure où, depuis quarante ans, les magazines d'enquêtes criminelles jouissaient d'un monopole de fait dans le traitement de cette question. Puis, en 1964, une ribambelle de nouveaux concurrents beaucoup plus directs firent leur apparition.

En 1952, Generoso Pope Jr. acquérait le *New York Enquirer*, alors en difficulté, et avec son rédacteur en chef Carl Grothman, en faisait le *National Enquirer*, un hebdomadaire vivant des scandales et des affaires criminelles, le premier de son espèce. Ce journal ne devait cesser d'accroître sa popularité dans les années 1950 et quand il renforça encore sa veine sensationnelle au début des années 1960, il connut une véritable explosion de son tirage, lequel atteignait 1,1 million en 1964. Le fumet nauséabond de cette réussite incita quelques vautours de la presse à lancer des tabloïds de leur cru, et à se jeter dans une surenchère où c'était à qui en rajouterait le plus dans la violence, le sexe et la dépravation. La presse à sensation d'aujourd'hui, centrée sur les «people» et dans l'ensemble modérée, n'a qu'un très vague rapport avec celle, sinistre et écœurante, des années 1965–

1975, qui assaillait le chaland dans les kiosques à journaux de l'époque. L'hebdomadaire qui s'en rapproche le plus aujourd'hui est le *Weekly World News*, à condition de remplacer son inévitable «bébé géant» et ses histoires d'extraterrestres kidnappeurs d'humains par des récits de bébés morts ou de viols cannibales. Rien de ce qu'on imprime aujourd'hui ne ressemble de près ou de loin à *Candid Press, Close-up Extra, Flash, It's Happening, Midnight* ou *Peeping Tom*, des titres qui remontent à la période 1965–1975. Ces titres, ainsi qu'au moins une trentaine d'autres, ont inondé les kiosques et les drugstores américains avec des meurtres sensationnels et des poitrines dénudées (en couverture !), dépassant allègrement tout ce que les *detective magazines* avaient jamais osé exhiber dans une histoire couvrant quatre décennies.

Pour survivre, les magazines policiers devaient répondre à cette attaque sur le flanc gauche. Ils recoururent donc à un mélange de ce que la télévision ne pouvait montrer et de ce que les tabloïds montraient déjà sans vergogne. Dans les années 1960, cette presse s'orienta donc vers toujours plus de crimes sexuels au lieu de revenir à une couverture stricte des affaires criminelles. Pourtant elle n'avait pas encore touché le fond, son extinction définitive ne devait survenir que dans les années 1970.

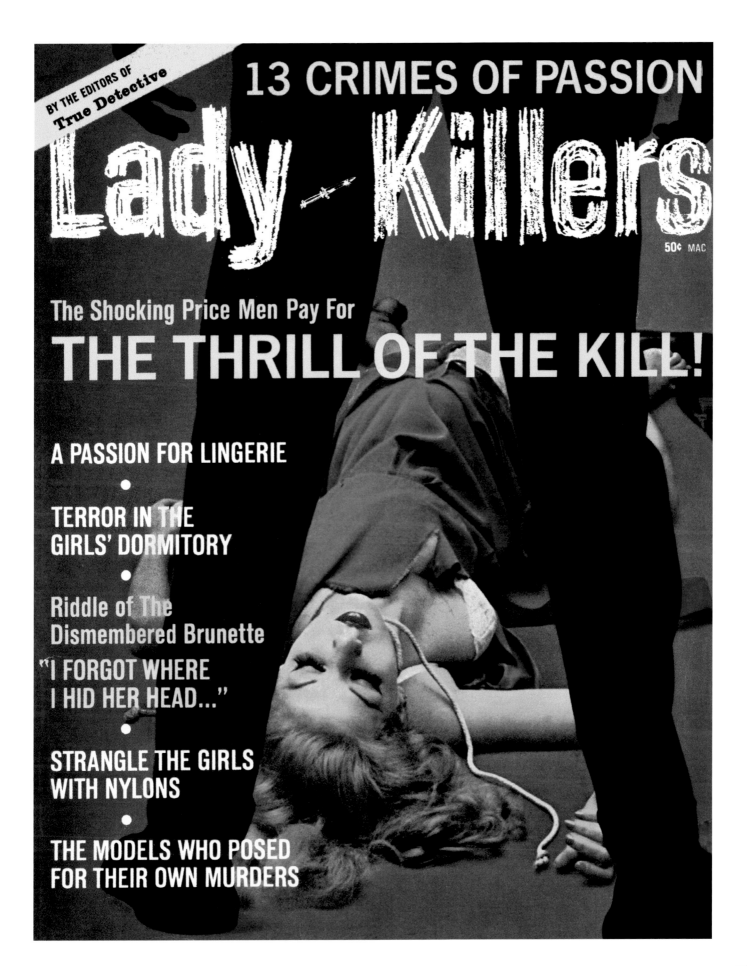

13 CRIMES OF PASSION

Lady - Killers

50¢ MAC

The Shocking Price Men Pay For

THE THRILL OF THE KILL!

A PASSION FOR LINGERIE

•

**TERROR IN THE
GIRLS' DORMITORY**

•

Riddle of The
Dismembered Brunette

**"I FORGOT WHERE
I HID HER HEAD..."**

•

**STRANGLE THE GIRLS
WITH NYLONS**

•

**THE MODELS WHO POSED
FOR THEIR OWN MURDERS**

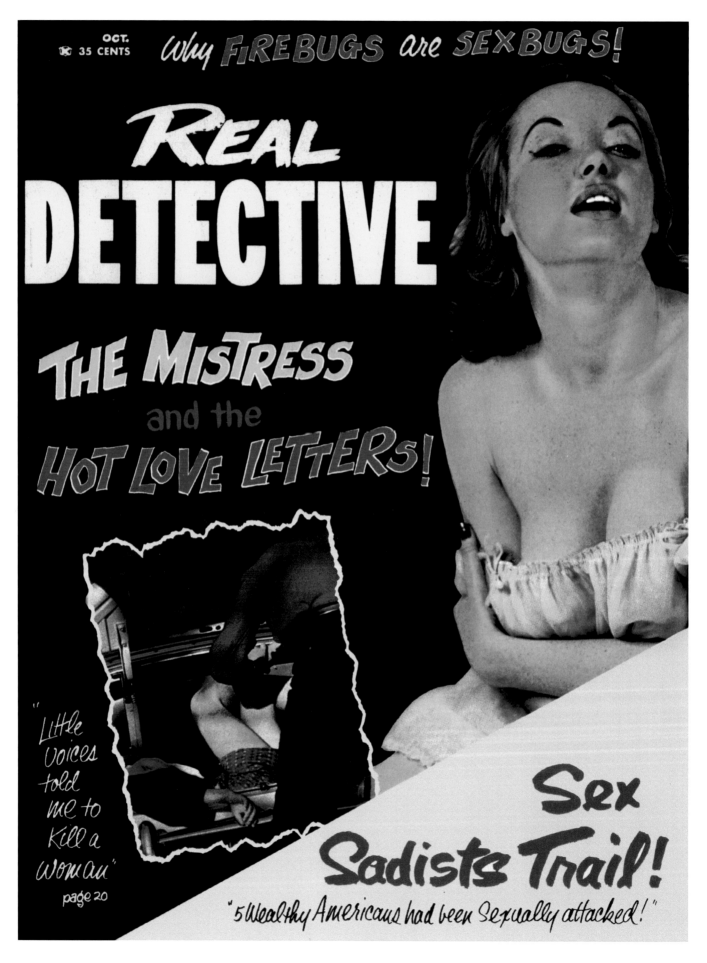

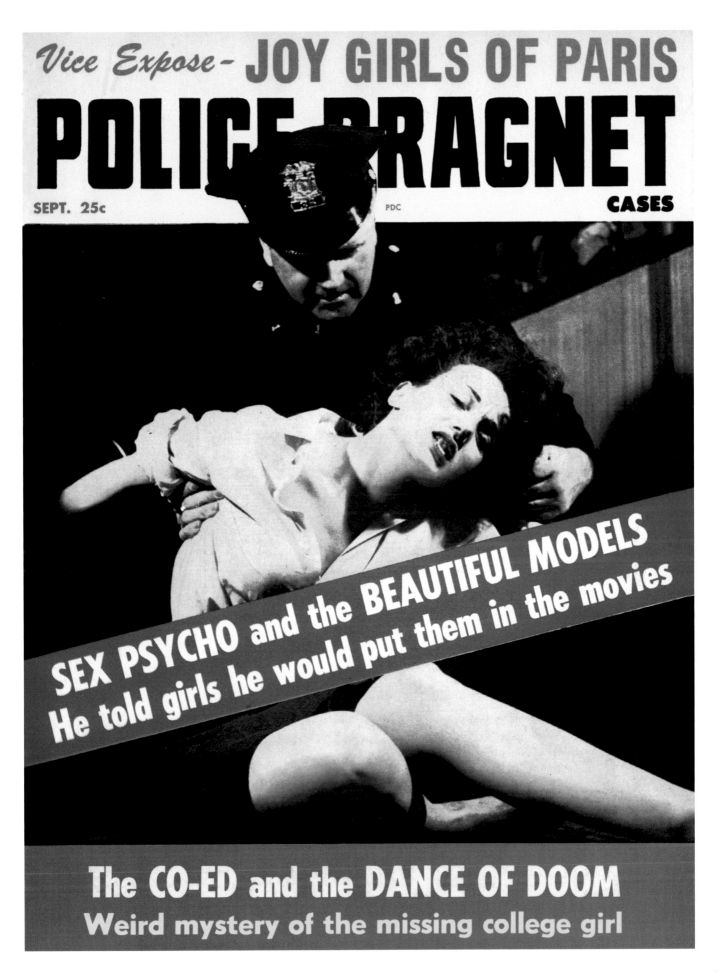

Vice Expose– **JOY GIRLS OF PARIS**

POLICE DRAGNET

CASES

SEPT. 25c

PDC

SEX PSYCHO and the BEAUTIFUL MODELS
He told girls he would put them in the movies

The CO-ED and the DANCE OF DOOM
Weird mystery of the missing college girl

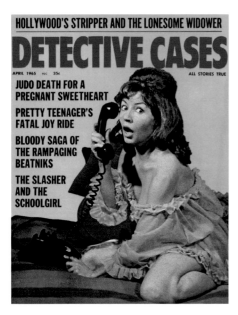

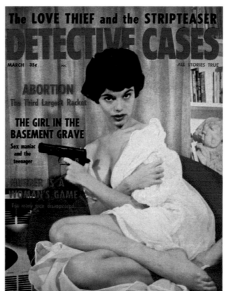

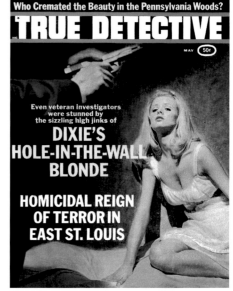

OPPOSITE *True Detective*, May 1963

ABOVE LEFT *Detective Cases*, April 1965

ABOVE CENTER *Detective Cases*, March 1963

ABOVE RIGHT *True Detective*, May 1969

PAGE 254 *Front Page Detective*, August 1969

PAGE 255 *Detective Cases*, May 1964

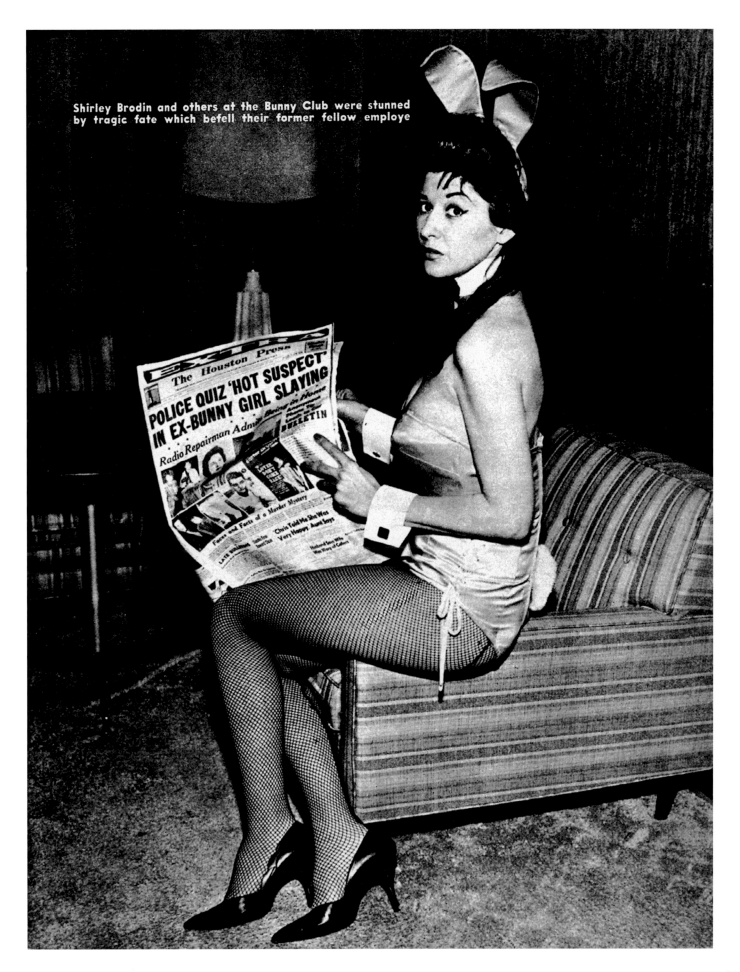

Shirley Brodin and others at the Bunny Club were stunned by tragic fate which befell their former fellow employe

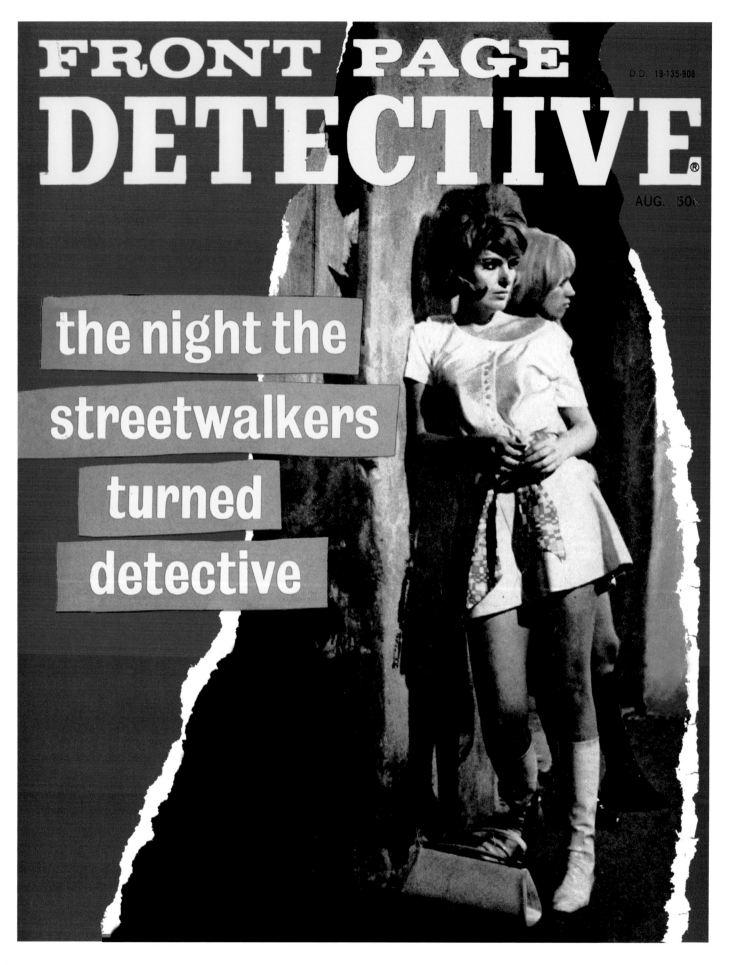

FRONT PAGE
DETECTIVE

D.D. 19-135-908

AUG. 50¢

the night the
streetwalkers
turned
detective

WHITE SLAVERY AND THE GIRL WATCHERS

DETECTIVE CASES

MAY 35¢ PDC **ALL STORIES TRUE**

HOT LOVE AND COLD MURDER

Passion played a major role in the real-life drama of the corpse that wouldn't stay dead

POISON CAME BY PARCEL POST

How brilliant detective work solved America's most sensational cross-country crime

RED LIGHT FOR DANGER

Death was waiting at the corner when the young minister stopped his car at the traffic signal

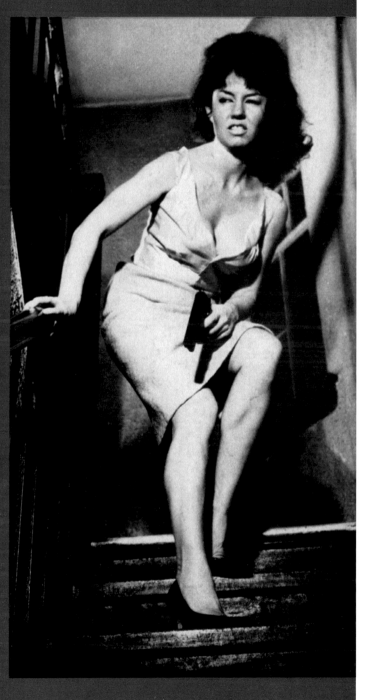

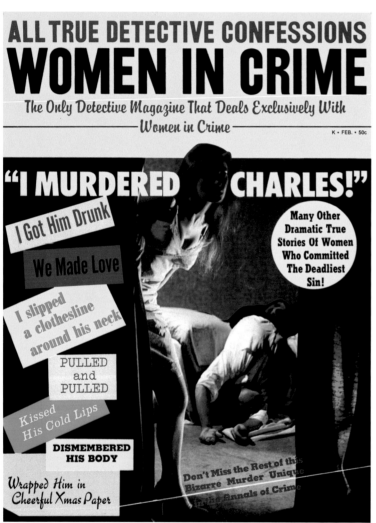

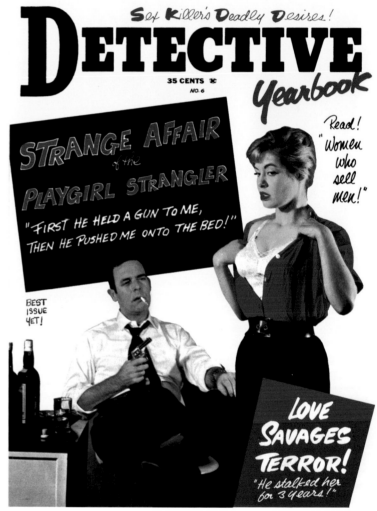

opposite *Front Page Detective*, April 1969

above left *Women in Crime*, February 1965

above right *Detective Yearbook*, 1964

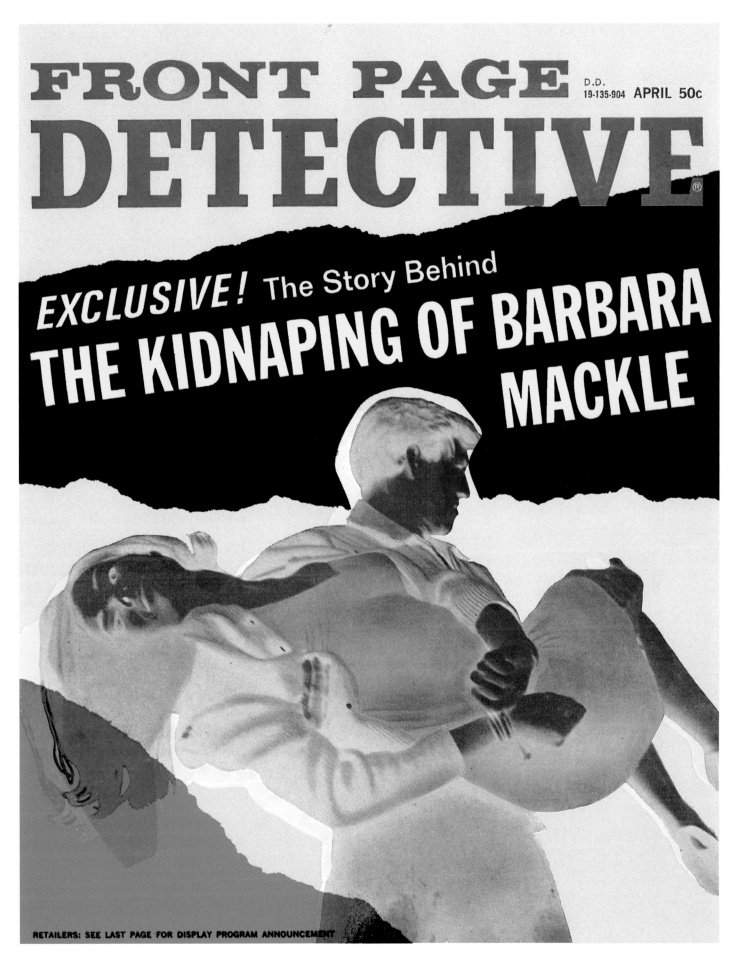

FRONT PAGE DETECTIVE

D.D.
19-135-904 APRIL 50c

EXCLUSIVE! The Story Behind
THE KIDNAPING OF BARBARA MACKLE

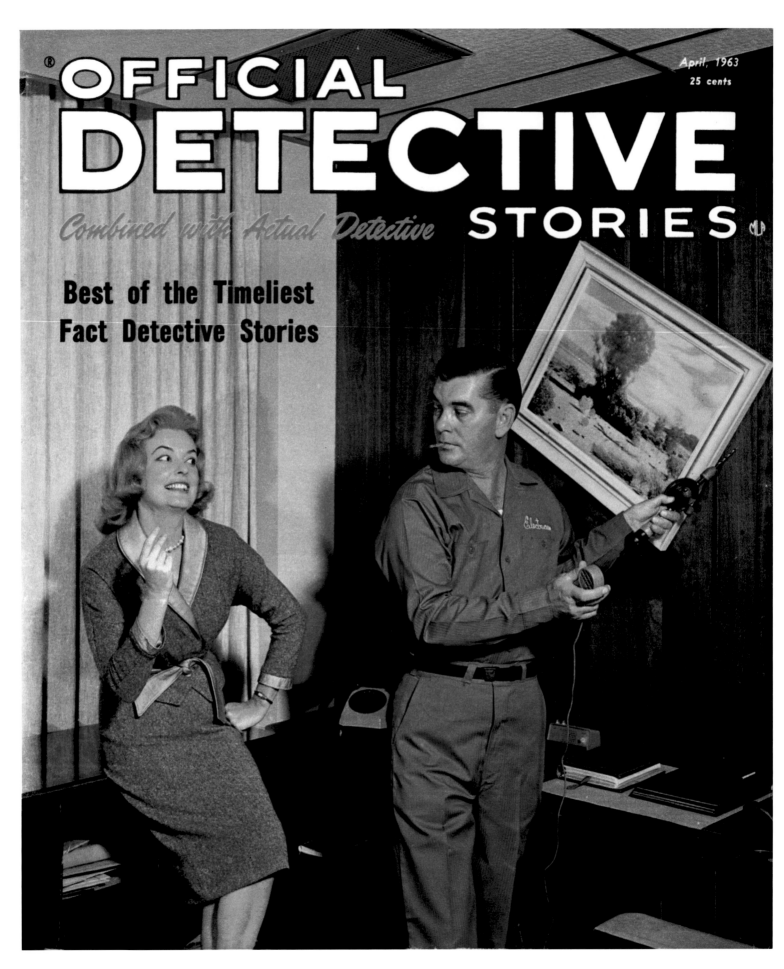

OFFICIAL DETECTIVE

Combined with Actual Detective

STORIES

April, 1963
25 cents

**Best of the Timeliest
Fact Detective Stories**

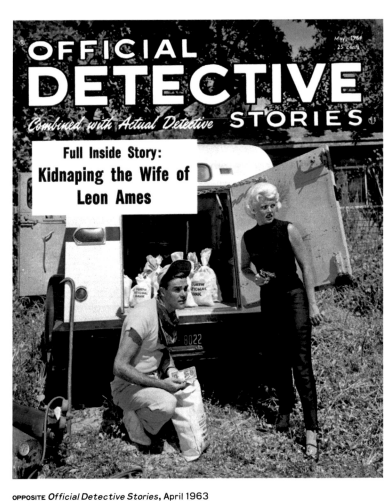

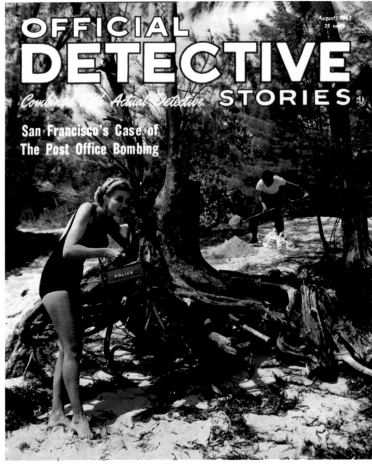

OPPOSITE *Official Detective Stories*, April 1963

ABOVE LEFT *Official Detective Stories*, May 1964

ABOVE RIGHT *Official Detective Stories*, August 1963

PAGE 260 *Detective Cases*, December 1963

PAGE 261 *Master Detective*, September 1969

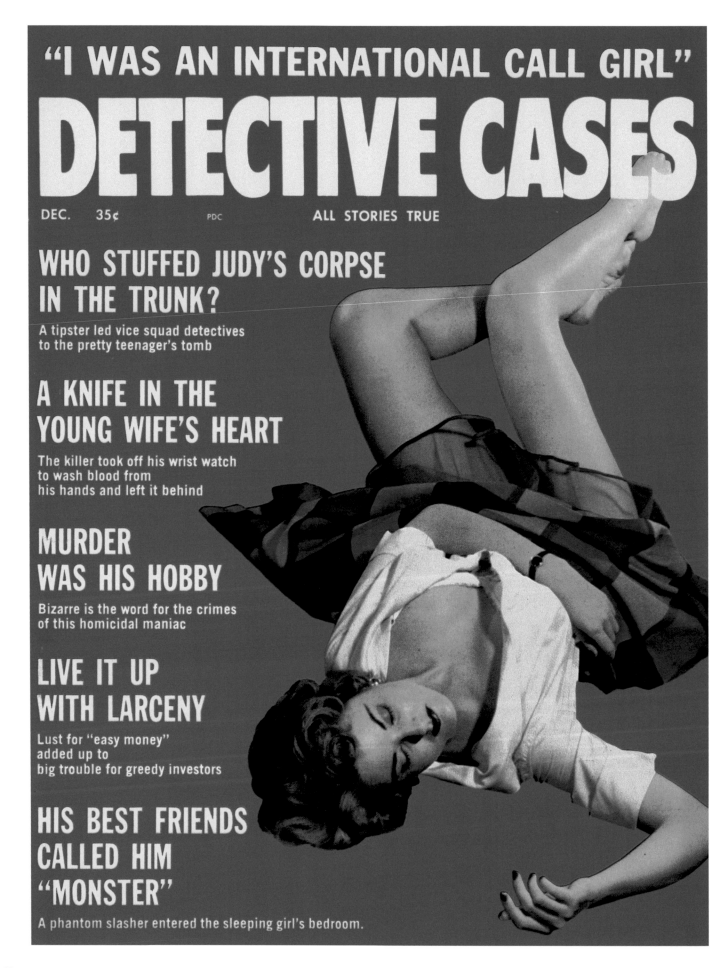

"I WAS AN INTERNATIONAL CALL GIRL"

DETECTIVE CASES

DEC. 35¢ PDC ALL STORIES TRUE

WHO STUFFED JUDY'S CORPSE IN THE TRUNK?

A tipster led vice squad detectives
to the pretty teenager's tomb

A KNIFE IN THE YOUNG WIFE'S HEART

The killer took off his wrist watch
to wash blood from
his hands and left it behind

MURDER WAS HIS HOBBY

Bizarre is the word for the crimes
of this homicidal maniac

LIVE IT UP WITH LARCENY

Lust for "easy money"
added up to
big trouble for greedy investors

HIS BEST FRIENDS CALLED HIM "MONSTER"

A phantom slasher entered the sleeping girl's bedroom.

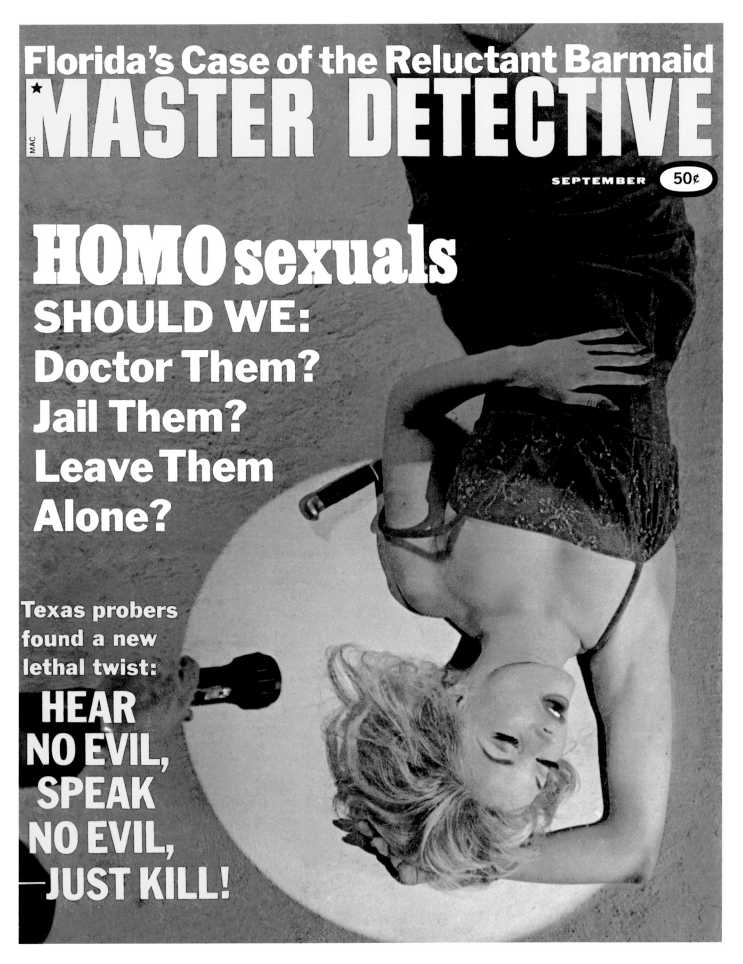

Florida's Case of the Reluctant Barmaid

MASTER DETECTIVE

SEPTEMBER 50¢

HOMOsexuals
SHOULD WE:
Doctor Them?
Jail Them?
Leave Them
Alone?

Texas probers
found a new
lethal twist:

**HEAR
NO EVIL,
SPEAK
NO EVIL,
JUST KILL!**

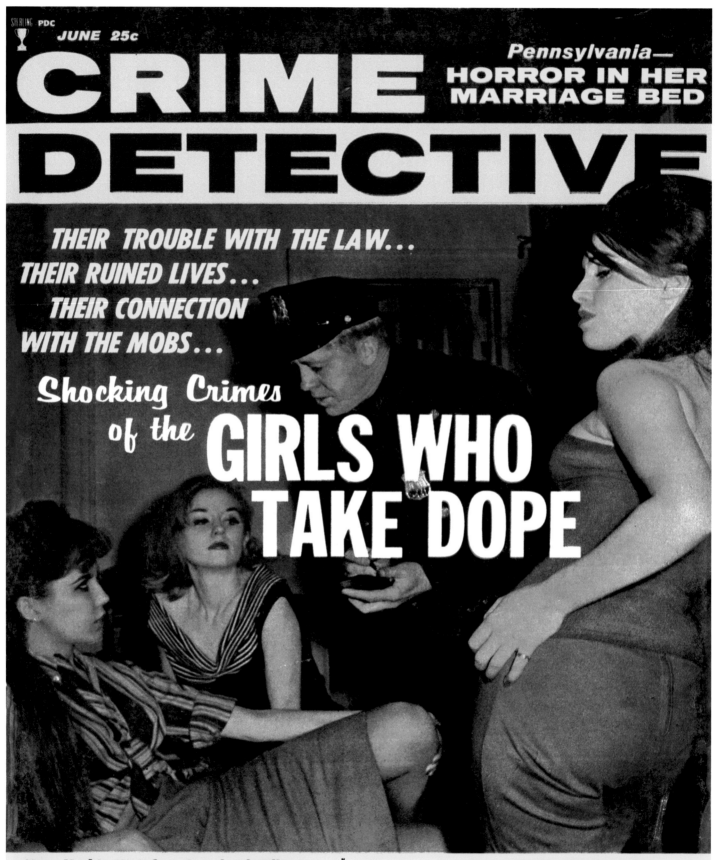

STERLING PDC

JUNE 25c

Pennsylvania—
HORROR IN HER MARRIAGE BED

CRIME DETECTIVE

THEIR TROUBLE WITH THE LAW...
THEIR RUINED LIVES...
THEIR CONNECTION
WITH THE MOBS...

Shocking Crimes
of the **GIRLS WHO TAKE DOPE**

New York's Weirdest Gangland Killing—
SHE WAS LITTLE AUGIE'S GORGEOUS MURDER JINX

Hunted across Wyoming by 100 Armed Men—
MAD GUNMAN AND HIS WILDCAT BRIDE

"'But that's the woman!' exclaimed
Sergeant Millendorf in a dumbfounded
voice. 'See the breasts? What was
she? A hermaphrodite or what?'"

— *STARTLING DETECTIVE YEARBOOK*, UNDATED

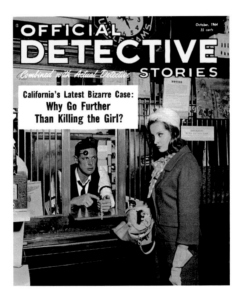

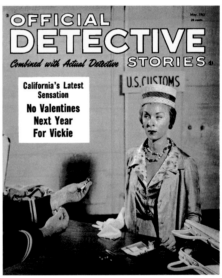

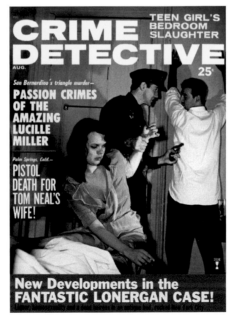

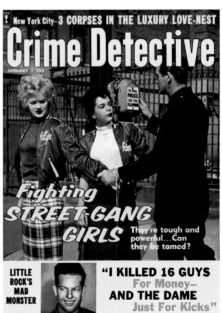

OPPOSITE *Crime Detective*, June 1962

CLOCKWISE FROM ABOVE LEFT *Official Detective Stories*, October 1964; *Official Detective Stories*, May 1961; *Crime Detective*, January 1961; *Crime Detective*, August 1965

"She was a wild little thing, with a regular collection of those bushy-haired beatniks in tight trousers."

— *OFFICIAL DETECTIVE STORIES*, JANUARY 1967

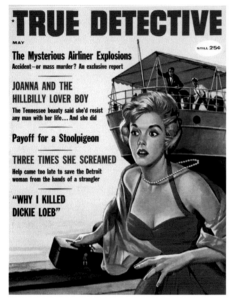

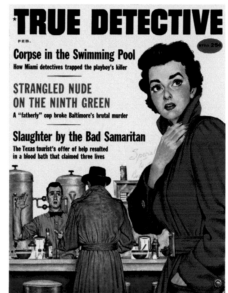

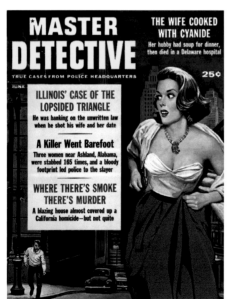

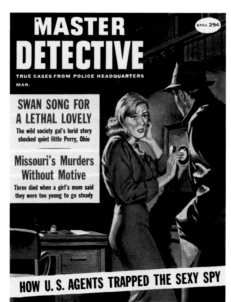

OPPOSITE *True Detective*, September 1966

CLOCKWISE FROM ABOVE LEFT *True Detective*, May 1960; *True Detective*, February 1960; *Master Detective*, March 1960; *Master Detective*, June 1961

PAGE 266 *Unsolved Murders*, Summer 1964

PAGE 267 *Front Page Detective*, June 1969

TRUE DETECTIVE

MAC

SEPTEMBER 35¢

At Last—A New Trap for Telephone Perverts!

The evidence stunned veteran detectives—
SLAYING OF THE CALIFORNIA PRIEST

Requiem for a pretty Texas divorcee...
COUNTRY MUSIC TO GET MURDERED BY

A 'first' for Cincinnati ballistics experts:
"SHAVED" BULLETS KILLED THE OHIO BARBER

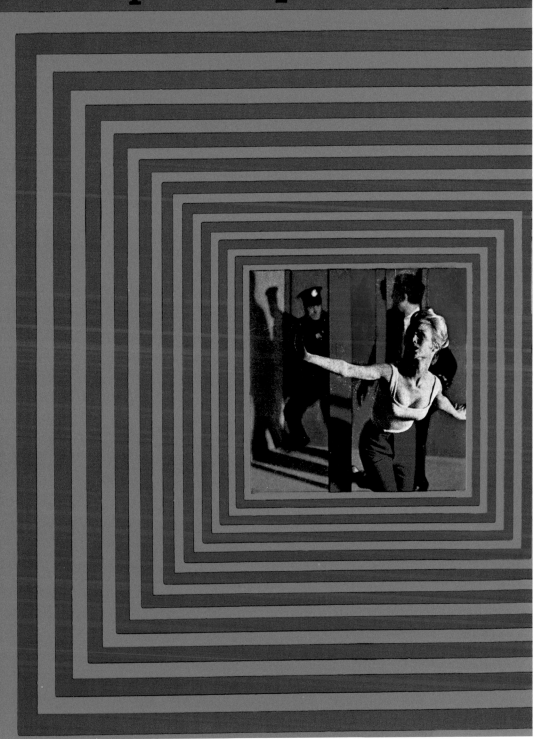

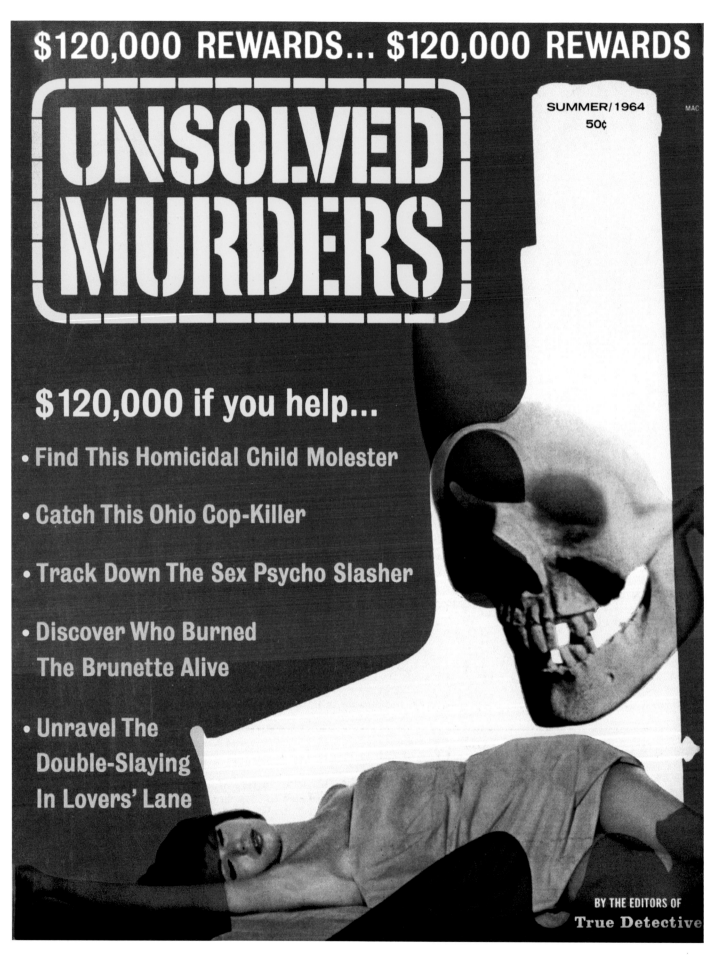

FRONT PAGE DETECTIVE

D.-D. 19-135-906

JUNE 50c

BLOODY TRAIL OF A LADY-KILLER

Louisiana Trailer Camp Murder

CHAIN THEM, ROB THEM, SHOOT IF YOU MUST

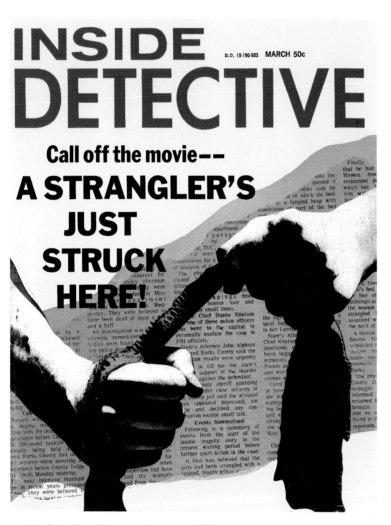

"The place: a fourth-rate bar in Pueblo, Colorado. The characters: two men. Both had a common obsession — sex."

— *HEADQUARTERS DETECTIVE,*
FEBRUARY 1966

OPPOSITE *Front Page Detective*, September 1969

ABOVE *Inside Detective*, March 1968

D.D. 19·135·909
SEPT. 50c

RONT PAGE
DETECTIVE®

as Vegas Beauty Strangled

'VE
COME
TO
KILL
YOU!

In her 3rd marriage,
lovely Ruth Janjua
sought happiness,
found only death

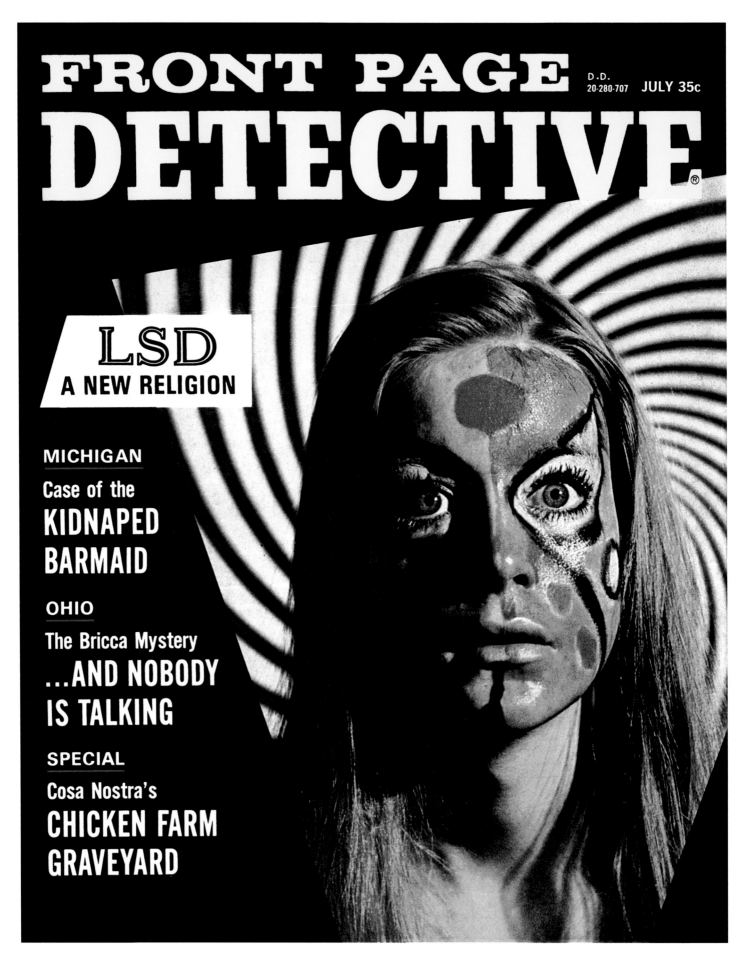

FRONT PAGE
DETECTIVE®

D.D.
20-280-707 JULY 35c

LSD
A NEW RELIGION

MICHIGAN
Case of the
KIDNAPED
BARMAID

OHIO
The Bricca Mystery
...AND NOBODY
IS TALKING

SPECIAL
Cosa Nostra's
CHICKEN FARM
GRAVEYARD

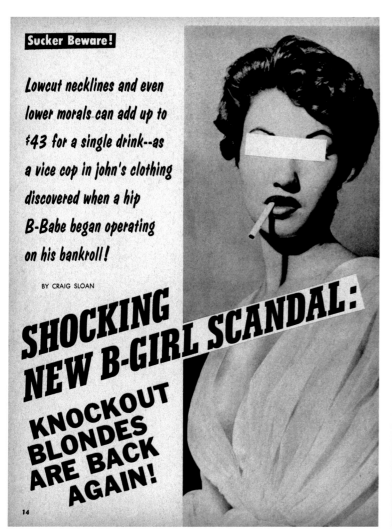

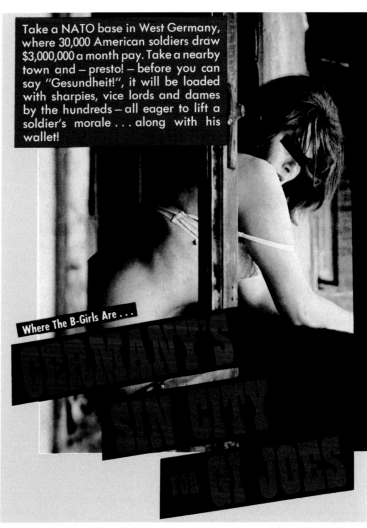

Sucker Beware!

Lowcut necklines and even lower morals can add up to $43 for a single drink--as a vice cop in john's clothing discovered when a hip B-Babe began operating on his bankroll!

BY CRAIG SLOAN

SHOCKING NEW B-GIRL SCANDAL:

KNOCKOUT BLONDES ARE BACK AGAIN!

14

Take a NATO base in West Germany, where 30,000 American soldiers draw $3,000,000 a month pay. Take a nearby town and — presto! — before you can say "Gesundheit!", it will be loaded with sharpies, vice lords and dames by the hundreds — all eager to lift a soldier's morale . . . along with his wallet!

Where The B-Girls Are . . .

GERMANY'S SIN CITY FOR GI JOES

OPPOSITE *Front Page Detective*, July 1967

ABOVE LEFT *Vice Squad*, April 1963

ABOVE RIGHT *Vice Squad*, August 1964

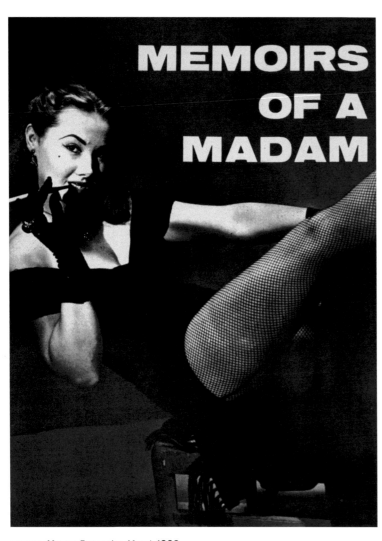

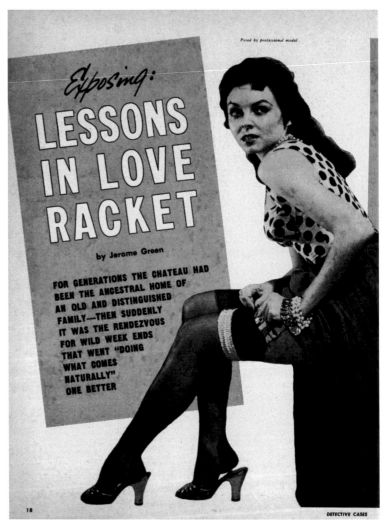

OPPOSITE *Master Detective*, March 1962

ABOVE LEFT *All True Police Detective*, June 1965

ABOVE RIGHT *Detective Cases*, August 1963

PAGE 274 *Inside Detective*, December 1963

PAGE 275 *True Police Cases*, June 1968

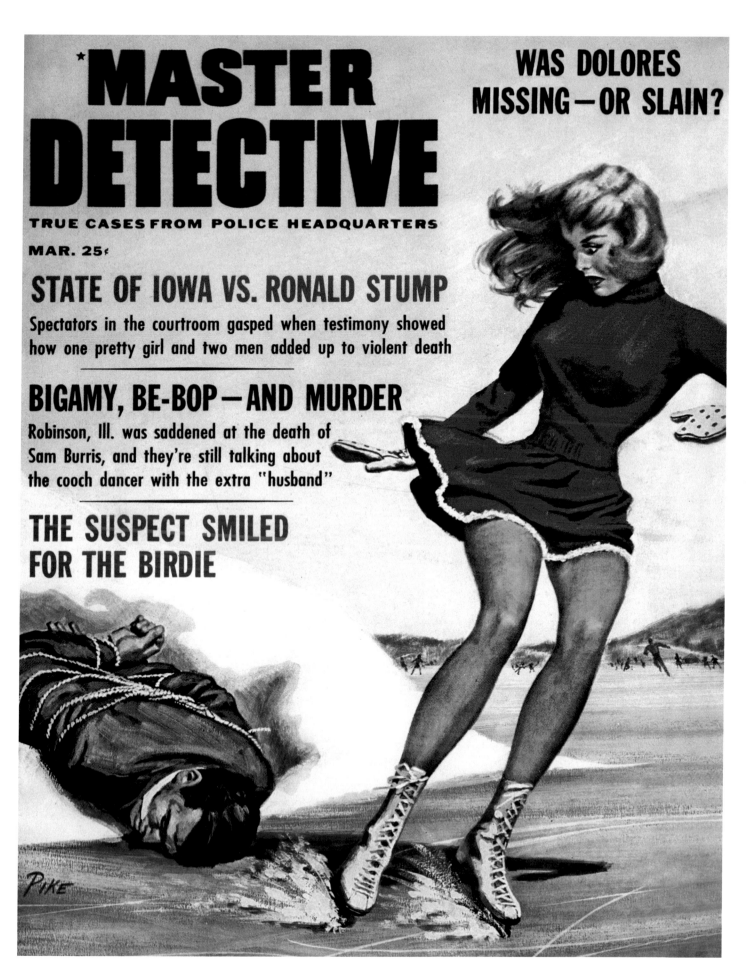

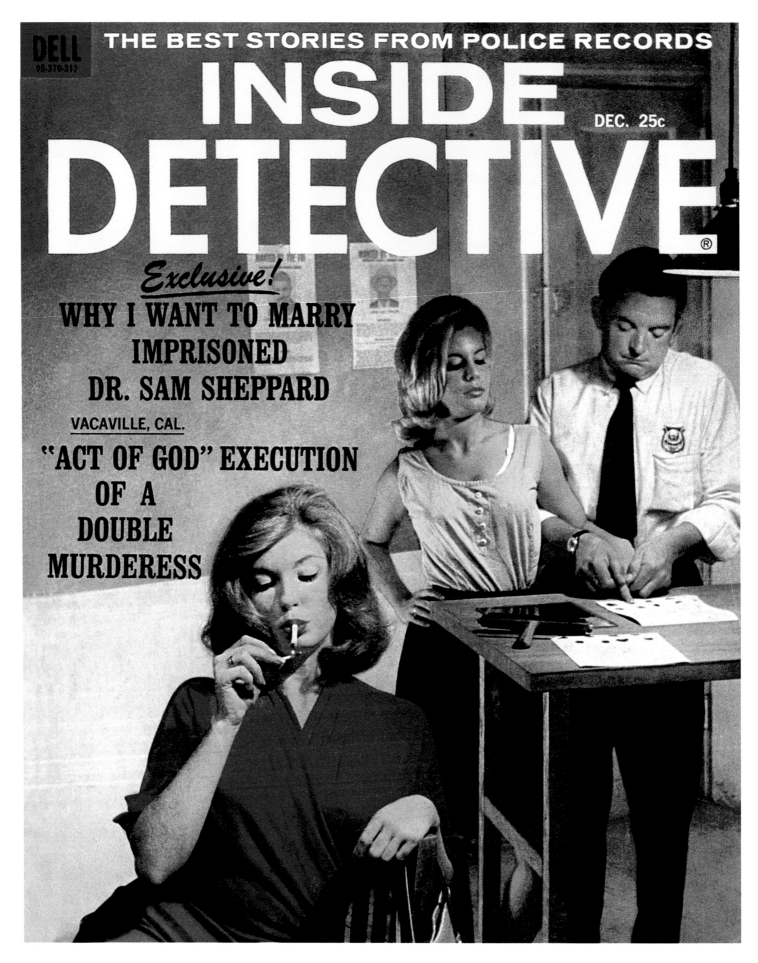

THE BEST STORIES FROM POLICE RECORDS

DELL
05-370-312

INSIDE DETECTIVE

DEC. 25c

®

Exclusive!

WHY I WANT TO MARRY
IMPRISONED
DR. SAM SHEPPARD

VACAVILLE, CAL.

"ACT OF GOD" EXECUTION
OF A
DOUBLE
MURDERESS

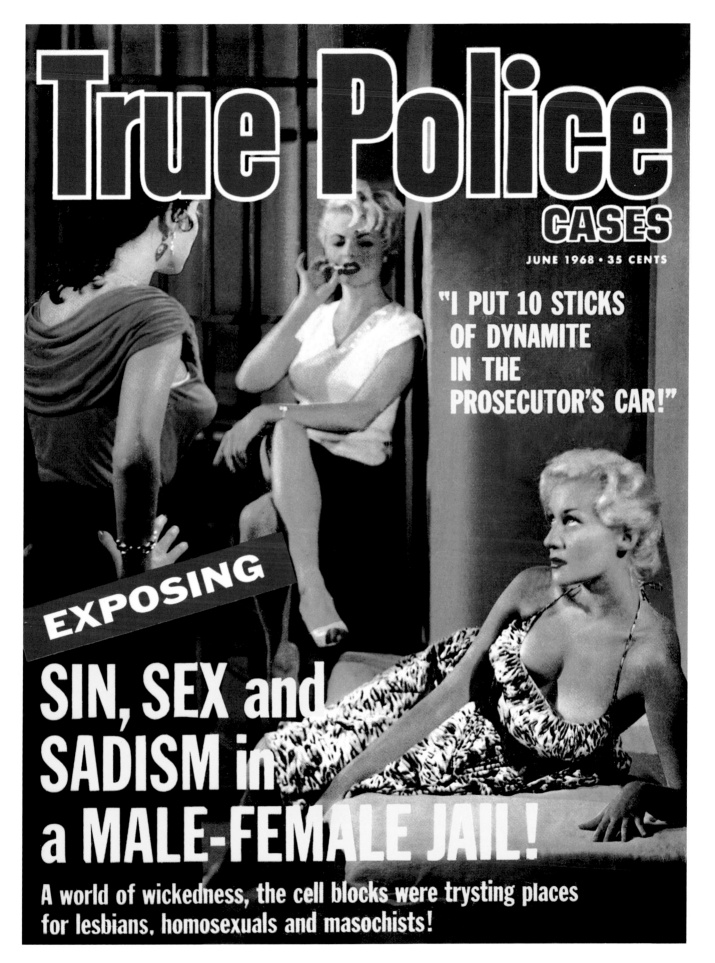

True Police CASES

JUNE 1968 • 35 CENTS

"I PUT 10 STICKS OF DYNAMITE IN THE PROSECUTOR'S CAR!"

EXPOSING

SIN, SEX and SADISM in a MALE-FEMALE JAIL!

A world of wickedness, the cell blocks were trysting places for lesbians, homosexuals and masochists!

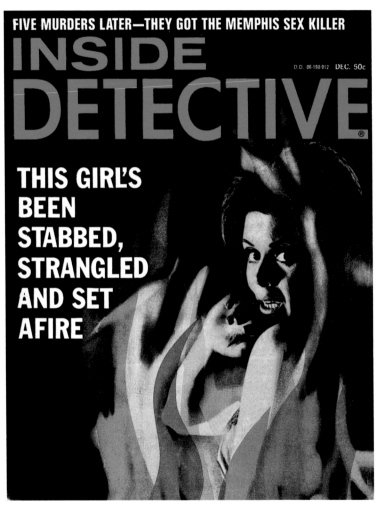

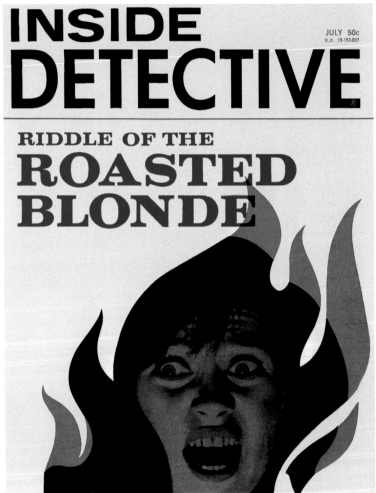

OPPOSITE *Inside Detective*, April 1969

ABOVE LEFT *Inside Detective*, December 1969

ABOVE RIGHT *Inside Detective*, July 1969

INSIDE DETECTIVE

D.D. 19-190-904 APRIL 50c

ARSON-MURDER CHARGED AS 6 DIE

IF YOU CAN'T BEAT 'EM—BURN 'EM

RETAILERS: SEE LAST PAGE FOR DISPLAY PROGRAM ANNOUNCEMENT

JAMES MICHAEL ROBBINS. *Alias,* Robinson. *Felony Theft.* Reward: TRUE DETECTIVE, $100. Age, 56; height, 5 feet, 10 inches; weight, 135 pounds; eyes, gray; hair, brown. *If located, wire Director Homer Garrison, Jr., Department of Public Safety, Camp Mabry, Austin, Texas.*

F.P.C. $\dfrac{8)\quad O\quad 29\qquad OIO\ 21}{I\ \ 18\ \ U\ \ OOI\ 21}$

BILLIE BERLIN BLEDSOE. *Armed Robbery.* Reward: TRUE DETECTIVE, $100. Age, 28; height, 6 feet; weight, 165 pounds; eyes, light brown; hair, dark brown, wavy; build, slender; complexion, medium. Oblong burn scar outside left forearm. Occupation, laborer. *If located, wire Chief of Detectives O. N. Martin, Police Department, Little Rock, Arkansas.*

F.P.C. $\dfrac{19)\quad 1\ \ Rr\quad 9}{1\ \ T\quad 11}$

JOSEPH HENRY SULLIVAN. *Murd* Rewards: TRUE DETECTIVE, $100; a thorities, $100. Age, 67; height, 5 fe 6 inches; weight, 145 pounds; hair, gra complexion, medium. Left index fin amputated at tip. Occupation, glazi watchman. *If located, wire Chief Police Elmer O. Stovern, Police Depa ment, Duluth, Minnesota.*

F.P.C. $\dfrac{18\ \ O\ \ 31\ \ W\ \ IOO\ \ 18\ \ AM}{M\ \ 20\ \ W\ \ III\qquad 14}$

APRIL, 1942

lice. Official charges appear below each photo.

ENARDO SCAVONE. *Alias*, Sarlo. *Murder.* Reward: TRUE DETECTIVE, 00. Age, 57; height, 5 feet, ⅛ inch; eight, 125 pounds; eyes, dark brown; air, black; complexion, florid; build, nall. Several upper teeth missing. Cut ar on lower lip at middle line. Occuation, laborer. *If located, wire Chief Detectives Thomas V. Meegan, Police epartment, Buffalo, New York.*

	12	M	11	R	OOO	16
F.P.C.						
		S	1	U	OIO	16

JOHN CHRISTOPHER ABELE. *Aliases*, E. E. Beckman, A. B. Conner, J. A. Wilkinson. *Bank Robbery.* Reward: TRUE DETECTIVE, $100. Age, 38; height, 5 feet, 9¼ inches; weight, 160 pounds; eyes, blue; hair, light chestnut; build, slender. Occupation, radio technician. Expert golfer. Uses poor English. *If located, wire Director J. Edgar Hoover, Federal Bureau of Investigation, Washington, D. C.*

	9	S	1	R	III	7
F.P.C.						
			S	1	Rt	II

PHILIP H. CHADWICK. *Aliases*, Chatard, Adams. *Violation of Federal Narcotics Laws.* Rewards: TRUE DETECTIVE, $100; authorities, **$1,000**. Age, 43; height, 5 feet, 8 inches; weight, 150 pounds; eyes, blue; hair, black; complexion, medium dark; build, slender. Is of Irish-French descent. *If located, wire Commissioner H. J. Anslinger. Treasury Department, Bureau of Narcotics, Washington, D. C.*

	20	M	9	R	I	6
F.P.C.						
		L	1	T	II	5

REWARDS $1900

I WAS A
TRUE DETECTIVE EDITOR
by Marc Gerald

DATELINE: NEW YORK CITY. 1989.

I was 22, just out of college, and looking for summer work to tide me over until graduate school kicked in that fall. Magazines seemed a natural destination, what with my degree in intellectual history, but with slots at *The New Yorker* and all the other high brows long taken, I set my sights a little lower. OK, a lot lower. An obsessive fan of *True Detective* magazine since my teens, I called its editor, Art Crockett, to inquire about jobs. "Good timing," he laughed. The magazine's longtime associate editor had died over the weekend and Crockett was just writing out his first "help wanted" in 20 years.

Dressed in my flea market finest, I hurried up to the magazine's Hell's Kitchen headquarters to meet with Art and his then chief lieutenant, Rose Mandelsberg. They made an interesting pair, the so-called King and Queen of the Dickbooks. Art was about 70, had a wandering right eye, wore three-piece suits, and chain-smoked Camels. A true pulp veteran, he'd worked in a variety of its genres, including men's adventure, suspense, and Westerns, since World War II. Rose was about half his age. A full-figured redhead whose fashion sense leaned toward the gaudy, she'd started as a secretary in the '70s and advanced to running *True Detective*'s sister magazines, *Master Detective*, *Inside Detective*, *Official Detective*, and *Front Page Detective*.

My interview went well enough, I guess. After wowing them with detailed descriptions of the exploits of my favorite serial killers, and literary critiques of my favorite true crime writers, I was ushered into a little room off the hall for a test edit. There before me were five photographs and a case file. My job was to caption the photographs.

I must admit, time (and many hundreds of crime cases) has dulled my memory of the particular homicidal humdinger I wrote that day, but my captions must have slayed 'em because a message was waiting for me when I got back to my apartment. The job was mine. The pay: a whopping $265 a week. I was inordinately thrilled. There was no way in hell I was going to grad school.

"I'm going to teach you the most important lesson you need to know to be a successful editor here," Art told me while redlining a couple of my cover line concepts. I'd been at the magazine about a week and was eager to soak up the King's wisdom.

"See this girl?" Art said, pointing to a grainy photograph of a fat, unsmiling Midwestern housewife. She was our story's murder victim, shown during happier times. "She's beautiful. In fact, I might even call her ravishing. Call this story 'No Mercy for the Ravishing Co-ed.'"

I was confused. "But she's 35 if she's a day. And ugly as hell!"

"When was the last time you bought a magazine about an ugly old woman?" Art asked. "Around here, a tomato's sexy, lovely, sultry even, unless she's truly ugly, and I mean truly terrifying to look at."

"What is she then?" I asked.

"Fun-loving." Art picked up the photograph and took a second look. "And from the looks of things, I'd say you're probably right. This girl looks fun-loving to me."

Nobody was getting rich off *True Detective* in 1989, so cover selection was no laughing matter. With no promotion budget, and no subscription base to speak of, the magazine was strictly a low-budget, point-of-purchase affair. Only a great cover sold the magazine; a bad one meant the die-hards picked the competition, one of Globe Publication's better-distributed and equally grisly offerings, including *True Police Cases*, *Startling Detective*,

OPPOSITE *True Detective*, June 1951

BELOW *True Detective Mysteries*, December 1937

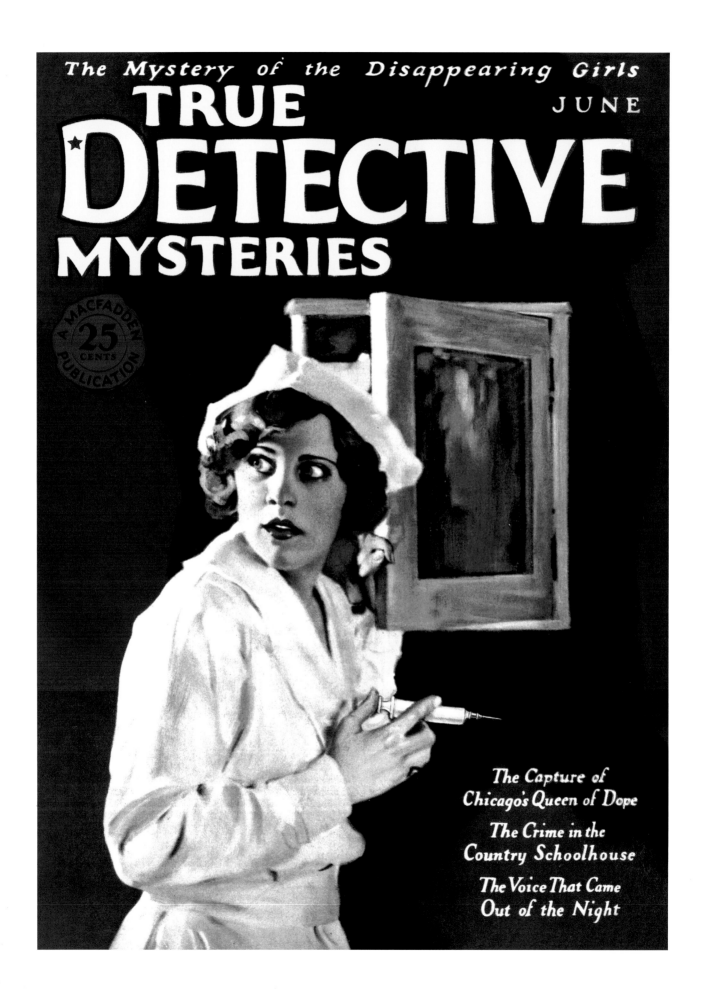

The Mystery of the Disappearing Girls

TRUE
JUNE

★DETECTIVE
MYSTERIES

A MACFADDEN PUBLICATION
25 CENTS

*The Capture of
Chicago's Queen of Dope*

*The Crime in the
Country Schoolhouse*

*The Voice That Came
Out of the Night*

"Gritty, dangerous, and retrospectively hip, <u>TD</u>'s format was established in its very first issue..."

Detective Files, *Dragnet Detective*, *Headquarters Detective*, and *Detective Cases*.

Art was fighting an uphill battle to keep *True Detective* alive. He could still pump out masterful story titles and cover copy on his Royal manual like "Excuse Me or I'll Kill You Next," and "Mother's a Hooker, My Wife's a Pervert and I'm Humiliated." Gone, however, were the Vargas-style, dames-in-distress covers of the '40s and '50s, as well as the misogynistic bondage nastiness that typified the covers of the '60s and '70s. Covers now showcased a kind of trailer-trash realism featuring tired, plain girls with fake guns posed in front of ludicrous country backdrops.

It just wasn't working. *True Detective* was owned in 1989 by a singularly dull father-son team named Reese Publications who had launched and folded over 50 magazines since the late 1950s, before getting (temporarily) lucky in the early '80s with *Video* magazine. The combined circulation for *True Detective* and its four sisters had slipped dramatically through the '80s to about 500,000. Still, there was apparently a modest profit, as it wasn't like Jay Rosenfield and his old man to keep *TD* going for the sake of the art, or because it was the title that invented the whole true crime magazine genre.

The *True Detective* I worked for was about a million miles from the lush glamour of the magazine fitness fanatic Bernarr Macfadden started in 1924 as part of his so-called "True" line. Along with *True Romance*, *True Story*, and *True Confessions*, *True Detective* took real people and put them in extraordinary places and situations. It wasn't the first true crime publication — that honor belongs to the broadsheet *Newgate Calendar* (first published in 1773), followed by *The National Police Gazette* tabloid — but it was the first magazine, and the first to bring real murder and mayhem into the modern age.

Gritty, dangerous, and retrospectively hip, *TD's* format was established in its very first issue as intricately staged crime scene photographs accompanied by 5,000-word crime-solving narratives. The magazine was pitched to readers who liked their cops heroic and their killers hard-nosed and brutal. As Macfadden melodramatically proclaimed in the magazine's original mission statement: "Stories will follow the clever, brainy, and brave men who investigate bizarre crimes committed by cunning men who leave no clues behind them and take the tangled knot of circumstances in their hands and slowly, patiently unwind all of its twistings and windings, until finally the great secret is revealed and the criminal is brought to justice."

While detective fiction magazines like *Black Mask* and *Amazing Detective*, which were also coming into their own in the '20s, featured better, more stylized writing filled with moral ambiguity and complex characters, *True Detective* had a major, unspoken selling point they lacked: sex. By 1928 the magazine was cheerfully covering murder in all of its manifestations, but it specialized in psychosexual violence, a successful formula all imitators would follow. Indeed, the only thing better than a grisly murder in a real-life detective magazine was a long, protracted rape before the murder that could be "purpled up" and told over the course of several hundred feverish words. Even if there was no evidence that it happened, a writer could, and would, still speculate about it. The formula never changed; early in my tenure Art taught me how to eliminate the *National Geographic* prologues some of our less understanding writers went in for — "It was a cold night along the shores of Maine..." — in favor of a more titillating, sexed-up intro.

"Yes, I realize she was brutally murdered," he would explain of a particular story's hapless

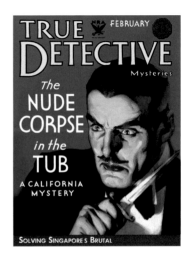

OPPOSITE *True Detective Mysteries*, June 1926

ABOVE *True Detective Mysteries*, February 1934

BELOW *True Detective Mysteries*, December 1925

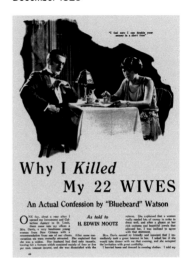

"You didn't have to be rich to get your story in our lurid pages ... All that was required to find stardom in <u>True Detective</u> was to die a semi-interesting death."

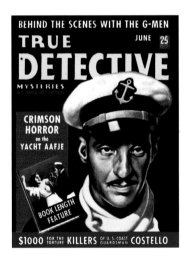

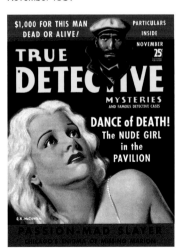

crime victim, "but what do you suppose she and her husband were doing the night before she got herself killed?"

Call it sick and twisted, or porn for psycho killers, but readers steeped in Judeo-Christian concepts of sin and retribution definitely responded to the formula. *True Detective* sold 2,000,000 copies a month at one time and spawned as many as 75 imitators to battle it out for newsstand space during true crime's peak of popularity just before World War II. *True Detective*'s readers never really lost their taste for blood, but by the mid-1950s the genre was in decline, a casualty of television, spiraling inflation, and changing literary tastes. Macfadden himself died in 1955, though he'd lost control of his company years before. The holding company that survived him would sell off the magazine to Reese in the late '60s.

While its audience hadn't completely abandoned the brand by the time I arrived, *True Detective* needed a major makeover of a format that hadn't changed a lick since its very first issue. The 5,000-word stories felt way too long for the modern reader and the language had gotten ridiculously moldy. *TD* may have been the last place on Earth where "lawmen" un-ironically "ferreted" for clues in cases that were real "lulus." Such text, and the magazine's peculiar fascination with devil worshippers, added to its camp appeal, but did nothing for sales.

The greatest problem was the editorial guidelines. While *True Detective* always lionized law enforcement, past editors (and looser libel laws) had allowed authors latitude to tell stories from multiple points of view, including the killer's own extreme and idiosyncratic voice. When I arrived police procedurals told in the third person were the only show in town. Printed guidelines from the 1980s and 1990s demonstrate how restrictive the format had become:

"All stories must be post-trial with the perpetrators convicted and sentenced at the conclusion"; "We also prefer that cases involve not more than three suspects. Too hard to follow otherwise"; "Do not pinpoint the guilty person too early in the story because it kills suspense."

It took serious journalistic and storytelling gifts to follow the guidelines and write a *True Detective* story that was still interesting. Unfortunately, most of our writers were unequal to the challenge. Not that I blamed them. Back in 1924 *True Detective* paid a princely $250 to $300 for 5,000 words. Indeed, cult favorite Jim Thompson, author of *The Killer Inside of Me* and *After Dark, My Sweet*, along with crime and suspense notables like Dashiell Hammett, Lionel White, Day Keene, Lawrence Treat, Bruno Fischer, Harry Whittington, and Harlan Ellison, not only cut his teeth writing for the magazine, he supported his family throughout the 1930s and 1940s largely on the magazine's generous pay. Fifty years later, writers were still making that same $250 for 5,000 words.

Somehow the best (or least beaten) writers on our roster could still bring chills to our faithful. Ann Rule, writing under these preposterous circumstances, rose far above the confines of the formula to produce some dazzling and truly harrowing stories. Sadly, she had quit writing for the magazines several years before my tenure began, though well after her best-selling book career had taken off.

She was an exception; most of our writers had been at it way too long to be inspired. Jack Heise was the most extreme case in terms of longevity. He'd joined *True Detective* in 1936, ironically with the very same issue in which Jim Thompson debuted. Twice a week we'd receive an envelope containing two sleep-written stories from his mobile home outside Spokane, Washington. At least his stories were

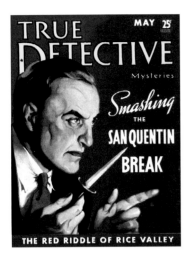

coherent. Others (whose names I'm omitting to protect their reputations) were devoid of grace, coherence, and innovation without the excuse of infirmity.

I was at *True Detective* for about a year when my dream started to sour. The low pay was a drag, but I managed to make a few side dollars writing porn. Harder to overlook were the opportunities that slipped by. The early 1990s, as you'll recall, were a cracked-up, whacked-out time, and all around us the media were chasing that death car right to the bank. TV shows like *America's Most Wanted*, *Unsolved Mysteries*, and *Cops* were just starting up, and true crime books were undergoing a renaissance not seen since Truman Capote's *In Cold Blood*. Meanwhile, I felt the magazine's brand name and built-in cool could, with a little tinkering, lead us to a younger, hipper audience, the same crowd who a few years later would find salvation in Quentin Tarantino's *Pulp Fiction*. Unfortunately, our publisher wasn't willing to spend the money (not that it would have cost much) nor give me permission to add some of the more audacious features I envisioned: true confessions from actual killers, "wanted" cases, "stupid criminal" profiles; in other words, the kind of weirdness around the margins you could only find in a real-life detective magazine.

Then Art died, and what enthusiasm I had for the magazine quickly disappeared. He'd been an amazing mentor, to say nothing of an honorable and decent man. When I got the call from the executive producer at *America's Most Wanted*, saying he'd read and loved some of my stories, asking if I wanted to try my hand writing dramatizations for the show, I jumped at the chance. Even if *America's Most Wanted* lacked *True Detective*'s style points, the opportunity rocked, and I moved to Washington, DC, to join the staff in 1991.

I was midway through my tenure with the show when I heard the shocking news: Globe Publications had bought out Reese. Now all that remained of America's once-thriving detective magazine genre belonged to one company. It could have meant a fresh start for my old friends at *True Detective*; instead it was the end. Globe eliminated its former competition with the August 1995 issue. One could make a case that America didn't need 11 detective magazines in the mid-'90s, but *TD*'s new owners showed how little they knew of history and reader loyalty by folding the choicest title.

A few months later Globe itself was shuttered, ending a major chapter of pulp history and leaving the magazines' graying readership to seek their thrills elsewhere.

At my most cynical I am inclined to think *True Detective* and its competitors performed a valuable social service. Many cops and killers have confided they got their first sexual thrills masturbating to the magazines. Without this harmless outlet, where do those fantasies find expression now? But to reduce the dickbooks to masturbation fodder for sadists is to underestimate the skill *True Detective* showed, at its best, in portraying aspects of life and death never seen in more legitimate media outlets. *TD* crossed all racial, ethnic, and social boundaries. You didn't have to be rich to get your story in our lurid pages. You didn't even have to leave a ravishing corpse — we editors could take care of that. All that was required to find stardom in *True Detective* was to die a semi-interesting death.

Then slap a sexy girl on the cover and give her a big gun …

TRUE DETECTIVE

JULY 25¢
A MACFADDEN PUBLICATION

DETECTIVE

MYSTERIES
AND FAMOUS DETECTIVE CASES

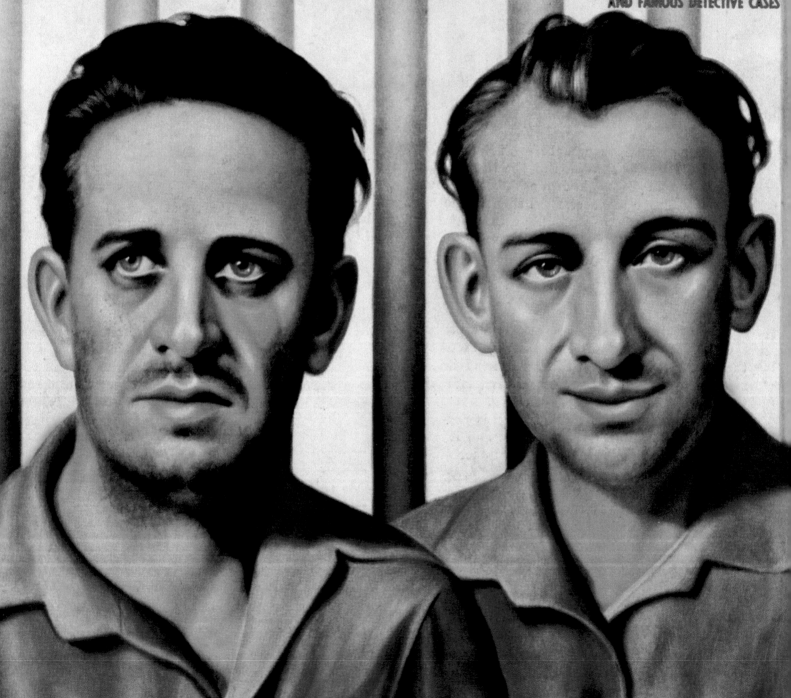

SOUTHERLAND AND MATHIS

ICH MORDETE FÜR DEN TRUE DETECTIVE

von Marc Gerald

DAS ENDE: NEW YORK, 1989

Ich war 22, kam gerade vom College und suchte für den Sommer einen Job, bevor im Herbst für mich die Uni anfing. Bei meinem Studienfach, Geistesgeschichte, schien etwas Journalistisches die naheliegende Wahl zu sein, da aber freie Stellen beim *New Yorker* und allen anderen anspruchsvollen Magazinen längst vergeben waren, schraubte ich meine Ansprüche ein wenig herunter. Na gut, sehr weit runter. Da ich schon lange ein leidenschaftlicher Fan des Magazins *True Detective* war, rief ich dessen Herausgeber Art Crockett an, um mich nach einem Job zu erkundigen. „Gutes Timing", lachte er. Der langjährige Mitherausgeber war am Wochenende zuvor verstorben, und Crockett hatte gerade das erste Stellenangebot seit 20 Jahren ausgeschrieben.

In meinen besten Flohmarktklamotten eilte ich zu der Redaktion in Hells Kitchen, um mich mit Art und seiner damaligen Bürochefin Rose Mandelsberg, dem sogenannten König der Schnüfflerhefte und seiner Königin, zu treffen. Art war etwa 70, hatte auf dem rechten Auge einen schweren Silberblick, trug einen Anzug mit Weste und steckte sich eine Camel nach der anderen an. Als echter Pulp-Veteran hatte er schon seit dem Zweiten Weltkrieg in vielen verschiedenen Genres gearbeitet, bei Adventure Magazines, Thrillermagazinen und Westernheften. Rose war ungefähr halb so alt wie er. Die vollschlanke Rothaarige mit einem etwas zum Schrillen tendierenden Modegeschmack hatte in den 1970er-Jahren als Sekretärin angefangen und leitete mittlerweile die Schwesternblätter des *True Detective – Master Detective, Inside Detective, Official Detective* und *Front Page Detective*.

Mein Vorstellungsgespräch muss wohl ganz gut gelaufen sein. Nachdem ich ihnen von meinen Lieblings-Serienmördern inklusive detaillierter Schilderung von deren Schandtaten und meinen Lieblingsautoren im True-Crime-Genre vorgeschwärmt hatte, schoben sie mich zu einem Praxistest in ein kleines Büro. Vor mir lagen fünf Fotografien und eine Akte des dazugehörenden Falls. Ich sollte mir Titel dazu einfallen lassen.

Ich muss einräumen, dass die Jahre – und viele hundert andere Fälle – meine Erinnerung an die mordslustigen Brüller getrübt haben, die ich damals verfasste, aber meine Überschriften müssen sie umgehauen haben, denn als ich zurück in meine Bude kam, wartete schon eine Nachricht auf mich. Ich hatte den Job. Das Gehalt: fantastische 265 Dollar pro Woche. Jetzt noch zur Uni zu gehen, kam für mich nicht infrage.

„Ich werde dir jetzt mal erklären, was das Wichtigste ist, um ein erfolgreicher Redakteur bei uns zu sein", sagte Art zu mir, während er ein paar von mir vorgeschlagene Schlagzeilen mit Rotstift redigierte. Ich war seit etwa einer Woche bei dem Blatt und hing begierig an den Lippen des Meisters.

„Siehst du dieses Mädchen?", fragte er und zeigte auf das grob gerasterte Foto einer fetten, mürrisch blickenden Landpomeranze. Sie war unser Mordopfer, hier noch in glücklicheren Tagen abgelichtet. „Sie sieht toll aus. Nein, eigentlich sogar atemberaubend. Nenn diese Story ‚Atemberaubendes Schulmädchen erbarmungslos niedergemetzelt."

Ich war verwirrt: „Aber die ist doch mindestens 35 an 'nem guten Tag. Und hässlich wie die Nacht!"

„Wann hast du das letzte Mal ein Heft wegen einer hässlichen alten Frau gekauft? Hier bei uns ist jede sexy, wunderschön, vielleicht sogar unwi-

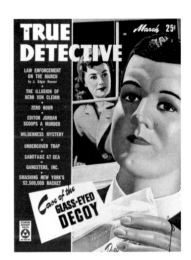

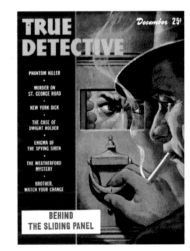

derstehlich, es sei denn, sie wär' wirklich hässlich, und damit meine ich, so hässlich, dass man Angst hat, hinzugucken."

„Und was ist die da?", fragte ich.

„Lebenslustig?" Art nahm das Foto in die Hand und betrachtete es noch mal. „Und wenn ich mir das so ansehe, würde ich sagen, du hast recht. Dieses Mädchen macht einen richtig lebenslustigen Eindruck."

1989 konnte man mit *True Detective* keine Reichtümer scheffeln, daher war die Cover-Auswahl kein Anlass zum Herumalbern. Ohne nennenswerte Werbeeinnahmen und kaum einen Abonnentenstamm war das Heft eine billige Angelegenheit, bei der es zwingend auf den Kaufanreiz ankam. Nur ein tolles Titelbild konnte das Heft an den Mann bringen; ein schlechtes Titelbild, und die Erzkonkurrenz machte das Rennen, eines der ähnlich schauerlichen, aber besser vertriebenen Blätter von Globe Publication, darunter *True Police Cases*, *Startling Detective*, *Detective Files*, *Dragnet Detective*, *Headquarters Detective* und *Detective Cases*.

Art kämpfte einen schier aussichtslosen Kampf um das Überleben von *True Detective*. Er konnte auf seiner alten Schreibmaschine immer noch tolle Artikelüberschriften und Coverschlagzeilen runterhacken wie: „Lassen Sie mich durch, oder Sie sterben als Nächster" oder „Meine Mutter ist Nutte, meine Frau ist pervers, und ich bin der Dumme". Verschwunden allerdings waren die schönen Cover der 1940er und 1950er mit den „Schönen in Nöten" im Vargas-Stil. Verschwunden auch die frauenfeindlichen Bondage-Gemeinheiten der 1960erund 1970er-Jahre. Auf den Titelblättern regierte mittlerweile eine Art Containerschlampen-Realismus mit langweiligen, durchschnittlichen Mädchen, die vor einer lächerlichen ländlichen Kulisse mit Spielzeugrevolvern herumfuchtelten.

So funktionierte es einfach nicht. 1989 war *True Detective* im Besitz eines geistlosen Vater-Sohn-Teams namens Reese Publications, das seit den späten 1950er-Jahren schon über 50 Magazine ins Leben gerufen und wieder eingestellt hatte, bis es in den frühen 1980ern mit dem *Video Magazine* einen – vorübergehenden – Erfolg landete. Die von *True Detective* und seinen vier Schwestertiteln verkaufte Auflage war in den 1980ern auf etwa 500 000 gesunken. Dennoch ließ sich offenbar noch Gewinn daraus schlagen, denn Jay Rosenfield und sein alter Herr hielten *True Detective* nicht um der lieben Kunst willen am Leben oder aus sentimentalen Gründen, weil es der Titel war, der das ganze True-Crime-Genre einst begründet hatte.

Den *True Detective*, für den ich arbeitete, trennten Lichtjahre von dem Glamour des Magazins, das der Fitness-Fanatiker Bernarr Macfadden 1924 im Rahmen seiner sogenannten True Line gestartet hatte. Neben *True Romance*, *True Story* und *True Confessions* befasste sich auch *True Detective* mit realen Menschen an ungewöhnlichen Schauplätzen und in ungewöhnlichen Situationen. Das Blatt war nicht die erste Publikation seiner Art, diese Ehre gebührt der Flugschrift *Newgate Calendar* (erstmals erschienen 1773), dicht gefolgt von dem Boulevardblatt *National Police Gazette*, aber es war das erste Magazin dieses Genres und das erste Blatt, das Mord und Totschlag in die neue Zeit führte.

Schonungslos, verwegen und im Nachhinein verdammt hip, definierte schon die allererste Ausgabe das Konzept von *True Detective*: detailgetreu nachgestellte Tatortfotos, begleitet von 5000-Wörter-Artikeln über die Aufklärung des Verbrechens. Das Magazin war auf Leser zugeschnitten, die ihre Cops heldenhaft und ihre Mörder abgebrüht und brutal liebten. Wie formulierte Macfadden das ursprüngliche Konzept des Heftes so melodrama-

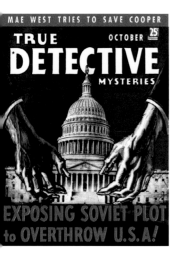
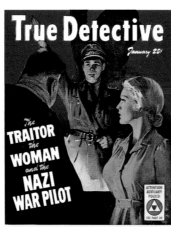

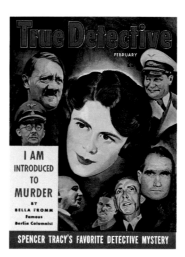

FROM ABOVE LEFT *True Detective Mysteries*, October 1935; *True Detective*, January 1943; *True Detective*, February 1942

tisch: „In den Storys begleiten wir die klugen und tapferen Männer, die in bizarren Verbrechen, begangen von gerissenen Tätern, die keine Spuren hinterlassen, ermitteln, die das verwirrte Knäuel der Ereignisse langsam und geduldig entflechten, bis zuletzt das große Geheimnis aufgeklärt und der Verbrecher seiner gerechten Strafe zugeführt ist."

Während Magazine mit fiktiven Kriminalgeschichten wie *Black Mask* oder *Amazing Detective*, die ebenfalls in den 1920ern aufkamen, bessere, stilistisch anspruchsvollere Texte boten, in denen es moralische Ambivalenz und komplexe Charaktere gab, hatte *True Detective* ein unschlagbares, wenn auch nie offen eingestandenes Verkaufsargument auf seiner Seite: Sex. 1928 befasste sich das Heft fröhlich mit allen erdenklichen Spielarten des Mordes, aber besonders gern mit psychopathischen Sexmorden, eine Erfolgsformel, der sich alle Nachahmer anschlossen. Ja, das Einzige, was in einem True Crime Magazine noch besser kam als ein abscheulicher Mord, war eine langwierige Vergewaltigung *vor* dem Mord, die man so richtig auswalzen und in mehreren Hundert fiebrigen Worten schildern konnte. Auch wenn es nicht den geringsten Hinweis auf eine Vergewaltigung gab, konnten die Autoren immerhin darüber spekulieren, und das taten sie mit Inbrunst. Das Prinzip hat sich nie geändert: Zu Beginn meiner Arbeit brachte mir Art bei, Einleitungen im Stil von *National Geographic*, wie sie einige unserer weniger begabten Autoren gerne schrieben – à la „Es war eine finstere Nacht an der Küste von Maine" –, durch ein prickelnderes, sexgeladenes Intro zu ersetzen.

„Ja, mir ist schon klar, dass sie brutal ermordet wurde", sagte er dann über das unglückselige Mordopfer, „aber was haben sie und ihr Ehemann wohl in der Nacht gemacht, bevor sie sich hat umbringen lassen?"

Man mag das krank und abartig oder gar Pornografie für Psychokiller nennen, aber Leser, die christlich-jüdische Vorstellungen von Schuld und Sühne verinnerlicht hatten, sprachen auf diese Formel an. Zu den Glanzzeiten der True Crime Magazines vor dem Zweiten Weltkrieg verkaufte *True Detective* bis zu zwei Millionen Hefte im Monat und rief rund 75 Nachahmer auf den Plan, mit denen es am Zeitungsstand konkurrieren musste. Die Leser des *True Detective* verloren ihren Blutdurst nie vollkommen, doch in den 1950er-Jahren begann es mit dem Genre insgesamt bergab zu gehen, es wurde ein Opfer des Fernsehens, der Inflation und des veränderten Lesergeschmacks. Macfadden starb 1955, da hatte er die Kontrolle über seine Firma jedoch längst abgegeben. Die Holdinggesellschaft, die ihn überlebte, verkaufte das Magazin schließlich in den späten 1960ern an Reese.

Als ich dort anfing, war dem Heft zwar die Leserschaft noch nicht gänzlich weggelaufen, eine Generalüberholung des Konzepts und der Aufmachung, die sich seit der allerersten Ausgabe kein Jota geändert hatten, war jedoch dringend fällig. Für den modernen Leser waren die Storys mit 5000 Wörtern viel zu lang, und der Sprachstil war lächerlich altbacken. *True Detective* war wahrscheinlich der letzte Fleck auf der Welt, an dem noch „Männer des Gesetzes" völlig unironisch nach Spuren in Fällen stöberten, die „wirklich dolle Dinger" waren. Derartige Texte und die eigenartige Begeisterung, die das Magazin für Satansjünger aufbrachte, trug ihm zwar einen gewissen Camp-Appeal ein, aber keine Rekordauflagen.

Das größte Problem waren die redaktionellen Vorgaben. Zwar hatte *True Detective* immer die heroische Arbeit der Ermittlungsbehörden in den Vordergrund gestellt, doch bei früheren Herausge-

"Schonungslos, verwegen und im Nachhinein verdammt hip, definierte schon die allererste Ausgabe das Konzept von <u>True Detective</u> ..."

bern – und als man noch nicht wegen jeder Kleinigkeit verklagt werden konnte – hatten die Autoren den Freiraum gehabt, Geschichten aus verschiedenen Blickwinkeln zu erzählen, auch aus der extremen Sicht des Mörders. Als ich anfing, gab es lediglich in der dritten Person geschilderte Berichte über polizeiliche Maßnahmen. Die schriftlich niedergelegten Richtlinien aus den 1980erund 1990er-Jahren belegen, wie restriktiv das Format geworden war: „In allen Geschichten müssen die Täter am Ende für schuldig befunden und verurteilt worden sein ... In Kriminalfällen sollten ferner nicht mehr als drei Verdächtige vorkommen. Sonst zu kompliziert ... Verraten Sie den Täter nicht zu früh, sonst ist die Spannung weg."

Man brauchte schon echtes journalistisches und erzählerisches Talent, um unter Berücksichtigung dieser Vorgaben noch Geschichten für den *True Detective* zu schreiben, die auch halbwegs interessant waren. Unglücklicherweise waren die meisten unserer Autoren dieser Herausforderung nicht gewachsen. Nicht, dass ich ihnen da einen Vorwurf machte. 1924 hatte der *True Detective* noch fürstliche 250 bis 300 Dollar für 5000 Wörter gezahlt. Ja, der Kultautor Jim Thompson, der Verfasser von *Der Mörder in mir* und *After Dark, My Sweet*, lernte neben anderen berühmten Krimiautoren wie Dashiell Hammett, Lionel White, Day Keene, Lawrence Treat, Bruno Fischer, Harry Whittington und Harlan Ellison nicht nur sein Handwerk als Autor für das Blatt, sondern bestritt in den 1930er- und 1940er-Jahren den Lebensunterhalt seiner Familie hauptsächlich durch die generösen Honorare dieses Magazins. 50 Jahre später zahlten wir noch die gleichen 250 Dollar pro Story.

Aber irgendwie schafften es unsere besten Autoren immer noch, unseren Fans Nervenkitzel zu bieten. Ann Rule sprengte trotz der grotesken Rahmenbedingungen die engen Grenzen des Genres und schrieb einige fantastische, wahrlich beängstigende Storys. Leider hatte sie einige Jahre, bevor ich dazukam, aufgehört, für solche Hefte zu schreiben, allerdings auch erst, nachdem sie schon mehrere Bestseller geschrieben hatte.

Doch sie war die Ausnahme; die meisten unserer Autorinnen und Autoren waren schon viel zu lange im Geschäft, um noch gute Einfälle zu haben. In puncto Ausdauer war Jack Heise der extremste Fall. Er war 1936 zu *True Detective* gekommen, ironischerweise bei genau der Ausgabe, in der auch Jim Thompson sein Debüt gab. Zweimal pro Woche erhielten wir einen Briefumschlag mit zwei Storys, die er in seinem Heim, einem Wohnwagen am Rande von Spokane in Washington, wie im Schlaf runtergeschrieben hatte. Wenigstens waren seine Geschichten stimmig. Andere, die sich nicht mit ihrer Hinfälligkeit herausreden konnten – und deren Namen ich hier anstandshalber verschweige –, brachten weder Stimmigkeit noch guten Stil oder gute Einfälle zustande.

Ich war etwa ein Jahr bei *True Detective*, als der Lack an meinem Traumjob abzublättern begann. Die miese Bezahlung war ätzend, doch ich verdiente noch etwas nebenbei, indem ich Pornogeschichten schrieb. Schwerer zu ignorieren waren die Chancen, die man sich entgehen ließ. Sie werden sich erinnern, was für eine irre, durchgedrehte Zeit die frühen 1990er waren: Überall um uns herum stürzten sich die Medien mit wachsender Begeisterung auf alles Tote. Fernsehsendungen wie *America's Most Wanted*, *Unsolved Mysteries* und *Cops* liefen gerade an, und Bücher über wahre Verbrechen erlebten eine Renaissance, wie es sie seit Truman Capotes *Kaltblütig* nicht mehr gegeben hatte. Ich glaubte damals noch, der gute Name

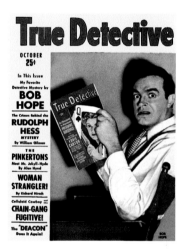

OPPOSITE *True Detective*, April 1942

ABOVE *True Detective*, October 1941

BELOW *True Detective*, April 1940

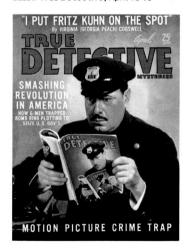

"Man musste nicht reich sein, um es in unser knallig aufgemachtes Blatt zu schaffen ... Um im _True Detective_ zum Star zu werden, musste man nichts weiter leisten, als sich halbwegs originell umbringen zu lassen."

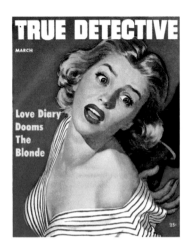

OPPOSITE _True Detective_, August 1957

ABOVE _True Detective_, March 1953

BELOW _True Detective_, April 1953

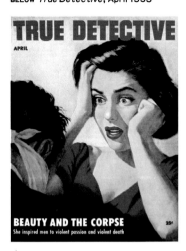

und der Kultstatus unseres Blatts könnten uns mit ein paar Modifikationen am Heft ein jüngeres, hipperes Publikum erschließen, die ganzen Leute, die ein paar Jahre später mit Begeisterung in Quentin Tarantinos _Pulp Fiction_ rennen sollten. Leider wollte unser Verleger weder Geld investieren – so viel hätte es gar nicht sein müssen –, noch mir gestatten, einige der etwas weniger betulichen Beiträge ins Heft zu nehmen, die mir vorschwebten: etwa Geständnisse von echten Mördern, Fahndungsaufrufe, Porträts der „dümmsten Verbrecher", kurz, den ganzen abseitigen Quatsch, den man nur in einem True Crime Magazine finden kann.

Dann verstarb Art, und damit verflog auch der letzte Rest Begeisterung, den ich noch für das Heft hatte aufbringen können. Art war ein toller Lehrmeister gewesen, vor allem aber ein netter und hochanständiger Kerl. Als mich der Produzent von _America's Most Wanted_ anrief, mir erklärte, einige meiner Storys hätten ihm sehr gut gefallen, und mich fragte, ob ich nicht Lust hätte, als Autor für die Sendung zu arbeiten, griff ich zu. Selbst wenn _America's Most Wanted_ nicht den Kultstatus von _True Detective_ hatte, die Chance war einmalig, also zog ich 1991 nach Washington, D. C., um und stieß zu seinem Team.

Etwa nach der Hälfte meiner „Amtszeit" bei der Sendung kam dann die schockierende Nachricht: Globe Publications hatten Reese aufgekauft. Damit befand sich alles, was noch von Amerikas einst prosperierendem Detective-Genre existierte, in den Händen einer einzigen Firma. Das hätte einen Neuanfang für meine alten Freunde bei _True Detective_ bedeuten können, doch es bedeutete das Aus. Globe liquidierte seinen früheren Konkurrenten mit der August-Ausgabe 1995. Man kann

einwenden, dass Amerika Mitte der 1990er nun wirklich keine elf verschiedenen Detective Magazines brauchte, doch die neuen Besitzer von _True Detective_ bewiesen, indem sie ausgerechnet den hochkarätigsten Titel darunter einstellten, dass sie wenig Geschichtsbewusstsein hatten und noch weniger von Leser-Blatt-Bindung wussten.

Ein paar Monate später wurde Globe schließlich selbst dichtgemacht, eines der wichtigsten Kapitel der Pulp-Geschichte war damit beendet, und eine ergrauende Leserschaft musste sich nun ihre Kicks woanders suchen.

Wenn ich einmal ganz zynisch sein wollte, würde ich sagen, dass der _True Detective_ und seine Konkurrenten sich um die Gesellschaft verdient gemacht haben. Viele Polizisten und Mörder haben gestanden, dass das Masturbieren über diesen Magazinen eine ihrer frühesten sexuellen Erfahrungen gewesen sei. Wo sollen sich diese Fantasien nun austoben, da dieses harmlose Ventil fehlt? Aber die Detective Magazines auf bloße Wichsvorlagen für Sadisten zu reduzieren, hieße, zu verkennen, wie gut der _True Detective_ in seinen besten Tagen Aspekte von Leben und Tod darstellte, die in seriöseren Medien erst gar keine Erwähnung fanden. _True Detective_ kannte weder rassische, ethnische noch soziale Schranken. Man musste nicht reich sein, um es in unser knallig aufgemachtes Blatt zu schaffen. Man musste nicht mal eine geschändete Leiche zurücklassen, darum kümmerten wir Redakteure uns schon. Um im _True Detective_ zum Star zu werden, musste man nichts weiter leisten, als sich halbwegs originell umbringen zu lassen.

Dann klatscht man nur noch ein heißes Mädchen aufs Cover und drückt ihr eine große Knarre in die Hand ...

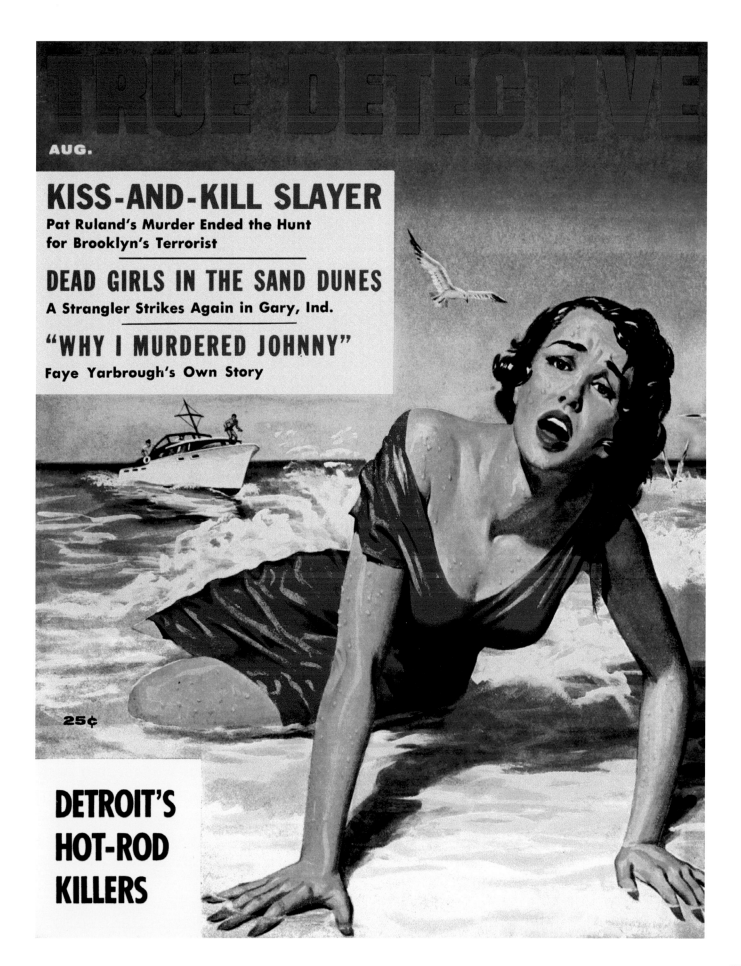

TRUE DETECTIVE

AUG.

KISS-AND-KILL SLAYER
**Pat Ruland's Murder Ended the Hunt
for Brooklyn's Terrorist**

DEAD GIRLS IN THE SAND DUNES
A Strangler Strikes Again in Gary, Ind.

"WHY I MURDERED JOHNNY"
Faye Yarbrough's Own Story

25¢

DETROIT'S
HOT-ROD
KILLERS

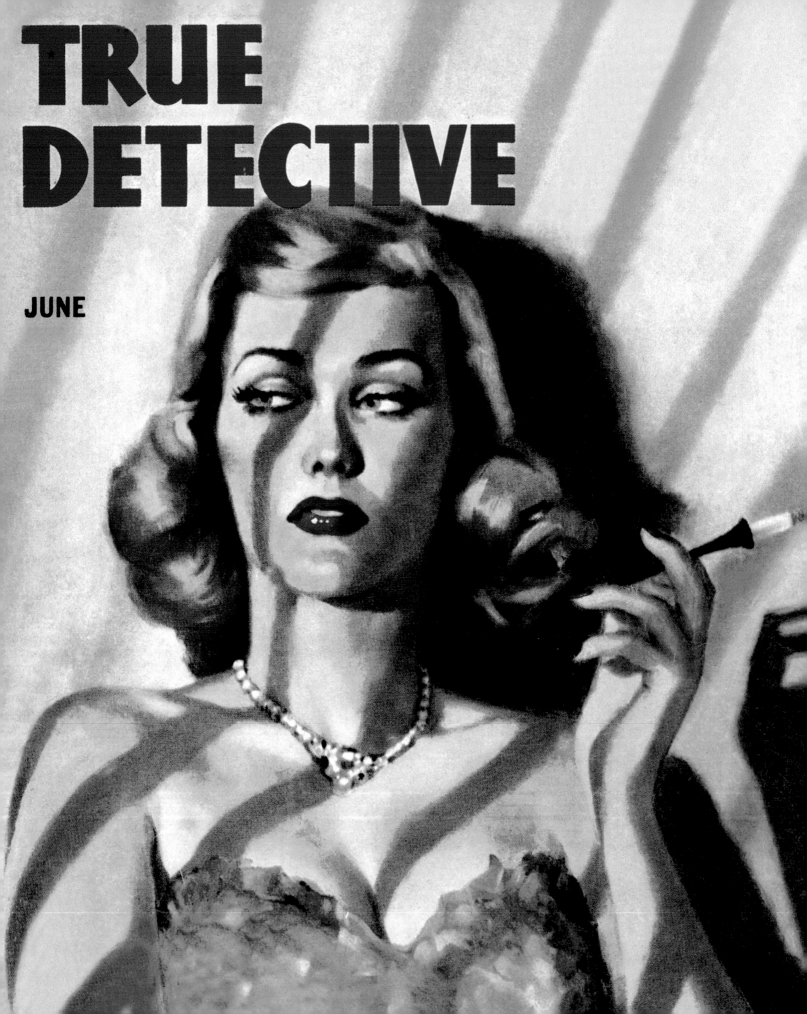

J'AI ÉTÉ RÉDACTEUR CHEZ TRUE DETECTIVE

Marc Gerald

DATE LIMITE : NEW YORK, 1989

J'avais 22 ans, je venais de décrocher une maîtrise d'histoire des idées et je cherchais un job qui me permette de tenir jusqu'à la rentrée universitaire de l'automne. Je pensai évidemment aux magazines culturels mais, comme tous les postes d'été au *New Yorker* et autres journaux intellos étaient pourvus, je revis mes ambitions sérieusement à la baisse. J'étais depuis mon adolescence un fan obsessionnel de *True Detective* et j'appelai donc Art Crockett, son rédacteur en chef. « Tu tombes à pic ! », me répondit-il en riant. Son adjoint de longue date était mort le week-end précédent, et il était en train de rédiger sa première annonce d'offre d'emploi depuis vingt ans.

Je revêtis le meilleur des mes costumes achetés au marché aux puces, et je me précipitai au siège du magazine, dans l'ancien quartier Hell Kitchen, derrière Times Square, où je fus reçu par Art Crockett et son bras droit de l'époque, Rose Mandelsberg. Ceux qu'on appelait le roi et la reine des *detective magazines* formaient un couple inhabituel. Lui devait avoir environ 70 ans, l'œil droit affligé d'un strabisme divergeant, vêtu d'un costume trois-pièces, il fumait sans arrêt. Véritable pionnier du *pulp*, il avait, depuis la Seconde Guerre mondiale touché à divers genres, notamment les aventures pour hommes, le suspense et le western. Son assistante, une rousse bien en chair avec un goût prononcé pour les vêtements bien voyants, était deux fois plus jeune que lui. Elle avait fait ses débuts comme secrétaire dans les années 1970 et avait grimpé dans la hiérarchie pour accéder à la direction des clones de *True Detective* : *Master Detective*, *Inside Detective*, *Official Detective* et *Front Page Detective*.

L'entretien se passa plutôt bien. Après les avoir inondés de détails sur les exploits de mes tueurs en série préférés et de critiques littéraires sur mes auteurs préférés d'enquêtes policières, je passai dans une petite pièce pour un test rédactionnel. Devant moi, cinq photographies et un dossier de faits divers criminel. J'étais censé rédiger les légendes des photos.

Je dois avouer qu'avec le recul du temps – et de plusieurs centaines d'affaires criminelles –, j'ai perdu le souvenir de mes géniales légendes, mais elles ont dû leur plaire, car, un message m'attendait sur mon répondeur téléphonique. J'étais embauché. Avec le salaire mirobolant de 265 dollars par semaine. J'étais au septième ciel, et il n'était plus question de continuer mes études.

« Je vais t'apprendre un principe essentiel à respecter si tu veux faire carrière ici », déclara Art Crockett qui soulignait au stylo rouge quelques-uns de mes titres de couverture. J'étais là depuis une semaine, avide de m'imprégner de la sagesse du grand maître du genre.

« Tu vois cette nana ? dit-il en me tendant la photo grossièrement agrandie d'une épaisse ménagère du Middle West au visage revêche.

Il s'agissait de la victime d'un de nos faits divers, fixée sur la pellicule en des temps plus heureux.

– Elle est très belle, continua-t-il. En fait, je pourrais même la qualifier de ravissante, et titrer l'article : « *Pas de pitié pour la ravissante lycéenne !* »

J'étais abasourdi :

– Mais elle a 35 ans bien sonnés. Et elle est laide comme un pou !

– Quand as-tu acheté pour la dernière fois un magazine qui parlait d'une femme vieille et moche ? rétorqua-t-il. Ici, une nana est toujours

« Mélange de réalisme et de brutalité, la formule prématurément branchée de True Detective était en place dès le premier numéro... »

mignonne, sexy et sensuelle, à moins qu'elle soit vraiment insupportable à regarder.

– Auquel cas, on la qualifie de... ?

– De nana qui aime s'éclater.

Il me reprit la photo et l'examina de plus près :

– Et à bien la regarder, je dirais que c'est toi qui as raison. Elle a plutôt l'air d'une fille qui aime s'éclater. »

En 1989, *True Detective* n'était plus très rentable, et le choix de la couverture était une affaire sérieuse. Sans budget de promotion, et pratiquement sans abonnements, toutes les recettes reposaient sur les points de vente. Et seule une couverture formidable avait des chances d'attirer le chaland. Si elle était mauvaise, les concurrents ramassaient la mise : ceux de Globe Publications, tout aussi effroyables mais mieux distribués, et notamment *True Police Cases*, *Startling Detective*, *Detective Files*, *Dragnet Detective*, *Headquarters Detective*, et *Detective Cases*.

Art Crockett se battait tant bien que mal pour maintenir *True Detective* en vie. Il arrivait encore à trouver dans son répertoire des titres remarquables pour ses couvertures ou ses articles, comme : « Pardonne-moi ou je te tue ! » et « Ma mère est une pute, ma femme une perverse, et je suis humilié. » C'en était fini des ravissantes pin up en détresse à la Vargas, ou des scènes ignobles de sadomasochisme qui faisaient les couvertures des années 1960 et 1970. Ce qu'on proposait maintenant, c'était un décor réaliste de banlieue minable, où posaient des filles moches brandissant de fausses armes, avec en toile de fond des paysages de campagne parfaitement grotesques.

Et ça ne marchait pas. En 1989, *True Detective* appartenait à un tandem père-fils singulièrement terne, nommée Reese Publications, qui avait lancé et arrêté plus de 50 magazines depuis les années

1950, avant d'avoir – provisoirement – la main plus heureuse au début des années 1980, avec *Video Magazine*. Les tirages combinés de *True Magazine* et de ses quatre clones avait chuté de façon spectaculaire, n'atteignant plus que 500 000 exemplaires. Jay Rosenfield et son vieux père parvenaient pourtant à dégager un modeste bénéfice, car ils n'étaient pas du genre à continuer *True Detective* pour l'amour de l'art ou par respect pour le magazine pionnier de l'enquête criminelle.

Le journal auquel je collaborais était à des années-lumière de la gamme de luxueux magazines « réalité » lancés en 1924 par le fanatique du culturisme Bernarr Macfadden. À l'instar de *True Romance*, de *True Story* et de *True Confessions*, *True Detective* utilisait des personnages réels qu'il plaçait dans des lieux et des circonstances extraordinaires. Ce n'était pas le premier périodique d'enquêtes authentiques. La primeur revenait au journal *Newgate Calendar* (publié pour la première fois en 1773), suivi par un tabloïd, le *National Police Gazette*. Mais *True Detective* fut le premier magazine, celui qui fit entrer les crimes réels et leur violence dans la modernité.

Mélange de réalisme et de brutalité, la formule prématurément branchée de *True Detective* était en place dès le premier numéro, avec ses photos de scènes de crime astucieusement montées, qu'accompagnaient les 5 000 mots du récit de l'enquête. Le magazine visait des lecteurs accros aux flics héroïques et aux tueurs impitoyables et brutaux. Comme le déclarait Macfadden avec emphase lors de son lancement : « Les articles suivront pas à pas les enquêtes menées par des hommes brillants et courageux, pour éclaircir le mystère de crimes étranges, commis par des malfaiteurs rusés qui ne laissent aucun indice derrière eux. Voici des fins limiers qui tentent de démêler

« On n'avait pas besoin d'être riche pour apparaître dans ses pages tapageuses... Tout ce qu'il fallait pour devenir une star de <u>True Detective</u>, c'était mourir d'une mort à peu près originale. »

l'inextricable écheveau de l'énigme et qui, lentement, patiemment, défont nœuds et entrelacs pour finalement parvenir à son élucidation, et livrer le criminel à la justice. »

Si l'on trouvait dans certains magazines de fiction criminelle comme *Black Mask* et *Amazing Detective*, également surgis pendant les années 1920, des histoires mieux écrites, plus élaborées, moins manichéennes et reposant sur des caractères plus complexes, *True Detective* bénéficiait d'un atout tacite qui leur faisait défaut : le sexe. En 1928, le magazine décrivait allègrement des crimes de toutes sortes, mais il se spécialisait déjà dans la violence psychosexuelle – un filon que tous ses imitateurs allaient exploiter. Pour un magazine d'enquêtes criminelles, la seule violence qui puisse surpasser un meurtre effroyable, c'était bien le viol – que l'on étirait au maximum avant de consacrer quelques centaines de mots évocateurs au meurtre sanglant qui suivait. Et même s'il n'y avait aucune preuve que ce viol ait eu lieu, le rédacteur du journal ne se privait pas de la possibilité alléchante d'en évoquer l'hypothèse. La formule de *True Detective* ne changea jamais. Dès mes débuts à la rédaction, Art Crockett m'apprit à éliminer les préliminaires habituels du genre : « Sur la côte du Maine, par une nuit glaciale... », au profit d'introductions sexy plus émoustillantes.

« Je sais qu'elle a été sauvagement assassinée, m'expliquait-il à propos de la malheureuse victime d'un crime. Mais que crois-tu qu'elle avait fait avec son mari ce soir-là, avant de se faire tuer ? »

On peut qualifier une telle écriture d'écœurante et lubrique, de littérature pornographique pour tueurs psychotiques, mais les lecteurs imprégnés des notions judéo-chrétiennes de péché et de châtiment réagissaient très bien à cette approche. À son apogée, *True Detective* se vendait à deux mil-

lions d'exemplaires chaque mois et il a engendré jusqu'à 75 imitations, lesquelles se battaient pour le déloger des kiosques, au plus fort de la popularité des magazines de faits divers criminels – juste avant la Seconde Guerre mondiale. Les lecteurs de *True Detective* ne se départirent jamais de leur inclination pour les meurtres sanglants, mais tous les magazines du genre amorcèrent leur déclin au milieu des années 1950, victimes de la télévision, de l'inflation galopante, et d'une évolution du goût des lecteurs. Macfadden mourut en 1955, ayant déjà perdu le contrôle de sa société depuis des années. La société de holding qui lui succéda devait vendre le magazine à Reese à la fin des années 1960.

Quand je suis entré dans l'équipe de rédaction, si *True Detective* n'avait pas totalement perdu son public, il avait toutefois besoin de changer de look. On n'avait pas modifié la formule depuis le premier numéro. Les articles de 5 000 mots paraissaient beaucoup trop longs aux lecteurs modernes et le style sentait ridiculement le moisi. Les articles de *True Detective* étaient peut-être les derniers au monde où l'on trouvait des « fins limiers » qui « furetaient » pour dénicher des indices lors d'enquêtes criminelles qualifiées de « sacrés casse-tête ». De pareils textes, et la fascination particulière du magazine pour les adorateurs du diable augmentaient peut-être son attrait pour ses sympathisants mais ne contribuaient pas à accroître ses ventes.

Le problème le plus grave restait celui des directives rédactionnelles. Si *True Detective* rendait toujours un hommage vibrant aux forces de police, les rédacteurs en chef – et l'assouplissement des lois sur la diffamation – avaient, par le passé, autorisé les auteurs à mener des récits selon plusieurs angles, et en particulier en adoptant le point

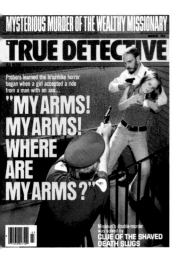
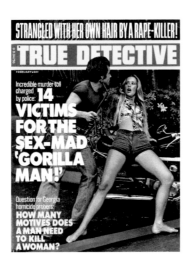
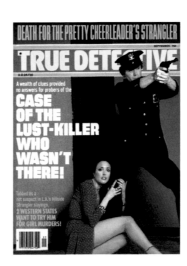

de vue extrême du tueur lui-même. Au moment de mon arrivée, les rapports de police à la troisième personne étaient la seule optique admise. Les directives écrites des années 1980 et 1990 montrent bien les restrictions auxquelles étaient, au terme d'une longue évolution, soumises ces publications : « Les articles ne doivent traiter que des affaires ayant été jugées, où le prévenu a été reconnu coupable et condamné à une peine par un tribunal » ; ou « Ne pas indiquer le coupable trop tôt dans l'histoire, pour ne pas nuire au suspense ».

Il fallait un grand talent de journaliste et de scénariste pour respecter ces indications tout en rédigeant pour *True Detective* un article qui présente encore quelque intérêt. Or la plupart de nos auteurs ne se montraient pas à la hauteur de ce défi. On peut les en excuser : en 1924, *True Detective* versait à ses auteurs la somme rondelette de 250 à 350 dollars pour un papier de 5 000 mots. Et Jim Thompson, l'auteur culte du *Démon dans ma peau* et de *La Mort viendra, petite*, a démarré sa carrière en écrivant dans *True Detective* (à l'instar d'autres bonnes plumes comme Dashiell Hammet, Lionel White, Day Keene, Lawrence Treat, Bruno Fisher, Harry Whittington et Harlan Ellison). C'est en grande partie grâce à ces collaborations qu'il a pu faire vivre sa famille pendant les années 1930 et 1940. Mais cinquante ans plus tard, les 5 000 mots étaient toujours payés 250 dollars.

On se demande comment les meilleurs – ou les moins épuisés – de nos auteurs parvenaient encore à faire frissonner notre public. Ann Rule qui travaillait pourtant dans des conditions impossibles, a pris son essor en dépit des contraintes du système et a réussi à produire des articles éblouissants et absolument captivants. Quand je suis arrivé, elle avait malheureusement arrêté d'écrire pour le magazine, où elle était pourtant restée longtemps après avoir décollé comme écrivain de best-seller.

Ann Rule était une exception. Les auteurs écrivaient pour le magazine depuis longtemps et leur inspiration s'était tarie, le record de longévité revenant à Jack Heise. Il était entré à *True Detective* en 1936, dans le même numéro que celui qui marqua les débuts de Jim Thompson. Depuis son mobile home près de Spokane, dans l'État de Washington, Heise continuait à nous envoyer deux fois par semaine une enveloppe contenant les deux histoires qu'il avait rédigées d'une plume somnolente. Au moins n'étaient-elles pas incohérentes, alors que les textes de certains autres (dont je tairai le nom par égard pour leur réputation) manquaient totalement de grâce, de cohésion et d'innovation, et ce sans avoir l'excuse du grand âge.

Je travaillais depuis un an chez *True Detective* quand mon rêve a commencé à se décomposer. Le maigre salaire était certes un inconvénient, mais j'arrivais à l'arrondir avec des histoires que j'écrivais pour la presse porno. Plus difficiles à oublier étaient les opportunités qui me passaient sous le nez. On se souvient de l'atmosphère pénible et déprimante du début des années 1990, quand tous les médias devaient faire face à de gros problèmes avec leur banque. Les séries télévisées comme *America's Most Wanted*, *Unsolved Mysteries*, et *Cops* ne faisaient que commencer et les romans basés sur des faits divers réels bénéficiaient d'une renaissance qu'ils n'avaient pas connue depuis *De sang-froid* de Truman Capote. Je sentais bien que l'image de marque et la fraîcheur innée de *True Detective* pouvaient, avec quelques retouches, nous amener un lectorat plus jeune et plus branché, celui qui, quelques années plus tard, devait se retrouver avec bonheur dans *Pulp Fiction* de Quentin Tarantino. Mais notre patron n'était pas prêt à y mettre

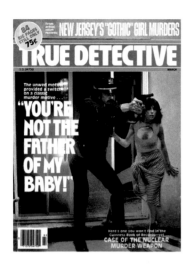 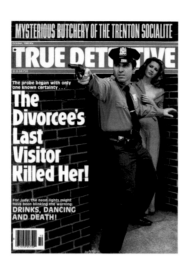 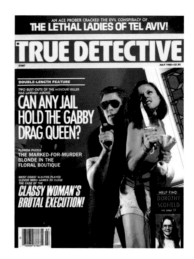 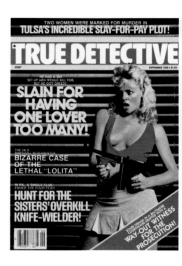

l'argent nécessaire (il n'en aurait pourtant pas fallu beaucoup), ni à me donner la permission d'introduire les innovations audacieuses que j'envisageais : aveux de tueurs réels, descriptions de criminels recherchés par la police, portraits de « criminels stupides », en d'autres termes, le type de bizarreries que l'on ne pouvait trouver que dans un magazine de faits divers.

Avec la mort d'Art Crockett, je perdis rapidement le peu d'enthousiasme qui me restait. Il s'était montré un mentor fantastique, sans parler de ses qualités d'honnêteté et de loyauté. Lorsque je reçus un coup de fil du producteur de *America's Most Wanted*, me disant qu'il raffolait de mes articles et me demandant si j'aimerais m'essayer à écrire des scénarios pour ses émissions, je sautai sur l'occasion. Ses productions n'avaient pas les qualités stylistiques de *True Detective*, mais la proposition était fort tentante et je partis rejoindre l'équipe de Washington en 1991.

J'étais à mi-parcours de mon contrat lorsque j'appris la terrible nouvelle. Reese s'était fait racheter par Globe Publications. Les quelques magazines de détectives autrefois si florissants, qui subsistaient, se trouvaient désormais dans les mains d'une seule société. Ce monopole aurait pu offrir à mes anciens collègues la possibilité d'un nouveau départ, mais en fait, il sonna le glas de *True Detective*. Avec le numéro d'août 1995, Globe devait mettre fin à l'activité de son ancien concurrent. On peut penser que l'Amérique des années

1990 n'avait plus que faire de onze magazines policiers mais, en choisissant de détruire le meilleur, les nouveaux propriétaires de *True Detective* manifestaient leur ignorance, tant en termes de longévité que de fidélité des lecteurs.

Quelques mois plus tard, Globe mettait la clé sous la porte, mettant ainsi fin à un chapitre entier de l'histoire du *pulp*. Les lecteurs grisonnants n'avaient plus qu'à aller chercher ailleurs de nouveaux frissons.

Dans mes moments de cynisme, je suis tenté de penser que *True Detective* et ses concurrents ont rempli une précieuse fonction sociale. De nombreux flics et criminels ont avoué avoir connu leur premier orgasme en se masturbant devant leurs pages. Sans ces exutoires inoffensifs, où ces fantasmes peuvent-ils maintenant trouver leur expression ? Mais réduire les histoires de cul à cette seule fonction serait sous-estimer l'habileté que montrait *True Detective*, à l'apogée de son art, à dépeindre des aspects de la vie et de la mort jamais représentés dans les médias classiques. Ce magazine ignorait les barrières raciales, ethniques ou sociales. On n'avait pas besoin d'être riche pour apparaître dans ses pages tapageuses. Ni même de laisser derrière soi un cadavre de toute beauté – les rédacteurs s'en chargeaient. Tout ce qu'il fallait pour devenir une star de *True Detective*, c'était mourir d'une mort à peu près originale.

Restait à gifler la pin-up de la couverture et à lui mettre une grosse arme dans les mains …

JULY 1991 ● $2.25

TRUE DETECTIVE

SINCE 1924
NO. 1 MOST RESPECTED
67 YEARS
CRIME JOURNAL

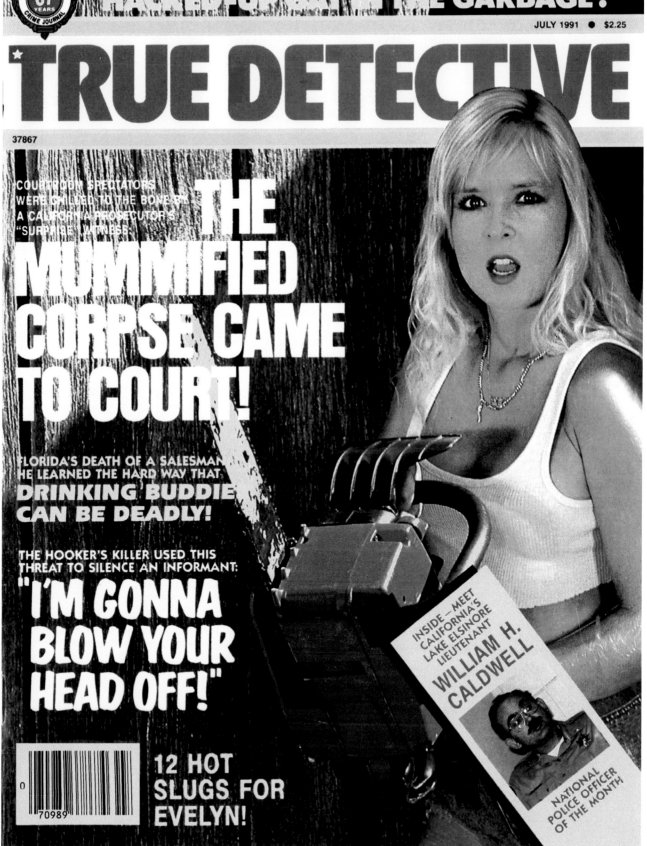

37867

COURTROOM SPECTATORS WERE CHILLED TO THE BONE BY A CALIFORNIA PROSECUTOR'S "SURPRISE" WITNESS:

THE MUMMIFIED CORPSE CAME TO COURT!

FLORIDA'S DEATH OF A SALESMAN HE LEARNED THE HARD WAY THAT

DRINKING BUDDIES CAN BE DEADLY!

THE HOOKER'S KILLER USED THIS THREAT TO SILENCE AN INFORMANT:

"I'M GONNA BLOW YOUR HEAD OFF!"

12 HOT SLUGS FOR EVELYN!

INSIDE—MEET CALIFORNIA'S LAKE ELSINORE LIEUTENANT **WILLIAM H. CALDWELL**

NATIONAL POLICE OFFICER OF THE MONTH

0 70989

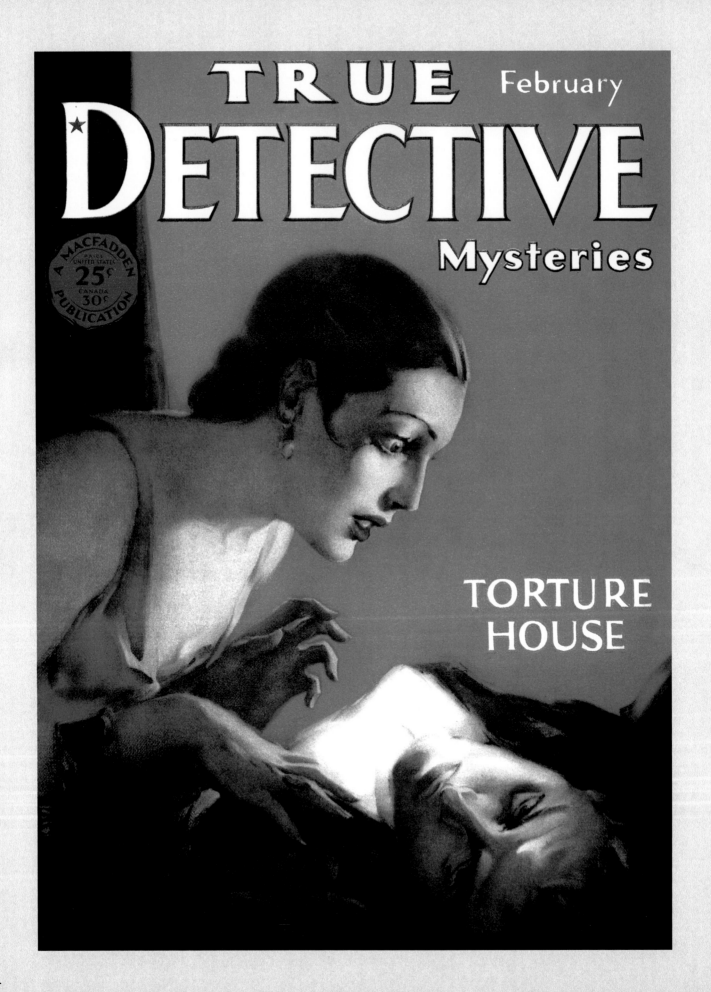

THE ARTISTS WHO MADE CRIME PAY

by George Hagenauer

Though far less celebrated than detective fiction magazine covers, true crime cover artwork was equally distinctive and thematically consistent from magazine to magazine. The progenitor of the style was Bernarr Macfadden's *True Detective Mysteries* magazine, America's first true crime title. When *True Detective* launched in 1924 most of its apparently painted covers were actually enhanced motion picture stills, while the interior photos used to illustrate the mainly fictional stories were largely theatrical re-creations shot in the well-equipped Macfadden photo studios mixed with the occasional real crime scene photograph. The latter served only to confuse, since the real victims and criminals didn't resemble the actors playing them in the staged photos fleshing out the story. On a couple of occasions this problem was solved by hiring the actual crime participants to pose for the staged photos!

As the genre expanded through the '30s and '40s, many fine artists found work in the true crime field, though not all were proud of it. As with pulp painters there was shame attached to this lowbrow art form and many worked anonymously.

The shortages of World War II — of men as well as paper, since a large number of artists were drafted — encouraged titles to drop painted covers in favor of less-expensive photographic covers. The end of rationing after the war sparked an explosion in detective publishing, however, and two of the new true crime publishers were responsible for some of the best-painted covers ever produced. Lionel White's *Detective World* and *Underworld Detective* took the portrait cover to its most lurid extreme,

while Skye Publications' *Best True Fact Detective*, *Police Detective*, and wonderfully tawdry *Women in Crime* sported covers worthy of the sexiest under-the-counter paperbacks to come in the 1950s.

Following World War II, the GI Bill program of financial assistance helped hundreds of former soldiers enter art school. When these artists graduated they revitalized the world of illustration, flooding the field with new talent. Sadly, this was exactly the point when true crime magazines were abandoning painted covers in favor of photographs. Macfadden was the last true crime publisher to use painted covers and featured some incredible art in the '50s and '60s. As well as employing the established masters, Macfadden gave a number of young artists the chance to work briefly in the true crime field before moving on to more legitimate careers. When the Macfadden magazines finally switched to photographs in the mid-'60s the 40-year reign of true crime art ended.

STOOKIE ALLEN specialized in comic book-style features about real-life people for pulp and fact magazines. His pages were done in the style of the Ripley's Believe It or Not! comic; a series of illustrations with captions beneath. His longest-running feature was "Men of Daring" for the Argosy pulp. He did a regular page on "Master Detectives" for *Master Detective* magazine in the early 1930s.

HAROLD BENNETT was a Canadian illustrator who worked for the significant subgenre of Canadian true crime magazines. American paper shortages and Canadian restrictions on importation of

certain American publications stimulated Canadian magazine production during the 1940s. Bennett was the rare artist for the new Canadian crime magazines who signed his work.

OZNI BROWN did many cover paintings for *True Detective* in the late 1940s and early '50s. He also painted covers and interior illustrations for the Hearst syndicate's *American Weekly* Sunday newspaper supplement.

AL BRULE was a diversified commercial artist who did some true detective covers in the 1950s and 1960s. While Brule worked in all areas of advertising and illustration, he is best known for his pin-up calendar art.

RICHARD CARDIFF's first true crime magazine work was for Fawcett's *Startling Detective* in the '30s. In the 1940s he moved up to Macfadden Publications, possibly because of Fawcett's increased use of photo covers. Through the '40s he was a major cover artist for *True* and *Master Detective* before shifting to the new *Saga* magazine in 1950.

JOHN COUGHLIN was one of the earliest detective pulp cover artists, producing most of the covers for Street & Smith's *Detective Story Magazine* from its inception in 1915 through the 1930s. In the early 1940s Coughlin also painted a number of covers for *Crime Detective*.

GERARD DELANO was a pulp artist who painted covers for adventure, Western, and detective pulps in the 1920s before his true crime work in the very early '30s. He studied under George Bridgeman at

OPPOSITE Edward Dalton Stevens, *True Detective Mysteries*, February 1930

ABOVE L. Fried, *Startling Detective Adventures*, June 1930s

BELOW Philip Lyford, *The Master Detective*, July 1934

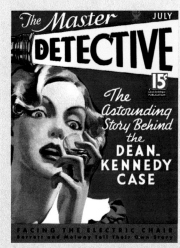

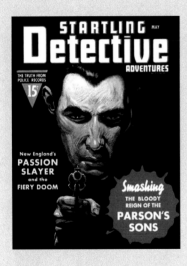 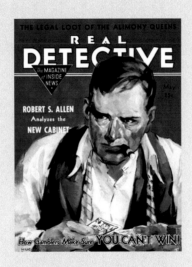 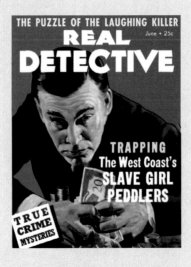 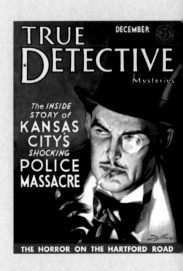

the Art Students League in New York as well as with noted illustrators Dean Cornwall, Harvey Dunn, and N. C. Wyeth. Delano's love of Western subjects lured him to move west in the 1930s and devote the rest of his life to creating Western fine art.

HOWELL DODD contributed cover art to Skye Publications' *Best True Fact Detective*, *Police Detective*, and *Women in Crime*. He also produced numerous paintings for men's adventure magazines in the 1950s.

JOHN DREW was a lesser-known artist who alternated between painting covers for detective pulp fiction and fact magazines.

PETER DRIBEN began his career in the 1930s doing covers for under-the-counter sex pulps like *Tattle Tales*, *Pep*, and *Snappy*. Driben, who had studied at the Sorbonne in Paris, produced a few covers for *Inside*, *Expose*, and *Exclusive Detective* before moving on to create the classic cover paintings for Robert Harrison's 1940s girlie titles *Flirt*, *Titter*, *Wink*, and *Beauty Parade*. He also worked in advertising and painted covers for sexy paperbacks.

JULES ERBIT was born in Budapest and well established as an illustrator in Europe before immigrating to the United States in 1930. One of his first regular assignments upon arriving in New York was painting covers for *Startling Detective*. Erbit's beautiful cover paintings of women brought him to the attention of pin-up calendar publishers Brown and Bigelow, who hired him as a

staff artist in 1933. Glamour was the focus of Erbit's work from that point on and he produced hundreds of paintings for calendars, playing cards, prints, and blotters. But since Fawcett's policy was to buy all rights to every painting used, and to reuse images over and over, Erbit's work continued to appear on the covers of most Fawcett true crime titles for years after he had become famous as a calendar artist.

JOHN FALTER was a fine artist who did covers for *True Detective* in the early stages of his career, during the Great Depression. He sold his first work to the pulps while he was still a teenager. In 1930, at age 20, he sold a painting to *Liberty* magazine, before it was purchased by Macfadden, which led to his working on the true crime titles. As a soldier in World War II, he designed recruitment posters, and upon his release from the military he formed a relationship with the *Saturday Evening Post* that would last 25 years. He painted 185 covers for the prestigious weekly before it folded in 1969. Suddenly unemployed at age 53, Falter did book cover illustrations, celebrity portraits, and an impressive portfolio of Harlem nightclub life in the years before his death in 1982.

ALBERT FISHER did many of the covers for Dell's true crime magazines *Inside Detective* and *Front Page Detective*. He shifted to other magazines and genres when Dell switched to photographic covers in the '40s, then in 1949 he painted the cover for the first issue of *Stag* magazine, generally considered to be the first men's adventure magazine of the 1950s. Later in the '50s Fisher switched

to painting rather sedate calendar art with a concentration on landscapes.

GRIFFITH FOXLEY, while best remembered as a very staid calendar artist, painted several covers for *True Detective* in the 1940s.

L. FRIED produced many covers for *Startling Detective* and *Daring Detective* in the '30s before his replacement by Stockton Mulford.

LOUIS GLANZMAN began his career creating superheroes like Amazing Man for second-string comic book publisher Centaur, and doing *True Comics* for squeaky-clean Parents Publishing. He wisely abandoned the low-paying comic field for more lucrative book and magazine illustration. True crime magazines were just a few of his many clients in the '40s, which ranged from sedate Collier's magazine to children's books.

F. R. GLASS was an Ohio artist who did paintings for the pulp magazines and books as well as theater design. He produced pulp-style covers for *Startling Detective* in its earliest incarnation before publisher Fawcett moved its editorial offices from the Midwest to New York City.

GEORGE GROSS first gained recognition for his pulp covers of astoundingly sexy women produced for Fiction House's *Jungle Stories* and a host of detective titles. It was only natural that he should be chosen by Skye when they started their sexy crime titles in 1948. Gross's beautiful blondes, brunettes, and redheads drew readers to *Women*

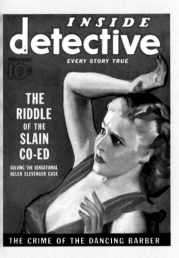

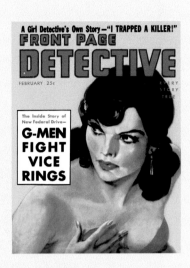

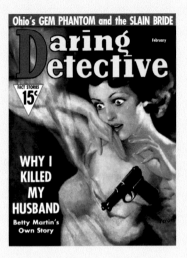

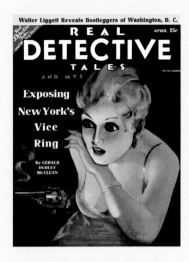

in Crime for several years before the company switched to photographic covers. Gross's late career included cover paintings for men's adventure magazines and numerous paperback covers of both the "good girl" and Western variety.

CARDWELL HIGGINS, a compatriot of pin-up master Alberto Vargas, produced many covers for sexy magazines including *Film Fun*, *Silk Stockings*, and *Gayety* in the 1930s. At that time he also provided illustration for advertising, comic books, and mainstream magazines. In the early 1940s Higgins painted some striking true crime covers, mainly for Martin Goodman's detective magazines, before the military drafted him to teach camouflage painting.

J. GEORGE JANES produced pin-up paintings used as interior illustrations for various girly and general humor magazines during the war. He later did many of the sexy portrait covers for Lionel White's *Detective World* and *Underworld Detective*.

LOU KIMMEL had a varied career, producing many Western-themed illustrations for the *Saturday Evening Post* and other magazines. In the post-war era he concentrated on paperback covers, including several early Mickey Spillanes, as well as illustrating for men's magazines and *True Detective* in the '50s and '60s.

MORT KUNSTLER did a small number of *True Detective* covers in the '50s before becoming a major illustrator for Martin Goodman's huge line of men's adventure magazines. Kunstler, sadly, did few paintings for Goodman's line of true crime magazines because they mainly used photographs for their cover illustrations.

JOE LITTLE contributed many illustrations to Hearst's *American Weekly* newspaper supplement and worked for various advertising agencies as well as producing covers for *True Detective* in the 1960s.

PHILIP LYFORD launched his career with a major WWI propaganda poster titled "In Flanders Fields," painted when he was quite young. He went on to become one of Chicago's top advertising artists in the 1930s, but still painted covers for major magazines including *Collier's*, *Boy's Life*, *College Humor*, and *Real Detective*.

ROBERT MAGUIRE was one of many talented artists who studied under Frank Reilly at the New York Art Students League during the post-war period. He was and is primarily a paperback cover artist working from the early 1950s to the present. He is best known for mixing images of tight, realistic faces and figures with highly impressionistic backgrounds. At the beginning of his career in the '50s he briefly produced covers for *True Detective*.

GEORGE MAYERS did numerous covers for the early issues of *True Police Cases*, as well as for *True* and *Argosy* in the 1940s. In the '50s, when photos largely replaced painted covers on magazines, he switched to paperback illustration, working for Avon, Dell, Pocket Books, and Popular Library.

MICHAEL McCANN produced most of the striking portrait covers for *Detective World* in the late '40s and later served as the magazine's art director. His inventive images of sexy women strangled, speaking directly to the viewer, or seen through bullet-shattered glass injected excitement into this art style matched by few others. He later produced paintings for men's adventure magazines, and as the illustration market grew less lucrative in the '50s, switched to comic books.

ROBERT McGINNIS is one of the best-known American paperback artists of the 1950s and '60s, reportedly producing over 1,000 covers. Many of his paintings illustrated "noir" fiction and featured beautiful women, making him a natural to (briefly) produce covers for *True Detective* and *Master Detective*.

STOCKTON MULFORD is best known for the Western-themed covers he painted for *Western Story* and other pulps during the '20s and '30s. In the 1930s he also painted covers (and the rare interior illustration) for Fawcett's *Startling Detective* and *Daring Detective*, signing his paintings only with the initial "M." Mulford was an extremely versatile artist, proficient in pastels as well as oils, but in later life he abandoned illustration altogether to sell art and antiques in upstate New York.

NORMAN NODEL was a comic book artist whose illustrative style also enabled him to do cover and interior illustrations for books and magazines. While his most noted work was the comic book adaptation of the James Bond novel *Dr. No*,

FROM ABOVE LEFT Armando Seguso, *Inside Detective*, December 1936; Delos Palmer, *Front Page Detective*, February 1937; Richard Cardiff, *Daring Detective*, February 1937; Alec Redmond, *Real Detective Tales*, April 1931

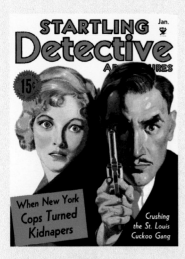

OPPOSITE Alec Redmond, *Real Detective*, January 1931

ABOVE George Rozen, *Startling Detective Adventures*, January 1934

BELOW Stockton Mulford, *Startling Detective Adventures*, August 1935

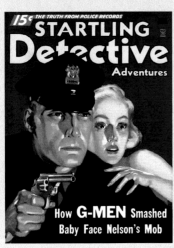

he also produced covers for some true crime publications in the '50s and '60s.

DELOS PALMER preceded Dalton Stevens as the primary *True Detective* cover artist, responsible for many of the earliest '20s covers, including the over-painted film stills. He may hold the record as the artist who worked for the most publishers and different magazines. After he left *True Detective* his paintings appeared on the covers of *Front Page Detective*, *American Detective*, *Inside Detective*, and *Real Detective*. When the demand for painted covers dropped in the 1940s and '50s, Palmer specialized in children's portraits, an odd career move for an artist whose forte for so many years was sex and violence.

BARYE PHILLIPS was one of the most prolific paperback cover artists of the 1950s, best known for illustrating Gold Medal's detective novels, including the *Shell Scott* series by Richard Prather. He also worked briefly for Macfadden, doing covers for *True Detective* and *Master Detective*.

JAY SCOTT PIKE has had one of the most varied careers of any illustrator in the 20th (and now 21st) century. Born in Philadelphia in 1924, he studied at New York's Art Students League before starting work as a professional illustrator in the post-war period. In the 1950s Pike illustrated everything from horror, romance, and war stories for the Marvel/Atlas comic book publishers, to pin-up calendars, to advertisements, to covers for major newsstand magazines. He also produced several memorable covers for *True Detective*. In recent years he's specialized in Civil War and other historical commissions in the fine arts field.

ALEC REDMOND was a Midwest illustrator who produced most of the early *Real Detective* covers before the magazine moved its editorial offices from Chicago to New York in early 1933.

PAUL REINMAN was a minor comic book artist whose career started in the 1940s, drawing both major heroes like Green Lantern, and long-forgotten second bananas like Sargon the Sorcerer. In the '50s and '60s he illustrated science fiction, horror, crime, and war stories. In 1959 Sol Brodsky tapped Reinman to paint the covers and interiors

for *Private Eye Magazine*, which may have contributed to its short run.

FRED RODEWALD began as a Western pulp artist. In the late 1940s he painted covers for Macmillan and other book publishers in addition to his sexy cover work for Skye's *Best True Fact Detective*, *Police Detective*, and *Women in Crime*.

GEORGE JEROME ROZEN and JEROME GEORGE ROZEN were twin brother painters with confusing names. They are best known for their pulp work—most notably George's paintings of pulp's most famous hero, The Shadow. Both brothers did many pulp and book cover paintings, though, for various publishers. Jerome also worked in advertising, and illustrated for many of the major slick magazines. George later moved on to paperback covers. Sadly their massive output includes only a few covers for true crime magazines in the 1930s and 1940s, though Jerome returned to create a handful of *True Detective* covers in the mid-'50s.

MARK SCHNEIDER was an artist primarily associated with the magazines of New York publisher Adrian B. Lopez. Lopez entered the field in 1937 with *Photo Detective*, one of the early crime titles with a frankly sexual orientation. Over the next five decades Lopez would produce cheap low-end magazines in every sensational genre from true romance to men's adventure, with titles switching themes at will. Thus *Sir!* morphed from a pin-up to a scandal to a men's adventure to an all-out sex magazine in the space of a decade. *Photo Detective* usually depended on cover photos of sexy women in transparent lingerie to attract readers, but like everything else in the Lopez organization, there was vacillation. When the magazine required painted covers, Schneider was usually the artist. He was a marginal talent at best, who produced rather strange compositions, so it may be that his effect on the magazine's sales contributed to Lopez's desire to use photo covers. Whatever the case, Lopez kept him on; his work appeared regularly in *Sir!* during the 1950s.

ARMANDO SEGUSO is best known for painting movie posters, including the first posters for *Gone With the Wind* in 1939. In the 1950s and early '60s he

was producing paperback covers—and several *True Detective* and *Master Detective* paintings.

EDWARD DALTON STEVENS, who signed his work Dalton Stevens, produced most of the covers for *True Detective* from the late '20s through the '30s. While Stevens could do full figure covers like "Torture House" or "Tong War," his common approach was a romance-style portrait of a pretty society woman or handsome detective. Stevens was born in 1878 in rural Virginia and studied with John Vanderpoel at Chicago's Art Institute, as did many illustrators of his day. He also studied at Chase School in New York and in Paris and was a successful illustrator long before he became a regular contributor to Macfadden's magazines. While only in his 20s he was selling to *Harper's* and *Century* magazines and painting book covers for best-selling authors like E. Phillips Oppenheim. A thoroughly catholic talent, Stevens contributed covers to *True Detective*, *Ghost Stories*, and other Macfadden magazines while doing interior illustrations for *Red Book* and *Cosmopolitan*.

MARLAND STONE was a cover artist for the movie magazine *Silver Screen* at the same time that he was creating covers for *Real Detective* and *Startling Detective* in the 1930s. He later graduated to doing illustrations for Hearst's Sunday supplements and various slick magazines.

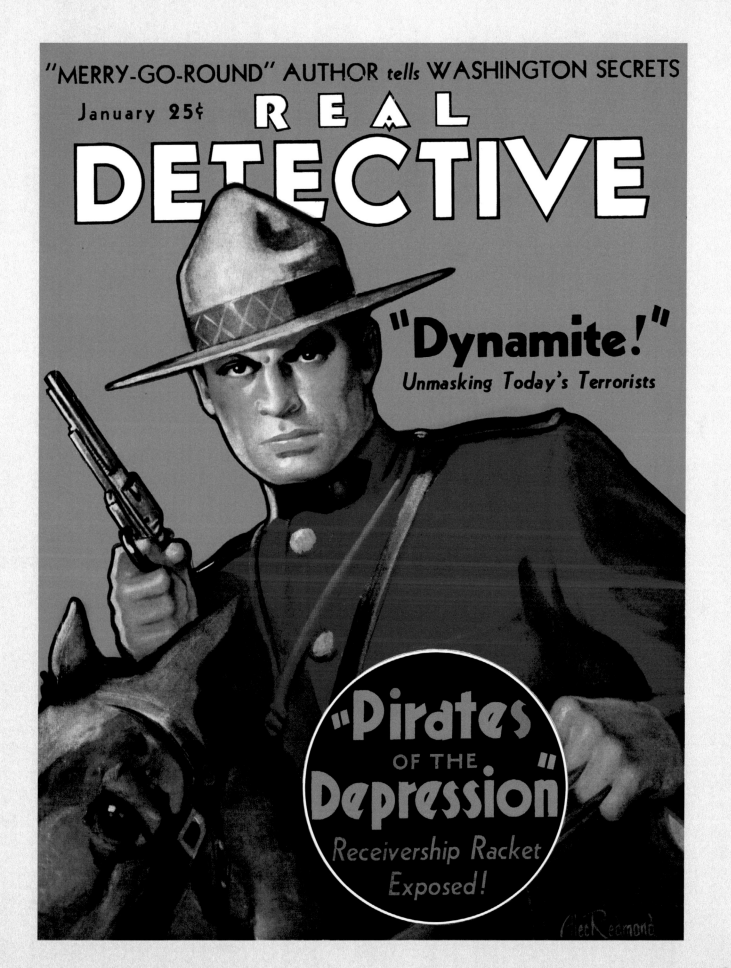

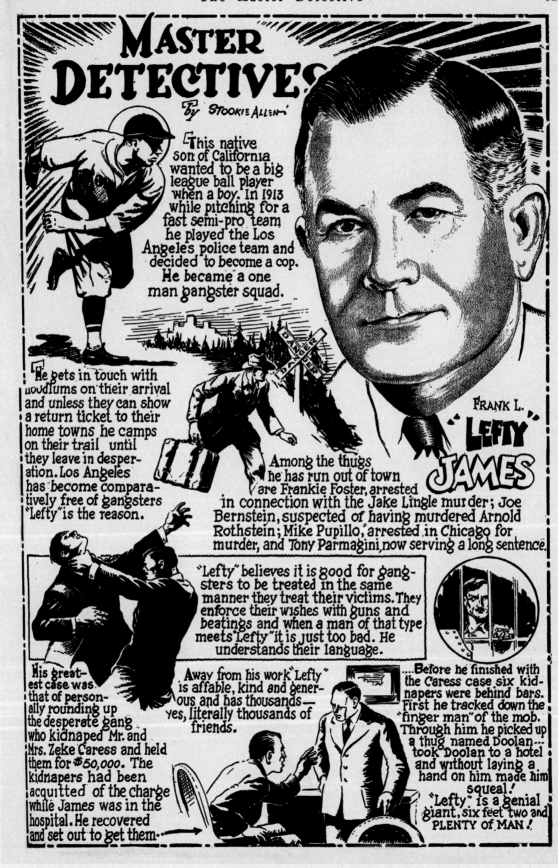

MASTER DETECTIVES

By STOOKIE ALLEN

This native son of California wanted to be a big league ball player when a boy. In 1913 while pitching for a fast semi-pro team he played the Los Angeles police team and decided to become a cop. He became a one man gangster squad.

He gets in touch with hoodlums on their arrival and unless they can show a return ticket to their home towns he camps on their trail until they leave in desperation. Los Angeles has become comparatively free of gangsters "Lefty" is the reason.

Among the thugs he has run out of town are Frankie Foster, arrested in connection with the Jake Lingle murder; Joe Bernstein, suspected of having murdered Arnold Rothstein; Mike Pupillo, arrested in Chicago for murder, and Tony Parmagini now serving a long sentence.

FRANK L. "LEFTY" JAMES

"Lefty" believes it is good for gangsters to be treated in the same manner they treat their victims. They enforce their wishes with guns and beatings and when a man of that type meets "Lefty" it is just too bad. He understands their language.

His greatest case was that of personally rounding up the desperate gang who kidnaped Mr. and Mrs. Zeke Caress and held them for $50,000. The kidnapers had been acquitted of the charge while James was in the hospital. He recovered and set out to get them—

Away from his work "Lefty" is affable, kind and generous and has thousands— yes, literally thousands of friends.

....Before he finished with the Caress case six kidnapers were behind bars. First he tracked down the "finger man" of the mob. Through him he picked up a thug named Doolan... took Doolan to a hotel and without laying a hand on him made him squeal! "Lefty" is a genial giant, six feet two and PLENTY OF MAN!

DIE KÜNSTLER, DIE SICH VERBRECHEN AUSZAHLEN LIESSEN

von George Hagenauer

Obwohl die Coverkunst der True Crime Magazines bislang nicht in dem Maße gewürdigt wurde, wie die der Magazine mit fiktiven Kriminalgeschichten, ist sie doch ebenso unverwechselbar und von Magazin zu Magazin thematisch konsequent. Der Urahn dieses Stils war Bernarr Macfaddens Magazin *True Detective Mysteries*, der erste echte True-Crime-Titel in den USA. Als *True Detective* 1924 auf den Markt kam, waren viele der vermeintlich gemalten Cover in Wirklichkeit übermalte Standfotos aus Kinofilmen. Die Fotos, die im Heft die vorwiegend fiktiven Kriminalgeschichten illustrierten, waren meistens in den professionell ausgestatteten Studios von Macfadden nachgestellte Verbrechensszenen, hin und wieder ergänzt um echte Tatortfotos. Diese Praxis hatte allerdings eine gewisse Verwirrung der Leser zur Folge, da die tatsächlichen Opfer und Täter ja anders aussahen als die Schauspieler auf den nachgestellten Bildern. Mitunter schuf man dadurch Abhilfe, dass man die an den tatsächlichen Verbrechen Beteiligten für die nachgestellten Aufnahmen verpflichtete!

Als das Genre in den 1930er- und 1940er-Jahren populär wurde, fanden viele Kunsthochschulabsolventen Arbeit bei diesen Magazinen, auch wenn nicht alle stolz darauf waren. Wie bei den Pulp-Fiction-Illustratoren auch schämten sich viele für diese triviale Kunst und arbeiteten anonym.

Die Verknappung der Ressourcen während des Zweiten Weltkriegs – Mitarbeiter fehlten ebenso wie Papier, da viele Künstler eingezogen wurden – bewog manche Blätter dazu, ihre gemalten Titelbilder zugunsten preiswerterer Fotocover aufzugeben. Die Aufhebug der

Rationierungen nach Kriegsende führte zu einer explosionsartigen Vermehrung der True-Crime-Titel. Zwei der neuen Verlage sollten einige der besten gemalten Cover auf den Markt bringen, die je produziert wurden. Lionel Whites *Detective World* und *Underworld Detective* hatten die grellsten Porträtcover aller Zeiten, während die Magazine *Best True Fact Detective*, *Police Detective* und das wunderbar geschmacklose *Women in Crime* von Skye Publications Titelbilder brachten, die auch den sündigsten erotischen Paperbacks der 1950er-Jahre gut zu Gesicht gestanden hätten.

Nach dem Zweiten Weltkrieg ermöglichte die GI-Bill, ein Stipendienprogramm, Hunderten von ehemaligen Soldaten ein Studium an den Kunstakademien. Nach Abschluss ihrer Ausbildung, brachten sie frischen Wind in die Welt der Coverillustration.

Leider wurden genau zu dieser Zeit die gemalten Cover der True Crime Magazines zugunsten von Fotocovern aufgegeben.

Macfadden war der Letzte im Genre, der noch Coverillustratoren beschäftigte und in den 1950er- und 1960er-Jahren ein paar unglaubliche Titelbilder veröffentlichte. Er beschäftigte nicht nur anerkannte Größen der Szene, sondern gab auch zahlreichen jungen Künstlern die Chance, für kurze Zeit im Bereich True Crime zu arbeiten, bevor sie sich respektableren Karrieren widmeten. Als auch die Macfadden-Titel Mitte der 1960er-Jahre auf Fotocover umstiegen, war die 40-jährige Geschichte der True-Crime-Malerei vorbei.

STOOKIE ALLEN hatte sich auf im Comicstil gezeichnete Beiträge über reale

Zeitgenossen für Pulps und True Crime Magazines spezialisiert. Er zeichnete seine Seiten im Stil des „Ripley's Believe It or Not"-Comics, als Reihe von Bildern mit Bildunterschriften. Am langlebigsten war sein *Men of Daring* für das Pulp Magazine *Argosy*. In *Master Detective* hatte er in den frühen 1930ern eine eigene Seite.

HAROLD BENNETT war ein kanadischer Illustrator, der für das wichtige Subgenre der kanadischen True Crime Magazines arbeitete. Die US-amerikanischen Rationierungen und die kanadischen Einfuhrbeschränkungen regten in den 1940er-Jahren eine kanadische Magazinproduktion an. Bennett war einer der wenigen Künstler, die ihre Bilder für diese Blätter signierten.

OZNI BROWN malte in den späten 1940er- und frühen 1950er-Jahren zahlreiche Cover für *True Detective*. Darüber hinaus malte er Cover und Illustrationen für die Sonntagsbeilage von Hearsts *American Weekly*.

AL BRULE war ein vielseitiger Werbegrafiker, der in den 1950er- und 1960er-Jahren auch einige Cover für True-Crime-Titel gestaltete. Bei aller Vielseitigkeit ist er jedoch am bekanntesten durch seine Kalender-Pin-ups.

RICHARD CARDIFF begann in den 1930ern bei Fawcetts *Startling Detective*. Möglicherweise wegen Fawcetts Umstellung auf Fotocover wechselte er in den 1940ern zu Macfadden und lieferte zahlreiche Cover für *True* und *Master Detective*, bevor er 1950 zum neuen Magazin *Saga* ging.

OPPOSITE Stookie Allen, *The Master Detective*, July 1933

ABOVE Ozni Brown, *Master Detective*, November 1952

BELOW John Falter, *The Master Detective*, February 1934

ABOVE Marland Stone, *Real Detective*, August 1934

CENTER J. George Janes, *Current Detective*, June 1944

BELOW Cardwell Higgins, *Feature Detective Cases*, September 1941

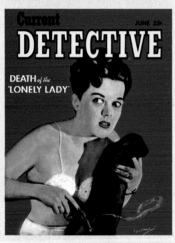

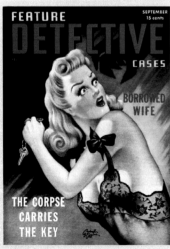

JOHN COUGHLIN war einer der ersten Coverkünstler für Pulps und gestaltete von der Heftgründung 1915 bis in die 1930er hinein die meisten Titelseiten des *Detective Story Magazine* von Street & Smith. Anfang der 1940er machte er auch einige Cover für *Crime Detective*.

GERARD DELANO war ein Pulp-Künstler, der in den 1920er-Jahren schon für Western-, Abenteuer- und Krimi-Pulps gearbeitet hatte, bevor er Anfang der 1930er-Jahre zum True Crime kam. Er hatte sowohl bei George Bridgeman an der Art Student's League in New York als auch bei den renommierten Illustratoren Dean Cornwall, Harvey Dunn und N. C. Wyeth studiert. Delanos Liebe zu Wildwestthemen bewog ihn in den 1930ern, in den Westen zu ziehen und nur noch Bilder mit Westernmotiven zu malen.

HOWELL DODD lieferte Cover für die sexlastigen True-Crime-Titel von Skye Publications. In den 1950ern schuf er zahllose Illustrationen für Adventure Magazines.

JOHN DREW war ein weniger bekannter Maler, der sowohl für Pulp Fiction wie auch für True Crime Magazines arbeitete.

PETER DRIBEN begann seine Karriere in den 1930er-Jahren als Coverkünstler für unter der Ladentheke gehandelte Sex-Pulps wie zum Beispiel *Tattle Tales*, *Pep* und *Snappy*. Driben, der an der Sorbonne in Paris studiert hatte, produzierte auch einige Cover für *Inside*, *Expose* und *Exclusive Detective*, bevor er dann in den 1940er-Jahren seine klassischen Coverbilder für Robert Harrisons Girlie-Titel *Flirt*, *Titter*, *Wink* und *Beauty Parade* malte. Er arbeitete auch in der Werbung und gestaltete Buchumschläge für erotische Paperbacks.

JULES ERBIT stammte aus Budapest und hatte sich in Europa bereits einen guten Ruf als Illustrator erworben, bevor er 1930 in die USA emigrierte. Cover für *Startling Detective* zählten zu seinen ersten festen Aufträgen in New York. Seine hübschen Frauenporträts weckten das Interesse von Brown and Bigelow, den Verlegern von Pin-up-Kalendern, die ihn 1933 als Künstler fest anstellten. Glamour stand von nun an im Mittelpunkt von Erbits Arbeit, und er malte

Hunderte von Bildern für Kalender, Spielkarten, Kunstdrucke und Schutzumschläge. Aber da Fawcett sich stets die Rechte an allen übernommenen Bildern sicherte und sie immer wieder neu verwendete, erschienen Erbits Bilder noch Jahre, nachdem er ein berühmter Kalender-Illustrator geworden war, auf True-Crime-Titeln von Fawcett.

Der Maler JOHN FALTER gestaltete in den ersten Jahren seiner Laufbahn, während der großen Wirtschaftskrise, Cover für *True Detective*. Erste Arbeiten für Pulps lieferte er bereits im Teenageralter ab. Zum True Crime kam er, als er 1930, da war er 20, ein Bild an das Magazin *Liberty* verkaufte, das später von Macfadden aufgekauft wurde. Als Soldat im Zweiten Weltkrieg entwarf er Rekrutierungsplakate. Nach seiner Entlassung aus der Armee knüpfte er Beziehungen zur *Saturday Evening Post* und gestaltete 185 Cover für diese renommierte Wochenzeitschrift, bis sie 1969 eingestellt wurde. Mit 53 plötzlich arbeitslos, verlegte sich Falter auf Buchumschläge und Promiporträts und schuf in den Jahren vor seinem Tod 1982 eine beeindruckende Kollektion von Bildern mit Szenen aus dem Nachtleben von Harlem.

ALBERT FISHER entwarf zahlreiche Cover für *Inside* und *Front Page Detective*, zwei True-Crime-Reihen von Dell. Als Dell in den 1940er-Jahren zu Fotocovern überging, wandte er sich anderen Magazinen und Genres zu und schuf 1949 schließlich das Cover der ersten Ausgabe des Magazins *Stag*, das allgemein als erstes Adventure Magazine für Männer gilt. Später wechselte Fisher in den 1950ern zu Kalenderproduktionen mit Landschaftsmotiven.

GRIFFITH FOXLEY, am ehesten als absolut seriöser Kalender-Künstler bekannt, schuf in den 1940ern mehrere Cover für *True Detective*.

L. FRIED schuf, bevor er durch Stockton Mulford ersetzt wurde, in den 1930er-Jahren zahlreiche Titelbilder für *Startling Detective* und *Daring Detective*.

LOUIS GLANZMAN begann seine Laufbahn als Zeichner von Superhelden wie dem *Amazing Man* für den zur zweiten Garnitur zählenden Comicverlag Centaur und zeichnete die *True Comics* für

den extrem biederen Verlag Parent's Publishing. Er tat gut daran, die schlecht bezahlte Arbeit im Comicgenre aufzugeben und sich den lukrativeren Buch- und Magazinillustrationen zu widmen. In den 1940er-Jahren waren True-Crime-Titel nur einige seiner zahlreichen Abnehmer, deren Palette von Colliers betulichem Magazin bis zu Kinderbüchern reichte.

F. R. GLASS kam aus Ohio und machte neben Pulp-Covern auch Bühnenbilder. Bevor der Verleger Fawcett seine Redaktionsbüros vom Mittelwesten nach New York City verlegte, entwarf Glass Cover im Stil der Pulps für *Startling Detective*.

GEORGE GROSS erwarb sich die ersten Meriten durch seine Pulp-Cover mit überraschend verführerischen Frauen, die er für die *Jungle Stories* des Verlages Fiction House und eine große Zahl von Detective-Titeln anfertigte. Da lag es nur nahe, dass Skye Publications ihn verpflichtete, als sie 1948 ihre sexy True-Crime-Reihe starteten. Gross' aufregende Blondinen, Brünette und Rotschöpfe fesselten die Leser über etliche Jahre, bis Skye dann auf Fotocover umstellte. Gross produzierte später Cover für Adventure Magazines und zahllose Paperbacks, sowohl in der Good-Girl-Manier als auch mit Westernmotiven.

CARDWELL HIGGINS, ein Landsmann von Pin-up-Meister Alberto Vargas, produzierte in den 1930ern viele Cover für Magazine mit einem guten Schuss Sex wie *Film Fun*, *Silk Stockings* und *Gayety*. Zu dieser Zeit lieferte er auch Illustrationen für die Werbung, für Comics und Mainstream-Zeitschriften. In den frühen 1940ern machte Higgins ein paar bemerkenswerte Cover für True-Crime-Titel, vornehmlich für die Magazine von Martin Goodman, ehe er schließlich zum Militär eingezogen und zum Fachmann für Tarnanstriche befördert wurde.

J. GEORGE JANES produzierte während des Krieges Pin-ups, die in diversen Girlie Magazines und Witzblättern erschienen. Später schuf er zahlreiche der sexy Cover, die Lionel Whites *Detective World* und *Underworld Detective* zierten.

LOU KIMMEL hatte eine bewegte Karriere und schuf viele Illustrationen mit

Wildwestmotiven für die *Saturday Evening Post* und andere Zeitschriften. Nach dem Krieg konzentrierte er sich auf Paperbackcover, unter anderem entstanden dabei mehrere Cover für frühe Titel von Mickey Spillane. Zugleich arbeitete er für Männermagazine und *True Detective* in den 1950er- und 1960er-Jahren.

MORT KUNSTLER machte eine Handvoll Cover für *True Detective* in den 1950er-Jahren, bevor er der Hauptillustrator für Martin Goodmans zahlreiche Adventure Magazines für Männer wurde. Leider malte Kunstler nur wenige Bilder für Goodmans True-Crime-Titel, da diese vorwiegend mit Fotocovern arbeiteten.

Von JOE LITTLE stammen viele Illustrationen für die Sonntagsbeilage von Hearsts *American Weekly*, außerdem arbeitete er für diverse Werbeagenturen und produzierte in den 1960er-Jahren Cover für *Detective*.

PHILIP LYFORD begann seine Karriere mit einem weitverbreiteten Propagandaplakat, „In Flanders Fields", das er noch in ziemlich jungen Jahren gemalt hatte. In den 1930er-Jahren zählte er zu den führenden Werbegrafikern in Chicago, gestaltete aber auch weiterhin Cover für auflagenstarke Magazine wie *Collie's*, *Boy's Life*, *College Humor* und *Real Detective*.

ROBERT MAGUIRE zählte zu den vielen talentierten Künstlern, die in der Nachkriegszeit bei Frank Reilly an der New York Art Students League studierten. Er ist seit den 1950er-Jahren bis heute in erster Linie auf Paperbackcover spezialisiert. Sein Markenzeichen sind knapp skizzierte, realistische Gesichter und Figuren vor einem ausgeprägt impressionistischen Hintergrund. Zu Beginn seiner Laufbahn produzierte er für einen kurzen Zeitraum Cover für *True Detective*.

GEORGE MAYERS gestaltete zahllose Cover für die frühen Nummern von *True Police Cases* wie auch für *True* und *Argosy* in den 1940er-Jahren. Als in den 1950ern auf den Magazinen die Coverillustrationen von Fotografien verdrängt wurden, wandte er sich den Paperbacks zu und arbeitete für Avon, Dell, Pocket Books und Popular Library.

MICHAEL McCANN schuf die meisten der packenden Porträtcover für *Detective World* und wurde später Artdirector dieses Magazins. Seine originellen Bilder von erotischen Frauen im Würgegriff ihres Mörders, die den Betrachter unmittelbar ansprachen, oder Bilder mit Blick auf die Szene durch eine zerschossene Glasscheibe machten seine Kunstwerke mit zum Aufregendsten, was das Genre zu bieten hatte. Später arbeitete er für Adventure Magazines, und als der Markt für Illustrationen in den 1950er-Jahren einbrach, sattelte er auf Comics um.

ROBERT McGINNIS zählt zu den berühmtesten Paperbackillustratoren der 1950er- und 1960er-Jahre und soll mehr als 1000 Cover gemalt haben. Viele seiner Bilder illustrierten Krimis der schwarzen Serie mit verführerischen Frauen. Da lag es nahe, ihn auch – leider viel zu wenige – aufregende Cover für *True* und *Master Detective* anfertigen zu lassen.

STOCKTON MULFORD verbindet man in erster Linie mit den Westernmotiven, die er in den 1920er- und 1930er-Jahren für *Western Story* und andere Pulps malte. In den 1930ern lieferte er auch Cover – und gelegentlich Illustrationen für das Heftinnere – für Fawcetts *Startling* und *Daring Detective*. Seine Bilder signierte er mit einem „M". Mulford war ein außerordentlich vielseitiger Künstler. Er malte in Öl und Pastell gleichermaßen versiert, doch in späteren Jahren gab er sein Handwerk auf und wurde Kunst- und Antiquitätenhändler im Norden des Staates New York.

NORMAN NODEL war ein Comiczeichner, dessen Stil ihn auch befähigte, Cover- und Innenillustrationen für Bücher und Magazine anzufertigen. Seine bekannteste Arbeit ist zwar die Comicversion des James-Bond-Romans *Dr. No*, doch er war auch in den 1950er- und 1960er-Jahren im True-Crime-Genre tätig.

DELOS PALMER war vor Dalton Stevens der wichtigste Coverkünstler für *True Detective*; von ihm stammen viele der Titelbilder aus den frühen 1920ern, darunter auch die mit übermalten Standfotos. Wahrscheinlich hat kein anderer Künstler für so viele unterschiedliche Magazine und Verlage gearbeitet wie er. Nachdem er *True Detective* verlassen

hatte, erschienen seine Arbeiten auf den Covern von *Front Page Detective*, *American Detective*, *Inside Detective* und *Real Detective*. Als die Nachfrage nach gemalten Covern in den 1940er- und 1950er-Jahren zurückging, verlegte sich Palmer auf Kinderporträts, ein seltsamer Schritt für einen Künstler, der sein Brot so lange Zeit mit Sex und Gewalt verdient hatte.

BARYE PHILLIPS war einer der produktivsten Künstler für Paperbackcover in den 1950ern, am bekanntesten sind seine Bilder für die Kriminalromane von Gold Medal Books, darunter auch die *Shell-Scott*-Reihe von Richard Prather. Er arbeitete aber auch kurz für Macfadden und machte Cover für *True* und *Master Detective*.

JAY SCOTT PIKE hatte eine der facettenreichsten Illustratorenkarrieren im 20. – und mittlerweile 21. – Jahrhundert. 1924 in Philadelphia geboren, studierte er an der Art Student League in New York, bevor er in der Nachkriegszeit als professioneller Illustrator zu arbeiten anfing. In den 1950er-Jahren illustrierte Pike praktisch alles: von Horror-, Liebes- und Kriegsgeschichten für die Comicverlage Marvel/Atlas über Pin-up-Kalender und Werbung bis hin zu renommierten Zeitschriften. Er schuf auch einige bemerkenswerte Titelbilder für *True Detective*. In den letzten Jahren hat er sich als Kunstmaler auf Motive aus dem Amerikanischen Bürgerkrieg und anderen vergangenen Epochen spezialisiert.

ALEC REDMOND stammte aus dem Mittelwesten und machte die meisten frühen Cover für *Real Detective*, bevor die Redaktion Anfang 1933 von Chicago nach New York City verlegt wurde.

PAUL REINMAN war ein wenig bekannter Comiczeichner, der sowohl bekannte Charaktere wie Green Lantern als auch längst vergessene Knallchargen wie Sargon the Sorcerer (Sargon der Zauberer) zeichnete. In den 1950er- und 1960er-Jahren illustrierte er Sciencefiction-, Horror-, Krimi- und Kriegsgeschichten. 1959 heuerte Sol Brodsky ihn an, Cover- und Innenillustrationen für das *Private Eye Magazine* anzufertigen, was möglicherweise mitverantwortlich für die Kurzlebigkeit des Magazins war.

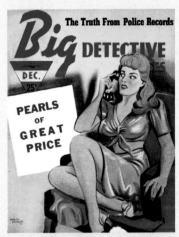

ABOVE Jerome Rozen, *True Detective*, June 1956

CENTER Harold Bennett, *Big Detective Cases*, December 1945

BELOW Lewis Berg, *Crime Detective*, April 1940

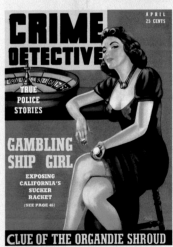

OPPOSITE George Gross original, 1948

ABOVE George Gross original, 1950

CENTER George Gross original, 1946

BELOW George Gross original, circa 1950

FRED RODEWALD begann bei den Western-Pulps. In den späten 1940ern machte er neben seinen sexy Covern für Skye auch Cover für Verlage wie Macmillan.

GEORGE JEROME ROZEN und JEROME GEORGE ROZEN waren Zwillingsbrüder mit reichlich verwirrenden Namen. Bekannt wurden sie durch ihre Pulp-Bilder – vor allem durch Georges Bilder des wohl größten aller Pulp-Helden, *The Shadow*. Aber beide Brüder malten Pulp-Illustrationen und Buchumschläge für die unterschiedlichsten Verlage. Jerome befasste sich auch mit Werbung und arbeitete für viele wichtige Hochglanzmagazine. George machte in späteren Jahren verstärkt Paperbackcover. Trotz ihres immensen Outputs lieferten beide aber nur wenige Arbeiten für True Crime Magazines in den 1930ern und 1940ern ab. Jerome produzierte allerdings in der Mitte der 1950er noch eine Handvoll Cover für *True Detectives*.

MARK SCHNEIDER assoziiert man in erster Linie mit den Magazinen des New Yorker Verlegers Adrian B. Lopez. Lopez debütierte in unserem Genre 1937 mit *Photo Detective*, einem der ersten True-Crime-Titel mit unverhohlen sexlastiger Ausrichtung. Während der folgenden fünf Jahrzehnte produzierte Lopez billige, minderwertige Magazine in praktisch jedem „Schund"-Genre von Liebesromanzen- bis Abenteuerheften, wobei

die einzelnen Titel scheinbar willkürlich ihre Konzeption änderten. So wandelte sich zum Beispiel *Sir!* innerhalb eines Jahrzehnts vom Pin-up-Heft erst zu einem Skandalmagazin, dann zu einem Adventure Magazine für Männer und schließlich zum reinen Sexheft. *Photo Detective* benutzte in der Regel Coverfotos von attraktiven Frauen in durchsichtiger Wäsche, um Leser anzulocken, doch wie bei allem von Lopez konnte sich dies schnell ändern. Wenn die Magazine ein gemaltes Cover wollten, wurde in der Regel Schneider beauftragt. Schneider war ein bestenfalls zweitklassiger Künstler, der recht seltsame Kompositionen ablieferte, also war es vielleicht sein negativer Einfluss auf die Verkaufszahlen, der die Fotocover für Lopez attraktiver machte. Trotzdem hielt Lopez ihm die Treue, und Schneiders Arbeiten erschienen während der 1950er-Jahre regelmäßig in *Sir!*.

ARMANDO SEGUSO ist am besten bekannt durch seine Filmplakate, darunter die ersten Plakate für *Vom Winde verweht* von 1939. In den 1950ern und 1960ern machte er Paperbackcover und einige Bilder für *True* und *Master Detective*.

EDWARD DALTON STEVENS, der seine Bilder mit „Dalton Stevens" signierte, gestaltete in den späten 1920ern und während der 1930er die meisten der

Cover von *True Detective*. Zwar verstand er sich auch auf szenische Cover, wie er sie für *Torture House* oder *Tong War* malte, doch gewöhnlich entschied er sich für Porträts hübscher Damen der Gesellschaft oder attraktiver Detektive im Stil der Liebesromane. Stevens kam 1878 im ländlichen Virginia zur Welt und studierte gemeinsam mit John Vanderpoel an der Kunsthochschule in Chicago, wie so viele Illustratoren der damaligen Zeit. Darüber hinaus studierte er noch an der Chase School in New York und in Paris und war schon lange, bevor er regelmäßig für Macfaddens Magazine zu arbeiten begann, ein erfolgreicher Illustrator. Mit gerade mal 20 Jahren arbeitete er schon für Magazine wie *Harper's* oder *Century* und gestaltete Buchcover für renommierte Autoren wie etwa E. Phillips Oppenheim. Als wirklich nach allen Seiten offener Künstler lieferte er Cover für *True Detective*, *Ghost Stories* und andere Magazine von Macfadden, während er zugleich Beiträge in *Red Book* oder *Cosmopolitan* illustrierte.

MARLAND STONE gestaltete in den 1930ern die Cover der Filmzeitschrift *Silver Screen*, aber auch Titelbilder für *Real* und *Startling Detective*. Später lieferte er Illustrationen für die Sonntagsbeilagen der Hearst-Blätter und diverse Hochglanzmagazine.

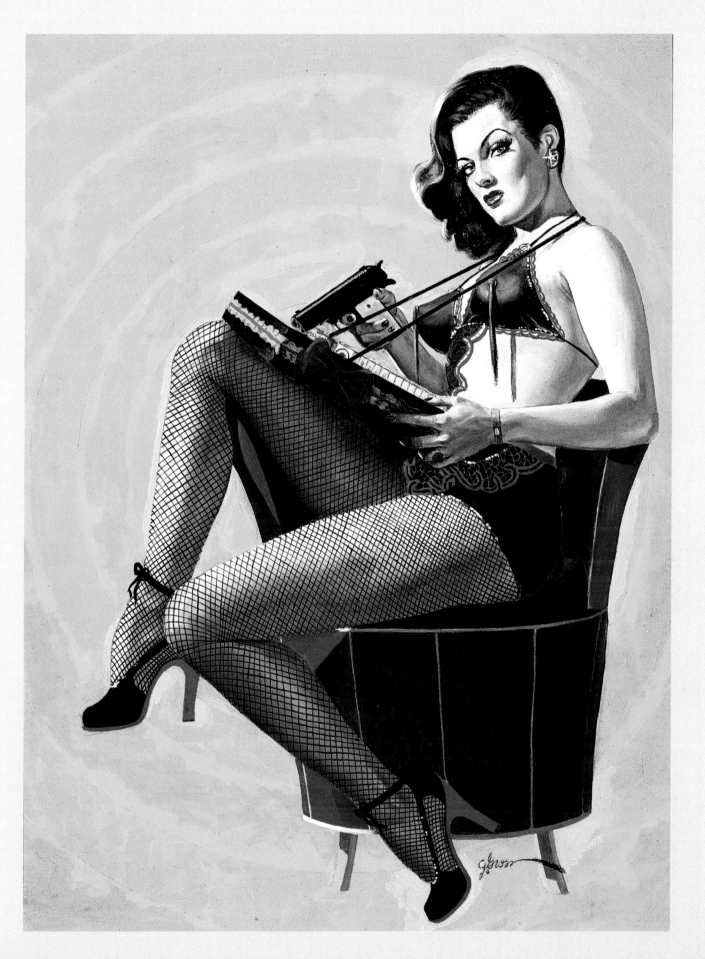

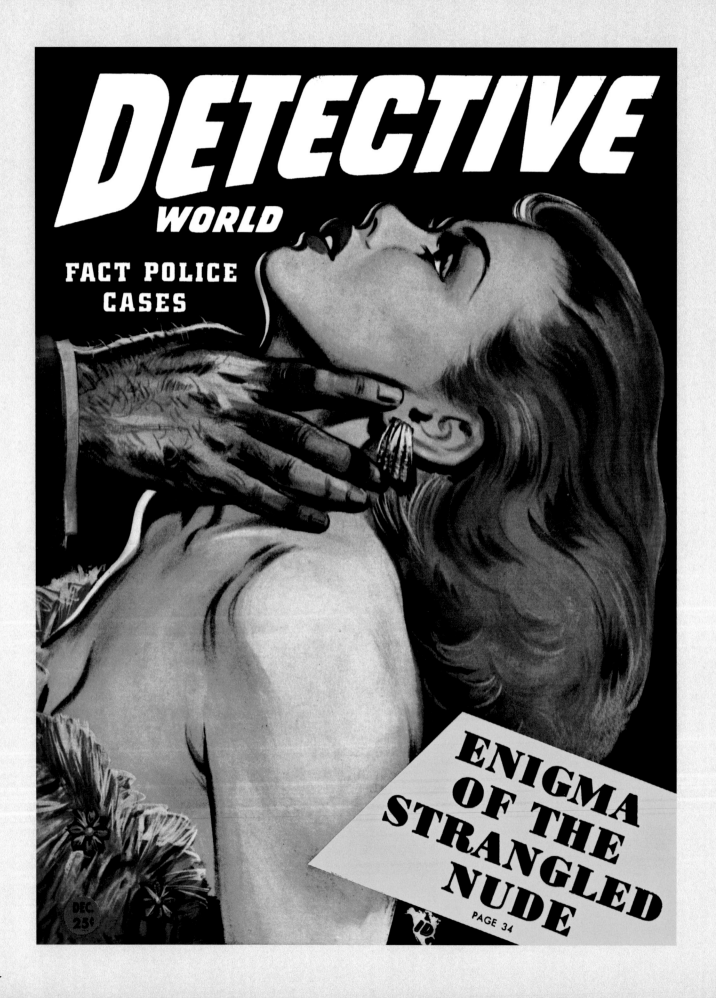

LES ARTISTES QUI ONT
RENDU LE CRIME PAYANT

George Hagenauer

Quoique beaucoup moins célébrées que les couvertures de *detective magazines* et de leurs fictions, celles des magazines d'enquêtes criminelles furent aussi caractéristiques et cohérentes dans leurs thématiques d'un magazine à l'autre. L'ancêtre du genre et le premier titre américain d'enquêtes criminelles, fut *True Detective Mysteries* de Bernarr Macfadden.

Quand *True Detective* est lancé en 1924, la plupart de ses soi-disant illustrations de couvertures sont en fait des photos de films retouchées. Les photos utilisées pour illustrer les récits largement inventés sont pour la plupart des reconstitutions de scènes de crime, effectuées dans les studios photo très bien équipés de Macfadden et mêlées à des photos extraites de véritables reportages criminels. Ces dernières ne font d'ailleurs que semer la confusion, car les victimes réelles et les criminels ne ressemblent pas aux acteurs qui interprètent leurs rôles dans les photos qui font revivre le fait divers. Il est même arrivé une ou deux fois que ce problème soit résolu en payant les véritables protagonistes d'une affaire criminelle pour qu'ils posent dans ces reconstitutions !

Avec le développement du genre dans les années 1930 et 1940, nombre d'artistes de qualité trouvèrent une activité dans ce secteur, bien qu'ils n'en fussent pas toujours très fiers. Cette forme d'art subalterne inspirait une certaine honte à ses créateurs et beaucoup d'entre eux s'y adonnaient clandestinement.

Les pénuries engendrées par la Seconde Guerre mondiale – le manque de papier et l'absence d'artistes, les hommes étant incorporés sous les drapeaux – ont poussé les responsables des maga-

zines à passer des couvertures peintes aux photos de couvertures, moins chères.

La fin des rationnements après la guerre a entraîné un boom du marché des *detective magazines*. Deux des nouveaux éditeurs créèrent alors quelques-unes des plus belles couvertures peintes jamais produites. *Detective World* et *Underworld Detective*, deux publications de Lionel White ont poussé le portrait de couverture jusqu'à ses plus spectaculaires possibilités, tandis que *Best True Fact Detective*, *Police Detective* et le merveilleusement indécent *Women in Crime*, trois magazines de Skye Publications, arboraient des couvertures très osées qui allaient s'échanger sous le manteau dans les années 1950.

Au lendemain de la Seconde Guerre mondiale, la GI bill, un programme d'assistance financière, a aidé des centaines d'anciens combattants à suivre des études artistiques. Quand ces artistes ont été diplômés, ils ont revitalisé le monde de l'illustration, inondant le marché de nouveaux talents. Malheureusement, c'est exactement le moment où les magazines d'enquêtes policières ont abandonné les couvertures peintes au profit des photos. Macfadden fut le dernier éditeur de magazines d'enquêtes criminelles à recourir aux couvertures peintes et à proposer des œuvres assez extraordinaires dans les années 1950 et 1960. Il faisait travailler des maîtres confirmés mais il donna aussi à un certain nombre de jeunes artistes l'opportunité de travailler brièvement aux magazines de la maison avant de s'orienter vers des carrières plus dignes d'eux. Quand les magazines Macfadden passèrent finalement à la photo de couver-

ture au milieu des années 1960, ils mirent un terme à un règne de quatre décennies d'illustrations.

STOOKIE ALLEN était spécialisé dans un style d'illustration de type B. D. pour les magazines *pulp* et d'enquêtes criminelles. Ses illustrations rappellent la B. D. de Ripley, *Believe It or Not!* Elles se composent d'une série d'illustrations avec des légendes humoristiques. Sa collaboration la plus longue fut réservée à *Men of Daring* pour Argosy. Il signa aussi une page régulière pour le magazine *Master Detective* au début des années 1930.

HAROLD BENNETT, un illustrateur canadien, a collaboré aux magazines d'enquêtes criminelles canadiens, sous-catégorie non négligeable du genre. Le rationnement de papier aux États-Unis et les restrictions canadiennes sur l'importation de certaines publications américaines ont stimulé la production de magazines canadiens dans les années 1940. Bennett fut l'un des rares artistes à signer ses créations pour ces nouveaux magazines d'enquêtes criminelles.

OZNI BROWN réalisa beaucoup d'illustrations de couvertures pour *True Detective* à la fin des années 1940 et au début des années 1950. Il peignit aussi des couvertures et des illustrations pour le supplément du dimanche d'*American Weekly* du groupe Hearst.

AL BRULE était un artiste commercial polyvalent qui réalisa quelques couvertures de magazines d'enquêtes criminelles dans les années 1950 et 1960. Si Brule a travaillé dans différents secteurs

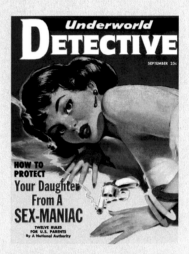

OPPOSITE Michael McCann, *Detective World*, December 1948

ABOVE Michael McCann, *Underworld Detective*, September 1952

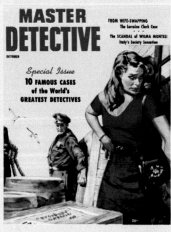

de la publicité et de l'illustration, il est davantage connu pour ses calendriers de pin up.

RICHARD CARDIFF signa, avec *Starling Detective* de Fawcett, sa première collaboration pour un magazine d'enquêtes criminelles. Dans les années 1940, il rejoignit le groupe Macfadden, peut-être à cause du recours croissant de Fawcett aux photos de couvertures. Au cours de cette décennie, il s'affirma comme un des meilleurs illustrateurs de couvertures chez *True* et *Master Detective*, avant de rejoindre *Saga*, qui venait de se créer, en 1950.

JOHN COUGHLIN fut l'un premiers artistes de couvertures des magazines *pulp* hebdomadaires. Il réalisa la plupart des couvertures pour *Detective Story Magazine* de Street & Smith's, de ses débuts, en 1915, jusqu'aux années 1930. Au début des années 1940, Coughlin créa aussi des couvertures pour *Crime Detective*.

GERARD DELANO illustra des couvertures de *pulps* (aventure, western et policier) dans les années 1920 avant de rejoindre les magazines d'enquêtes policières au tout début des années 1930. Il étudia avec George Bridgeman à l'Art Student's League de New York ainsi qu'avec des illustrateurs réputés comme Dean Cornwall, Harvex Dunn et N. C. Wyeth. Dans les années 1930, son attachement au thème du western le poussa à partir s'installer dans l'Ouest et il voua le restant de ses jours à peindre des toiles sur ce thème.

HOWELL DODD réalisa des couvertures pour les magazines d'enquêtes criminelles sexy de Skye Publications : *Best True Fact Detective*, *Police Detective* et *Women in Crime*. Il créa aussi de nombreuses peintures pour les magazines d'aventures pour hommes dans les années 1950.

JOHN DREW fut un illustrateur peu connu qui composait des couvertures tant pour les magazines d'enquêtes policières que pour les magazines de fictions policières.

PETER DRIBEN a commencé sa carrière dans les années 1930 en réalisant des couvertures pour des *pulps* sexy semi-clandestins comme *Tattle Tales*, *Pep* et *Snappy*. Driben, qui avait étudié à la Sorbonne, à Paris, réalisa également quelques couvertures pour *Inside*, *Expose* et *Exclusive Detective* avant de créer, dans les années 1940, les couvertures classiques des magazines de charme de Robert Harrison : *Flirt*, *Titter*, *Wink* et *Beauty Parade*. Il a également travaillé dans la publicité et peint des couvertures pour des livres de poche sexy.

JULES ERBIT est né à Budapest et il était déjà un illustrateur chevronné en Europe avant d'immigrer aux États-Unis en 1930. Une de ses premières commandes en arrivant à New York fut une série de couvertures pour *Startling Detective*. Les belles images de femmes peintes par Erbit attirèrent sur lui l'attention de Brown et Bigelow, éditeurs de calendriers de pin up, qui l'engagèrent comme membre de l'équipe en 1933. Dès ce moment, le style glamour définit le style d'Erbit et il réalisa des centaines d'illustrations pour des calendriers, des cartes à jouer, des gravures et des buvards. Mais comme la politique de Fawcett consistait à acheter les droits de toutes les illustrations utilisées et à les recycler sans cesse, les images d'Erbit continuèrent à apparaître en couverture sur la plupart des magazines d'enquêtes criminelles de Fawcett, des années après qu'il fut devenu célèbre comme illustrateur de calendriers.

JOHN FALTER, artiste-peintre, a créé des couvertures pour *True Detective* au début de sa carrière, dans les années qui suivirent la crise de 1929. Il a vendu ses premières images à des *pulps* alors qu'il était encore adolescent. En 1930, âgé de 20 ans, il vend une peinture au magazine *Liberty*, avant le rachat de ce dernier par Macadden, lequel amena Falter à travailler pour des magazines d'enquêtes criminelles. Mobilisé au moment de la Seconde Guerre mondiale, il dessina des affiches en faveur de l'engagement volontaire et une fois rendu à la vie civile, il noua une relation avec le *Saturday Evening Post* qui devait durer 25 ans. Il peignit 185 couvertures pour le prestigieux hebdomadaire avant la disparition du titre en 1969. Brusquement au chômage, à 53 ans, Falter réalisa des couvertures de livres, des portraits de célébrités et un impressionnant portfolio sur la vie nocturne de Harlem avant sa mort survenue en 1982.

ALBERT FISHER réalisa de nombreuses couvertures pour *Inside Detective* et *Front Page Detective*, deux magazines d'enquêtes criminelles du groupe Dell. Il collabora à d'autres magazines et d'autres types d'illustrations lorsque Dell, dans les années 1940, opta pour les couvertures photographiques, puis, en 1949, il peignit la couverture du premier numéro de *Stag*, généralement considéré comme le premier magazine d'aventures pour hommes des années 1950. À la fin de la décennie, Fisher opta pour la peinture de calendrier plus conventionnelle, se concentrant sur des paysages.

L. FRIED a réalisé de nombreuses couvertures pour *Startling Detective* et *Daring Detective* dans les années 1930 avant son remplacement par Stockton Mulford.

LOUIS GLANZMAN commença sa carrière en créant des superhéros comme Amazing Man pour l'éditeur de B. D. de seconde catégorie Centaur, et en collaborant à *True Comics* pour Parent's Publishing, éditeur d'une irréprochable moralité. Il abandonna le domaine de la B. D. qui payait mal pour celui de l'illustration de livres et de magazines. Il comptait autant le très pondéré magazine Collier's que des éditeurs de littérature enfantine parmi sa nombreuse clientèle, dont les magazines d'enquêtes criminelles ne constituaient qu'une petite partie.

F. R. GLASS, originaire de l'Ohio, réalisa des illustrations pour les *pulps* (magazines et livres) et fut également décorateur de théâtre. Il créa aussi des couvertures de style *pulp* pour le *Startling Detective* des premiers temps avant que l'éditeur Fawcett, d'abord installé dans le Middle West, s'installe à New York.

GEORGE GROSS se fit d'abord connaître par les couvertures de *pulps* représentant des femmes extraordinairement sexy qu'il créa pour *Jungle Stories*, une publication Fiction House et une kyrielle d'autres *detective magazines*. Il est donc tout naturel qu'il ait été choisi par Skye quand ceux-ci lancèrent leur collection de magazines d'enquêtes policières en 1948. Les belles créatures de Gross, blondes, rousses, ou brunes attirèrent des lecteurs plusieurs années durant, avant que le groupe opte pour les photos de couvertures. À la fin de sa

carrière, Gross réalisa des couvertures peintes pour des magazines d'aventures pour hommes et de nombreuses couvertures de livres de poche, de type « jeunes filles de bonne famille » ou western.

CARDWELL HIGGINS, compatriote du maître des pin up Alberto Vargas, a réalisé de nombreuses couvertures pour des magazines de charme dont *Film Fun*, *Silk Stockings* et *Gayety* dans les années 1930. À l'époque, il a aussi illustré des publicités, des livres de B. D. et des magazines grand public. Au début des années 1940, Higgins a peint quelques puissantes couvertures de magazines d'enquêtes criminelles surtout pour les magazines policiers de Martin Goodman, avant d'être engagé par les militaires pour enseigner l'art de la peinture de camouflage.

J. GEORGE JANES a réalisé des illustrations de pin up pour divers magazines humoristiques et de charme durant la guerre. Par la suite, il a composé un grand nombre de portraits sexy pour les couvertures des magazines Lionel White.

LOU KIMMEL a eu une carrière variée, réalisant de nombreuses illustrations western pour le *Saturday Evening Post* ainsi que d'autres magazines. Au lendemain de la guerre, il se concentra sur des couvertures de livres de poche, dont plusieurs Mickey Spillane des débuts, illustrant aussi des magazines pour hommes et *True Detective* dans les années 1950 et 1960.

MORT KUNSTLER réalisa quelques couvertures pour *True Detective* avant de devenir l'un des principaux illustrateurs des nombreux magazines d'aventures pour hommes de Martin Goodman. Malheureusement, pour les magazines d'enquêtes criminelles du groupe, il n'a créé que peu de couvertures, celles-ci étant pour la plupart réalisées par des photographes.

JOE LITTLE a réalisé un grand nombre d'illustrations pour le supplément hebdomadaire d'*American Weekly*, un journal du groupe Hearst. Il a travaillé pour diverses agences publicitaires et créé des couvertures pour *True Detective* dans les années 1960.

PHILIP LYFORD a lancé sa carrière avec un poster de propagande de la Première

Guerre mondiale intitulé « In Flander's Fields » qu'il avait peint quand il était très jeune. Il devint l'un des artistes publicitaires les plus connus de Chicago mais il continua à illustrer de nombreuses couvertures de magazines dont celles de *Collier's*, *Boy's Life*, *College Humor* et *Real Detective*.

ROBERT MAGUIRE fut un des artistes les plus talentueux ayant étudié sous la direction de Frank Reilly à la New York Art Students League au lendemain de la Seconde guerre mondiale. Il est resté un artiste spécialisé dans les couvertures de journaux, ce du début des années 1950 jusqu'à aujourd'hui. Il est célèbre pour ses réalisations mélangeant des visages et des individus aux traits secs, réalistes, sur des fonds très impressionnistes. Au début de sa carrière, dans les années 1950, il a réalisé quelques couvertures pour *True Detective*.

GEORGE MAYERS a réalisé de nombreuses couvertures à partir des sujets de *True Police Cases* ainsi que de *True* et *Argosy*. Dans les années 1950, quand les photos remplacèrent largement les couvertures peintes des magazines, il opta pour l'illustration des livres de poches, travaillant pour Avon, Dell, Pocket Books et Popular Library.

MICHAEL McCANN a réalisé la plupart des percutants portraits de couverture de *Detective World* avant de devenir par la suite le directeur artistique du magazine. Ses images inventives parlaient directement au spectateur, qu'il s'agisse de femmes sexy étranglées ou aperçues à travers une paroi de verre étoilée par un coup de feu. Elles injectaient dans cet art un style avec lequel peu de confrères pouvaient rivaliser. Il a par la suite réalisé des illustrations pour les magazines d'aventures pour hommes et avec la rentabilité en baisse du marché de l'illustration, McCann est passé au monde de la B. D.

ROBERT McGINNIS fut, dans les années 1950 et 1960, l'un des plus célèbres illustrateurs américains de livres de poche, pour lesquels il aurait réalisé plus d'un millier de couvertures. Nombre d'entre elles illustraient des fictions « noires » et mettaient en scène de belles femmes, ce qui en faisait un collaborateur tout désigné de *True Detective* et *Master Detective* pour lesquels il

créa également des couvertures pendant un bref laps de temps.

STOCKTON MULFORD est plus connu pour les couvertures western qu'il a créées pour *Western Story* et d'autres *pulps* dans les années 1920 et 1930. Dans les années 1930, il réalisa également des couvertures (et les rares illustrations de pages intérieures) pour *Startling Detective* et *Daring Detective*, deux magazines Fawcett, signant ses réalisations de sa seule initiale « M ». Mulford était un artiste extrêmement polyvalent, aussi à l'aise dans le pastel que la peinture à l'huile. À la fin de sa vie, il a néanmoins abandonné l'illustration pour se consacrer à la vente d'objets d'art et d'antiquités dans le nord de l'État de New York.

NORMAN NODEL fut un dessinateur de B. D. dont le style lui permit de créer illustrations de couvertures et pages intérieures pour des éditeurs de livres et de magazines. Si son travail le plus célèbre reste l'adaptation en B. D. du roman *James Bond contre Dr. No*, il réalisa aussi beaucoup de couvertures pour quelques magazines d'enquêtes criminelles.

DELOS PALMER fur le premier créateur des couvertures de *True Detective* avant Dalton Stevens. Il créa un grand nombre des couvertures du début des années 1920, y compris les photos de tournage retouchées. Il détient sans doute le record de l'artiste qui travailla pour le plus grand nombre d'éditeurs et de magazines différents. Après son départ de *True Detective*, ses illustrations apparurent sur les couvertures de *Front Page Detective*, *American Detective*, *Inside Detective* and *Real Detective*. Quand la demande de couvertures et d'illustrations chuta dans les années 1940 et 1950, Palmer se spécialisa dans les portraits d'enfants, un étrange virage professionnel pour un illustrateur dont la spécialité avait si longtemps été le sexe et la violence.

BARYE PHILLIPS fut l'un des artistes de couvertures les plus prolifiques des années 1950. Il est célèbre comme étant l'illustrateur des couvertures des polars Gold Medal's, et notamment de la série des *Shell Scott* de Richard Prather. Il travailla aussi brièvement pour Macfadden,

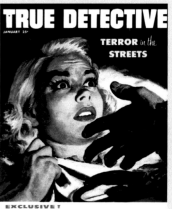

ABOVE Joe Little, *True Detective*, January 1954

CENTER George Mayers, *True Police Cases*, December 1948

BELOW Fred Rodewald, *True Crime*, May 1949

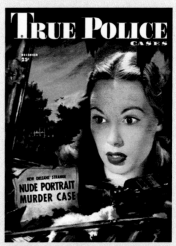

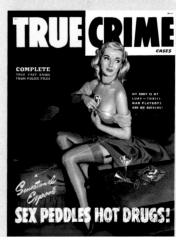

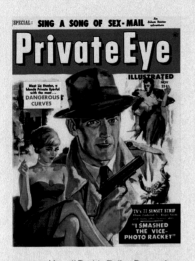

OPPOSITE Howell Dodd, *Police Detective*, December 1954

ABOVE Paul Reinman, *Private Eye Illustrated*, November 1959

BELOW *The Big Story*, October 1951

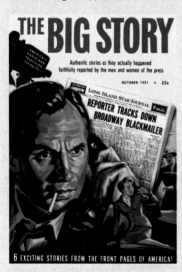

réalisant des couvertures pour *True Detective* and *Master Detective*.

JAY SCOTT PIKE est l'un des illustrateurs américains dont la carrière a été (et continue d'être) la plus variée. Né à Philadelphie en 1924, il a étudié à l'Art Student League de New York avant de commencer à travailler comme illustrateur professionnel au lendemain de la Seconde Guerre mondiale. Dans les années 1950, Pike a tout illustré : horreur, romance, histoires de guerre pour les magazines de B. D. Marvel/Atlas, calendriers de pin up, annonces publicitaires, couvertures de grands magazines. Il est aussi l'auteur de quelques mémorables couvertures pour *True Detective*. Ces dernières années, il s'est spécialisé dans les tableaux à vocation historique, notamment sur la guerre de Sécession, réalisés sur commande.

ALEC REDMOND, originaire du Middle West est l'auteur de la plupart des premières couvertures de *Real Detective* avant le déménagement des bureaux de l'éditeur de Chicago à New York, début 1933.

PAUL REINMAN, artiste de B. D. mineur, a débuté dans les années 1940. Il a dessiné des héros importants dans l'histoire de la B. D. comme Green Lantern, et des seconds couteaux depuis longtemps oubliés comme Sargon the Sorcerer. Dans les années 1950 et 1960, il a aussi illustré des histoires de science-fiction, d'horreur, de fictions policières et de guerre. En 1959, Sol Brodsky engagea Reinman pour réaliser les couvertures et les pages intérieures de *Private Eye Magazine*, ce qui pourrait bien expliquer en partie la brève existence du magazine.

FREE RODEWALD commença sa carrière comme illustrateur de western. À la fin des années 1940, il peignit des couvertures pour Macmillan et d'autres éditeurs et des couvertures sexy pour *Best True Fact Detective*, *Police Detective* et *Women in Crime* publiés par Sky.

GEORGE JEROME ROZEN et JEROME GEORGE ROZEN sont deux frères jumeaux aux prénoms identiques mais inversés. Ils sont plus connus pour leur travail sur les *pulps*, et surtout, en ce qui concerne George, pour ses illustrations du plus célèbre héros de *pulps*, le Shadow. Les deux frères ont réalisé beaucoup d'illustrations de *pulps* et de couvertures de livres, mais pour divers éditeurs. Jerome a aussi travaillé dans la publicité et réalisé des illustrations pour bon nombre de magazines prestigieux.

George est passé par la suite aux couvertures de livres de poche. Malheureusement, leur production massive ne comporte que quelques couvertures de magazines d'enquêtes policières réalisées dans les années 1930 et 1940, même si Jerome a effectué au milieu des années 1950 une poignée de couvertures pour *True Detective*.

MARK SCHNEIDER a commencé sa carrière sous les auspices d'Adrian B. Lopez un éditeur associé à divers magazines new-yorkais. Lopez lui-même avait percé dans le secteur en 1937 avec *Photo Detective*, un des premiers magazines de faits divers criminels à orientation nettement érotique. Dans les cinq décennies qui suivirent, Lopez devait lancer divers magazines bas de gamme dans tous les genres sensationnels, du sentimental aux aventures pour hommes avec des titres dont le contenu changeait à volonté. Ainsi, *Sir!* fut d'abord un magazine de pin up, avant de devenir une feuille à scandales puis un magazine d'aventures pour hommes, un magazine de sexe pur et simple, tout cela en une décennie… *Photo Detective* tablait en général sur ses couvertures de femmes sexy en dessous transparents pour racoler le chaland. Mais sur ce point comme sur tout le reste, la ligne éditoriale était sujette à des hésitations. Quand le titre avait besoin de couvertures illustrées, Schneider était celui auquel on avait recours. C'était un talent de second ordre qui produisait d'assez étranges compositions si bien qu'il se peut que son effet sur les ventes du magazine ait encouragé Lopez à passer aux photos de couvertures. Quoi qu'il en soit, Lopez a gardé Schneider dans son équipe et ses illustrations sont apparues régulièrement dans *Sir!* tout au long des années 1950.

ARMANDO SEGUSO est surtout connu comme dessinateur d'affiches de cinéma, notamment les premières affiches d'*Autant en emporte le vent*, en 1939. Dans les années 1950 et au début des années 1960, il a réalisé des couvertures de livres de poche et plusieurs illustrations pour *True Detective* et *Master Detective*.

EDWARD DALTON STEVENS, qui signait ses œuvres Dalton Stevens, a créé la plupart des couvertures de *True Detective*, de la fin des années 1920 jusqu'aux années 1930. Si Stevens a pu réaliser des couvertures à plusieurs personnages en pied comme pour « Torture House » ou « Tong War », il s'est surtout cantonné aux portraits de mondaines élégantes ou de séduisants détectives.

Stevens est né en 1878 dans la Virginie rurale et il a étudié avec John Vanderpoel au Chicago's Art Institute, comme beaucoup d'illustrateurs de l'époque. Il a également suivi les cours des Chase School de New York et de Paris et il était devenu un illustrateur réputé bien avant de devenir un collaborateur régulier des magazines de Macfadden. Alors qu'il n'avait pas encore 30 ans, il publiait déjà dans *Harper's* et *Century* et créait des couvertures de livres pour des auteurs à succès comme E. Phillips Oppenheim. Talent très éclectique, Stevens a donné des couvertures aussi bien à *True Detective* ou *Ghost Stories*, publications Macfadden, que des illustrations de pages intérieures pour *Red Book* ou *Cosmopolitan*.

MARLAND STONE réalisa des couvertures pour le magazine de cinéma *Silver Screen* en même temps qu'il créait des couvertures pour *Real Detective* et *Startling Detective* dans les années 1930. Par la suite, il a rallié le groupe Hearst dont il a illustré les suppléments dominicaux, collaborant également à différents magazines.

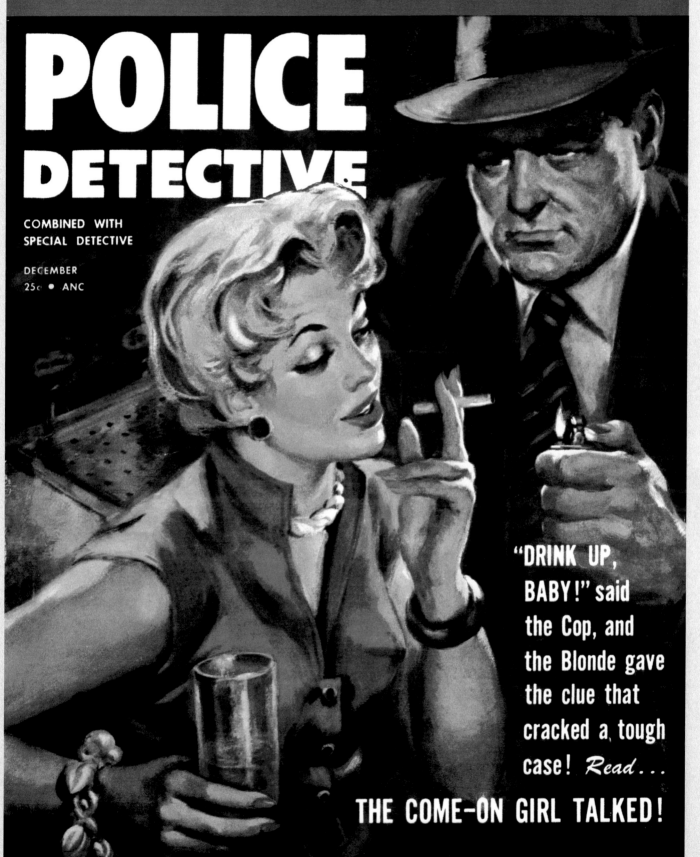

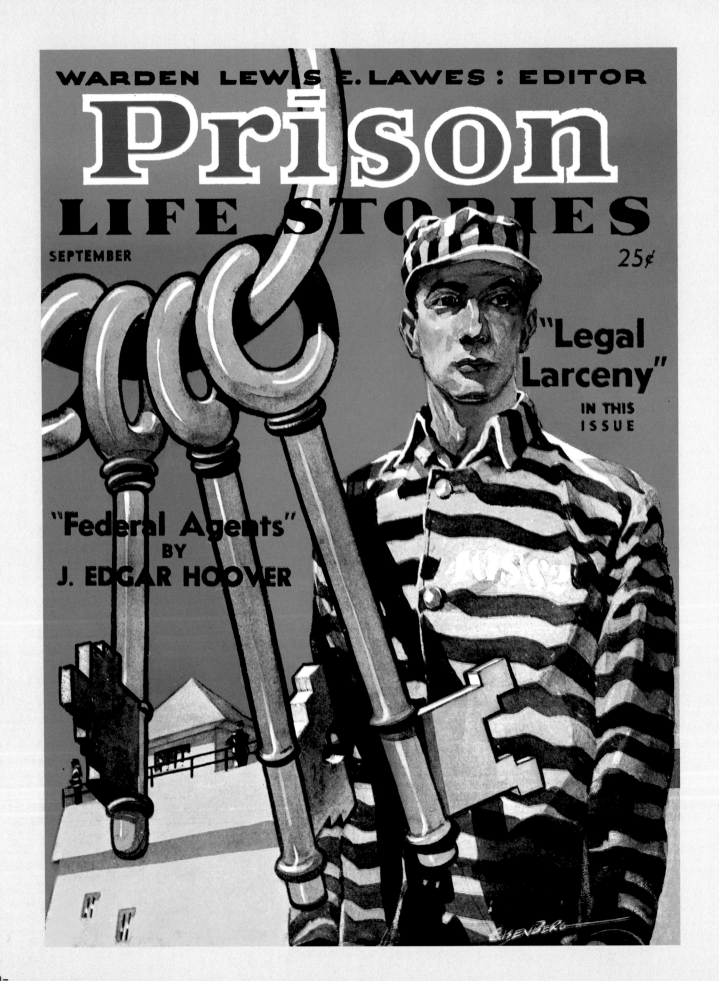

THE WRITERS WHO BROUGHT DEATH TO LIFE

by George Hagenauer

The true crime writers were a mix of moonlighting newspaper reporters, a few mystery writers, a surprising number of policemen and real detectives, and even the occasional crook. Many of the best writers' identities were hidden, as they preferred keeping this side of their careers quiet. The cops and robbers, on the other hand, were eager to have their names seen, but most were writers in only the most liberal sense. While many stories in true crime magazines were credited as written by law enforcement personnel, the bylines to most of these were followed by "as told to." It was the staff writer's or local journalist's name following these words who converted the cop's tale into readable text. This system enabled a number of crime fighters to become celebrated authors in the magazines, enhancing their careers or helping them start new ones.

Most of the stories of heroic cops and vicious serial killers were written by a core group of former or current newspapermen and freelance writers. For the newspaper reporters their detective magazine assignments meant doing longer versions of the stories they turned out for their day jobs. For these ghostwriters, the true crime magazines were a training ground that produced many of the top crime book authors of the 20th century.

It seems natural that mystery and suspense novelists would have cut their teeth writing for true crime magazines, but the fact is few did. A number of the more famous writers were recruited later to slum in the true crime field, covering major cases for newspaper syndicates that later were reprinted in the true crime magazines. More common was

the transition of detective pulp magazine writers into true crime since both genres paid a similar low word rate, especially as the pulps declined in the 1940s.

ERNEST BOOTH, a San Quentin convict, wrote both fiction for H.L. Mencken's *American Mercury* and non-fiction for various true crime magazines, between several botched escape attempts. His "Ladies of the Mob" was made into a movie starring Clara Bow.

RAY BRENNAN, a Chicago reporter, regularly sold stories to true crime and men's magazines. His biggest story came in the 1950s when he became convinced that Prohibition era bootlegger Roger Touhy had been framed by Al Capone and unjustly sent to prison. Brennan argued Touhy's case in numerous detective magazine articles that were finally rewritten as the book *The Stolen Years*. With Brennan's help, Touhy made parole — only to be cut down shortly after his release in a typical Chicago gangland-style shotgun slaying.

ROBERT ELLIOT BURNS's "I Am a Fugitive from the Georgia Chain Gang!" was serialized in *True Detective* from January through June 1931. Written in hiding after convict Burns had twice escaped the chain gang, it was a brilliantly written exposé of corrupt Southern justice and penal brutality. Burns was a World War I veteran who had gone awry of the law during a hobo phase. Picked up in Georgia, he was convicted and assigned to the gang where he suffered terrible abuse. Following his first escape he "went straight," becoming the editor of *Greater Chicago Magazine*. When

his criminal past came to light he was tricked into returning to the Georgia chain gang and escaped a second time. He then contacted *True Detective* with his story, which was later rewritten into a best-selling book and in 1932 became the classic film *I Am a Fugitive from a Chain Gang*. The story was instrumental in abolishing chain gangs throughout the South.

WILLIAM J. BURNS, head of the Burns Detective Agency and formerly with the Department of Justice, "wrote" a very popular series of stories about his major cases for *True Detective*, starting in 1930.

LESLIE CHARTERIS, creator of *The Saint*, wrote true crime for newspapers, slick magazines, and occasionally the true crime magazines.

GEORGE DOUGHERTY, a chief of detectives for the New York Police Department, came to the attention of *True Detective* editor Shuttleworth in 1931 when Fulton Oursler obtained his vanity press autobiography. Dougherty proved a competent writer and was regularly cover-bannered for his tales of crime in the big city.

ERLE STANLEY GARDNER, creator of fictional lawyer Perry Mason, was also a lawyer. In 1946 a public defender appealed to him to help save William Marvin Lindley, a penniless indigent sentenced to be executed for a murder he did not commit. Gardner reviewed the case, became convinced of Lindley's innocence, and convinced the governor to stay the execution. Gardner was so well respected that Lindley was later

By ELIOT NESS
DIRECTOR OF
PUBLIC SAFETY,
CLEVELAND, OHIO

OPPOSITE & BELOW *Prison Life Stories*, September 1935

SPECIAL AGENTS
of the
Federal Bureau of Investigation
By J. EDGAR HOOVER

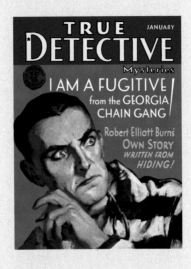

acquitted and released. In 1948 Gardner convinced Henry Steeger, publisher of *Argosy* magazine, to create the "Court of Last Resort." For this magazine feature Gardner assembled a volunteer team of major detectives and criminologists who worked to free people who'd been unjustly convicted. Gardner then summarized the results of their work each month in *Argosy*. This ambitious magazine project solved dozens of cases and freed as many innocent men and women, resulting in a book and television series.

WALTER GIBSON wrote two complete *Shadow* pulps every month for years, was a stage magician, and edited a magic magazine. As the pulps sank he turned to true crime writing, producing hundreds of articles for various magazines.

BRETT HALLIDAY, the creator of fictional private eye Michael Shayne, wrote for *Master Detective* in the mid-'40s.

DASHIELL HAMMETT started as a real-life detective for the Pinkerton agency but wrote only one true crime story, "Who Killed Bob Teal?," published in the November 1924 issue of *True Detective*.

J. EDGAR HOOVER sought to enhance his power base within the nation through publicity, developing the FBI public relations department. He also worked with freelance writer Courtney Ryley Cooper to ensure that his FBI exploits got into the press so as to promote the G-Man as the new American hero and role model for youngsters. Though it's unimaginable today that the head of the FBI would be submitting stories to detective magazines, articles credited solely to J. Edgar

appeared in almost every true crime magazine from the mid-'30s on. The column "With the G-Men," often bylined by Hoover, was a regular feature in *Real Detective*, alongside such lurid headlines as "Louisiana's Slain Panty Clad Beauty." Hoover was not picky about where he appeared as long as he got press. The magazines were only too happy to make him a star, as the presence of America's top government crime fighter gave them legitimacy and increased sales.

ALAN HYND, America's preeminent true crime writer for the first 75 years of the 20th century, began selling to *True Detective* in the 1920s. Hynd's approach was to do his research and then write a story well, but only once, soon amassing dozens of articles that could be sold and resold. Macfadden's *Liberty*, the cheap mass-market general interest Depression era magazine, regularly featured true crime stories. With *Liberty's* success other publishers began increasing their use of true crime articles. Hynd responded by selling second rights of his old articles to these better paying markets.

Within a year, he reversed, writing new articles first for the mass-market magazines and selling second rights to the true crime press. When Fawcett decided to launch the upscale true crime magazine *True Police Cases* in 1946, Alan Hynd was top of their list. Unfortunately, *True Police Cases* sold poorly and was converted into a sleazy rag with strippers on the cover. Not wanting to lose Hynd, the publisher moved him over to their slick *True* magazine. There he earned $1,200 for rewrites of stories he had churned out

earlier for pennies a word. The *True* deal included a contract to produce casebooks of Hynd's articles for Fawcett's paperback line.

DEAN JENNINGS was a prolific early contributor to the true crime magazines who later became a major writer of mobster and true crime biographies in both paperback and hard cover editions.

LEWIS E. LAWES, warden of Sing Sing prison, turned prison writing into a cottage industry with his book *10,000 Nights in Sing Sing*. That and popular subsequent books led to movie adaptations and to Lawes briefly editing his own true crime magazine, *Prison Life Stories*.

ELLERY QUEEN (Frederick Dannay and Manfred B. Lee), in addition to editing a mystery magazine, did a true crime series for the *Hearst Sunday* magazine and occasional true crime magazine stories.

CRAIG RICE (Georgine Anne Randolph Craig) found herself periodically providing "the women's view" to cases like the Black Dahlia murder. Her work for newspapers was inevitably reprinted in true crime magazines.

ANN RULE's grandfather and uncle were sheriffs, while a cousin was a prosecuting attorney and another uncle was a medical examiner.

As a teen, Ann prepared meals for prisoners in the local jail, coming to know them as human beings and becoming intrigued with how seemingly normal people became criminals.

Upon graduating college, she became the youngest policewoman ever hired

in Seattle, Washington. Her education included the victim's side of crime from experience at the Washington State Department of Public Assistance and the Oregon State Training School for Girls. Her degree in creative writing helped her crack *True Detective* in 1968, where she became its Northwest correspondent. Since the editors believed their readers related better to lawmen, they required her to become Andy Stack, a mix of her son's first name and her father's "Stack" nickname. She agreed since "I realized how quickly most felons got out of prison, and I was divorced with four young children, so in the interest of our protection, I kept the male pseudonym."

For 14 years "Andy Stack" covered hundreds of murder cases for *True Detective* and its former competitors, now all owned by the same publisher. In the mid-'70s Ann began writing a book for W.W. Norton on a series of similar, unsolved murders of beautiful young women in the Northwest. Before she finished, the press revealed that the prime suspect in the serial killings was Ted Bundy, a young psychology student she had met in 1971 while both volunteered for a crisis hot line. She and Bundy had become close friends, so when the suspicions progressed to indictment, Rule's book became an intensely personal look into the mind of a serial killer. Initially she had doubts that her friend could be the obsessed killer who had butchered so many young women. Her doubts disappeared when she compared casts of bite marks left on the victims to casts of Bundy's teeth.

Putting aside her original manuscript, Ann Rule managed to write *The Stranger*

Beside Me, her book on the Bundy case, in just three months. It was an instant best seller when it debuted in 1980. *Stranger's* success meant Rule could have stopped writing for the low-paying detective magazines, but she continued for another two years, reportedly because she enjoyed the work so much.

JIM THOMPSON, author of *The Killer Inside Me*, *The Grifters* and *The Getaway*, wrote sporadically for true crime magazines from the mid-'30s to the early 1950s. His articles on Oklahoma and Texas crime appeared in *True Detective*, *Master Detective*, and *Real Detective*, and were often of the "as told to" style — that weird mix of first and third person narrative common to the stories presented by local cops but written by someone else. By the '30s most of the better magazines preferred to use actual crime photos whenever possible. These could usually be had from local papers or by slipping the police five dollars.

When photos weren't available, Thompson improvised. His sister and his wife regularly posed as corpses found in ditches or tall grass. Thompson never explained the extent to which the psychotic, abusive cops and small town psychopaths in his novels were influenced by his experiences as a true crime writer. Most likely many of his fictional characters were just exaggerated versions of the cops and criminals he'd met covering small town killings in the 1930s.

MANLY WADE WELLMAN, a Weird Tales and sci-fi pulp author, wrote occasional articles for detective magazines throughout his decades' long career.

DETECTIVE

AMAZING COLLECTION OF THRILLING TRUE STORIES

WINTER EDITION

25¢

The Year's Best Detective Reading

DIE AUTOREN, DIE DEM TOD LEBEN EINHAUCHTEN

von George Hagenauer

Die True-Crime-Autoren waren ein bunter Haufen von Journalisten, die sich schwarz etwas nebenbei verdienten, einigen wenigen Kriminalschriftstellern, einer überraschend hohen Zahl von Polizisten und echten Detektiven und sogar einzelnen Ganoven. Viele der besten Autoren wurden in den Magazinen nie namentlich genannt, da sie diese Seite ihres Schaffens lieber verborgen hielten. Die Cops und Gangster hingegen waren scharf darauf, ihre Namen abgedruckt zu sehen, doch die meisten konnte man nur mit viel gutem Willen als Autoren bezeichnen. Zwar wurden die meisten Storys Vertretern der Strafverfolgungsbehörden zugeschrieben, doch stand daneben oft „nacherzählt von", und dann folgte der Name des Journalisten oder Hausautors, der den Bericht eines Cops in lesbare Form gebracht hatte. Dieses System erlaubte es einer ganzen Zahl von Ermittlern, in den Magazinen zu gefeierten Autoren aufzusteigen, was ihrer Karriere Auftrieb gab oder ihnen sogar eine neue erschloss.

Die meisten Geschichten über heroische Cops und brutale Serienmörder wurden von einem Kern ehemaliger oder noch aktiver Journalisten und freischaffender Autoren verfasst. Für die Zeitungsleute bedeutete die Arbeit für die Magazine lediglich, längere Fassungen der Geschichten zu schreiben, die sie ohnehin hauptberuflich verfassten. Für diese Ghostwriter waren die True-Crime-Titel ein willkommenes Versuchsfeld, das viele der besten Krimiautoren des 20. Jahrhunderts hervorbrachte.

Man sollte annehmen, dass sich Krimi- und Thrillerautoren darum gerissen hätten, für die True Crime Magazines zu arbeiten, doch das war nur selten der Fall. Eine Reihe bekannterer Schriftsteller wagte sich später in dieses Genre und berichtete für die großen Pressedienste über berühmte Kriminalfälle der Zeit; ihre Artikel wurden dann in den True-Crime-Blättern nachgedruckt. Doch in der Regel waren es – vor allem nach dem Niedergang der Pulps in den 1940ern – die Autoren aus den alten Detektivheftchen, die ins True-Crime-Fach wechselten; dort erwartete sie ein ähnlich mieses Zeilenhonorar wie in ihrem altem Genre.

ERNEST BOOTH, ein San-Quentin-Insasse, schrieb zwischen mehreren missglückten Ausbruchsversuchen sowohl fiktive Geschichten für H. L. Menckens *American Mercury* wie authentische Erzählungen für verschiedene True-Crime-Hefte. Sein *Ladies of the Mob* wurde sogar mit Clara Bow in der Hauptrolle verfilmt.

RAY BRENNAN, ein Reporter aus Chicago, verkaufte regelmäßig Geschichten an True Crime Magazines und Männermagazine. Seine größte Story kam ihm in den 1950ern unter, als er zu der Überzeugung gelangte, Roger Touhy, ein Alkoholschmuggler aus der Prohibitionszeit, sei von Al Capone hereingelegt worden und zu Unrecht im Gefängnis. Brennan legte Touhys Fall in zahllosen Artikeln in Detective Magazines dar, die schließlich zu dem Buch *The Stolen Years* zusammengefasst wurden. Mit Brennans Hilfe gelang es Touhy tatsächlich, auf Bewährung freizukommen, nur um kurze Zeit später bei einer für Chicago typischen Abrechnung unter Gangstern umgenietet zu werden.

ROBERT ELLIOT BURNS' Geschichte *I am a Fugitive from the Georgia Chain Gang!* erschien von Januar bis Juni 1931 in Fortsetzungen im *True Detective*. Verfasst in seinem Versteck nach nicht einem, sondern zwei Ausbrüchen aus der Sträflingskolonne, war es eine brillant geschriebene Entlarvung der korrupten Justiz in den Südstaaten und der Brutalität im Strafvollzug. Burns war kein gewöhnlicher Krimineller, sondern ein Weltkriegsveteran, der nach seiner Entlassung vom Militär während einer Lebensphase als Landstreicher geringfügig mit dem Gesetz in Konflikt geraten war. In Georgia aufgegriffen, wurde er in eine Chain Gang gesteckt, wo er Fürchterliches ertragen musste. Nach seiner ersten Flucht kehrte er ins „bürgerliche" Leben zurück und wurde Herausgeber des *Great Chicago Magazine*. Als seine kriminelle Vergangenheit publik wurde, lockte man ihn mit einem Trick zurück nach Georgia und steckte ihn wieder in die Chain Gang, aus der er ein zweites Mal entfloh. Nach dieser zweiten Flucht bot er seine Geschichte dem *True Detective* an. Umgeschrieben und in Buchform wurde Burns' Geschichte zum Bestseller, nach dem 1932 der heute als Klassiker geltende Film *Jagd auf James A.* (*I Am a Fugitive from a Chain Gang*) gedreht wurde. Die Geschichte trug mit dazu bei, das System der Sträflingskolonne in den ganzen Südstaaten abzuschaffen.

WILLIAM J. BURNS, der Kopf der Burns Detective Agency, war zuvor beim Justizministerium gewesen. Er „schrieb" für den *True Detective* ab 1930 eine sehr populäre Reihe über seine bedeutendsten Fälle.

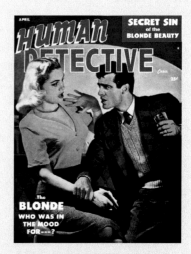

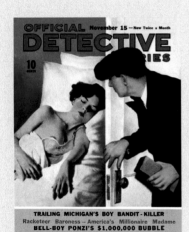

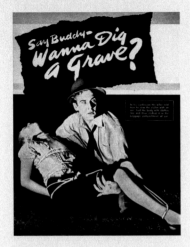

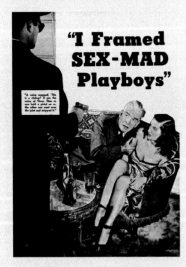

LESLIE CHARTERIS, der Erfinder von *The Saint*, schrieb in Zeitungen und Zeitschriften über wahre Verbrechen und gelegentlich auch für die True Crime Magazines.

GEORGE DOUGHERTY war Chef der New Yorker Kriminalpolizei. *True-Detective*-Chefredakteur Shuttleworth wurde auf ihn aufmerksam, als Fulton Oursler 1931 seine im Eigenverlag erschienene Autobiografie erworben hatte. Dougherty entpuppte sich als kompetenter Autor und unschätzbar wertvolle Informationsquelle, dessen Storys über die Kriminalität im Big Apple regelmäßig auf dem Cover groß angekündigt wurden.

ERLE STANLEY GARDNER, Erschaffer des fiktionalen Rechtsanwalts Perry Mason, war auch Rechtsanwalt. 1946 bat ihn ein Strafverteidiger, ihm zu helfen, den unschuldig wegen Mordes zum Tode verurteilten, mittellosen William Marvin Lindley zu retten. Gardner prüfte den Fall, kam zu der Überzeugung, dass Lindley tatsächlich unschuldig war, und konnte den Gouverneur bewegen, die Hinrichtung auszusetzen. Gardners Urteil galt so viel, dass Lindley später freigesprochen wurde. 1948 ließ Gardner sich von Henry Steeger, dem Herausgeber des Magazins *Argosy*, überreden, den Court of Last Resort einzurichten. Für diese feste neue Rubrik im Heft sammelte Gardner einige namhafte Detektive und Kriminologen als Freiwillige um sich, die in den Fällen zu Unrecht Verurteilter ermittelten. Ihre Ergebnisse fasste Gardner dann allmonatlich in *Argosy* zusammen. Dank dieses ambitionierten Magazinprojekts wurden Dutzende von Fällen in den Staaten neu aufgerollt und ebenso vielen Unschuldigen die Freiheit wiedergegeben. Später entstanden daraus ein Buch und eine Fernsehserie.

WALTER GIBSON verfasste jahrelang zwei komplette *Shadow*-Romane pro Monat. Er war darüber hinaus noch Varietézauberer und gab ein eigenes Magiermagazin heraus. Nach dem Aus für die Pulps kehrte er wieder zu True-Crime-Geschichten zurück und verfasste Dutzende von Artikeln für die unterschiedlichsten Magazine.

BRETT HALLIDAY, Erfinder des Privatdetektivs Michael Shayne, schrieb

Mitte der 1940er-Jahre regelmäßig für *Master Detective*.

DASHIELL HAMMETT begann als echter Detektiv bei der Pinkerton-Detektei. Er verfasste lediglich eine einzige echte True-Crime-Story, *Who Killed Bob Teal?*, die im November 1924 im *True Detective* erschien.

J. EDGAR HOOVER wollte seine Machtposition innerhalb des FBI durch ähnliche Publicity festigen und ausbauen. Hoover richtete nicht nur eine eigene PR-Abteilung im FBI ein, er heuerte eigens die freie Autorin Courtney Ryley Cooper an, um seine Heldentaten publiziert zu sehen, und beriet sich mit Fulton Oursler sowie anderen Verlegern, wie man den G-Man als neuen amerikanischen Helden und Vorbild für die Jugend promoten konnte. Auch wenn es heute unvorstellbar wäre, dass der Chef des FBI Detective-Blättern Storys zukommen ließe, ab Mitte der 1930er-Jahre erschienen in nahezu jedem True Crime Magazine Artikel, die angeblich von niemand anderem als J. Edgar verfasst worden waren. In den späten 1930ern war die Kolumne „With the G-Men", oft von Hoover selbst unterschrieben, ein fester Bestandteil im *Real Detective*, garniert mit so reißerischen Schlagzeilen wie „Die ermordete Unterwäscheschönheit aus Louisiana". Für Hoover spielte es keine Rolle, wo er abgedruckt wurde, solange es nur Publicity brachte. Die Magazine halfen nur zu gerne dabei, ihn zum Star zu machen, denn die Mitarbeit von Amerikas oberstem Verbrecherjäger legitimierte sie und steigerte zudem die Auflage.

ALAN HYND war bis 1975 wohl der herausragendste True-Crime-Autor in den USA. Er begann in den 1920er-Jahren, Geschichten an *True Detective* zu verkaufen. Hynd pflegte die Recherche zu machen und dann seine Story zu schreiben, und das gut, aber nur einmal. So hatte er bald einen Berg von Artikeln zusammen, die er verkaufen und wiederverkaufen konnte. Macfaddens *Liberty*, eine Publikumszeitschrift während der großen Wirtschaftskrise, brachte in ihren Anfangsjahren regelmäßig Artikel über wahre Verbrechen. Beeindruckt vom Erfolg dieses Magazins kopierten andere Verleger sein Konzept und brachten ebenfalls verstärkt True-Crime-Artikel. Hynd nutzte diese

Gelegenheit, um seine alten Beiträge aus dem *True Detective* zur Zweitverwertung diesen solventeren Blättern zu überlassen.

Doch innerhalb eines Jahres kehrte er diese Praxis um und gab seine neuen Artikel an die auflagenstarken, großen Zeitschriften, während er die Zweitverwertung den True-Crime-Blättern überließ.

Als Fawcett 1946 beschloss, ein hochwertigeres True Crime Magazine, *True Police Cases*, auf den Markt zu bringen, stand Alan Hynd ganz oben auf seiner Wunschliste. Unglücklicherweise lief *True Police Cases* schlecht und wurde bald zu einem Schundheft mit Stripperinnen auf dem Titel zurückgefahren. Weil sie Hynd nicht verlieren wollten, ließen die Verleger ihn für ihr schickes Magazin *True* schreiben. Dort verdiente er 1200 Dollar pro Stück für Neufassungen von Storys, die er vor Ewigkeiten massenweise für die True Crime Magazines geschrieben hatte. Zum *True*-Deal gehörte sogar, dass Hynds gesammelte Kriminalfälle von Fawcett in der hauseigenen Paperbackreihe veröffentlicht wurden.

DEAN JENNINGS war ein sehr produktiver Mitarbeiter bei den True Crime Magazines und wurde später ein bekannter Verfasser von Gangsterbiografien und True-Crime-Büchern.

LEWIS E. LAWES, ein Gefängniswärter in Sing Sing, machte mit seinem Buch *10 000 Nights in Sing Sing* aus Knastaufzeichnungen eine einträgliche Heimarbeit. Der riesige Erfolg dieses Buches und weiterer Titel ähnlicher Machart, die Filmadaptionen nach sich zogen, bewog Lawes, eine Zeit lang ein eigenes True Crime Magazine herauszugeben, *Prison Life Stories*.

ELLERY QUEEN (Frederick Dannay und Manfred B. Lee); das Autorenduo gab nicht nur ein Mystery-Magazin heraus, sie schrieben auch eine True-Crime-Serie für das *Hearst Sunday Magazine* und gelegentlich Beiträge für True Crime Magazines.

CRAIG RICE (Georgine Anne Randolph Craig) schrieb regelmäßig „aus weiblicher Perspektive" über Verbrechen wie den Black-Dahlia-Mord. Ihre Zeitungsartikel wurden von den True Crime Magazines nur zu gerne nachgedruckt.

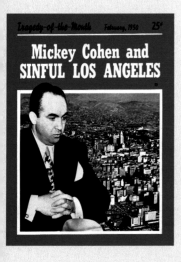

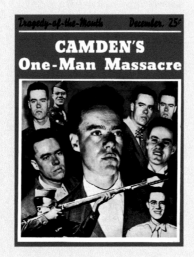

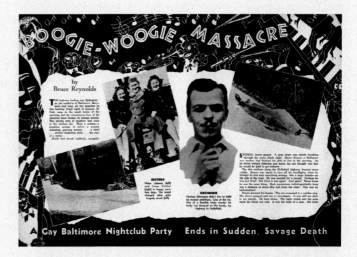

ANN RULES Großvater und ein Onkel waren Sheriffs, ein Vetter war Staatsanwalt und ein weiterer Onkel Gerichtsmediziner.

Als Teenager bereitete Ann das Essen für die Gefangenen im örtlichen Gefängnis zu. So kam sie zum ersten Mal in persönlichen Kontakt mit Kriminellen. Nach ihrem College-Abschluss war sie die jüngste Polizeibeamtin, die je in Seattle, Washington, eingestellt worden war. Um ihre Ausbildung abzurunden, lernte sie durch ihre Arbeit beim Washington State Department of Public Assistance auch die Seite der Verbrechensopfer kennen und absolvierte ein Praktikum in der Oregon State Training School for Girls.

Ein Abschluss in Creative Writing half ihr, 1968 *True Detective* zu „knacken", und sie wurde nach kurzer Zeit Korrespondentin im Nordwesten. Da die Herausgeber der Meinung waren, die Leser würden eher auf männliche Polizeibeamte ansprechen, bat man sie, das Pseudonym Andy Stack anzunehmen, zusammengesetzt aus dem Vornamen ihres Sohnes und dem Spitznamen ihres Vaters, „Stack". Sie stimmte zu: „Mir wurde klar, wie schnell Kriminelle wieder aus der Haft entlassen werden konnten. Ich war geschieden und hatte vier Kinder, darum behielt ich das Pseudonym schon allein aus Sicherheitsgründen bei."

14 Jahre lang berichtete Andy Stack über Mordfälle für *True Detective und* dessen ehemalige Konkurrenzblätter, die nun alle bei demselben Verlag waren.

Mitte der 1970er-Jahre begann Ann Rule für W. W. Norton mit der Arbeit an einem Buch über eine Serie sehr ähnlicher Morde an attraktiven jungen Frauen im Nordwesten. Sie war mit ihrer Arbeit

schon ziemlich weit gekommen, als die Presse als Hauptverdächtigen für die Serienmorde Ted Bundy präsentierte, einen jungen Psychologiestudenten, den sie 1971 kennengelernt hatte, als sie beide ehrenamtlich bei einer Krisen-Hotline arbeiteten. Sie und Bundy waren damals gute Freunde geworden, und so verschob sich der Ansatz ihres Buches von einer unvoreingenommenen Neufassung ihrer Detective-Magazine-Artikel hin zu einer intensiven Beschäftigung mit der Psyche eines Serienmörders, als sich die Verdachtsmomente verdichteten und Anklage erhoben wurde. Anfangs zweifelte Ann daran, dass ihr zurückhaltender junger Freund ein manischer Serienmörder sein könnte, der so viele junge Frauen brutal ermordet hatte. Als sie die Abdrücke von Bissspuren an den Opfern mit Abdrücken von Bundys Zähnen verglich, gab es keinen Zweifel mehr an seiner Schuld.

Ann Rule legte ihr ursprüngliches Manuskript zu den Akten und schaffte es, in nur drei Monaten ihr Buch über die Bundy-Morde *The Stranger Beside Me* zu schreiben. Das Buch wurde sofort nach seinem Erscheinen 1980 ein Bestseller. Der Erfolg von *Stranger* hätte es Rule erlaubt, ihre schlecht honorierte Arbeit für die Detective Magazines einzustellen, doch sie machte noch zwei Jahre weiter, weil ihr angeblich die Arbeit solchen Spaß machte.

JIM THOMPSON, Autor von *Der Mörder in mir, Grifters* und *Getaway* schrieb von Mitte der 1930er- bis Anfang der 1950er-Jahre sporadisch für True Crime Magazines.

Seine Beiträge erschienen unter anderem in *True Detective, Master*

Detective und *Real Detective* und waren häufig von der Machart der nacherzählten Artikel –, dieser seltsamen Mischung aus Schilderungen in der ersten und in der dritten Person, wie sie Geschichten eigen war, die von örtlichen Polizisten erzählt, aber von einem anderen niedergeschrieben wurden. Schon in den 1930er-Jahren bevorzugten die besseren Magazine echte Tatortfotos. Die bekam man gewöhnlich von den örtlichen Tageszeitungen, oder indem man einem Polizisten fünf Dollar zuschob.

Wenn es keine Fotos gab, oder wenn er keine fünf Dollar hatte, improvisierte Thompson. Seine Schwester und seine Frau lagen regelmäßig als vermeintliche Leichen in Straßengräben oder Feldern. Thompson hat sich nie dazu geäußert, inwieweit seine psychotischen, bösartigen Cops und Kleinstadtpsychopathen von seinen Erfahrungen als True-Crime-Autor geprägt sind. Aber es ist wahrscheinlich, dass sie lediglich überspitzte Ausgaben der Cops und Kriminellen sind, denen er seit den 1930er-Jahren bei der Recherche zu diversen Morden, über die er für die Magazine geschrieben hatte, begegnet war.

MANLY WADE WELLMAN war ein Horror- und Sciencefiction-Autor und schrieb während seiner ganzen Karriere gelegentlich für Detective Magazines.

TRUE POLICE CASES

DETECTIVE STORIES BY FAMOUS AUTHORS

DECEMBER
25c

A TRUE CRIME STORY BY CRAIG RICE

MASQUERADE OF DEATH BY ALAN HYND

MINISTER OF MURDER BY LESLIE CHARTERIS

LES AUTEURS QUI ONT RENDU LA MORT VIVANTE

George Hagenauer

Parmi les auteurs d'histoires policières, on trouve des journalistes ou reporters de la presse classique payés au noir, des écrivains de romans à suspense, un nombre étonnant de policiers et de détectives professionnels, et même quelques truands. Dans leur majorité, les vrais écrivains, peu désireux d'afficher cet aspect moins glorieux de leur carrière, ne signaient pas les histoires policières qu'ils vendaient aux magazines. Les gendarmes et les voleurs étaient au contraire toujours d'accord pour endosser des articles qu'ils n'avaient pourtant pas écrits de leur main. Les histoires qu'ils signaient portaient la mention « propos recueillis par… », accompagnée du nom d'un rédacteur du magazine ou d'un correspondant local, qui avait réécrit leur témoignage pour le rendre agréable à lire. Ce système offrait aux policiers et détectives une certaine notoriété et donnait un coup de pouce à leur carrière, ou leur ouvrait de nouvelles opportunités professionnelles.

Les aventures narrées par les flics héroïques ou les ignobles tueurs en série étaient le plus souvent l'œuvre d'un groupe restreint de journalistes pigistes. Ces derniers se contentaient souvent de rédiger pour les *detective magazines* des versions étoffées d'articles déjà écrits pour les journaux qui les employaient. Certains de ces écrivains anonymes sont devenus les meilleurs auteurs de roman policier du XXᵉ siècle.

Il peut paraître naturel que les auteurs de romans à énigmes et à suspense aient fait leurs premières armes dans les magazines d'enquêtes criminelles. Ils sont en fait très peu nombreux à avoir débuté ainsi. Il n'était pas rare, en revanche, que des écrivains déjà confirmés viennent à l'occasion « s'encanailler » dans des magazines policiers. Il s'agissait alors de reportages sur des crimes et procès spectaculaires commandés initialement par les journaux et les agences de presse et repris, plus tard, par les magazines policiers.

Les auteurs de fictions *pulp* furent plus nombreux à s'essayer à la narration du fait divers authentique, surtout lorsque le *pulp* commença à décliner dans les années 1940, les deux genres payant de manière équivalente.

ERNEST BOOTH, détenu de la prison de San Quentin écrivait à la fois des *pulp fictions* pour l'*American Mercury* de H. L. Mencken et des faits divers criminels pour différents magazines, le tout entre plusieurs tentatives d'évasions successives. *Ladies of the Mob* fut même adapté au cinéma, avec Clara Bow en vedette.

RAY BRENNAN, reporter à Chicago, revendait régulièrement ses papiers aux magazines érotiques ou d'enquêtes criminelles. Sa meilleure histoire policière date des années 1950. Il avait acquis la conviction qu'un certain Roger Touhy, contrebandier à l'époque de la prohibition, avait été injustement arrêté et emprisonné, victime d'un coup monté par Al Capone. Brennan étudia le dossier et défendit la cause de Touhy dans de multiples articles de magazines, réunis ensuite dans un livre, intitulé *The Stolen Years*. Avec son aide, le condamné réussit à obtenir la liberté conditionnelle – mais il fut abattu peu après au cours d'un règlement de comptes coutumier entre gangsters de Chicago.

ROBERT ELLIOT BURNS. Son *I am a Fugitive from the Georgia Chain Gang !* parut sous forme de feuilleton dans *True Detective*, de janvier à juin 1931. Ce récit dénonçait avec force et talent la justice corrompue et la brutalité carcérale des États du Sud américain. Ancien combattant de la Première Guerre mondiale, Robert Elliot Burns avait mal tourné pendant la période de vagabondage qui avait suivi sa démobilisation. Il finit par être arrêté et condamné en Géorgie, où il séjourna dans des bagnes successifs et fut terriblement maltraité. Après s'être évadé une première fois, il retrouva le droit chemin et finit par être nommé, sous un faux nom, rédacteur en chef du *Greater Chicago Magazine*. Il fut pourtant bientôt rappelé par son passé et retrouva la dure vie du bagne, d'où il s'évada une deuxième fois. C'est alors qu'il contacta *True Detective* avec des textes autobiographiques qui, une fois parus dans le magazine, furent ensuite remaniés en livre et devinrent un best-seller adapté au cinéma en 1932. Son récit contribua à l'abolition des bagnes dans le sud des États-Unis.

WILLIAM J. BURNS, directeur de la *Burns Detective Agency* et ancien fonctionnaire au ministère de la Justice, « signa », à partir de 1930, dans *True Detective,* une série très populaire, retraçant ses enquêtes les plus intéressantes.

LESLIE CHARTERIS, auteur de *The Saint,* relatait des faits divers pour les journaux et occasionnellement pour les magazines policiers.

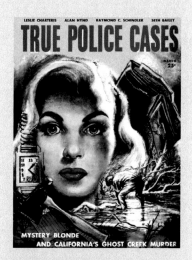

OPPOSITE *True Police Cases,* December 1947

ABOVE *True Police Cases,* March 1948

BELOW *True Police Cases,* March 1947

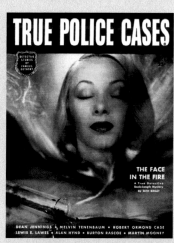

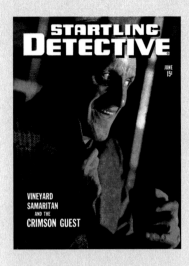

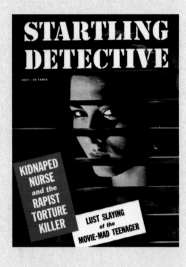

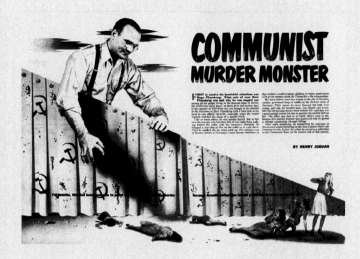

GEORGE DOUGHERTY, commissaire divisionnaire de la police judiciaire de New York, retint l'attention de Shuttleworth, grâce à l'autobiographie qu'il avait publiée. Le policier se révéla un écrivain talentueux et une source inestimable en faits divers criminels new-yorkais, lesquels faisaient régulièrement la couverture du magazine.

ERLE STANLEY GARDNER, l'auteur de la série des Perry Mason, était avocat. En 1946, un jeune avocat fit appel à lui pour l'aider dans l'affaire William Marvin Lindley, un homme sans ressources condamné à mort pour un meurtre qu'il niait avoir commis. Gardner étudia le dossier et, convaincu de l'innocence de Lindley, réussit à obtenir du gouverneur qu'il sursoie à l'exécution. Et grâce à la réputation de Gardner, l'accusé finit par être acquitté et libéré. En 1948, il persuada Henry Steeger, le directeur d'*Argosy*, d'ouvrir dans son magazine une section spéciale, le « tribunal de la dernière chance ». Gardner réunit une équipe bénévole de détectives et de criminologistes reconnus, qui examinaient les dossiers d'innocents injustement condamnés. L'écrivain résumait chaque mois leurs travaux dans *Argosy*. Ce projet journalistique ambitieux permit d'élucider ainsi une dizaine d'affaires et d'obtenir la libération des détenus. Ces affaires firent ensuite l'objet d'un livre et d'une série télévisée.

WALTER GIBSON produisit chaque mois pendant des années deux volumes d'aventures de *The Shadow*. Il était également illusionniste de théâtre et dirigeait un magazine de magie. Avec le déclin des *pulp fictions*, il se tourna vers le récit d'enquêtes criminelles et il fournit des dizaines d'histoires aux *detective magazines*.

BRETT HALLIDAY, qui avait créé le détective privé Michael Shayne, publia dans Master Detective au milieu des années 1940.

DASHIELL HAMMET, qui avait été détective pour l'agence Pinkerton, n'écrivit qu'une nouvelle basée sur un crime réel, *Who Killed Bob Teal?*, publiée dans *True Detective* en novembre 1924.

J. EDGAR HOOVER vit dans la publicité un moyen d'asseoir son pouvoir, développant un réseau de relations publiques au sein de l'agence fédérale. Il s'assura la collaboration du pigiste Courtney Ryley Cooper pour faire relayer par la presse ses exploits, essayant de promouvoir le « G-Man » (l'agent fédéral) comme nouveau modèle de héros américain pour la jeunesse. S'il est aujourd'hui inimaginable qu'un patron du FBI propose des articles aux *detective magazines*, les histoires signées d'un simple « J. Edgar » parurent dans presque tous les grands titres à partir du milieu des années 1930. *Real Detective* publia une colonne régulière, intitulée « Aux côtés des agents fédéraux » et qui, fréquemment signée par Hoover, côtoyait des histoires aux titres aussi saisissants que *La Belle de Louisiane assassinée en petite culotte*. Du moment que son nom apparaissait dans la presse, le chef du FBI ne faisait pas la fine bouche sur les supports qui l'accueillaient et les éditeurs ne pouvaient que s'en réjouir, la signature vedette leur garantissant à la fois légitimité et hausse des ventes.

ALAN HYND fut le plus éminent de ces journalistes de faits divers, collaborant à *True Detective* dès les années 1920. Il étudiait consciencieusement ses sujets avant de rédiger ses articles d'un seul trait, et amassa rapidement un large stock d'histoires qu'il vendait et revendait. Lors de ses débuts, *Liberty*, le magazine grand public à 25 cents créé par Macfadden pendant la crise, ouvrait régulièrement ses colonnes aux histoires policières. D'autres éditeurs s'inspirèrent de ce modèle, et Alan Hynd revendit ses droits sur un marché plus lucratif.

Hynd se mit à écrire directement dans les magazines grand public et à revendre ensuite ses droits aux magazines de détective. Quand Fawcett décida en 1946 de lancer *True Police Cases*, un magazine haut de gamme, Alan Hynd figurait en tête de sa liste d'auteurs. Malheureusement, *True Police Cases* qui se vendait très mal fut converti en un canard sordide exhibant des stripteaseuses en couverture. Soucieux de ne pas perdre son auteur fétiche, Fawcett le promut dans l'équipe de *True*, un magazine plus élégant, où Hynd touchait 1 200 dollars pour chaque remake de ses anciennes histoires policières. Le contrat prévoyait même la création chez l'éditeur d'une collection de poche consacrée aux enquêtes de Hynd.

DEAN JENNINGS fut un collaborateur des magazines policiers avant de publier des biographies de truands et des récits de crimes dans l'édition.

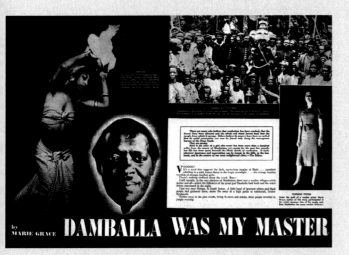

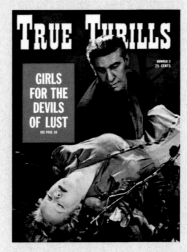

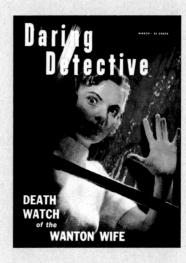

LEWIS E. LAWES, directeur de la prison de Sing-Sing, inaugura la « littérature carcérale à domicile » avec son livre *10 000 nuits à Sing-Sing*. Il ne tarda pas à créer son propre magazine, *Prison Life Stories*.

ELLERY QUEEN (Frederick Dannay et Manfred B. Lee), éditeur d'un magazine de mystère, travaillait pour les suppléments hebdomadaires du groupe Hearst et pour les magazines policiers.

CRAIG RICE (Georgine Anne Randolph Craig) offrait à ses lecteurs un point de vue féminin sur des affaires. Ses articles pour les journaux étaient repris par les magazines policiers.

ANN RULE a grandi avec un grand-père et un oncle shérifs dans le Michigan, un cousin procureur, et un autre oncle médecin légiste. Adolescente, elle aidait à préparer des repas pour les détenus de la prison du comté, apprenant à les connaître et intriguée de voir que des gens normaux pouvaient devenir des criminels.

Après des études universitaires, elle suivit la tradition familiale et devint la plus jeune policière que la ville de Seattle ait jamais connue. Pour parfaire sa formation, elle apprit à connaître le point de vue des victimes en travaillant au *Department of Public Assistance* de l'État de Washington. Sa formation universitaire l'aida à percer dans *True Detective* où elle ne tarda pas à être nommée correspondante du magazine pour le Nord-Ouest. Les éditeurs, convaincus que leurs lecteurs préféraient les policiers aux policières, lui demandèrent de prendre un pseudo-

nyme : Andy Stack, mélange du prénom de son fils et du surnom de son père. Ce nom de plume lui convenait : « Je me suis rendu compte que les malfaiteurs ne restaient pas longtemps en prison. Comme j'étais divorcée avec quatre enfants à élever, j'ai gardé le pseudonyme masculin pour nous protéger. »

Pendant 14 ans, Andy Stack assura la couverture de centaines de meurtres pour *True Detective* et ses clones. Au milieu des années 1970, Ann Rule entreprit, pour l'éditeur W. W. Norton, la rédaction d'un livre sur les meurtres en série non élucidés de jolies jeunes femmes dans le nord-ouest des États-Unis. Son manuscrit était déjà bien avancé lorsqu'elle apprit que le suspect numéro un était Ted Bundy, un jeune étudiant en psychologie avec qui elle avait travaillé dans un service d'assistance téléphonique « SOS Suicide ». Ils étaient devenus amis et, quand les soupçons se transformèrent en accusation, le livre d'Ann Rule changea, passant du récit détaché de faits divers à un regard personnel sur le fonctionnement mental d'un tueur en série. Elle avait d'abord refusé de croire que son ami pouvait sauvagement massacrer autant de jolies femmes. Mais la similitude entre des traces de morsures retrouvées sur les cadavres et les moulages dentaires de Bundy ne laissait aucun doute sur sa culpabilité.

Abandonnant son premier manuscrit, Ann Rule parvint à écrire en trois mois *The Stranger Beside Me*, qui relatait l'affaire Bundy. Ce roman fut un best-seller en 1980. Avec l'immense succès de son livre, Ann Rule aurait pu mettre fin à ses collaborations pour les magazines policiers, mais elle continua à écrire pour eux pendant deux ans.

JIM THOMPSON, auteur du *Démon dans ma peau*, des *Arnaqueurs* et du *Guet-apens* publia des articles dans les magazines policiers, du milieu des années 1930 au début des années 1950.

Avec le Texas et l'Oklahoma pour zones de reportage, ses histoires parurent dans *True Detective*, *Master Detective* et *Real Detective*. Elles étaient écrites dans le style « propos recueillis par… » – ce mélange de première et de troisième personne dans un récit narré par un journaliste sur la base de témoignages de policiers. Dès les années 1930, les meilleurs magazines policiers préféraient utiliser les véritables photos d'une affaire criminelle obtenues auprès de la presse locale ou en glissant un billet de cinq dollars dans la main d'un policier.

Lorsqu'il n'avait ni clichés ni dollars, Thompson improvisait. Sa femme et sa fille posaient pour lui en cadavres découverts dans un champ ou un fossé. Il n'expliqua jamais dans quelle mesure les flics grossiers et les psychopathes de ses romans étaient héritiers de son expérience de journaliste de faits divers. Il est probable que ses personnages de fiction n'ont été que les caricatures des policiers et des criminels qu'il avait rencontrés dans les villes perdues dans les années 1930.

MANLY WADE WELLMANN écrivit pour les magazines policiers pendant toute sa carrière d'écrivain de science-fiction et d'horreur.

ABOVE LEFT & CENTER *True Thrills*, 1942

ABOVE RIGHT *Daring Detective*, March 1952

AMERICAN TRUE CRIME PUBLISHING COMPANIES

AMAZING DETECTIVE CASES CORP., 147 W. 42nd St., New York, NY: *Amazing Detective Cases*, started 1940, quarterly, (purchased from Real Detective Tales Inc. in the late 1950s)

AMERICAN ALMANAC CO. (also ACTION PLAYBOOKS INC., BAFFLING MYSTERIES INC., EMESS PUBLISHING CO. and TIMELY DETECTIVE CASES INC.), 404 N. Wesley Ave., Mount Morris, IL: *American Detective Annual*, started 1934, annual; *Baffling Detective Fact Cases*, started 1947, bimonthly; *Current Detective*, started 1944, monthly; *Photo Detective*, started 1937, monthly; *Timely Detective Cases*, started 1943, monthly

BROOKSIDE ENTERPRISES INC., 55 W. 42nd St., New York, NY: *1955 Police Report*, single issue; *Detective Cases*, started 1955, bimonthly; *Police Dragnet Cases*, started 1955, bimonthly; *Police Files*, started 1953, bimonthly

CAL-YORK FEATURES INC., 24 W. 45th St., New York, NY: *Private Eye*, start date and frequency unknown

CLAYTON PUBLISHING (possibly also SECURITY PUBLISHING CORP. and PYRAMID PUBLISHING), New York, NY: *Confessions of a Federal "Dick,"* 1930s, single issue; *The Confessions of a Stool Pigeon*, 1931, single issue; *Uncle Sam's Gang Smashers*, 1937, single issue

CLOSE-UP INC., 1 Appleton St., Holyoke, MA and 241 Church St, New York, NY: *Confidential Detective Cases*, started 1942, bimonthly; *Human Detective Cases*, started 1945, bimonthly; *Revealing Detective Cases*, started 1942, bimonthly

COUNTRY PRESS INC. (also RURAL HOME PUBLISHING), 1100 W. Broadway, Louisville, KY, and Broadway and 11th, Louisville, KY: *Daring Detective*, 1934 to 1943, monthly; *Dynamic Detective*, 1937 to 1943, monthly; *Pictorial Detective*, started 1945, monthly; *Real Police Story*, started 1937; *Startling Detective Adventures*, started 1927, monthly; *True*, started 1937, monthly; *True Police Cases*, started 1936, monthly; *True Thrills*, started 1942

COUNTRYWIDE PUBLICATIONS (also STORIES, LAYOUT & PRESS INC. and M.F. ENTERPRISES INC.), 150 Fifth Ave., New York, NY, before 1974,

then 257 Park Ave. South, New York, NY: *Crime Does Not Pay*, started 1967, bimonthly; *Heroes and Villains*, started 1976, bimonthly; *Mobs and Gangs*, started 1977, bimonthly

CURRENT DETECTIVE STORIES INC. (also EXCLUSIVE DETECTIVE STORIES INC.), 350 Fifth Ave., New York, NY: *10 True Crime Cases*, started 1946, bimonthly; *Exclusive Detective*, started mid-1940s, quarterly

DELL PUBLISHING COMPANY INC., 261 Fifth Ave., New York, NY: *Big Detective Cases*, started 1948, annual; *Front Page Detective*, started 1937, monthly, (purchased from Exposed Publishing in the mid-1940s); *Inside Detective*, started 1935, monthly, (purchased from Exposed Publishing in the mid-1950s)

DESIGNS PUBLISHING CORP, 211 E. 37th St., New York, NY: *Vice Over America*, 1951, single issue

DETECTIVE HOUSE INC. (also ASTRO DISTRIBUTING, HANRO CORP., MAGAZINE HOUSE, MAGAZINE VILLAGE, NEWSBOOK PUBLISHING, PUBLISHERS PRODUCTIONS, and YOUR GUIDE PUBLICATIONS), 114 E. 32nd St., New York, NY, and 441 Lexington Ave., New York, NY: *1950 Detective Year Book*, single issue; *All True Fact Crime Cases*, started 1949, bimonthly; *The Best True Fact Detective Cases* (changed to *Best True Fact Detective* by 1951), started mid-1940s, quarterly, then bimonthly in 1951; *Crime Detective*, started 1938, monthly, (purchased from Macfadden Publishing prior to 1957); *Detective Annual*, start date unknown, annual; *Homicide Detective*, started 1951, bimonthly (purchased from World at War Publishing by 1954); *Line-Up Detective Cases*, started 1946, quarterly; *Police Casebook Annual*, started 1956, annual; *Police Detective Cases*, started 1945, bimonthly; *Police Reporter Yearbook*, started 1956, annual; *Real Crime Detective*, started 1953, bimonthly; *Scoop Detective Cases*, started 1943, bimonthly; *Smash Detective Cases*, started 1945, quarterly; *Special Detective Cases*, started 1937, bimonthly, from 1948 to mid-1950s; *True Cases of Women in Crime*, started 1945, quarterly; *True Crime Cases*, started 1946, bimonthly; *True Crime Detective Cases*, started 1943, monthly, then quarterly by 1946; *True Homicide Cases*, started 1955, bimonthly

DETECTIVE PUBLICATIONS INC., 750 Third Ave., New York, NY: *Front Page Detective*, started 1937, monthly (purchased from Dell Publishing in mid-1960s); *Inside Detective*, started 1935, monthly (purchased from Dell Publishing in mid-1960s)

DETECTIVE STORIES PUBLISHING CO. (also OFFICIAL DETECTIVE STORIES INC.), 731 Plymouth Ct., Chicago, IL: *Actual Detective Stories of Women in Crime*, started 1937, monthly; *Detective*, started 1940, quarterly compilation of stories from *Official*, *Intimate* and *Actual Detective*; *Intimate Detective Stories*, started 1940, monthly; *Official Detective Stories*, started 1934, monthly

EXPOSED PUBLISHING CO. (possibly a division of MACFADDEN PUBLISHING), 149 Madison Ave., New York, NY: *Front Page Detective*, started 1937, monthly; *Inside Detective*, started 1935, monthly

FACTUAL PUBLICATIONS INC., 471 Park Ave., New York, NY, and 171 Park Ave., New York, NY: *Illustrated Detective*, started 1954, bimonthly; *Official Police Cases*, started 1955, bimonthly

FAWCETT PUBLICATIONS (also COUNTRY PRESS), Fawcett Place, Greenwich, CT, and 22 W. Putnam Ave., Greenwich, CT: *Daring Detective*, started 1934, monthly (Country Press before 1949); *Startling Detective Adventures*, started 1927, monthly, (shortened to *Startling Detective* by 1949); *True Police Cases*, started 1946, monthly

FINGER PRINT PUBLISHING ASSOCIATION, 1920 Sunnyside Ave., Chicago, IL: *Finger Print Magazine*, started 1919, monthly

FRANK A. MUNSEY CO., 280 Broadway, New York, NY: *Love Crime Detective*, started 1942, monthly

FRANK COMUNALE PUBLISHING CO., 87 S. Penataquit Ave., Bay Shore, Long Island, NY, and 505 Fifth Ave., New York, NY: *Dramatic Detective*, started 1945, bimonthly; *Federal Detective Bureau*, started 1950, monthly

GILBERTSON CO., 101 Fifth Ave., New York, NY: *Did Justice Triumph?*, started 1967, quarterly

GLOBE COMMUNICATIONS CORP., Pittsford, NY: *Detective Cases*, started 1950 (purchased from

Brookside Enterprises in the late 1960s); *Detective Files*, start date unknown, bimonthly; *Headquarters Detective*, started mid-1940s, bimonthly (purchased from Macfadden Publishing in mid-1970s); *Startling Detective Yearbook*, annual (purchased from Fawcett Publications in mid-1970s)

GRAPHIC ARTS CORP., Ninth and Sibley, St. Paul, MN: *Al Capone on the Spot*, 1931, single issue; *Jim Jam Jems*, start date unknown, monthly

JALART HOUSE INC., P.O. Box 175, Port Chester, NY: *Police Detective Yearbook*, started 1958, annual

J.B. PUBLISHING CORP., 220 W. 42nd St., New York, NY: *Wanted*, start date unknown, bimonthly

M.F. ENTERPRISES INC., 150 Fifth Ave., New York, NY: *Crime and Punishment*, started 1967, bimonthly; *Crime Does Not Pay*, started 1967, bimonthly

MACFADDEN PUBLISHING (also ARTVISION PUBLISHING, CRIME CONFESSIONS INC., CRIME DETECTIVE INC., CURRENT DETECTIVE STORIES INC., HEADLINE DETECTIVE INC., HEADQUARTERS DETECTIVE INC., HILLMAN PERIODICALS INC., NEW METROPOLITAN FICTION INC., NON-PAREIL PUBLISHING, POSTAL PUBLICATIONS, SENSATION MAGAZINE INC., and W. A. SWANBERG), Washington and South Avenues, Dunellen, NJ: *All-Fact Detective*, started 1942, monthly; *American Detective*, 1931 to 1938, monthly; *Complete Detective Cases*, started late 1930s, bimonthly; *Crime Confessions*, started 1939, monthly; *Crime Detective*, started 1938, monthly; *Exposé Detective*, started 1942, monthly; *Famous Detective Cases*, started 1934, monthly; *Front Page Detective*, started 1937, monthly; *Great Detective Cases*, start date and frequency unknown; *Headline Detective*, 1939 to 1943, monthly; *Headquarters Detective*, started mid-1940s, bimonthly; *Inside Detective*, started 1935, monthly; *The Master Detective*, started 1929, monthly; *Real Detective Tales*, started 1924, monthly (purchased from Real Detective Tales Inc. in mid-1940s); *Sensation*, started 1941, quarterly; *True Detective Mysteries*, started 1924, monthly

MAGAZINE VILLAGE INC., Purchase, NY: *Crime Annual*, start date unknown, annual

MARKALL PUBLISHING CO., 105 W. Adams St., Chicago, IL: *Unsolved Murders*, started 1954, bimonthly

MARKRITE ENTERPRISES INC., 19 Biltmore Ave., Tuckahoe, NY: *The Big Story Magazine*, started 1951, monthly

THE PICTURE DETECTIVE PUBLISHING CO., The Charlton Building, Derby, CT: *District Attorney's Detective*, started 1949, bimonthly; *Federal Crimes Detective*, started 1949, bimonthly; *Police Record Detective*, started 1953, quarterly

POPULAR BOOK CORP. PUBLISHING, 96-98 Park Pl., New York, NY: *Exposé of Racketeers and Their Methods*, 1930, single issue

REAL DETECTIVE TALES INC. (also CRIME FILES INC., UNIVERSAL CRIME STORIES INC. and UNCENSORED DETECTIVE INC.), 4600 Diversey Ave., Chicago, IL, then 1050 N. LaSalle St., Chicago, IL, from early 1940s: *Amazing Detective Cases*, started 1940, quarterly; *National Detective Cases*, started 1943, quarterly; *Real Detective Tales*, started 1924, monthly; *Uncensored Detective*, started 1942, monthly

REPUBLIC FEATURES SYNDICATE INC., 39 W. 55th St., New York, NY: *Private Investigative Detective Magazine*, started 1956, quarterly

RGH PUBLISHING CORP., 460 W. 34th St., New York, NY: *Front Page Detective*, started 1937, monthly (purchased from Detective Publications by 1984); *Inside Detective*, started 1935, monthly (purchased from Detective Publications by 1984); *The Master Detective*, started 1929, monthly (purchased from TD Publishing by 1983); *Official Detective Stories*, started 1934, monthly, (purchased from TD Publishing by 1972); *True Detective Mysteries*, started 1924, monthly (purchased from TD Publishing by 1983)

ROSTAM PUBLISHING INC., P.O. Box 1374, New York, NY: *Police Detective*, started 1946, bimonthly (purchased from Skye Publications after 1973)

SHARD PRINTING CO. INC., 1008 W. York St., Philadelphia, PA: *Detective and Murder Mysteries*, started 1936, bimonthly

SKYE PUBLISHING CO. (also BANNISTER PUBLISHING and MALE PUBLISHING CORP.), 270 Park Ave., New York, NY, 60 W. 46th St., New York, NY, and Louisville, KY: *Complete Detective Cases*, started late 1930s, bimonthly (purchased from Macfadden Publishing by 1953); *Crime Confessions*, started 1939, monthly (purchased from Macfadden Publishing by 1957); *Deadline Detective*, started 1953, bimonthly; *Detective News*, start date unknown, bimonthly; *Exposé Detective*, started 1942, monthly, (purchased from Macfadden Publishing by 1956); *Eyewitness Detective*, start date unknown, bimonthly; *Eyewitness Detective Extra*, start date and frequency unknown; *Police Detective*, started 1946, bimonthly; *Special Detective Cases*, started 1937, bimonthly (purchased from Detective House in 1956); *True Cases of Women in Crime*, started 1945, quarterly (purchased from Detective House by 1957); *True Crime*, started 1943, bimonthly; *True Mystery*, started 1950, bimonthly

STARLING HOUSE INC. (also PONTIAC PUBLISHING CORP.) 260 Park Ave. South, New York, NY, 201 Park Ave. South, and 235 Park Ave. South, New York, NY: *Confidential Detective Cases*, started 1942, bimonthly (purchased from Close-Up Inc. in late 1950s, listed as Pontiac Publishing from 1970)

TD PUBLISHING CORP., 206 E. 43rd St., New York, NY: *Lady Killers*, 1963, single issue; *Unsolved Murders*, 1964, single issue; *The Master Detective*, started 1929, monthly (purchased from Macfadden Publishing in 1953); *Official Detective Stories*, started 1934, monthly (purchased from Triangle Publications in 1970); *True Detective Mysteries*, started 1924, monthly (purchased from Macfadden Publishing in 1953)

TRIANGLE PUBLICATIONS INC., 400 N. Broad St., Philadelphia, PA: *Official Detective Stories*, started 1934, monthly (purchased from Detective Stories Publishing by 1943); *Tragedy-of-the-Month*, started 1949, monthly

THE TYPE SHACK (also G.C. LONDON PUBLISHING CORP.), P.O. Box 48, Rockville Center, NY: *Police Detective Annual*, start date unknown, quarterly; *Real Detective Tales*, started 1924, monthly (purchased from Macfadden Publishing after 1972)

UNIVERSAL CRIME STORIES INC. (also FIVE-STAR MAGAZINES INC. and SPARKLING PUBLICATIONS), 366 Madison Ave., New York, NY: *Best Detective Cases*, started 1948, quarterly; *Five-Star Detective*, started 1954, monthly; *Rare Detective Cases*, start date unknown, monthly

WAVERLY PUBLISHING INC., 1476 Broadway, New York, NY: *News Flash Detective Cases*, started 1946, bimonthly

U.S. CRIME INC., 17 E. 45th St., New York, NY: *U.S. Crime*, started 1952, every six weeks

VOLITANT PUBLICATIONS (also HISTRIONIC PUBLICATIONS, MR. MAGAZINE INC., PICTURE MAGAZINES INC., and TRU-LIFE DETECTIVE CASES INC.), 103 Park Ave., New York, NY, and 105 E. 35th St., New York, NY: *Famous Police Cases*, started 1949, bimonthly; *Sensational Detective Cases*, started 1940, monthly; *Sensational True-Crime Detective Cases*, started 1941, monthly; *True-Life Detective Cases*, started 1941, monthly; *Vital Detective Cases*, started 1943, bimonthly

WILLIAM H. WISE & CO., 50 W. 47th St., New York, NY: *Certified Detective Cases*, start date unknown, monthly; *Line-Up Detective*, start date and frequency unknown

WORLD AT WAR PUBLISHING CO. (DETECTIVE WORLD INC. by 1950, also HOMICIDE DETECTIVE INC. and UNDERWORLD DETECTIVE INC.), 19 W. 44th St., New York, NY. Previously, Lionel White, Alfred Larke, and Elihu Joseph, 55 Morton St., New York, NY: *Detective World*, started 1942, bimonthly, then eight times a year by 1950; *Famous Kidnapings*, date unknown, single issue; *Homicide Detective*, started 1951, bimonthly; *Underworld Detective*, started 1949, nine times a year

ZENITH PUBLISHING CORP., 655 Madison Ave., New York, NY: *Complete Police Cases*, started 1954, quarterly

ACKNOWLEDGMENTS

Thanks go to George Hagenauer and Marc Gerald for additional writing, as well as to Lee Horsley and Robert Lesser whose chapters were not used. Thanks to Patterson Smith (patterson-smith.com) and Graham Holroyd for providing those hard to find 1920s issues of *True Detective* and to Daniel Hearn for sharing his knowledge and original George Gross paintings, seen on pages 6, 312 and 313. Finally, thanks to Bill Smith for his preliminary layouts for the book.

Eric Godtland would like to thank CultMags.com for being the bottomless well for back issue collectors, and his wife Erin and daughters Calia and Ava, mother and father Diane and Duane and brother Dustin Sorenson for all of their support over the years, as well as James Huxtable, Marti Schein and David Rawson. Thanks also to Dian Hanson for being pleasantly surprised that I am not a crappy writer.

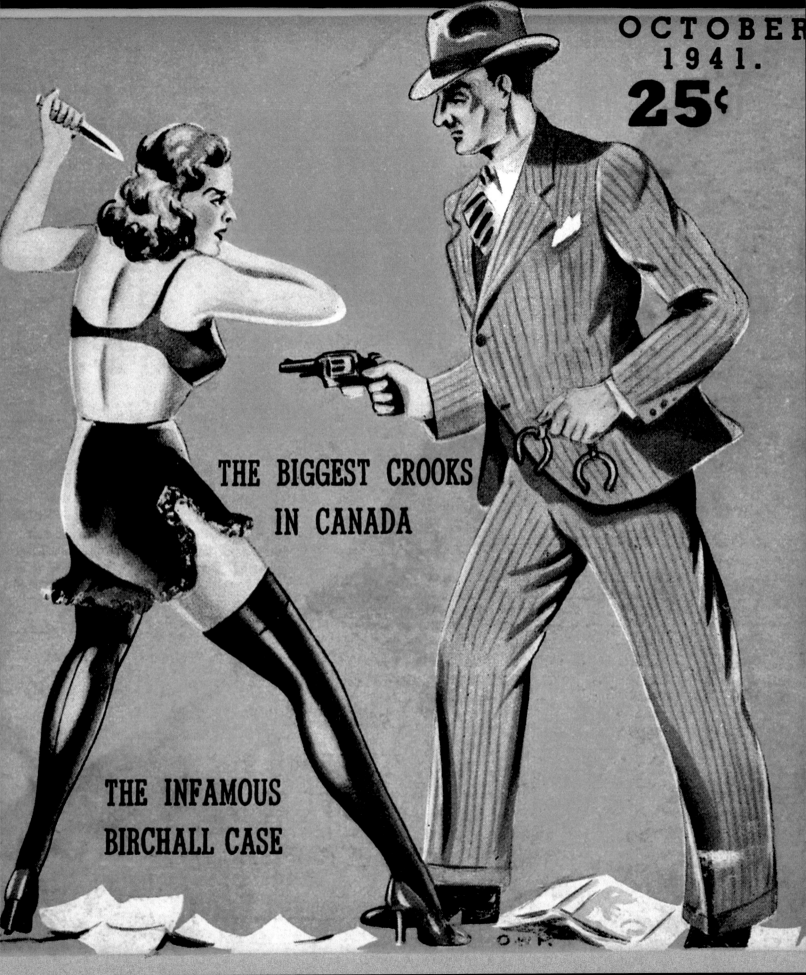